JOHN HEDGECOE

The
Photographer's
Handbook

EBURY PRESS

Photography **John Hedgecoe**

Text **Leonard Ford and John Hedgecoe**

Project Director **Roger Pring**

With special contributions from:
Michael Allman, Heather Angel,
Gerry Cranham, Robert Forrest, Bill Gaskins,
Adrian Holloway, Ewan Mitchell, W. E. Pennell,
Gordon Ridley and David Waterman

The Photographer's Handbook was conceived, edited and designed by
Dorling Kindersley Limited 29 King Street London WC2

Copyright © 1977 by Dorling Kindersley Limited, London

Text copyright © 1977 by Dorling Kindersley Limited and John Hedgecoe
Photographs by John Hedgecoe copyright © 1977 John Hedgecoe

First published in Great Britain
in 1977 by Ebury Press Chestergate House
Vauxhall Bridge Road London SW1V 1HF

Printed in Italy by A. Mondadori Verona

ISBN 0-85223-123-7
second printing, November 1977

Contents

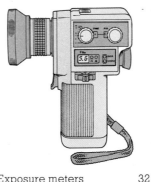

Color film

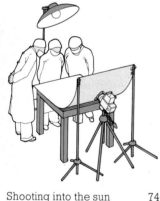

Working with light

Using lenses

Working with black and white

Working with color

Controlling movement

Composition

Photographing people

Studio techniques

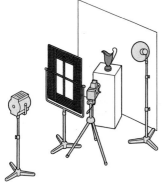

Special darkroom techniques

Special projects

Storage and display

Preface

This book is designed to explain the full scope of photography, from the fundamentals of taking photographs, processing and printing them to the advanced aspects of such topics as composition, studio work and darkroom techniques. With the help of photographs and illustrations, it also aims to show you how the full range of available photographic equipment works, and how you can use it to achieve almost every possible effect.

The Photographer's Handbook is fundamentally a reference book. There are over 600 self-contained entries, each of which contains a practical explanation of a specific topic. Appropriate cross-references to other entries are listed at the end of each entry. Entries on similar subjects are close to one another and grouped under page heads, which themselves fall into sections.

The first three sections provide a comprehensive guide to cameras, lenses, exposure meters, lights and the other equipment you can use for taking photographs. The next three sections tell you about black and white film, how to process it and make prints from negatives; this is followed by three sections which cover color film, processing and printing.

Then come eight sections – 166 pages in all – which cover every aspect of actually taking photographs. Each of these eight sections expounds a theme; the basic principles are explained, and the potential is explored, often beyond conventional limits.

For example, the first of the eight sections, "Working with light", discusses the fundamentals of lighting, namely controlling its direction and quality. Several other entries are devoted to working with natural light, showing you how to work in daylight, dusk, moonlight and available light indoors. However, also included here are the creative effects which can be achieved by pointing your camera at the sun – something the beginner is usually advised to avoid. Even the possibilities of lens and iris flare – normally considered mistakes – are examined. Another set of entries discusses working with artificial light. The techniques of using one lamp, two lamps and multiple lighting are explained, but again the full range of possibilities is explored. The reader is told, for example, how to work in candlelight and in street lighting, how to photograph fireworks and illuminated signs at night, and how to use flash to make a daylight shot look as if it was taken at night.

The other seven of these sections – "Using lenses", "Working with black and white," "Working with color", "Controlling movement", "Composition", "Photographing people", and "Studio techniques" – work in the same way, always taking the possibilities to their limits as well as explaining fundamentals.

These eight sections are followed by a lengthy section on "Special darkroom techniques". This sets out every special effect which can be achieved in the darkroom – effects like solarization, posterization, montage, silk screen, vignetting, step-and-repeat images, color toning, print and negative retouching and so on. The beginner should read this section in conjunction with the sections on black and white, and color, processing and printing.

The "Special projects" section, which follows, tells you how to photograph unusual subjects such as wildlife, underwater scenes and the sky at night, and how to construct special presentations like instructional sequences and slide-tape shows. The next two sections contain practical advice on "Storage and display" and "Fault analysis", and the final section, "Working in photography" is for the amateur who is thinking of turning professional.

The book ends with a twenty-five page, alphabetically arranged, glossary containing definitions of technical terms, brief descriptions of equipment and techniques, and detailed formulae for mixing developers, reducers, toners and so on.

How you use the book depends on how specific your interest or enquiry is. If you want to find out about a general topic, say, photographing people or controlling movement, or even more specific aspects like taking group portraits or sports photography, turn to the contents list at the front of the book. Here the section and page heads are listed with their page numbers. On these pages you will find a number of entries, each discussing a different aspect of the topic. For a comprehensive view read all the entries and take note of any cross-references at the end of the entries.

If your interest is more specific – you want to use computer flash, buy a motor drive unit or photograph stained glass – turn to the index at the back of the book. The page number relating to the main entry on a topic is printed in bold type. Your query should be answered by the single entry, but take note of any other pages referred to in the index, and of the cross-references at the end of the entry.

The basic camera

If you sit in a darkened room (a camera obscura) which has a small hole through which light can enter, say, from a brightly lit garden, an image of the garden will be seen on the opposite wall. It is from this principle, known over 1000 years ago, that all our sophisticated cameras derive. By the 16th century convex spectacle lenses – the type required for short sight – were used instead of pinholes. The lens gave a bright and sharp image on the focusing screen and this was used for tracing outlines of landscapes, buildings and still life.

The photographic camera only became a possibility in the 19th century with the invention of suitable light-sensitive materials, able to record the image direct. Light-sensitive emulsions were coated on to glass, slipped into the camera in place of the focusing screen, exposed for the required time and then developed. Mechanical shutters became essential to control timing, and apertures to control the brightness of the image. By the 1890s George Eastman's rollfilm camera allowed many pictures to be taken at one loading. Many thousands of camera designs have since been tried, culminating in the six main camera types described on the pages which follow.

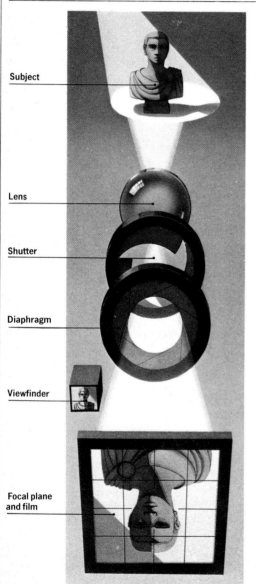

Subject

Lens

Shutter

Diaphragm

Viewfinder

Focal plane and film

Light source and subject. Some form of light source – be it sun, an electric lamp, or just a candle – is needed to illuminate the subject of any photograph. Remember: photography means "writing with light." Light reaching subject and background is reflected in all directions, and some of these light rays will pass through the lens to make up the image. Where the subject is colored the reflected rays will be colored too. The position of the light source (its height and direction) and the quality of the light (whether harsh like

Lens. Basically in its simplest form the lens is a disk of glass ground and polished until it is thinner at the edges than the center, in other words convex. The lens accepts the ever-widening beams of light reflected from every point on the subject, and causes them to converge to points again, which collectively make up an inverted image. This focusing of the light gives a bright and clear image. Lens "bending power" is described as focal length, which is the distance from the lens to the focal plane – where the image is formed

Shutter. The shutter is an on/off device which allows you to choose the exact moment the photograph is taken, and to control the total time light is able to act on the film. There are two main shutter types: light-tight metal blades located close to the lens and diaphragm, able to block all light from entering the camera, left, and larger light-tight blinds running just in front of the film, far right. Bladed shutters are simpler, but the blind, or "focal plane" shutter allows for lenses to be changed mid-film, and for a reflex system so you

Diaphragm. The diaphragm, aperture, or "stop" is always located close to the lens. It acts like the iris (the colored part) of the human eye. By varying its diameter we can control the amount of light entering the camera and therefore the brightness of the image. A large aperture used with a dimly lit subject can give the same brightness as a small aperture used in brilliant lighting conditions. Most diaphragms are made up from sets of thin metal blades – by rotating a control ring the aperture is smoothly reduced in diameter.

Viewfinder. All cameras designed for use in the hand require some form of viewfinder to allow you to aim the camera and compose the image accurately. This may be an optical peep-sight as shown left, or a simple wire frame which shows you the boundaries of the picture. Many cameras today use some form of reflex viewfinding system. This uses a second lens or even the taking lens itself to show the exact image which the film will record on a focusing screen. Single lens reflex viewfinding has the

Focal plane. This is the flat surface on which a sharp image of the subject is formed. If a photograph is being taken the film is stretched across the focal plane. The nearer the camera is to the subject the further the focal plane is from the lens. You therefore need some focusing mechanism to move the lens away from or toward the back of the camera so that you can get sharp images of near or distant subjects. All cameras are designed so that, when properly focused, the focal plane coincides with the surface film.

Types of camera. The modern camera designs described on the following pages offer a variety of picture sizes, viewfinders, body shapes and styles, and, of course, prices. The large format view camera, once the only form of camera, is now used mostly by professionals for specialist purposes. Its modern version is the monorail or baseboard 4 x 5 ins (10.2 x 12.7 cm). Most progress has been toward smaller, handier format cameras – firstly the 35 mm or roll-film direct viewfinder and twin lens reflex types.

During the past twenty years, however, the dominant design trend has been the single lens reflex. This includes both the universally popular 35 mm pentaprism types and roll-film versions used by professionals and advanced amateurs. More recently the desire for convenience cameras which exploit improvements in lens/film resolving power has resulted in 110 size pocket cameras and sub miniature designs. Rapid change lenses, magazine backs, exposure automation and instant picture

devices have also helped to make cameras much more versatile and faster to use.

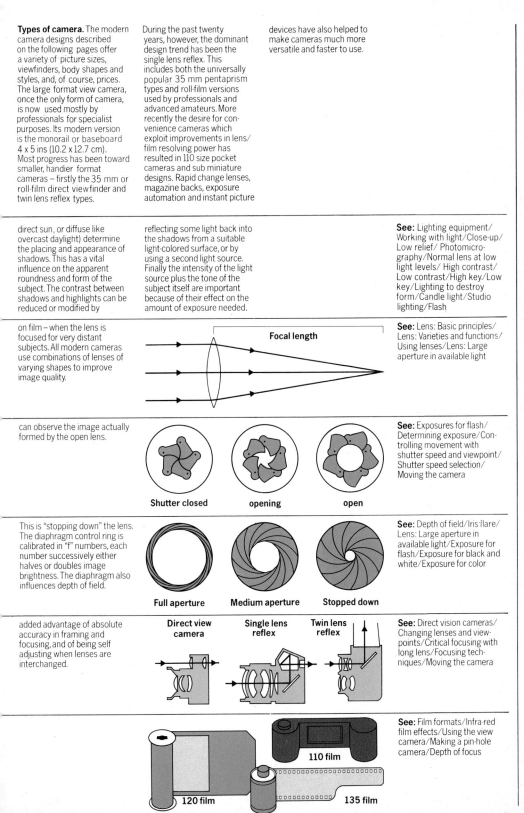

direct sun, or diffuse like overcast daylight) determine the placing and appearance of shadows. This has a vital influence on the apparent roundness and form of the subject. The contrast between shadows and highlights can be reduced or modified by

reflecting some light back into the shadows from a suitable light-colored surface, or by using a second light source. Finally the intensity of the light source plus the tone of the subject itself are important because of their effect on the amount of exposure needed.

See: Lighting equipment/ Working with light/Close-up/ Low relief/ Photomicrography/Normal lens at low light levels/ High contrast/ Low contrast/High key/Low key/Lighting to destroy form/Candle light/Studio lighting/Flash

on film – when the lens is focused for very distant subjects. All modern cameras use combinations of lenses of varying shapes to improve image quality.

Focal length

See: Lens: Basic principles/ Lens: Varieties and functions/ Using lenses/Lens: Large aperture in available light

can observe the image actually formed by the open lens.

Shutter closed **opening** **open**

See: Exposures for flash/ Determining exposure/Controlling movement with shutter speed and viewpoint/ Shutter speed selection/ Moving the camera

This is "stopping down" the lens. The diaphragm control ring is calibrated in "f" numbers, each number successively either halves or doubles image brightness. The diaphragm also influences depth of field.

Full aperture **Medium aperture** **Stopped down**

See: Depth of field/Iris flare/ Lens: Large aperture in available light/Exposure for flash/Exposure for black and white/Exposure for color

added advantage of absolute accuracy in framing and focusing, and of being self adjusting when lenses are interchanged.

Direct view camera **Single lens reflex** **Twin lens reflex**

See: Direct vision cameras/ Changing lenses and viewpoints/Critical focusing with long lens/Focusing techniques/Moving the camera

110 film

120 film **135 film**

See: Film formats/Infra-red film effects/Using the view camera/Making a pin-hole camera/Depth of focus

Simple direct vision camera

The direct vision camera is so called because it uses a sighting device which is quite separate from the taking lens. You view the subject directly through a tube-like system, usually with a simple lens at each end, and the viewing area is outlined to show how much of the scene will be included.

For and against

The advantage of this camera design is that you always have a sharp, bright view of the subject,' and only the minimum of settings have to be made before taking the picture. Mechanically it is simple and cheap to construct, and the camera body can be kept small. Most have "fixed focus" lenses set for subjects between about 6 ft (2 m) and infinity and controls for the bladed shutter and aperture

simply coded in weather con-dition symbols. Your photography is certainly limited with such a basic camera. The aperture and shutter may not allow exposures under dim lighting conditions, and you will probably be unable to record the subject sharply and leave the background unsharp. Lenses cannot be interchanged.

Typical low cost, direct vision camera.
The Prinz Junior 35, below, will produce up to 36 pictures, 36 x 24 mm format, on standard 35 mm film. Its simple mechanics are limited to a two-speed bladed shutter and a means of winding on the correct length of film between exposures. The lens is fixed focus, but because its largest aperture is relatively small, sharpness extends from about 6 ft (2 m) to infinity.

Parallax

A simple direct vision viewfinder cannot share exactly the same viewpoint as the camera lens. It is usually positioned an inch or so away on the camera body and arranged to see the same amount of a distant subject as the lens records on film. But when you start using the camera close up, dis-placement between the two view-

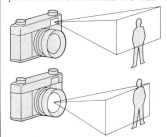

points results in the finder show-ing more of the top and less of the bottom of the picture than appears in the photograph, above. The closer the subject the worse this parallax error becomes.

Lens attachments

Some manufacturers provide a range of attachments. As well as polarizing, neutral density and color filters which can be attached to the lens, there are telephoto and wide-angle convertor attach-ments, below. Some have view-finder adaptors attached to them. Others are used with substitute viewfinders which fit in a standard accessory shoe.

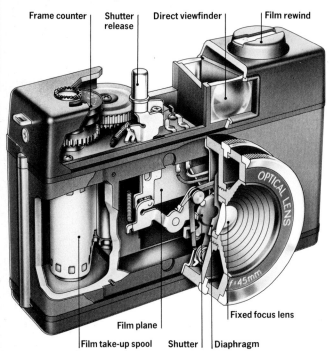

Frame counter | Shutter release | Direct viewfinder | Film rewind

OPTICAL LENS

f:45mm

Fixed focus lens

Film plane

Film take-up spool | Shutter | Diaphragm

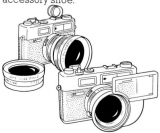

Film load and transport systems. Some 35 mm cameras of this type are designed to use drop-in 126 cartridges, but most take standard cassettes of double perforated film, enough to expose 20 or 36 pictures. The cassette is loaded into a compartment, and film threaded across the back of the camera into a take-up spool. You close the back, wind on 2 or 3 exposures using the film wind knob or flip lever and the camera is ready for use. The film wind also cocks the shutter so it is impossible to make a double exposure. After taking the last picture you disengage the film wind mechanism and rewind the exposed film into its cassette. Then open the camera back and remove the film.

Controls. The three basic camera settings control focusing, aperture and shutter. The simplest cameras have fixed focus lenses rendering anything from a full length figure to a distant landscape sufficiently sharp for normal viewing. If the lens has adjustable focusing the control ring will carry either symbols denoting, say, portraits, groups and landscapes, or a scale of subject distances. Some shutters are single speed (about 1/60 second), but most offer two or three speeds. The control ring or lever may be marked in weather symbols or even film ASA ratings, the idea being that you keep to the fastest shutter speed for pictures on fast films and the slowest for slow films. The most useful controls show actual exposure times.

Aperture adjustment can simply mean a piece of metal with a small hole in it which is swung into position behind the lens when a lever is moved from "cloudy" to "sunny." Several simple cameras have an

adjustable diaphragm, controlled by a ring with three or four weather symbols.

Direct vision with interchangeable lens

The most advanced direct vision cameras, such as the Leica CL, right, offer a number of useful features. A rangefinder ensures accurate focusing. When you turn the focusing ring two pictures in the central part of the viewfinder shift and merge, an arrangement which under dim lighting conditions is often easier to observe than an image on a focusing screen. The camera shutter is a focal plane design, a blind just in front of the film. This offers speeds from about 1/500 second to 1 second, and because of its position allows lenses to be changed without fogging the film. Interchangeable lenses range from wide-angle to telephoto. When a lens is attached to the body, it is coupled to the rangefinder system and a coded notch changes the frame outline in the viewfinder so that it matches the new angle of view. The rangefinder also controls parallax compensation in the viewfinder to suit the focused subject distance. The Leica CL has a built-in meter which makes a direct reading by means of a light sensitive cell.

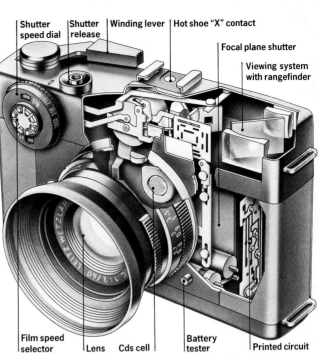

Shutter speed dial | Shutter release | Winding lever | Hot shoe "X" contact
Focal plane shutter
Viewing system with rangefinder

Film speed selector | Lens | Cds cell | Battery tester | Printed circuit

For and against

Because of these features, the camera is excellent for sports and documentary work which requires easy panning and a quiet shutter. The disadvantages are that you cannot see the effect of depth of field nor view the image exactly as it will appear on the film; both of these important facilities are provided by a single lens reflex.

Viewfinder. The rangefinder focusing system uses two windows, below – one the actual viewfinder and another placed further along the camera body. Light from the far window is reflected by mirrors into the viewfinder where it forms a superimposed "ghost" image. Focusing the camera lens causes a small mirror lens to move, shifting the ghost image sideways. You therefore look through the viewfinder and focus until both images coincide. During focusing the mask which forms the viewfinder frame moves diagonally to indicate parallax compensation.

Sophisticated direct vision camera.
The Leica CL, above, is a sophisticated direct vision 35 mm camera with coupled rangefinder, focal plane shutter and interchangeable lenses. The built-in meter measures the central portion of the image behind the lens. It uses a light sensitive cell on a spring-loaded bracket which moves it out of the way just before exposure.

Metering. Unless an expensive swing up arrangement is used, such as the through-the-lens system in the Leica CL, above, the light sensitive cell for a direct vision camera must be mounted on the outside of the camera body. Its view of the subject may therefore lack accuracy. To operate these meters you simply set the ASA film speed on an external dial, and a needle or light signal read-out in the viewfinder will show when shutter and aperture are set to give correct exposure.
See: Built-in meters

Design variations

Most direct vision cameras are designed for 35 mm or smaller film, but some are available which take larger formats. The Horseman 2¼ x 3½ ins (6 x 9 cm) hand camera, below, for example, has a folding baseboard, a range of shuttered lenses and rangefinder focusing. It also offers a number of camera movements for technical photography. The Rapid Omega 200 is a rapid action 2¼ x 2¾ ins

Horseman 985

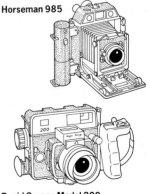

Rapid Omega Model 200

(6 x 7 cm) roll-film press camera, above. It has three interchangeable lenses, each with a coupled rangefinder and fitted with a bladed shutter. The film magazine is protected from light during lens changes.

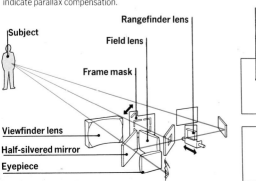

Subject | Rangefinder lens | Field lens | Frame mask | Viewfinder lens | Half-silvered mirror | Eyepiece

Out of focus | In focus

The single lens reflex

The single lens reflex is the most highly developed and deservedly popular camera for advanced work. The basic idea – using a hinged mirror to reflect the image formed by the camera lens on to a viewing screen until just before the moment of exposure – originated with 19th century plate cameras. But today's 35 mm and roll-film models have a sophistication and precision unimaginable 100 years ago. The photographer has all the advantages of a focusing screen viewfinder, but no longer has the bother of introducing film in place of the screen before shooting.

For and against

The greatest single advantage is total absence of parallax error (see Glossary). You can see exactly what the lens will place on film – the amount included, the precise distance focused, and, by stopping down the lens, the limits of depth of field. As lenses are interchanged the new field of view is automatically visible on the screen. You can attach the camera to a telescope or a microscope, fit diffusers and masks over the lens, and still see the precise image the lens will produce. And because of the SLR's world-wide popularity the newest and most advanced electronic and optical technology tends to be designed to suit this

camera before the others. Solid state through-the-lens metering, zoom lenses, motor-drive, are all part of an ever-widening "system" built around the single lens reflex body. The disadvantages of this design include the brief but sometimes disconcerting loss of image in the viewfinder at the moment of exposure, extra camera weight, complexity, and of course, price. Some photographers find focusing on a screen more difficult than focusing with an image-coinciding rangefinder, particularly in dim light or when the lens is stopped down. To overcome the latter problem most lenses use "pre-set

diaphragms." These are set to the stop required for correct exposure in the usual way, but remain fully open until just before the moment of exposure. The focusing screen therefore always shows a bright image for viewfinding, and aids critical focusing.

See: Depth of field/ Single lens reflex system/Built-in exposure meters/Focusing techniques

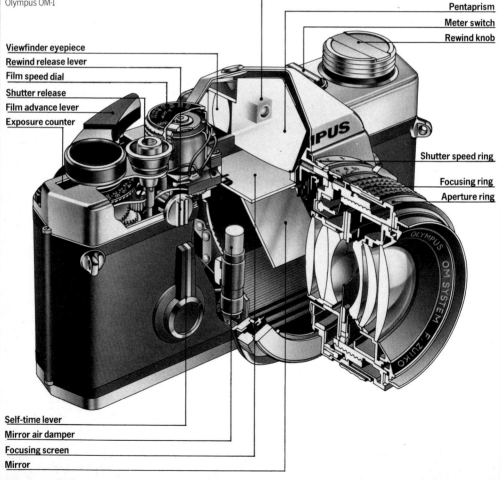

Olympus OM-1

Viewfinder eyepiece
Rewind release lever
Film speed dial
Shutter release
Film advance lever
Exposure counter

Cds cell
Pentaprism
Meter switch
Rewind knob

Shutter speed ring
Focusing ring
Aperture ring

Self-time lever
Mirror air damper
Focusing screen
Mirror

Pentaprism. The pentaprism – basically a five-sided block of glass silvered on three surfaces – is used in the eye level single lens reflex for two purposes. First, it reflects the horizontally mounted focusing screen, allowing it to be seen through the eyepiece at the rear of the camera. The image is reflected across the roof of the prism, avoiding the upside-down or left-to-right reversal which a single 45° mirror would produce. Secondly, it offers a compact, folded up, but comfortably long optical path between screen and eyepiece which are really only an inch or so apart. This reduces eyestrain and the need for complicated wide angle eyepiece optics.

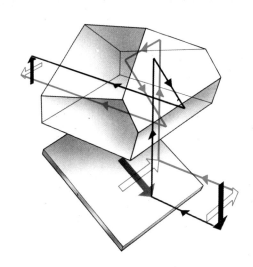

Waist-level finder. Some 35 mm SLR cameras have a slide-off removable pentaprism unit. This facilitates the fitting of interchangeable focusing screens, below, or a folding hood which converts the camera to waist-level use. Access to the focusing screen also allows grease pencil

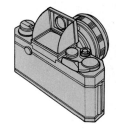

marks or image outlines to be drawn on the glass, for making multiple images in the camera. **See:** Multiple images

Focusing screens. All focusing screens offer a grained ground glass surface on which the image can be resolved. Beyond this you can choose from screens incorporating split-image or microprism focusing aids. Screens with ruled grid lines allow measurements to be made and lines in copying and architectural work to be kept straight and parallel.

Fresnel focusing screen. This is a thin, embossed plastic sheet which has a light-concentrating effect. Positioned immediately under the focusing screen its concentric ridges simply "turn-in" outward-projecting light, improving and distributing image brightness more evenly over the whole viewfinder image.

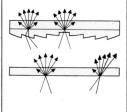

Split image focusing. Some people find it difficult to focus a ground glass screen, particularly under dim lighting conditions. As a focusing aid a "split image" or focusing screen rangefinder may be sunk into the center of the underside of the screen. It

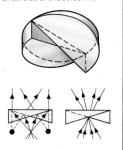

consists of two half-circular glass wedge shapes which cross each other in the plane of the focusing surface. If the image is sharply focused the picture appears continuous across this central area. Incorrect focusing of the camera lens causes the light to fall on the prism shapes in such a way that the image in the center appears split and offset. Some screens incorporate a central cluster of microprisms which scramble an unsharp image over this zone.

Focal plane shutter. The shutter consists of two blinds. One blind follows the other – forming a gap which, passing rapidly across the film makes the exposure. Gap width is controlled by the shutter speed dial. For speeds below 1/60 sec and for time exposures the second blind is delayed and the entire frame remains uncovered for the required period.

First blind opens to expose the film.

Second blind follows.

Gap between blinds determines exposure.

Exposure over, whole film has received same exposure.

Exposure sequence. When you depress the shutter release button of a SLR camera first the mirror comes up, allowing light to reach the back of the camera but blocking its entry through the viewfinder. The automatic diaphragm closes to the pre-set aperture and the shutter fires. Then the aperture re-opens and the mirror falls back into place.

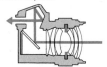

Light passes through lens to viewfinder via mirror.

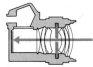

Shutter release button pressed, mirror up, diaphragm closes.

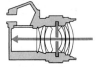

Shutter exposes film.

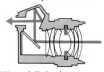

Mirror falls back, diaphragm re-opens.

Camera systems

One of the advantages of buying a sophisticated camera is that the manufacturer backs it up with a comprehensive range of components. The camera body remains the heart of the system, so if you plan to extend your photography gradually until you can tackle almost anything, choose the initial camera with care. Thereafter you have an ever-increasing range of lenses, from fisheye to extreme long-focus. A choice of motor drives enables pictures to be exposed at up to four per second: these are best used with a 250 picture interchangeable magazine back and can be triggered by remote electric or wireless control. Extension tubes and bellows allow you to take life-size close-ups, (1:1 ratio), and with bellows extensions you can get close-ups which are several times life-size. The camera body can be attached with an adaptor to a microscope, making even greater enlargements possible. Other specialized adaptors, clamps, stands, and lens attachments allow you to photograph anything from a grain of pollen to the surface of the moon.

Camera body. A single lens reflex camera body, below, will accept interchangeable items like those shown on these pages, from pentaprism to ring flash.

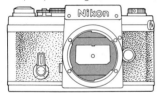

Lenses

A typical range of interchangeable lenses includes fisheye and other extreme wide-angle lenses which have focal lengths between 8 and 21 mm. Wide-angle, normal and moderately long-focus telephoto lenses of 24 mm, 55 mm and 135 mm respectively form the hard core of the average range. Then come a selection of a dozen or so telephotos, up to 1000 mm in focal length. Special lens designs include wide-angle models with shift mounts, macro lenses for close work, and compact long-focus mirror lenses. The variable focal length, or zoom, lens may eventually replace several of the lenses shown here. Each lens has a precision coupling for attachment to the appropriate camera body, and the whole range is matched in color rendering and image quality.
See: Lenses: varieties and functions/Using lenses

Key
1. 55 mm
2. 8 mm fisheye
3. 18 mm
4. 25 mm
5. 28 mm shift
6. 800 mm mirror
7. 200 mm
8. 75–150 mm zoom
9. 600 mm
10. 1000mm

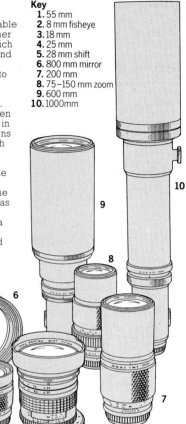

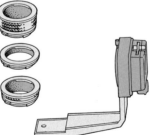

A comprehensive lens set. This comprises a selection of wide-angle, normal, and telephoto lenses plus a zoom.

Extension tubes and bellows

All the units in this group, right, are designed to fit between lens and camera so that you can focus very close subjects sharply. Rings or tubes of different lengths can be used singly or coupled together in various permutations. The bellows system allows continuous variation of lens-to-film distance. It is supported on a rail which allows independent movement of the camera body at one end affecting image size, and focusing of the lens at the other. You can buy a bracket which holds color slides, stamps, and other small objects in front of the camera lens for copying.

Close-up equipment. The set of interlocking extension tubes, right, above, can be used in any combination. The extension bellows, right, and the slide-copying camera body attachment, top right, complete the equipment for close-up work.

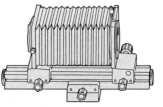

Ring flash

This is an electronic flash light source which is attached to the camera around the standard or macro lens. It is energized from a separate power pack. The circular flash tube produces very even, soft frontal illumination giving excellent detail in close-ups where maximum visual information is required.
See: Electronic flash

Clip-on ring flash head. The thick lead connects to the electronic flash power pack; thin leads trigger flash from shutter.

Viewfinders

Some camera systems offer an interchangeable range of eyepiece devices for viewing the ground glass focusing screen. Chief among these is the pentaprism, a specially shaped block of glass which allows an upright, left-to-right corrected image to be seen through an eyepiece at the back of the camera. Another is simply an unfolding hood which gives a direct view of the screen from above. This is intended for use when the camera is held at waist level or below. The hood shades the screen from extraneous light and a folding magnifier enlarges the image. Yet another alternative is a combined pentaprism and focusing screen exposure meter. This is usually coupled directly with the camera's shutter speed and lens aperture controls. A meter needle or light signal read-out appears alongside the focusing screen.

Key
1. Folding waist-level hood **2.** Pentaprism **3.** Combined exposure meter and interchangeable viewfinder

Focusing screens

Focusing screens are often interchangeable. The standard screen has an overall mat focusing surface with a central microprism spot; the spot area appears to have a jagged pattern when the image is not in focus. A split image type screen is similar but the image in the spot area divides clearly in half when unsharp. For special applications you can easily change to a mat screen with a hair line grid of squares. Knowing the spacing of the lines allows you to measure the exact size of the image, which is useful for close-up/technical work. Some other screens are clear apart from a central microprism. This gives an exceptionally bright image ideal for low light work, although depth of field effects cannot be checked with any accuracy.

Key
1. Cross line **2.** Split image **3.** Center microprism **4.** Clear interchangeable focusing screen

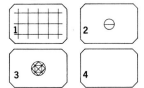

Specialized equipment

You can add an enormous amount of specialized equipment to a modern advanced camera system. The selection below suggests some of the accessories now available; others are described in more detail on other pages.

Photomicroscope adaptor
The camera body is attached through this adaptor to the optical system at the top of a microscope. Usually this functions in parallel with the normal binocular eyepieces, so you can use the microscope normally and just press the shutter cable release to record what you see.

Endoscope adaptor
An endoscope is a long thin tube containing a series of lenses and a fiber optic system to duct light to the far end. Attached to the camera body it makes possible photography of internal body organs, the insides of inaccessible machinery and so on.

Remote control devices
These usually function in conjunction with the camera and motor drive. The camera shutter is triggered by a radio pulse transmitted from up to ¼ mile (400 m) away and picked up by a receiver linked to the camera's electro release. A microphone or photocell can equally well be used to fire the camera when triggered by sound or light respectively. Applications for this sort of equipment include natural history and security surveillance, and any situation where you cannot be behind the camera – when the camera is attached to the wing of an aircraft, for example.

A repro copy stand
This resembles the column of an enlarger, supporting the camera (with a macro lens) at an adjustable height above a copy board. It is an efficient aid for copying drawings, text from books, or small objects such as stamps or coins. Two lamps clamped at the sides provide even lighting.

Underwater housings
The camera and basic lens range encased in an underwater housing can be used down to specified depths ranging from 20 to 650 ft (6.1 to 200 m). The controls for aperture, focusing, shutter speed and film transport are generally attached through links to large, easily handled dials and levers on the outside of the housing.
See: Lens attachments/Telescope adaptor

Interchangeable backs and motor drives

Instead of the normal camera back you can change to a specialized model, for example one which exposes date, time and other dialled-in information alongside each frame. Backs with enlarged film chambers allow you to shoot 250 or even 750 exposures before reloading. They are ideal for use with an electric motor drive which automatically winds on the film one frame immediately after an exposure has been made. Provided you use a short shutter speed, a motor drive enables you to take in sequence at rates of up to four frames per second.

Backs, bulk cassettes and motor drives. Besides the motor drive which is fitted directly on to a camera with a standard back, left, there are various kinds of interchangeable camera backs: the 250 exposure film back, bottom left; the data recording back, bottom right; and the 750 exposure with motor drive, below.

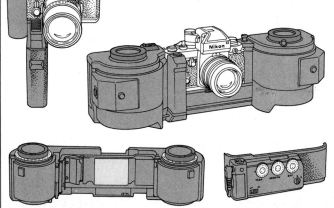

Roll-film single lens reflex

Roll-film SLR cameras are designed for 70 mm wide film – either 120 or 620 roll-film, or double perforated film in bulk. Most models give pictures 2¼ ins (6 cm) sq, but a few give rectangular pictures 2¼ x 2¾ ins (6 x 7 cm) or 1⅝ x 2¼ ins (4.5 x 6 cm). The Hasselblad shown here forms the basis of an extensive system. Various auxiliary view-finders are available, including a penta-prism to correct the

laterally reversed image on the focusing screen. The whole camera is larger, heavier, slower to crank and much more expensive than its minia-ture counterpart.

For and against
One significant advant-age of roll-film SLRs is the improved image which results from a negative over four times the area of 35 mm. Most models offer interchangeable

magazines so that you can change from color to black and white, from negative to transparency even in mid-film, or sub-stitute an instant picture back. The lenses may also have bladed shutters along with the camera's focal plane blind; these allow electronic flash -synchronization at fastest

shutter speeds. But per-haps most important of all, the roll-film SLR gives the amateur access to pro-fessional camera systems where standards of qual-ity and reliability are among the highest obtainable. Unfortunately every item in these sys-tems is highly expensive relative to 35 mm.

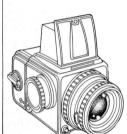

Hasselblad 500 CM

Hood.
Normally the hood is collapsible with a flap-up focusing magnifier, but this can be interchanged with other hoods.

Magazine.
This holds roll-film feed and take-up spools. The slide-in light-proof metal plate prevents fogging during a mid-film interchange, but must be removed before the shutter will fire. Film is shifted through a gear-train connection with the camera body.

Lens.
Each interchange-able lens has its own focusing mount and – in this model – has its own fully synchro-nized bladed shutter. Shutter blades are programmed to remain open until just before the mirror rises.

Focusing screen
Pressure plate
Dark slide
Film back
Film advance mechanism
Film advance crank

Mirror
Shutter release
Focusing ring
Shutter unit
Depth of field preview lever
Light value lock knob
Shutter/aperture setting ring

Film wind.
Film is wound on by several turns of a large knob. Alterna-tively the body may have a built-in electric motor.

2¼ x 2¼ ins (6 x 6 cm) models. Roll-film single lens reflexes are produced to a number of different designs. The Rollei SL66 2¼ x 2¼ ins (6 x 6 cm) incorporates an extension bellows to facilitate close-up work, and also a tilting lens panel which allows a degree of depth of field control. In the Rollei SLX, changes of shutter speed and aperture setting are achieved by linear motors controlled by automatic exposure devices. Both cameras are provided with interchangeable magazines.

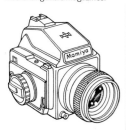

Mamiya RB67

2¼ x 2¾ ins (6 x 7 cm) models. In this group the Mamiya RB67, above, contains a revolving magazine back to take advantage of the extended format in horizontal and vertical use. An extension bellows is also fitted. The Pentax 6 x 7, below, resembles an inflated version of the same manufacturer's 35 mm camera, the controls being similarly positioned. A number of interchangeable viewfinders are also available.

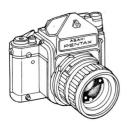

Pentax 6 x 7

1⅝ x 2¼ ins (4.5 x 6 cm) models. This design, the so-called "ideal format", enables the camera to be made considerably smaller and lighter than the models shown above. The Bronica ETR can be fitted with a hand grip incorporating a film-wind lever and shutter release. The camera can then be held and operated in almost the same manner as a 35 mm SLR. The Mamiya 645 resembles the Hasselblad in shape and the range of accessories which are obtainable; a revolving tripod head can be fitted to the camera for use in the vertical format.

Twin lens reflex

The twin lens reflex design is much older than the SLR and was one of the most popular "advanced" types of camera prior to World War II. The few which are produced today are mostly 2¼ ins (6 cm) sq roll-film models. The camera body is divided into two entirely separate halves and uses two lenses of identical focal length. The top one forms an image via a 45° fixed mirror on to a full size focusing screen on the top of the camera. Only the bottom lens is fitted with diaphragm and bladed shutter, and this forms its image directly on to the film.

For and against
The focusing screen of the TLR provides more image information than a direct vision viewfinder camera, but without the complexity and cost of the SLR. The camera is mechanically simple and unlike the SLR you can observe the image on the focusing screen at all times, even during exposure. However, it also appears reversed left-to-right, and parallax error between the slightly differing viewpoints of the two lenses causes inaccuracies, particularly in close-up. The TLR is also bulky for its picture size and therefore rather awkard to carry about. **See:** Parallax

Rolleiflex

Parallax and its control.
To counteract parallax a warning marker line under the focusing screen may denote the effective top of the frame and is linked to the focusing knob, which moves it increasingly into frame. For full correction mount the camera on a tripod, focus and compose the picture, then before exposing raise the whole camera by an amount equal to the distance separating the two lenses.

Viewfinder/focusing screen.
The focusing screen is surrounded by a folding metal hood, right, to prevent top light diluting the image. It also has a fold-down focusing magnifier. The whole hood can be replaced by a pentaprism eyepiece.

Interchangeability of lenses.
A few TLR cameras allow interchangeable lenses, which are each supplied as matched pairs, the bottom lens having a bladed shutter. A light-proof flap is lowered within the camera body to prevent fogging when the lens is changed in the middle of a film.

Variations in design.
Rolleiflex and Yashicamat cameras have fixed lenses and have to use accessory attachments to convert to wide-angle and telephoto. Rolleiflex allows picture size conversion to 35 mm. Cambo's scaled up TLR for 4 x 5 ins (10.2 x 12.7 cm) pictures accepts sheet film

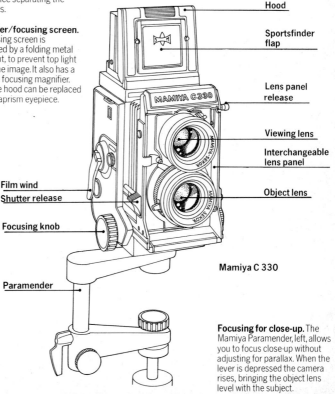

Hood

Sportsfinder flap

Lens panel release

Viewing lens

Interchangeable lens panel

Object lens

Film wind

Shutter release

Focusing knob

Paramender

MAMIYA C330

Mamiya C 330

Focusing for close-up.
The Mamiya Paramender, left, allows you to focus close-up without adjusting for parallax. When the lever is depressed the camera rises, bringing the object lens level with the subject.

110 pocket cameras

Pocket size cameras using 16 mm wide 110 film have become popular in recent years. New, high definition films and improved lenses coupled with machine processing, (110 is not designed for user-processing) allow prints up to about 8 x 6 ins (20 x 15 cm) to be made from the 17 x 13 mm negatives. Special projectors are made for transparencies this size. Most pocket cameras use a fixed lens with a focal length of about 25 mm. This offers extensive depth of field and may focus down to about 1½ ft (0.5 m), often with the aid of a rangefinder. Most use a direct vision viewfinder, often with some form of parallax compensation.

110 cartridge. The special 16 mm wide film for 110 pocket cameras is supplied in an instant-loading plastic cartridge consisting of feed chamber and take-up spool connected by a film path and rectangular picture aperture.

Cable release socket

Shutter button

Focusing lever

Viewfinder

Kodak

Pocket | MATIC 60 camera

Rangefinder | **Electric eye** | **Lens** | **Magicube flash bulb**

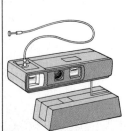

110 accessories. Both flash cubes and clip-on electronic flash units are made for 110 cameras. 110 slides can be projected through a 35 mm projector, but brightness and detail will suffer. Special projectors for 110 employ either the rotary system, above, or the conventional push-pull system. To avoid camera shake during long exposures it is worth getting a special table-top stand, left, and a cable release.

35 mm pocket cameras. Some manufacturers of 35 mm direct vision finder cameras have successfully honed down their camera body size to hippocket proportions. Examples include the Rollei XF35 and the Minox 35EL, above, both of which give 24 x 36 mm format.

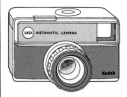

126 pocket cameras. These are generally simple direct vision cameras, such as the Kodak Instamatic, left. Some have fixed focus lenses with depth of field from about 4 ft (1.2 m) to infinity. Others have dial focusing with settings for portraits, groups and landscapes.

Subminiature cameras

Whereas pocket cameras of the drop-in plastic cassette variety are designed primarily for the snapshotter, one or two high quality instruments are made which have even smaller proportions. The Minox C, drawn below lifesize, is typical of such cameras—fully equipped for serious photography and built with the precision of a watch. The picture produced is only 8 x 11 mm, but such is the quality of the lens system that acceptable enlarge-

ments up to 8 x 6 ins (20 x 15 cm) are possible. Typical depth of field given by the 15 mm lens at widest aperture is from 3 ft (91 cm) to infinity.

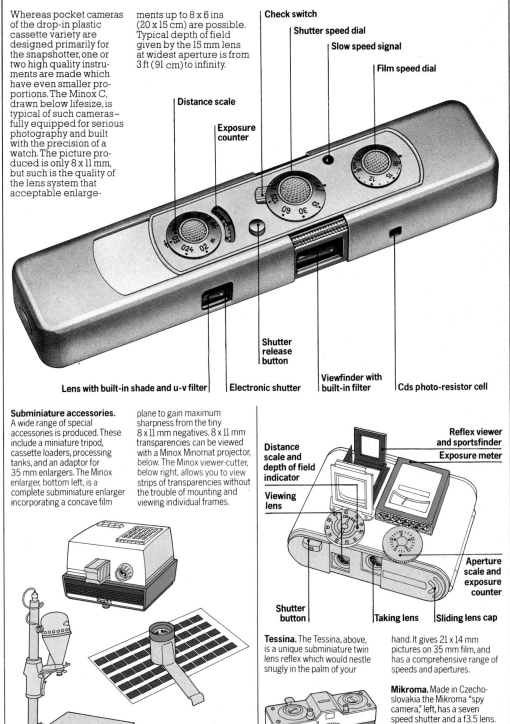

Check switch

Shutter speed dial

Slow speed signal

Film speed dial

Distance scale

Exposure counter

Shutter release button

Lens with built-in shade and u-v filter | Electronic shutter | Viewfinder with built-in filter | Cds photo-resistor cell

Subminiature accessories.
A wide range of special accessories is produced. These include a miniature tripod, cassette loaders, processing tanks, and an adaptor for 35 mm enlargers. The Minox enlarger, bottom left, is a complete subminiature enlarger incorporating a concave film

plane to gain maximum sharpness from the tiny 8 x 11 mm negatives. 8 x 11 mm transparencies can be viewed with a Minox Minomat projector, below. The Minox viewer-cutter, below right, allows you to view strips of transparencies without the trouble of mounting and viewing individual frames.

Distance scale and depth of field indicator

Viewing lens

Reflex viewer and sportsfinder

Exposure meter

Aperture scale and exposure counter

Shutter button

Taking lens | Sliding lens cap

Tessina. The Tessina, above, is a unique subminiature twin lens reflex which would nestle snugly in the palm of your

hand. It gives 21 x 14 mm pictures on 35 mm film, and has a comprehensive range of speeds and apertures.

Mikroma. Made in Czechoslovakia the Mikroma "spy camera," left, has a seven speed shutter and a f3.5 lens.

Camera design

Today's view or sheet film camera is an updated version of that mainstay of 19th century photography, the plate camera. Although it is now constructed in metal rather than wood, its essentially simple design would still appear familiar to an early photographer. Basically the view camera consists of a lens with diaphragm and a bladed shutter unit linked by flexible bellows to a large – usually 4 x 5 ins (10.2 x 12.7 cm) – glass focusing screen.

The camera is first set up on a tripod and the image composed and focused on the screen, where it appears upside-down. (Used outdoors on a bright day you may need a black focusing cloth over your head and the camera back to see the image clearly.) The lens diaphragm is next stopped down to give sufficient depth of field, and the shutter closed. The focusing screen is replaced with a film

holder containing a sheet of film loaded in the darkroom. A sliding sheath or panel in the holder is removed, revealing the light-sensitive film to the dark interior of the camera. You then fire the shutter to make the exposure, and reverse the procedure – returning to the darkroom to unload the film holder and process the sheet of film.

For and against

Most modern view cameras are unit-constructed on a monorail. Identical front and back standards carry either lens panel or focusing screen; bellows of various types can be interchanged or linked together to give extra long extension. Extreme swings, tilts and shifts are possible at both ends of the camera, and backs interchange to give larger or smaller picture formats. In fact each manufacturer of a monorail view camera offers a complete "system" to the

technical, specialist user of this type of equipment. View cameras can be used with a wide range of lenses; their long bellows allow extreme close-up photography without additional equipment. The ability to expose and process pictures individually is often helpful, although more so in the studio than in the landscape work from which the view camera takes its name. Some special films, such as high contrast black and white lith for example, are available only in sheet form. But probably the most important feature of the view camera is the ability to swing, tilt and offset the lens position relative to the film plane – a facility known as "camera movements." In experienced hands these movements allow extra control over image shape and perspective, and depth of field. Inevitably, view cameras are heavier, more bulky and much

slower to use than smaller format designs. Baseboard view cameras aim to reduce these disadvantages by needing only to be unfolded for use. And they may also have an optical direct vision viewfinder to allow the camera to be used in the hand.

See: Using the view camera/Architecture/Using old cameras/Sheet film processing

The monorail view camera. Typically 4 x 5 ins (10.2 x 12.7 cm) format, right, built up from interchangeable, multiple units, assembled on a rail or tube whose length can be extended according to the job in hand. The front, back and middle standards which clamp and focus along the rail are identical, and therefore inter-changeable, as are the two clip-on sets of bellows. The camera, right, is assembled for use with a long focus lens or for working close-up. For wide-angle work both bellows and the middle standard are replaced by just a single short "bag" bellows.

Inverting focusing hood. Contains mirror to correct up-side down image.

Focusing screen. Displaces backward whenever a film holder is inserted.

Film holders. Several kinds, right, fit 4 x 5 ins (10.2 x 12.7 cm) view camera backs. The popular double holder for sheet film carries one sheet each side, so by reversing the holder two pictures can be exposed. The instant picture back gives individual pull-out pictures within seconds. The film pack holder contains up to 16 thin sheets of film; and the rollfilm back allows eight 2¼ x 3¼ ins (6 x 8.3 cm) images on 120 film.

Baseboard view cameras.
These are of two main kinds.
The older variety like the
Gandolfi, right, is built in
brassbound mahogany with
metal hinges and struts. It is
intended for use only on a
tripod stand. To close the
camera you remove the lens
panel and detach the front
standard at the bottom,
placing it horizontally on the
baseboard.

Gandolfi

Linhof

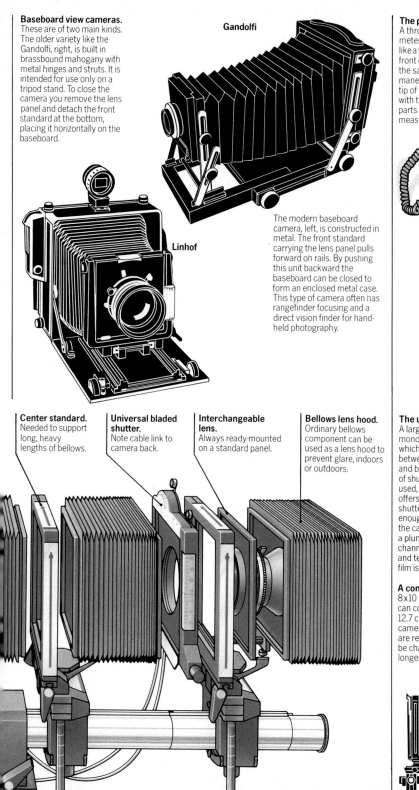

The modern baseboard
camera, left, is constructed in
metal. The front standard
carrying the lens panel pulls
forward on rails. By pushing
this unit backward the
baseboard can be closed to
form an enclosed metal case.
This type of camera often has
rangefinder focusing and a
direct vision finder for hand-
held photography.

The probe exposure meter.
A through-the-lens exposure
meter accessory, below, shaped
like a film holder, which inserts in
front of the focusing screen in
the same way. You then
maneuver the light sensitive
tip of the probe to coincide
with the highlight and shadow
parts of the image you wish to
measure.

Center standard.
Needed to support
long, heavy
lengths of bellows.

**Universal bladed
shutter.**
Note cable link to
camera back.

**Interchangeable
lens.**
Always ready-mounted
on a standard panel.

Bellows lens hood.
Ordinary bellows
component can be
used as a lens hood to
prevent glare, indoors
or outdoors.

The universal shutter.
A large bladed shutter unit (see
monorail view camera, left),
which can be clipped in-
between the front standard
and bellows. It enables a range
of shutterless lenses to be
used, thus saving in cost, and
offers facilities such as a
shutter speed scale large
enough to read from behind
the camera. A cable linkage to
a plunger in the film holder
channel automatically closes
and tensions the shutter as
film is inserted.

A conversion back. An
8 x 10 ins (17.8 x 20.3 cm) back
can convert a 4 x 5 ins (10.2 x
12.7 cm) camera to a full frame
camera. Larger conical bellows
are required and the lens must
be changed to one of
longer focal length.

Instant picture cameras

The instant picture process was invented by Dr Edwin Land in 1947. An instant picture camera will issue a finished, permanent print in black and white or color a few seconds after exposure.

For and against

The main advantage of this instant availability is that you can check results on the spot and reshoot if necessary. No darkroom is required, and there are no additional costs other than the film itself. Against this, picture size is limited to the size of camera. One type of film gives an enlargeable negative, but you need a clearing tank to remove impurities and facilities for washing and drying. Instant picture films are more expensive per shot than conventional types of film.
See: Special film types

Cameras for peel- apart film

Cameras for this type of film are of two sizes – producing pictures 3¼ x 4¼ ins (8.3 x 10.7 cm) or 3¼ x 3⅜ ins (8.3 x 8.6 cm). The camera back opens to accept a daylight-loading film pack. After each exposure two tabs are pulled to draw a "sandwich" of negative and positive paper out of the camera through a pair of rollers. The rollers break and spread a pod of jellied chemical between the two materials. After several seconds they are peeled apart to give a finished positive and a throw-away negative. Cameras built for peel-apart film are of the direct vision type and are very simple to operate. Most of them have automatic exposure control.

Simple automatic camera. The most basic peel-apart film cameras, right, offer scale focusing, a flash cube mounting, and usually have automatic exposure control. The "f" number and shutter speeds are unmarked.

Folding camera. This is a more expensive camera, left, but much more compact because it folds flat. Focusing is by rangefinder and the camera has a more advanced lens than the cheaper models.

Passport portrait camera. Several special-purpose instant cameras are made for peel-apart film. This one, right, has four lenses and so will give four identical images on one sheet, each 2 x 1½ ins (5 x 4 cm). Other types will simultaneously photograph written particulars about the subject which can be inserted into part of the camera and so produce an ID card.

Cameras for integral processing

Integral processing means that the negative is processed and print produced within one piece of material. A white plastic card is ejected from the camera through rollers immediately after each exposure. On one face a color picture slowly appears, and reaches full density after 5 to 10 minutes. The image is permanent and there is no chemically contaminated waste paper to discard. While peel-apart material automatically corrects what would normally be an image reversed left-to-right, special cameras are required for integral processed film. The optical system must combine with the material itself to give a right reading color image on the ejected card. Kodak and Polaroid systems achieve this in different ways.

Kodak EK. The Kodak integral processing instant picture material automatically generates a color picture on the back surface of the material exposed to the camera image. The film can therefore be used in any suitable roller-equipped camera in which the lens projects directly on to the film. In the Kodak EK4 and EK6 cameras, below, a double reflex arrangement "folds up" the optical system so that body size remains compact for the size of picture, 2⅝ x 3⁹⁄₁₆ ins (6·5 x 9 cm). The image is composed through a direct vision finder next to the lens. Focusing is by distance scale aided by symbols and a head-size measuring circle which appears within the finder. The camera contains a built-in battery.

Kodak EK camera

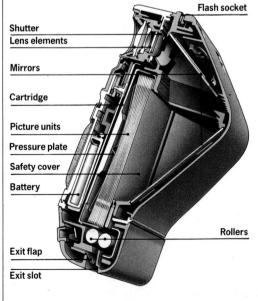

Flash socket
Shutter
Lens elements
Mirrors
Cartridge
Picture units
Pressure plate
Safety cover
Battery
Rollers
Exit flap
Exit slot

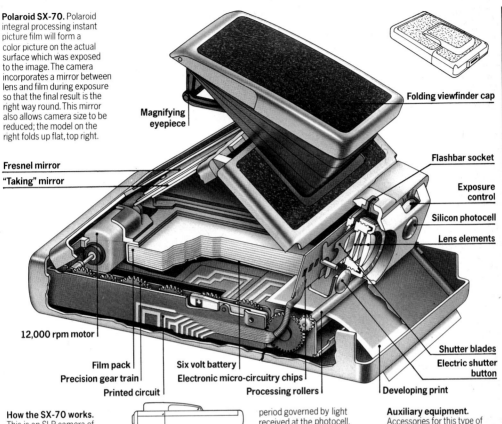

Polaroid SX-70. Polaroid integral processing instant picture film will form a color picture on the actual surface which was exposed to the image. The camera incorporates a mirror between lens and film during exposure so that the final result is the right way round. This mirror also allows camera size to be reduced; the model on the right folds up flat, top right.

Magnifying eyepiece

Folding viewfinder cap

Fresnel mirror

"Taking" mirror

Flashbar socket

Exposure control

Silicon photocell

Lens elements

12,000 rpm motor

Film pack

Precision gear train

Printed circuit

Six volt battery

Electronic micro-circuitry chips

Processing rollers

Shutter blades

Electric shutter button

Developing print

How the SX-70 works.

This is an SLR camera of unusual design, intended only for use with SX-70 instant color film. When folded up, top right, the camera is the size and shape of a cigar case. All optical and other delicate parts are totally enclosed within the metal body. When you pull the viewfinder casing upward to unfold the camera the lens panel automatically takes up position. It carries a photocell window and an electric button for exposing the picture. You hold the camera with the front of the baseplate slightly tilted upward, and view through an eyepiece lens at the back of the hood.

For focusing and viewfinding, center right, light which passes through the lens is reflected off two mirrors in the main camera body. One mirror is fixed, the other is hinged; it normally covers the film pack housed in the base unit. Once a sharp image has been focused on the surface of the second mirror light is reflected upward and passes through a small aperture to the viewfinder. Here the image is seen, postage stamp size, on a concave mirror which is viewed through an eyepiece.

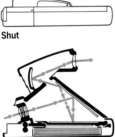

Shut

Viewing

Exposure

When the picture button is pressed the bladed shutter closes while the hinged mirror rises, above, to reveal a high quality optical mirror on its under surface. This will reflect the image directly on to the now uncovered film surface. It also seals off any light entry from the viewfinder eyepiece. The shutter blades open to give an exposure

period governed by light received at the photocell. Finally the mirror drops, the shutter re-opens and an electric motor drives the sheet of exposed film forward between spring loaded rollers and through a light trap out of the camera. The material is actually delivered about one second after the ending of the exposure. A pod of reagent built into the film sheet has been ruptured by the rollers and spreads evenly between the layers. It contains white pigment to protect the emulsion from light, as well as to trigger chemical processing. Gradually a color picture builds up on the white film, taking a few minutes to reach full values.

Each pack contains ten sheets of film and a wafer-shaped battery to power the camera. Battery change is thus ensured every ten pictures. Film packs are each protected by a cardboard light sheath to allow camera loading in daylight. The camera motor automatically discards the sheath immediately the new pack is in place. Other, cheaper cameras for SX-70 film include non-folding types using a fixed mirror, scale focusing and a direct vision viewfinder.

Auxiliary equipment.

Accessories for this type of camera include an electrical cable release; a supplementary close-up lens element; a lens hood; and an adaptor to allow tripod mounting. A special flashbar contains ten built-in midget flashbulbs – five either side – each within its own reflector. As soon as you plug the bar into the camera the shutter timing is automatically reprogrammed for flash. Each exposure ignites one of the bulbs from the camera's internal battery.

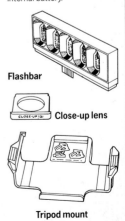

Flashbar

Close-up lens

Tripod mount

Choosing the equipment for the job

There is no universal camera for all occasions. Some camera systems, such as the modern SLR outfit, aim to allow you to tackle any kind of subject by means of an elaborate and often costly series of accessories. While this may be true, the resulting kit may not be the fastest, most efficient way of working because of the adaptation involved.

The actual image size required is a vital factor in choosing equipment. Is it to be a small color transparency for projection, or a negative capable of undergoing considerable enlargement? Every photographer has his own personal working choices, based perhaps on his preferred method of focusing, the conspicuousness of his equipment, his darkroom facilities and so on. Shown below and right are typical equipment choices for a variety of subjects. The ideal equipment is shown in black. Alternatives are in brown.

Architecture. Exterior and interior photographs of large buildings often demand a wide-angle lens and preferably a camera offering movements. A tall building photographed from ground level may be recorded without tapering vertical lines if the lens can be raised above the center of the picture format, instead of tilting the whole camera. A monorail view camera offers this and an unrivalled range of other movements to control perspective and sharpness. The camera needs a firm tripod, a focusing hood or cloth, film holders, and an exposure meter. A cable release, a spirit level for checking horizontal and vertical alignment, and green or orange filters for sky control are also useful. Both normal and wide-angle lenses should be carried. A faster, more mobile but limited alternative would be a 35 mm SLR equipped with a wide-angle shift lens and an internal metering system.

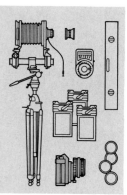

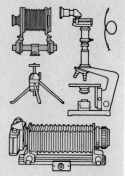

Macro or photo-micrography. Extreme close-up photography calls for a combination of long camera bellows and (preferably) a macro lens or, for closer photography still, a camera which will conveniently mount on to a microscope. The 35 mm single lens reflex fulfils both requirements. With extension bellows and the several excellent macro lenses made for this format, direct image magnification of up to three times is obtainable. A tripod – perhaps a small table one – and cable release are essential. The SLR body attaches to a microscope through an adaptor. The viewfinder system allows accurate checking of the image right up to the moment of exposure. The alternative is a fully extended view camera using a short focus lens to give modest magnification macro images. This camera body will also couple with a microscope.

Sport and action. Mobility and freedom to choose the right moment are vital. The camera needs to be quick and simple to operate – particularly in terms of focusing and framing. The optical finder of a direct viewfinder camera allows you to view the scene before the subject actually enters the picture area. This is helpful for panning. Split-image rangefinder focusing is often quicker and more accurate than a focusing screen. A long lens with a trigger focus arrangement for speed, and of mirror construction to save weight and length would be ideal. A motor drive is useful for brief but intensive action sequences, and where an indoor sport allows the use of additional lighting an electronic flashgun is excellent for freezing motion. Most other hand cameras can be used for this work if operated in stripped-down form, say with a wire frame finder accessory.

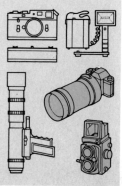

People indoors. This combines the problems of interiors and portraiture. A wide range of cameras will tackle this job well, but a 35 mm single lens reflex with a wide-angle lens would show as much of the surroundings as possible, even under cramped conditions. Some auxiliary lighting will improve illumination and reduce contrast, particularly when used with daylight indoors. Electronic flash is very portable and matches daylight in color – it does however need to be used skilfully if a realistic balance of natural and artificial lighting is to be achieved. Take a tripod and cable release in order to make short time exposures in dim lighting or when subjects are to be posed. As an alternative kit a 6 x 6 cm SLR might be chosen for its finer image quality, and the subject lit by lightweight tungsten halogen lamps.

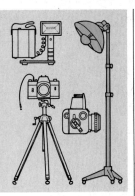

Portraits. The twin lens reflex is a good choice for portraits in the studio or outdoors. Its larger format gives a more grain-free result, and the camera has the advantage of allowing facial expression to be checked even at the moment of exposure. Ideally the TLR should allow the use of long focus lenses. Remember that parallax error can be very marked in close-ups. Electronic flash with modeling lamps forms an ideal studio light source, particularly for children. Use daylight outdoors as far as possible, supplemented if necessary by reflectors. It is good to have the camera supported on a tripod as a convenience in posing the portrait, though you may have to work solely with a hand-held camera in daylight. As an alternative a rollfilm or 35 mm SLR could be used and studio spots and floods substituted for flash.

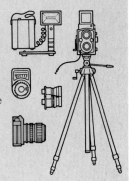

Wild life. The subject may be such that the camera can be set up in advance overlooking a bird's nest, fox's den or whatever and then operated from a distance. In this case a motorized viewfinder camera (quietest shutter) with a radio or similar remote control system is ideal. If nocturnal creatures are to be recorded one or two off-camera electronic flash units can be used for lighting. The equipment can be clamped to branches of trees and disguised with foliage. On other occasions the photographer himself may be in a hide, and will therefore need a tripod-mounted SLR camera with a long lens. If this lens is of a trigger focus type it can also be used with the camera hand-held for stalking and recording game. In general choose equipment which is rugged, lightweight, and silent to operate.

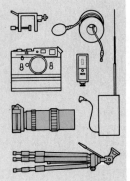

Underwater. First choice here is from among several special cameras and lenses which have now been designed for this work. Underwater lenses are computed to give best resolution when water is in contact with the front element of the lens. The 35 mm underwater body has enlarged rings for control of focus, shutter speed, aperture and shutter release. The internal air content is delicately balanced to produce nil weight when maneuvered under water. Lighting, necessary in deeper water, is provided by battery powered quartz iodine underwater lamps, either mounted both sides of the camera or carried separately by another diver. Several 35 mm or roll-film camera systems now include an underwater camera housing for particular combinations of body and lens. There are also simple plastic bags with glass lens windows for containing any direct vision camera, but these are safe in shallow water only.

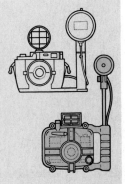

Lens design

The modern camera lens is built up from numerous separate glass elements. These are of two types: those which are thickest in the center and converge light, and those which are thickest at the edges and cause light to diverge. Used alone a converging element will form an image on film, but of rather poor quality, with color broken up at the edges and these will be less sharp than the center. However, by combining a converging element with a slightly weaker diverging element made in a different type of glass most errors will be corrected, although together the two elements still form a converging lens.

The lens designer uses lens elements as building blocks, varying their number, shape, type of glass and spacing. His aim is to create a compound lens with a usefully wide aperture capable of giving a high quality image over a particular negative size throughout its entire focusing range. Making corrections by adding further elements increases the cost, size and weight of the lens, and the slight absorption and reflection of light at each glass surface add up and reduce performance. However, this situation improves steadily with advances in technology. Transparent substances, known as "anti-flare coating" are evaporated on to the surface of each element to reduce reflection, and computers calculate eccentric new glass shapes. Each camera lens is therefore a compromise between various conflicting needs, and generally speaking its performance is directly related to price.
See: Using lenses

Optical principles

When a light ray passes obliquely through a block of glass with non-parallel sides, such as a prism, it alters direction. A converging lens really acts like a series of prisms. Light is bent most acutely near the lens circumference and least at its center, where the glass is effectively parallel-sided. In this way a beam of light reflected from a point on the subject is converged to a point of focus. Light from higher or lower parts of the subject come to focus below or above this point and so make up a recognizable upside-down image which can be projected on to film. A diverging lens disperses light rays. It cannot form an image on film or a focusing screen. However, when the eye views the subject through such a lens a miniature, upright image can be seen. This sort of lens is therefore used in direct vision viewfinders.

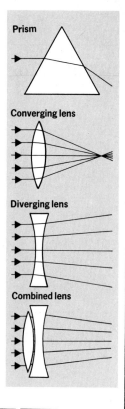

Prism

Converging lens

Diverging lens

Combined lens

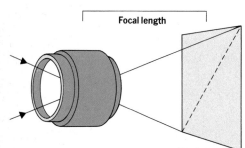

Focal length

Focal plane

External ring
controlling diaphragm

Bladed shutter may
be fitted here

Converging lens
elements

Diverging lens
elements

Diaphragm blades

Bayonet fixing

Front of lens barrel

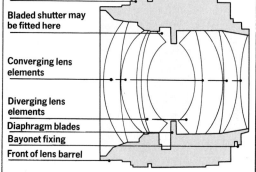

Focal lengths. A normal general purpose camera lens is designed to have a focal length (the distance from the lens to the focal plane) approximately equal to the diagonal of the negative or image area.

Lenses of shorter focal length, wide-angle lenses, and lenses of longer focal length, long or telephoto lenses, can often be fitted in place of a normal lens. The wide-angle lens enables a wider angle of view and closer focusing than the normal lens, while the long lens promotes a narrower angle of view and more distant focusing. Both usually have slightly smaller maximum apertures than normal lenses. At the same "f" number the wide-angle gives greater depth of field and the long focus less than the normal lens.
See: Focal plane/Normal lens/Wide-angle lens/Long lens.

Internal construction. A high quality normal angle camera lens such as the 50 mm f 1.4 Olympus Zuiko shown above, is a combination of advanced mathematical design, precision optics and engineering. The number of lens elements, their shapes, spacing, and the type of optical glass required for each is first determined by computer. Each element is then ground, polished and vacuum coated with several anti-reflective layers. Meanwhile the metal lens barrel must be designed and engineered to extremely fine tolerances. When assembled every lens element must be optically centered, correctly spaced, and held firmly, yet be resistant to normal shocks and temperature variations. The focusing movements must be smooth and positive. Finally the complete lens must couple up and fit exactly within the camera body, often with mechanical links engaging to control diaphragm and shutter.

Depth of focus

There are points either side of the exact point of focus, at which an image is still rendered acceptably sharp. The distance between these points is called depth of focus. If you view a bright subject highlight when rendered out of focus it appears spread into an enlarged disk of light. As you focus on the highlight it progressively reduces to a size acceptable as a point as you approach the position of exact focus. At a point beyond this it again expands into an out-of-focus light disk. The highlight, in fact, comes into focus when its diameter equals the diameter of the cone of light projected by the lens, and it goes out of focus again when its diameter once again becomes smaller than the diameter of the cone of light. Therefore, as the lens diaphragm is stopped down and the cone of light projected by the lens becomes narrower, depth of focus increases.

Depth of field

Depth of field is concerned with the nearest and furthest parts of the subject which can be rendered sharp at a given focusing setting. For example, when the lens is focused for a portrait 8 ft (2.4 m) away some nearer foreground objects and some background objects may also appear acceptably sharp. In this case depth of field perhaps extends from 6 ft (1.8 m) through to 12 ft (3.6 m). Depth of field increases as the lens is stopped down, when it is focused for distant subjects, or when the lens has a short focal length. This is why small format cameras – which have short focus lenses as standard – give considerably more depth of field than the much longer focal length standard lenses used in large format cameras. Depth of field usually extends rather further behind the distance for which the lens is focused than in front.

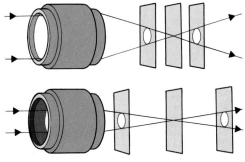

Focusing latitude. A point of light is in focus when its diameter coincides with, or is greater than, the diameter of the cone of light projected through the lens. Depth of focus with a lens at wide aperture, top diagram, is limited to a small area either side of the point of exact focus. However, when the lens is stopped down and the cone of light projected through it narrows, bottom diagram, depth of focus is greatly increased.

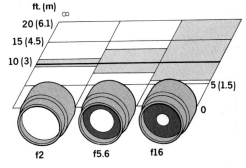

Effect of aperture. In the diagram above, a camera lens is focused for 10 ft (3 m). At widest aperture, f2, depth of field extends only from 9 ft (2.7 m) to 11½ ft (3.5 m). Depth of field increases as the lens is stopped down; at f5.6 it reaches from 8 ft (2.4 m) to 13 ft (4 m) and at f16 from 6 ft (1.8 m) to 20 ft (6.1 m). Many lenses carry scales showing the depth of field they offer at a range of apertures and focusing distances.

Lenses and formats

There is a limit to the area over which a lens will project a sharp, distortion-free image. This is why lenses are designed from the outset for a particular format (negative size) camera. A normal angle 50 mm lens for a 24 x 36 mm format camera cannot, for example, be used as a wide-angle on a 2¼ ins sq (6 x 6 cm) camera – the picture would have darkened corners. In the reverse situation it is possible to use an 80 mm normal lens for 2¼ ins sq (6 x 6 cm) format as a long-focus lens on a 24 x 36 mm format camera. However, the surplus image surrounding the area actually used may create internal reflections and general lowering of image contrast.

Format coverage. The lens shown above has an 80 mm focal length designed to cover a 6 x 6 cm format negative. Used on a 4 x 5 ins (10.2 x 12.7 cm) camera the image has vignetted corners. The lens could be used on cameras for 24 x 36 mm but then projects an excessive image patch, scattering light. It also costs much more than an 80 mm lens designed for this format.

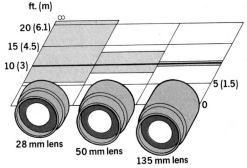

Effect of focal length. The situation drawn above again shows the camera focused for 10 ft (3 m), this time using three different lenses all stopped down to f 5.6. The 50 mm standard lens provides depth of field from 8 ft (2.4 m) to 13 ft (4 m). The 28 mm wide-angle lens however, offers from 6 ft (1.8 m) to infinity, while the 135 mm long focus lens gives less than 1 ft (30 cm).

Normal

As the prime optic in any set of lenses, the normal focal length lens frequently offers a maximum aperture, such as f2 or f1.8, wider than the others in the series. Construction is typically either six or eight elements.

Wide-angle

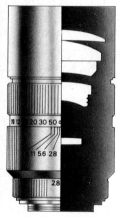

A lens of short focal length corrected to cover a wide field of view. Most wide-angle lenses for SLR cameras now have "inverted telephoto" construction. This design allows the lens to focus at the same distance from the film as a normal lens.

Telephoto

A telephoto is a long-focus lens incorporating some light diverging elements at the camera end. These have the effect of making the lens-image distance less than the focal length would otherwise require. The telephoto is therefore shorter than a lens of conventional design, although it has the same focal length. Both give images of identical size.

Long-focus

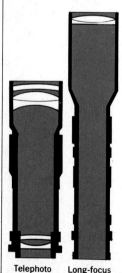

A long-focus lens gives a high resolution image over quite a narrow field of view. Its long focal length means that the main lens elements must be mounted at the front of a long tube to be sufficient distance from the film to form a sharp image. These lenses have modest maximum apertures – typically f4.5 or f5.6. Optical corrections often restrict minimum subject distance to 10 ft (3 m) or more.

Telephoto Long-focus

Mirror

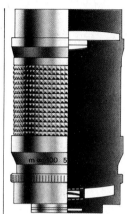

Lenses of extremely long focal length – 500 mm and over – are so large and heavy they usually have to be mounted directly on to a tripod. To overcome this inconvenience some lenses are built to a mirror design. Two curved mirrors "fold up" the light path by bouncing the light backward and forward inside the lens, thus making the lens much shorter and, because the mirrors replace some large glass elements, much lighter.

Zoom

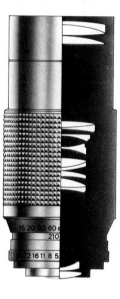

Zoom lenses are specially designed to have a variable focal length. By rotating an extra control ring the lens changes throughout a continuous range of focal lengths– enlarging or reducing the image size. The zoom therefore acts as a more convenient substitute for a range of interchangeable lenses. Zoom range is still relatively restricted, typically 70 to 150 mm or 40 to 120 mm. Maximum aperture is seldom wider than f3.5 and the lens is expensive.

Fisheye

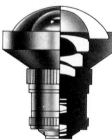

Most wide-angle lenses are "corrected" to record vertical and horizontal lines in the subject as vertical and horizontal lines in the image. Fisheye lenses render straight lines as curves and give the whole image a fish's eye or convex mirror reflection appearance. Typical fisheye lenses for 35 mm cameras have focal lengths of between 6 and 16 mm. Some give a full format rectangular image; others only a circular area, center frame.

Special purpose lenses

Lenses are designed to give optimum image quality under specified practical conditions. Standard camera lenses are intended to perform best when the subject is many focal lengths from the lens, lit by visible light and with the intervening space filled by air. But it is equally possible to design lenses to suit specialized working conditions.
U-V lenses are corrected for ultra-violet light as well as the visible spectrum. They are intended for scientific photography in which ultra-violet light sources are often used.
The design of soft focus lenses leaves one pronounced optical error, "spherical aberration". This gives halos to highlights and a general softness of outline. Control is possible because the effect is reduced by stopping down.
See: Underwater photography

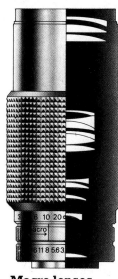

Macro lenses

Macro lenses are most fully corrected for subjects very close to the lens. While they can be used for distant subjects too, sharpness is then slightly poorer than that given by a general purpose lens.

Lens hoods

A lens hood is intended to shade the lens from light just outside its angle of view – light which might otherwise flare into the picture area. Intense light sources – the sun, lamps for backlighting in the studio and reflective surfaces – are the worst offenders. They can result in overall gray, degraded images, or streaks or patches of unwanted light. A hood is shaped to suit one angle of view. If a lens hood for a normal lens is used on a wide-angle lens all four corners of the image will show darkening because of the hood's protrusion into the field of view. Neither will it shade a long focus lens as closely as a hood designed for such a lens. You should therefore have a hood for each lens.
See: Shooting into the sun

Hood for wide-angle lens

Hood for standard lens

Hood for long lens

Lens attachments

Starburst
This consists of a disk of molded glass with radial ridges, or a grid of crossed lines. Intense point light sources or bright reflections in the image reproduce with tapering star-like rays, giving a glitter effect.
Soft focus
Coupled to a normal lens, this attachment gives similar results to a soft focus lens. The glass disk usually has molded concentric circles, and its effect is to spread light areas and soften outlines to give romantic, mood images. Soft focus is most pronounced at wide apertures.
Variable diffuser
This looks rather like a bladed shutter but has clear plastic leaves which can be made to protrude increasingly into the circular field of the lens. The result is an increasing degree of soft focus and diffusion. The blades are shifted by a

large, numbered control ring, which allows effects to be repeated.
Soft focus aperture disk
This is a metal disk with a large central hole surrounded by a pattern of smaller holes. The smaller holes give an overlapping halo effect to bright parts of an otherwise sharp image. Changing to a disk with fewer holes, or stopping down, reduces the effect. Most disks are intended for use in conjunction with soft focus lenses.
Close up lens
A weak converging lens element which, when placed in front of any camera lens, enables you to focus closer than the main lens allows.
Telephoto convertor
This is a supplementary lens system comprising several lens elements, intended to fit on the front of a normal lens, to convert it to a telephoto – admittedly one of inferior image quality.

Fisheye convertor
A large diameter supplementary lens system which converts a normal lens to a fisheye optic. Quality is inferior to a fully designed fisheye but is acceptable for some effects.
Bifo
A bifo or "half-lens" is a close-up supplementary lens cut to a half-circle, the other half being clear. In a scene with quite separate foreground and background elements, the camera lens is focused for the background, then the attachment rotated so that light only passes through the half-lens from the foreground, which is thus brought into sharp focus.
Squeeze lens
This is an "anamorphic" supplementary lens system containing cylindrical lens elements. When mounted on a normal lens it squeezes the image by

reducing either its vertical or its horizontal size without affecting the other dimension.
Right angle mirror
This looks like a lens but is really a silvered mirror attachment through which you can take candid pictures of subjects at right angles to the scene in front of the camera. The mirror looks out through a hole in the side of the lens while a fake lens at the front preserves the deception.
Prism lens
A faceted clear glass disk designed to give either 3, 4, 5 or 6 displaced overlapping images of the center part of the picture. It can be attached to any lens.
Spot lens
A selective lens having an overall lens shape with a flat glass central zone. It has no effect on the center of the picture but detail grows increasingly out of focus toward the edges.

Hand-held meters

To record an image reasonably accurately on a photographic film must receive the correct quantity of light energy. The eye cannot measure subject brightness reliably, and although film manufacturers enclose a packing slip suggesting typical camera settings these only apply to a few typical outdoor subjects and lighting conditions. Therefore some form of light measuring meter is vital to any serious photographer. All meters work on the basis of converting light into electronic current, which can be measured on a scale and translated into appropriate shutter speeds and "f" numbers relative to the ASA speed of the film. The separate meter, designed to hold in the hand, uses a light sensitive cell behind a window in some convenient part of the casing. The cell is normally pointed toward the subject. Your meter may use a selenium cell which generates a minute current of electricity, measured on a galvanometer. This sort of meter, such as the Weston, therefore requires no battery. More recently developed meters use a cadmium sulfide or CdS cell which is "photo-resistant", meaning that its electrical resistance changes in proportion to the

light it receives. This sort of meter is much more sensitive but only works when a small battery is in circuit with the cell and read-out galvanometer. Both forms of meter are designed to measure light within approximately the same angle of view as a normal camera lens. A supplementary light-diffusing dome fits over the cell for incident light readings, which are readings of the light source rather than the subject. To read the exposure a calculator dial on the outside of the meter is first set for the ASA speed rating of the film you are using. On most meters the light reading shown on the galvanometer scale is noted and this number set on the calculator dial opposite an arrow. The calculator then lines up the shutter speed and "f" number combinations which will give a correctly exposed negative. Some meters do not have a galvanometer needle read-out, but use two small illuminated signals instead. You rotate the calculator until both indicators light up. Other designs use two needles, one controlled by the calculator dial. The galvanometer then needs no scale of numbers; you just turn the calculator until one needle exactly covers the other.

Selenium meters. Meters of this kind are electrically self-contained and simple. Their disadvantage is that sensitivity is directly related to the size of the cell and this takes up quite a large area of the meter surface. Cell response is extremely weak so that readings in dim light are difficult and rather unreliable. To help improve accuracy the needle moves over two scales, "high" and "low." In bright light conditions a perforated flap restricts the light and numbers are read from the high scale. Under dimmer conditions the flap is removed and the reading is then made from the low scale.

Light-diffusing dome

Weston Euro-Master

Specialized meters. Some photographers prefer to use a narrow angle spot meter. ASA film speed and the camera shutter setting are first dialled-in. You observe the subject through a telescopic eyepiece, and a superimposed circle shows the small area which is being measured. Switch the meter on by pulling a trigger and the "f" number for correct exposure lights up as a

CdS Meter. This type of meter is externally similar to a selenium meter, but it has a smaller cell. Its pill-size internal battery needs changing about once a year, or whenever it registers less than full power; a battery test button is provided. CdS meters are sensitive to a very wide range of lighting conditions, and even give readings in moonlight. However, they are

rather slow to register their readings and bright light conditions tend to be "remembered" by the cell for some time, so you may have to wait a few minutes after measuring in bright sunshine before using the meter indoors. Slight over-response to red sometimes results in inflated readings of subjects or strong lights of this color.

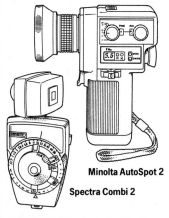

Minolta AutoSpot 2

Spectra Combi 2

digital display. Other types of meter offer features such as measurement of incident and reflected light simultaneously, using a head which rotates. You can also use plug-in accessories which allow you to measure light through a microscope, or off a camera focusing screen, or off the baseboard of an enlarger.

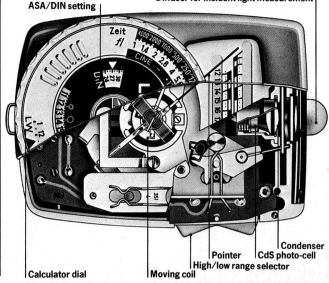

Gossens Lunasix
ASA/DIN setting

Diffuser for incident light measurement

Calculator dial

Moving coil

Pointer

High/low range selector

CdS photo-cell

Condenser

Built-in meters

The simplest built-in meters have a cell pointing directly at the subject from above or around the camera lens, and a moving needle read-out on top of the camera body which needs translating into shutter/aperture settings. Most meters however, are directly coupled to one or both camera exposure controls. They often use cells which read from the image formed behind the lens. The cells are either CdS type, or the newer, fast reacting silicon. Meter read-out is shown in the viewfinder. The coupling of meters to camera exposure controls takes various forms. You can get a manual matching system which allows you to vary aperture and shutter speed until the meter indicates a correct exposure. Or, you can get a semi-automatic system which can be either a shutter priority system or an aperture priority system. With the former you simply set the shutter speed you want and the meter automatically sets the appropriate aperture. With an aperture priority system you set the aperture and the meter provides the right shutter speed. Fully automatic metering systems set both aperture and shutter speeds automatically. This is ideal if you want to take pictures in a hurry. For more considered shots the camera will generally allow you to override the meter. At its best through-the-lens metering works with all lenses, takes into account accessories such as extension rings and bellows which affect exposure, and is quicker to use than a hand-held meter.
See: Determining exposure

Viewfinder display. Built-in meters usually display their reading in the viewfinder, alongside the picture area. This may take the form of a follow pointer, or center needle system, or an arrangement of light signals. Follow pointer systems show two needles, one freely controlled by the meter, the other moved by altering the camera's aperture or shutter speed control until both needles coincide. Another arrangement uses a single needle which points to a static mark denoting correct exposure. In this case camera exposure controls affect the meter circuit. Under- and over-exposure positions are also shown, and the shutter/aperture in use may appear on adjacent scales. Some recently introduced cameras use light emitting diodes to display information. The points of light can trace out signals like "+", "—", and even "O.K.". At slow shutter speeds a flashing signal may suggest use of a tripod, and at low light levels suggest use of a flashgun.

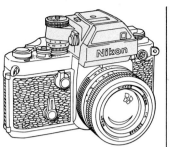

Nikon F2SB

Add-on meters. These range from separate meters which mount in the camera accessory shoe, to substitute pentaprism viewfinders for single lens reflex cameras. The latter make their readings from the focusing screen and are coupled mechanically to the camera's aperture and shutter speed controls. Correct exposure is indicated on a light signal read-out beside the screen.

Weighting. Through-the-lens meters vary as to the amount of the picture they measure. Some read the entire focusing screen area and so give an integrated measurement. Others measure only a center spot area, marked on the focusing screen. Still others read most of the scene but pay special attention to the central zone. This "center-weighted" arrangement is often programmed to suit typical subjects. For example, the contour pattern, above, shows cells arranged to pay more attention to the foreground area of a landscape than the sky. Some cameras offer a choice of two of these forms of measurement, either of which the photographer can select to suit specific subject conditions.

Center-weighted

Center spot

Flash metering

Flash is too brief to measure on a normal exposure meter. Special hand-held meters are therefore made with circuitry able to measure accurately flash intensity and duration. They are broadly similar in appearance to an exposure meter, having a light sensitive cell and galvanometer needle read-out. However, flash meters are designed to measure incident light, and must be held near the subject, pointing toward the camera. First set the camera shutter to the speed recommended for flash, and the meter for the ASA rating of the film. Then fire a test flash via a long trigger lead connecting meter to flash, or by using the manual button on the flash head. The meter needle moves to a stationary position on a scale, reading out "f" numbers or numbers which relate to a calculator dial. An alternative is an automatic or computer flashgun. This carries its own fast reacting exposure sensor which views the subject and actually cuts off the flash in midstream when enough light has been received. The lens aperture is usually set to an "f" number suggested for the ASA rating of your film. The flashgun then does the rest, giving shortest flash when the subject is close, or light toned, or both. Closest and furthest distance limits are shown on a scale or signalled by lights.
See: Flash/Flash techniques

Color temperature meter

A color temperature meter serves a different function to an exposure meter, although some give exposure readings as well. Its prime function is to analyze the color content of your subject lighting. This allows you to check whether the lighting is compatible with the color film in your camera and thereby get the most accurate subject color reproduction. You point the meter toward the light source and press a button. The reading on the dial shows whether the film can be used straight or if it will require a correcting filter over the lens. Color temperature meters are mostly used by professionals doing critical work under difficult light conditions. If you keep to the usual light sources and have a steady domestic electricity supply you will not need one.
See: Color temperature

Studio lighting

Studio tungsten lighting is the general term used to describe photographic lamps which produce light from an electrically heated filament of tungsten wire. This form of studio lighting still remains the most versatile; you can achieve an endless range of effects and you can actually observe the results – something you cannot do with flash. Lighting units themselves divide into two groups: those with large reflectors and diffused glass bulbs; like the three on the right, which give soft, diffused illumination; and those with compact, clear glass lamps and polished reflectors, such as spotlights, below right, or quartz-iodine lamps, both of which give hard lighting and sharp edged shadows. Spotlight accessories include folding barn-doors, below left, and conical snoots, below center, both of which restrict the beam.
See: Lighting quality

Floodlight

Mushroom reflector

Umbrella reflector

Barn doors **Snoot**

Spotlight

Bulbs

The most common bulbs for photographic studio lighting are shown below. The photoflood bulb, 1, is an over-run 275 watt bulb, which gives brilliant light for 2 or 3 hours only. A larger "No. 2" photoflood bulb, 2, offers longer life but is more expensive. The integral reflector bulb, 3, is a self-contained unit requiring only a bulb holder. The clear glass spotlight bulb, 4, has a coiled filament to give hard light.

Bulb flash

A bulb produces powerful lighting in a burst short enough to freeze most movement. It is ignited by a few volts of electricity – usually from a small battery – switched on by contacts in the camera shutter. Flashgun and shutter are therefore linked by a wire lead, or through the camera accessory shoe, the "hot shoe". The contacts trigger the bulb slightly ahead of the shutter itself, so there is time for maximum light output to be reached by the time the shutter is fully open. Exposure calculation is based on the "flash factor" recommended for the particular reflector, bulb size and ASA film rating. This factor denotes distance from bulb to subject multiplied by "f" number. For example, a flash factor of 110 means that with the flashgun 10 ft from the subject the lens should be set to f 11.

Magicube

Quartz-iodine

Quartz-iodine, right, and similar tungsten halogen lamps produce more light than other hard illumination sources and do not discolor with age. Q.I. lamps generate considerable heat, and must be ventilated.

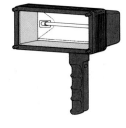

Lighting stands

A good stand will support the lamp head safely at all heights. Adjustable telescopic stands can have tripod, 1, or castored, 2, bases. A counterbalanced boom stand, 3, allows quick height adjustment, while a simple lamphead clip, 4, allows you to use any convenient support.

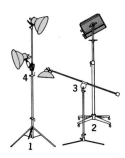

Flash and shutter synchronization

Cheaper cameras which only take bulbs or cubes are synchronized at low speeds, usually around 1/25 sec. More complex cameras usually have two settings. The "M" setting is for use with bulb flash which peaks more slowly and more gradually than electronic flash, see graph below. Typically, when set on "M" the shutter will open

some 15 milliseconds after the flash has been triggered and remain open for 14 milliseconds. Electronic flash is of much shorter duration and peaks almost instantaneously. An "X" setting usually fires the flash the moment the shutter is fully open.

"M" setting: bulb flash

Shutter open

0 10 20 30 40 50
Milliseconds

"X" setting: electronic flash

Shutter open

Light output

0 10 20 30 40 50
Milliseconds

Electronic flash

Electronic flash will give thousands of flashes from the same gas-filled tube. The electrical circuitry is much more costly than for bulbs, but electronic flash costs almost nothing to run. Most low powered electronic flash units use rechargeable batteries in a power pack forming part of the head. Others can be used directly off the mains electricity supply. The light output is largely related to size and weight. Medium output units use packs which can be slung from the shoulder. Large studio units may use packs which stand on the floor. In all cases a low voltage synchronizing lead connects through suitable "X" contacts to the camera shutter mechanism. Here an internal circuit to trigger the flash is completed only when the shutter is fully open.

Studio flash

Studio electronic flash works on the same principle as the hand-held units. However, since an electricity supply is available the flash can be mains operated. This means that more powerful units can be used, and each flash head may have a small built-in tungsten modeling lamp to preview the lighting when setting up. Like conventional studio lamps some heads are designed to give soft overall lighting, others harsh spotlighting. Often one flash power-pack is used to supply up to four heads, through a system of output level selector switches. The camera synchronizing lead is attached only to the nearest flash unit – each head has a photo cell sensor and so they all respond to the flash and fire in full synchronization.

Electronic flashgun

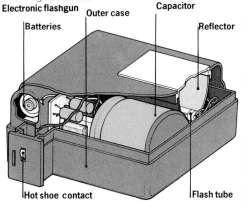

Outer case · Capacitor · Batteries · Reflector · Hot shoe contact · Flash tube

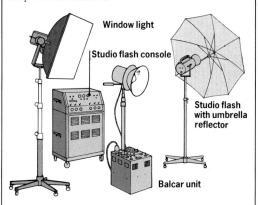

Window light · Studio flash console · Studio flash with umbrella reflector · Balcar unit

Electronic flash components. The flash tube is usually U-shaped to save space, and is backed by a polished reflector. This helps increase light intensity but gives harsh quality. The head unit may pivot, below left, so that softer lighting can be produced by reflecting off the ceiling. The power unit houses batteries, capacitors, the triggering circuit and the exposure controlling cell. Batteries usually allow between 50 and 100 flashes. The mains electricity charger may be a separate or built-in unit. Relative to flashbulbs, single unit clip-on electronic flashes, below left, are quite weak. To produce more light a flash with a larger powerpack is needed. This is most easily carried as a separate unit on a shoulder harness, below right, and wired to the flash head. Extra or alternative heads can be plugged-in, for example a "ring flash" which completely encircles the lens and so gives soft, even lighting, particularly suited to close-up record photography.

Computer flash

Computer flashguns use a sensor, a fast-reacting light sensitive cell which points toward the subject. The lens aperture is determined according to recommendations based on the ASA rating of the film and the flash is attached to the camera's "X" shutter synchronization setting. Firing the shutter starts the flash, but its duration is determined by the light sensitive cell. Measuring light reflected from the subject, the cell quenches the flash as soon as the right quantity of light has been received. This means, for example, that a close light-toned subject is given a much shorter duration flash than a darker subject further away. The two flashes might last 1/50,000 second and 1/1500 second respectively. A self-regulated computer flash therefore improves your exposure accuracy.

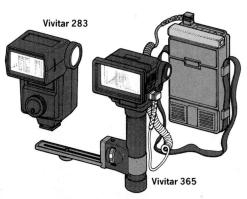

Vivitar 283 · Vivitar 365

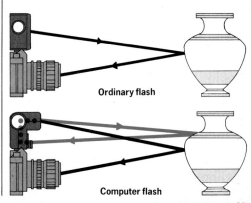

Ordinary flash · Computer flash

The 35 mm camera kit

A camera kit is like a tool-box. Not only do you need camera, lenses, meter, flashgun and films, but a range of other, non-photographic items which become invaluable when working on location. Remember, you may be stuck miles from any store. First consider the small accessories – lens hood, cable release, filters and holder, table tripod, and a gray/white card for making meter readings. Then there are the "fixing" aids such as adhesive tape, staple gun, staples, modeling clay and pins. It is important to carry certain items for repairs and replacements: a small screwdriver, lens tissue, a spare camera attaching tripod screw, some fuses, an extra ultra fast film (in case of flash failure), a spare meter battery, color conversion filters for shooting daylight color film in tungsten lighting and vice versa. It is helpful to compile your own check list and keep it pasted into the gadget bag lid.

Protecting your camera and film

A camera case alone cannot fully protect your equipment. Never leave it where it will overheat (the interior of a car in summer is notorious for high temperatures). Remember that dust and dirt can be abrasive and damage the lens, and a damp atmosphere, particularly a salty one, will corrode the mechanism. When photographing in dusty or damp conditions keep the camera in a plastic bag whenever possible. And if you are storing a camera in an unfavorable climate put it in a plastic bag with the packet of silica gel which is supplied with most new cameras. This will absorb damp and keep it away from your lens. Use X-rayproof bags for your film when passing security at airports.
See: Camera faults

Ever-ready cases

The idea of an "ever-ready case" is that it completely covers and protects the camera, yet allows almost immediate use. The case is contoured to fit your particular camera model and lens. It usually has a flap-down front, rapidly opened by unsnapping which allows unobstructed instant use of the lens and viewfinder.

Custom cases

Various metal or leather hinged cases are sold for photographic equipment. They contain a solid block of foam plastic and a padded lid. The idea is that the photographer cuts out cavities shaped to fit his particular items. Moreover, by buying extra foam blocks you can prepare one insert for your still photography kit, another for movie gear, and so on.

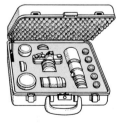

Camera supports

A camera support must be strong, firm and allow as much adjustment of height and angle as possible. If the support is intended to be carried around, its design should be as compact and lightweight as possible. Monopods act as simple props (the photographer still holds the camera), but with care allow exposures of 1/8 sec or shorter. A clamp or table tripod is very useful provided you find something to mount it on. Larger, telescopic-legged tripods often have a center column for quick height changes which will also reverse to allow low viewpoints.

Adjustable heads
A tripod allows up and down adjustments, but for a full range of tilts some sort of swiveling head is also needed. This may be a ball and socket arrangement, locked and unlocked by a clamp, or it might be a full pan and tilt head with a control arm.
See: Time exposures

Shutter releases

It is good practice to avoid camera shake by using a cable release whenever exposure times demand use of a tripod or other support. The release is a flexible, sheathed cable which screws into a socket on or near the shutter release button. Pressing the cable release plunger smoothly fires the shutter, and by turning a screw the plunger can be locked-in for time exposures with the shutter set on "B". Releases range in length from less than one inch (2.5 cm) to 12 ft (3.6 m) or more – the latter being pneumatically operated by squeezing an air bulb. Some specialized equipment may require a twin or triple cable release where several camera functions must operate at the same time.

Studio stand

Large format tripod

Standard tripod

Lightweight tripod

Monopod

Table tripod

Pneumatic release

Cable release

Ultra-high supports. These are occasionally used on location when a high viewpoint is needed but cannot be found. Special ladder camera stands can be assembled in short sections for any height up to about 15 feet (4.5 m). Beyond this it is possible to use a telescopic mast system which allows the camera to be carried up to 40 feet (12.2 m). A car is used to steady the baseplate, right. The mast is often raised by means of an air pump and the camera shutter fired electrically.

Clamps. A G clamp makes a compact and very useful camera support accessory. It should be adapted to carry a ball and socket or pan and tilt head. The clamp allows the camera to be attached to the back of a chair, side of a ladder or any other firm support. Similarly heavy duty laboratory clamps and stands can be used to grip the camera, as well as holding reflectors, backgrounds and, when you are taking still life close-ups, the subject itself.

How film works

Photography really began with the discovery of a practical light-sensitive chemical for recording the image formed in the camera. This chemical was, and still is, the metal silver. "Silver halides", which are compound salts of silver like silver bromide, silver iodide and silver chloride, will break down under the action of light to form tiny grains of black metallic silver. However it takes a long time for light to decompose sufficient silver halides to form a visible image, but the formation of just a few atoms will do. These can later be amplified millions of times by development using chemicals able to increase the silver in the light-struck areas. Since light forms black silver the camera image is recorded in negative tones – highlights black and shadows white. The silver halides are therefore normally coated on a transparent film base so that, after processing, light may be passed through the negative image to print it on to silver halide coated paper, to form a black and white positive.

Of course, there are problems in coating film evenly and securely with a layer of chemical crystals. The coating must be even or the material will vary in light sensitivity and show coating marks. It must be sufficiently well attached to withstand liquid processing, washing and drying, yet allow the free entry and chemical action of the developer. To meet these exacting requirements gelatin is used – mixed with the silver halides to form a light sensitive emulsion. In fact certain impurities in the gelatin actually help increase the light sensitivity of the emulsion provided it is "ripened" – heated for several hours during manufacture. Emulsions are coated on to a suitable plastic or cellulose triacetate base which is coated on its other side with an anti-halation dye. This gives the back of the film its dark appearance before processing. Processing removes this dye leaving the film colorless. The dye helps prevent light reflecting back from the rear of the film to form halos around highlights.

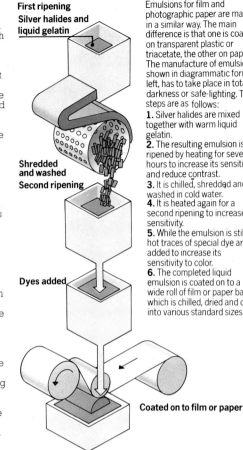

First ripening
Silver halides and liquid gelatin

Shredded and washed
Second ripening

Dyes added

Coated on to film or paper

How emulsion is made.
Emulsions for film and photographic paper are made in a similar way. The main difference is that one is coated on transparent plastic or triacetate, the other on paper. The manufacture of emulsion, shown in diagrammatic form, left, has to take place in total darkness or safe-lighting. The steps are as follows:
1. Silver halides are mixed together with warm liquid gelatin.
2. The resulting emulsion is ripened by heating for several hours to increase its sensitivity and reduce contrast.
3. It is chilled, shredded and washed in cold water.
4. It is heated again for a second ripening to increase sensitivity.
5. While the emulsion is still hot traces of special dye are added to increase its sensitivity to color.
6. The completed liquid emulsion is coated on to a wide roll of film or paper base, which is chilled, dried and cut into various standard sizes.

Black and white film

— Gelatin supercoat
— Emulsion
— Gelatin and cellulose

— Triacetate base

— Gelatin anti-curl layer containing anti-halation dye

Processing stages

1. Exposure. The immediate effect of exposing the image on to photographic film is to form a few atoms of metallic silver within each tiny light-struck silver halide crystal. (Many millions of crystals are contained in each square centimeter of film.) The effect gives no visible change, but the silver specks forming this invisible or "latent" image will act as centers for development later.

2. Development begins. Developing agents (usually metol, phenidone and hydroquinone) in the solution donate electrons to the development centers formed by the latent image. These encourage the formation of more silver until complete grains are converted to black metallic silver – typically an amplification factor of about 10 million times. The highlight areas begin to appear.

3. Development is completed. As development continues, mid-tones and finally shadow details appear, and the highlights steadily increase in density. Development is halted after the recommended time, according to film type, developer type and temperature and amount of agitation given. The film is transferred to a brief water rinse or a weak acetic acid "stop bath".

4. Fixation. If you looked at film at this stage, it would carry a black negative image, but the rest of the emulsion would still appear creamy-white and remain light-sensitive. Still in the dark therefore, the film is placed in a fixing solution containing hypo. This converts un-developed halides into colorless salts. Fixing takes from two to ten minutes depending on type.

5. Washing. This stage has no visible effect, but is important because all remaining chemicals must be removed from the film if the image is to remain permanent. Either water can be run continuously through the film tank, or you can give several changes of water allowing the film to soak for a minute or so each time. If your water supply contains grit or other sediment fit a water filter or a fine muslin bag over the faucet.

6. Drying. Finally the washed film is hung up to dry, usually suspended from a rod or cord, with a clip at the bottom end. It is very important that the film dries evenly and does not collect dust. Rinsing the film in "wetting agent" (weak detergent) at the end of washing helps to prevent the accumulation of drops of water. Some photographers remove surplus water by running the film through special wipers.

Speed ratings

Various international speed ratings have been devised to relate the light sensitivity of one film to another. The three series now in use are: ASA, the American standard system by which doubling of speed is shown by doubling of the number; DIN, the German system which denotes doubling of speed by a rating increase of three; GOST, the Russian system which uses a similar arithmetical increase to ASA.
See: Film speed

ASA	DIN	GOST
16	13	14
32	16	27
64	19	55
125	22	110
200	24	180
400	27	360
800	30	720
1250	32	1125
2000	34	1800

Color sensitivity

Basically photographic emulsion is sensitive only to the ultra violet-to-blue zone of the spectrum. Printing papers and films intended for copying black and white originals have this sensitivity, allowing the use of bright orange safe-lighting. Some emulsions are made with ultra violet-to-green sensitivity (orthochromatic, used in deep red safe-lighting). Most general purpose film emulsions are sensitive to all colors (panchromatic, used in darkness).

Slow

Film is generally designated as slow if it has an ASA rating of about 50 or less. Its relative insensitivity is due to two main factors. First, the silver halide grains are exceptionally small, and secondly the emulsion may be thinly coated to improve resolution. A third factor found in some films intended for darkroom use, such as process film, is that the film may not be sensitive to all colors.

All pictures are enlargements from sections of 35 mm negatives. They are reproduced here magnified 20 times to show how resolution decreases as film speed increases.

Medium

Medium speed films – say with ratings between 50 and 160 ASA – are used for a wide range of subjects and lighting conditions. They represent a good compromise between light sensitivity and fine grain, and are rather less contrasty than slow films. This also means that a medium speed film offers greater exposure "latitude" (permitted exposure error) than other film types. Emulsions of this kind respond well to fine grain development. In the case of subminiature formats medium speed film is a good choice for most work, because of the need for a high resolution image capable of considerable enlargement.

Fast

Black and white films within the range of 160 – 800 ASA are fast. Grain is likely to become apparent in enlargements beyond about x 8, for example 8 x 10 ins (20.3 x 25.4 cm) from 24 x 36 mm, particularly if the film is "pushed" in development. Fine grain development will help reduce this mealy appearance but usually sacrifices some speed. Graininess apart, fast film will allow you wide scope to photograph any subject under any lighting conditions other than the very bright or the exceptionally dark. Emulsion contrast is rather lower than with normal or slow films, and this can be of some advantage with subjects in contrasty lighting provided that correct exposure is given. Fast films should always be loaded keeping the camera away from strong light.
See: Available light/ Variations in processing

Ultra-fast

Films with an ASA rating of over 800 include the fastest emulsions currently available. At present the maximum is about 1250, but in favorable conditions this can be raised by a factor of two or three times by boosted development. Without exception such films have a pronounced grain pattern. The emulsion is also coated thickly – the additional halides contributing to the extra speed. This causes lowered resolution. The film must be loaded or unloaded indoors or in deep shadow.
See: Variations in processing

When slow film is best

Slow films are used whenever big enlargements with a lot of detail are required. They are especially good for still life, below. However, a slow film needs more light than a fast film to make a correct exposure. So the wide apertures and long exposures which are often necessary will reduce depth of field and blur moving images. But if you want this sort of effect slow film enables you to photograph under brilliant sun-lit conditions yet still achieve shallow depth of field or blurred movement effects without over-exposing.
See: Depth of field

When medium speed film is best

Medium speed film is all purpose film useful for most normal situations. It is heavily used in the studio, below, especially in large format work. If you use it outdoors in bright lighting conditions you can obtain a useful range of meter readings, but as the light fails, you may be confronted with unacceptably long exposures and large aperture settings. In most cases enlargement up to 8 x 10 ins (20.3 x 25.4 cm) from the whole of a 35 mm format negative is possible without noticeable lose of detail.
See: Studio techniques

When fast film is best

Fast films are generally used when big, finely detailed enlargements are not required, and lighting conditions are dim or generally unknown. It is the film to use when fast shutter speeds are necessary to freeze moving subjects, as in sports photography. If you want very great depth of field, fast film helps because it enables you to stop the lens well down. The converse is also true. Readings taken in bright conditions using fast film may require small aperture settings, thus depriving you of control of depth of field in your pictures.
See: Depth of field

When ultra-fast film is best

Ultra-fast films are most useful for working in dim existing-light conditions – dark interiors, deep shadow outdoors, night-time streets and so on. It is very grainy film, so where a strong grain pattern is desired as a visual effect in a picture, ultra-fast film can be used in normal light conditions with a dark gray neutral density filter to avoid over-exposure. There are few conditions under which this film will not produce a picture, so it is useful to carry one or two rolls as a precaution against flash failure or other lighting equipment malfunction on location.
See: Night photography

Special black and white copying film

Copying is the term generally applied to the photographing of printed matter, drawings, photographs and so on. Black and white films made for this sort of work tend to be of two main types. First, normal contrast, which is able to record faithfully the full range of tones in a photograph, or a design using shades of gray. Fine grain is important here, and since the camera is likely to be used on some form of copying stand, the film can be quite slow. For copying colored originals panchromatic sensitivity is essential, but for monochrome photographs an emulsion sensitive only to blue allows processing under orange safelighting.

The second type is very high contrast film which gives very dense blacks, clear whites, and virtually nothing in between. This is intended for text, diagrams and ink drawings and is often called line film. It is processed in high contrast developer.

The emulsion is again slow, fine grain, and normally only sensitive to blue, although some panchromatic line films are made. Most of these copying films are available only in sheet film sizes, although a few line emulsions are sold in bulk rolls for 35 mm and 16 mm microfilm and similar cameras.

Contour line film

This has effectively two combined emulsions. One gives a direct positive and the other a negative image when normally processed. The film records an image in which subject high-lights and shadows appear very dense but one chosen tone value, usually a mid-gray, appears light. Used to copy a normal photograph it gives a print like a black line drawing.

Autoscreen

This is a special form of lith film, which has been pre-fogged behind a finely ruled screen. It is intended for copying full tone range photographic images and when processed in lith developer gives a negative made up from tiny dots, like a picture reproduced in a newspaper.
See: Photo-silkscreen

Lith film

This has a very high contrast, very thinly coated emulsion which is intended to be developed in special lith developer. It produces a line negative with extreme contrast and sharpness. Most lith films must be handled and processed **under deep safelighting.**

Microfilm and microfiche

These are high contrast, fine grain thin emulsion films capable of resolving very fine detail. They are used for recording documents and pages of books greatly reduced in size. The film is usually processed to a negative, then enlarged and viewed in a microfilm reader. Microfilm is usually 16 mm or 35 mm wide. Microfiche, above, is sheet film used in cameras which place micro-images in rows. In the example above, 207 pages of printed matter are contained on a 4 x 5 ins (10.2 x 12.7 cm) sheet of microfiche.

Infra-red film

Infra-red film has color sensitivity specially extended into the infra-red region. It is normally exposed using an infra-red transmitting filter, over the camera lens to eliminate all other wavelengths. The film reproduces green foliage as snowy white, below, and it is often used to photograph sunlit landscapes in which blue skies appear black. Considerable penetration of atmospheric haze is possible. The film can also be used under no-light conditions, using an infra-red emitting lamp or flashbulb mounted on the camera, both these sources being virtually invisible to the eye. This is especially useful for photographing animals at night. Certain skin disorders and other medical conditions show up better on infra-red than on normal film.

Nuclear emulsions

This is a special emulsion with a high concentration of very fine grain silver halides, used either in a solid block, like a solidified jelly, or coated on glass plates which are then stacked to form a similar structure. The whole block is exposed to nuclear particles, either in the laboratory, or high above the earth suspended from a balloon. Charged particles such as electrons, protons and cosmic rays leave developable tracks as they pass through the block or collide with atoms in the emulsion. After processing, the block forms a three-dimensional model in which each track appears as a black silver trace.

Reversal film

Most slow, fine grain black and white films can be made to give a direct positive (black and white transparency) image instead of a negative, if given special reversal processing. Some film emulsions are specially designed for this purpose, and have the advantage of producing a neutral black image of sufficient contrast and density to give a high quality image when they are projected.

X-ray film

Sheet film designed to respond to X-rays has a plastic base coated both sides with a silver halide emulsion. The emulsion is sensitive to white light as well as to short wave ultra-violet and X-rays. In industrial work X-ray film is usually placed in contact with a thin lead foil "intensifying screen". However, in medical work much less radiation can be tolerated – and the film is exposed in contact with a "salt screen". Films are processed in a high activity black and white developer and viewed on a light box.

X-ray image. An X-ray tube produces wavelengths short enough to penetrate most substances (but not lead), and form a shadow image on a sheet of film. The telephone, right, was placed over a sheet of X-ray film backed by a lead intensifying screen. The tube was positioned overhead.

Instant picture material

Instant picture photographic materials enable a finished contact size print to be produced within a minute of making the exposure in the camera. The exposed emulsion is brought into contact with a receiving paper, with a viscous, jelly-like layer of chemicals spread between the two. A negative black silver image is produced within seconds, and then a silver halide solvent encourages the transfer of silver from unexposed areas to the receiving paper, forming a positive print. Positive and negative are peeled apart and the negative is either thrown away or, if it is a film base type, it may be treated and washed to form a conventional negative. Instant pictures are ideal if results must be checked on the spot. Lighting, exposure and composition can all be altered immediately if necessary.

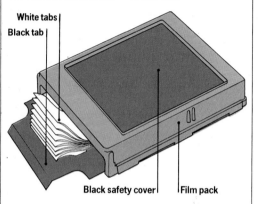

White tabs
Black tab

Black safety cover | Film pack

How the pack works. The pack, above, is loaded into the camera and black masking paper removed to allow the first light-sensitive sheet to face the lens. You make the exposure, then pull a paper tab which draws the exposed material into the back of the pack, facing a receiving sheet. A second, larger tab now protrudes from the pack through the camera rollers. Pulling this tab draws the sandwich completely out through the rollers which break and spread a pod of jellied chemical across the paper.

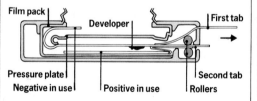

Film pack | Developer | First tab
Pressure plate | Second tab
Negative in use | Positive in use | Rollers

Pulling first tab. After the exposure has been made, the first tab, the white one, is pulled. This brings the exposed negative around to the back of the pack where it faces a sheet of photographic paper.

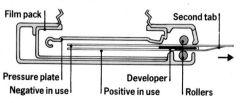

Film pack | Second tab
Pressure plate | Developer
Negative in use | Positive in use | Rollers

Pulling second tab. Developer from the pod is spread between negative and paper. Powerful alkali chemicals now trigger the developing agents, which produce a black and white negative in seconds.

The instant picture process.
1. After loading film pack in camera pull black safety tab. This makes the camera ready for use. Compose the image in the viewfinder and press shutter release.

2. Pull the first tab to bring the negative to the back of the pack into contact with a sheet of photographic paper.

3. Immediately pull the second tab which draws the negative and positive materials out of the camera rollers. These crush a pod spreading developer evenly between the two surfaces.

4. After the required time the two materials are peeled apart. Chemicals remaining on the face of the print are absorbed into an underlying layer, leaving a complete and permanent black and silver image.

Types of instant film. The range of black and white instant materials includes a high speed (3000 ASA) and a slower, high contrast emulsion – both of which are of the non-reclaimable negative type. A popular medium speed (125 ASA) material uses a film-based negative. After it's peeled apart from its print, this needs soaking in a 12 percent sodium sulfate solution to clear the chemical remnants, followed by washing and drying. The resulting negative is fine grain and quite permanent. It allows high quality enlargements to be made in the normal manner on conventional printing paper. It is important to remember with all peel-apart instant print materials that low temperatures will greatly slow processing. In cold weather you may have to warm the material by placing it under your arm immediately after its removal from the camera. A simple metal sheath is provided to prevent chemical staining.

Film backs. Instant film packs either fit into instant cameras or into special holders or backs designed to fit various conventional cameras. One type of holder intended for 4 x 5 ins (10.2 x 12.7 cm) view cameras, right, looks like an oversized sheet film holder. Another fits the Hasselblad, right, and yet another suits oscilloscope and other recording cameras. Each holder contains its own pair of pod-crushing rollers, which must be regularly cleaned.

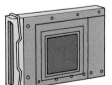

Hasselblad back

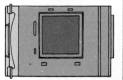

View camera back

Film packing and formats

Sheet films such as 4 x 5 ins (10.2 x 12.7 cm) are supplied 10 or 25 to a box. The most popular rollfilms are 120 and 620, and there is a film 70 mm wide without backing which gives 70 exposures. These all give pictures with dimensions 6 cm by either 7, 6, or 4.5 cm. 127 film is a narrower rollfilm giving pictures 42 mm square. Instant loading 126 cartridges contain 35 mm wide film attached to backing paper, with single perforations spaced to allow 12 or 20 pictures 28 mm square. Double perforated 35 mm film is packaged in 20 or 36 exposure cassettes. The 110 cartridge contains 16 mm wide film for pictures 13 x 17 mm.

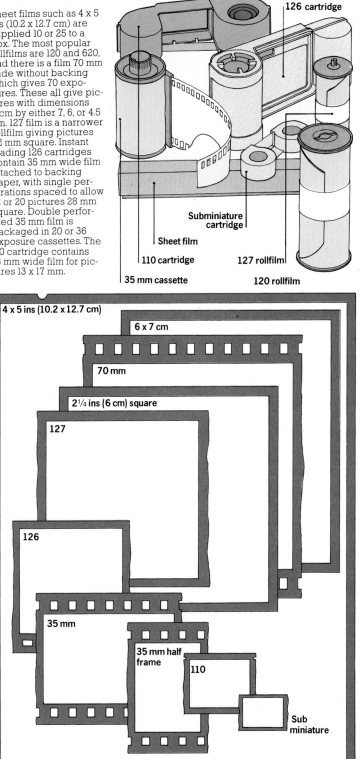

126 cartridge

Subminiature cartridge

Sheet film

110 cartridge

35 mm cassette

127 rollfilm

120 rollfilm

4 x 5 ins (10.2 x 12.7 cm)

6 x 7 cm

70 mm

2¼ ins (6 cm) square

127

126

35 mm

35 mm half frame

110

Sub miniature

Bulk film loader

Instead of buying 35 mm film in cassettes you can purchase a bulk length, typically 15 meters, and then keep reloading cassettes yourself. The easiest method is to keep the film in a daylight charger, which allows cassette refilling without a darkroom. This routine saves money, but there is always some risk of the film scratching due to carelessness or the overuse of old cassettes.

1. In the dark, place bulk film in loader so that it rolls counter-clockwise. Thread 3 ins (8 cm) into cassette compartment and replace lid. Attach end of film to a cassette spool with masking tape.

2. Put spool in cassette, place in compartment and fit door. Turn light on and move frame counter to zero. Wind film on to spool up to desired number of frames (not more than 36) and then wind two more.

3. Remove compartment door. Cut clean across film 1½ ins (4 cm) from cassette and remove cassette. Cut a tongue as on ready-loaded film.

Basic requirements

In processing film it is vital to allow the various solutions to act evenly on the emulsion–in the right sequence, and at a time and temperature which will give the required degree of development, fixing, washing and so on. You don't necessarily need a darkroom to process roll and 35 mm film. A light-tight closet or changing bag, or even an ordinary room with the curtains drawn at night will suffice for loading the film into a daylight developing tank. All other operations can then be carried out in normal room lighting – preferably in or near a sink with running hot and cold water. The devel-oping tank accepts a reel or "spiral" designed to hold the film in the form of an open coil. This allows plenty of space for processing liquids to circulate and evenly affect the entire emulsion. And once the loaded reel is placed in the tank and the lid secured, solutions can be poured in or out through a light-tight hole in the lid itself. Take care to separate dry oper-ations from wet stages. Load the dry reel and tank well away from the sink, and make sure your hands are dry too. Have all your bottles or con-tainers of solution ar-ranged in the correct sequence in or near the sink. They could all be standing in a shallow dish of warm water to maintain the required temperature, normally 68°F (20°C).

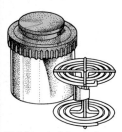

Stainless steel developing tank and 2¼ ins (6 cm) reel

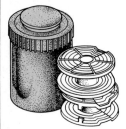

Plastic developing tank and two 35 mm reels

Daylight loading tank

Developing tanks

The processing tank itself may be of plastic or stain-less steel construction. Plastic units normally have reels which can be altered in width to accommodate either 35 mm or rollfilm. Stainless steel tanks are more hard-wearing and easier to clean, but the reels can be difficult to load until you become prac-ticed. Some tanks have a rod which you insert into the solution entry hole and twist to agitate the reel; others just have to be tilted to give agitation.

Daylight loading tank
Some tanks even allow you to load the reel in normal lighting. The cassette is placed in a loading chamber and its protruding tongue of film attached to the reel center. You close the lid and turn a handle to wind the film on to the reel. An externally operated knife then cuts the film end.

Sheet film tank
A darkroom is really required for processing sheet film. Each one is clipped into a stainless steel hanger, which is then suspended in a large tank of developer and covered with a light-tight lid. A separate tank is needed for every solution you use.

Developing equipment

You need a timer to clock each stage of processing, a measuring jug and a funnel to return solutions to their bottles. Timers should be of the type which ring after a pre-set number of minutes– they should accurately time periods between about 3 minutes and 1 hour. Funnels and beakers can be stainless steel, plastic or glass. Clear plastic is cheap, fairly hard-wearing and allows clear and easy measuring-out of sol-utions. A short hose unit allows the cold water faucet to be directly connected to the tank for washing. A photographic water filter between faucet and hose will eliminate grit and other impurities if this is a problem. Finally, clips are required to attach to the top and bottom of the processed film when this is removed from the reel and hung up to dry.

Preparing chemicals

Most processing chemicals today are bought as concentrated solutions, or ready-to-mix powders. Developer powders are often boxed in two packages – these must be dissolved in the order specified, in water at about 125°F (52°C). Add the powder to about three-quarters of the final volume of water slowly, stirring gently, then top-up with some more water to the full amount. If developers are prepared from basic chemicals working to a formula, you must always dissolve them one at a time in the order listed. Fixers can be obtained in solution form, but are cheaper to mix from dry chemicals. Remember that hypo crystals need dissolving in hot 130°-140°F (55-60°C) water. Most unused developers have a shelf life of six months in concentrated form, particularly if stored in full, stoppered bottles.

Choice of solution

Each developer formula has its own performance characteristics – for instance it may be intended to give fine grain, or increased emulsion speed, or contrast. Generally speaking, high contrast, speed enhancing and high acutance developers have poor keeping properties. They are usually prepared, used and then thrown away. Most fine grain types have a long working life which can in fact be prolonged by "replenishment"–pouring off a small quantity of solution and then "topping up" with replenisher solution containing fresh developing agents.

"Fine grain" developers
These are mostly rather slow working, low contrast producing, and work on the basis of avoiding the "clumping" together of silver grains into larger visible specks.

High definition or "acutance" developers
These are intended to form a silver image mostly on or near the surface of the film, reducing the loss of detail caused by diffusion of the image within the thickness of the emulsion.

High energy developers
Fast working, active formulæ are included in these. They are designed to effect an increase in the speed rating of the film by two or three times. Grain is accentuated.

High contrast developers
These are also very energetic, intended for line and lith emulsions, on which they form intense black tones without degrading white areas.

MQ or PQ developers
These have formulæ combining energetic and soft working agents (typically metol+hydroquinone or phenidone+hydroquinone). These general-purpose developers can be used for both negatives and prints.

Stop baths
These are weak acid solutions designed to halt development completely. Their use is most necessary with highly active developers–with other types a water rinse will suffice. Some stop baths contain an indicator dye which changes color when the bath is neutralized (exhausted).

Fixers
These are of two main kinds–making use of either sodium thiosulfate (hypo) or the more rapid but expensive ammonium thiosulfate as a fixing agent. A weak acid is also present and the formula is often completed with an agent which physically hardens the emulsion gelatin, to speed drying and help protect it from abrasion.

Cautionary Note
All photographic chemicals poured down drains should be diluted with generous quantities of water. Acid fixing solutions can be very corrosive if allowed to seep into wood and most other building materials.

The right developer for the film

In practice choice of developer has to be related to film characteristics too. For example, it is futile to shoot on a fast, coarse grain emulsion and then hope that by processing in fine grain developer the result will be equivalent to a fine grain film. As the table, right, shows, best results occur from matching the developer to the film. Mis-matches are generally counterproductive, but there are times when a film is known to be under- or overexposed, and choice of a particular developer can go some way toward correcting results. For underexposure you can process in a high energy developer; for overexposure in a fine grain type which also reduces effective film speed. For most work, a general purpose, moderately fine-grain developer with good keeping properties will give excellent results.

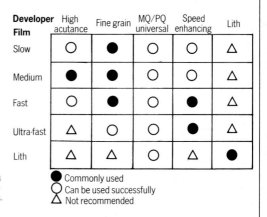

Developer / Film	High acutance	Fine grain	MQ/PQ universal	Speed enhancing	Lith
Slow	○	●	○	○	△
Medium	●	●	○	○	△
Fast	○	●	○	●	△
Ultra-fast	△	○	○	●	△
Lith	△	△	○	△	●

● Commonly used
○ Can be used successfully
△ Not recommended

Mixing developer. Work in a well-ventilated area and be sure that powders or liquids cannot spill where they will affect photographic materials. Mix solutions in a glass, plastic or stainless steel container, and use a rod of one of these materials as a stirrer. Follow the manufacturer's instructions carefully, paying particular care to dissolve components in the order stated. Use warm water, ideally 68°F (20°C).

1. Pour the dry powder slowly into the warm water, stirring gently all the time. Do not allow chemical to solidify on the bottom, but avoid whipping too much air into the solution.

2. The solution may appear cloudy, but provided it is free of sediment the next component can be added in sequence. Finally top right up with water.

3. Use a storage bottle just large enough for the quantity of developer. Label with the name, dilution and date. Allow the solution to cool and settle, preferably for at least 12 hours before you use it.

Loading the processing tank

Loading requires skill and practice because the job must be carried out in the dark. The film must not be kinked or finger marked in handling and it must be wound on to the reel so that no parts of the roll are in contact with any other. In some tanks the film end is attached to the reel core, so that film is wound, slightly bowed, from the center outward. Others feed in film from the outer rim of the reel. Before you use a tank for the first time be sure to practice loading the reel in daylight, using an unwanted processed film. Then try doing it with your eyes shut, and finally with the lights out.

Reel-loader

This is a jig device designed to assist the loading of reels which wind the film from the center outward. The loader is set up on the darkroom bench and the leading end of the film passed through a curved feed guide and attached to the reel center. Then you slowly turn a handle to draw the whole film smoothly on to the reel.

35 mm film on a metal reel.
1. Cut off the shaped tongue of film. Attach the film end to the clip, or spike, at the center of the spool. Be sure to switch out the light.

120 film on a plastic reel.
1. Switch out the light. Break the seal of the roll-film and unwind backing paper until you find the springy end of the film. Feed this end into the entry slots of the reel.

1. In total darkness line up your loader to receive the film. The same loader can be turned round to take 35 mm or 120 roll-film, as shown here.

2. Unroll backing paper and feed film through the guide so that it bows slightly. Attach the end of the film to the teeth at the center of the spool.

2. Now bow the film slightly between thumb and index finger. Rotate the reel in your other hand so that film is pulled smoothly out of the cassette and on to the reel.

2. By rotating each half of the reel alternately the film is drawn into the spiral grooves. Allow the backing paper to unwind and fall on to the bench.

3. Turn the reel to feed the film on to the spool.

4. When film is almost loaded detach backing paper and finish loading. Remove reel from loader.

3. Cut or tear the film and check that this last part is wound on to the reel. Lower the reel carefully into the tank body; close the lid tightly and switch on the light.

3. Detach the backing paper and ensure that the film end is completely wound on to the reel. Place the reel inside the tank body. Secure the lid and switch on the light.

Changing bag

This is a light-proof bag with sleeves. First the tank, reel, top and film are placed in the bag. You insert your hands through the sleeves, load the reel, place it in the tank and secure the top.

Processing

Always remember that film processing is a complex job. You cannot actually see what is happening inside the tank and mistakes at this stage can ruin up to 36 unrepeatable negatives. Have everything properly prepared in advance. Remember the sequence of stages (write them down if this helps), concentrate on what you are doing, and watch particularly timing, temperature and agitation.

Even when you are quite experienced avoid distractions once the processing sequence has begun, until the film is safely washing or hanging up to dry. If you are working with re-usable developer solutions it is worthwhile soaking the film in water (at the same temperature as the other processing solutions) before development). This helps to avoid contamination of the developer by chemicals which are released from the film backing during processing.

Time and temperature

The amount of development a film receives depends upon temperature, the time the solution is allowed to act, and the degree of agitation. Within limits, low temperature can be compensated for by increasing developing time, and vice versa. However, below about 55°F (13°C) some developing agents (e.g. hydroquinone) cease to function, giving very flat results. Above 75°F (24°C) the film becomes physically soft and easily damaged. Most developers are intended to be used at 68°F (20°C). As a rough guide double the processing time for each drop of 10°F (5½°C).

1. Have all your solutions waiting at the correct, 68°F (20°C), temperature – perhaps by standing everything in a dish of warm water. Even the loaded tank can be pre-warmed in this way.

2. Pour in the developer fairly quickly and tap the tank to help dislodge air bubbles. Start the timer.

3. Agitate the tank according to the maker's instructions, either by inverting the tank, rolling it on the bench or rotating the agitation rod. Do this for the first 15 seconds, repeated every half minute.

4. At the end of the development time suggested by the manufacturers, pour the solution back into the storage bottle, using a funnel.

5. Pour in stop bath, agitate and leave for between half and one minute. Then pour all solution from the tank. Pour in the fixer, agitating for the first 15 seconds. Thereafter agitate for 15 seconds every minute.

6. After one minute in the fixer the film is no longer light sensitive. Having fixed the film for the required time return the fixer to its bottle.

Developer exhaustion

Developer solution life is determined by the way the solution is stored, and the quality of film which it processes. Assuming that the developer is returned to a tightly closed bottle or, for sheet film tanks, a lid is floated on the surface of the solution to minimize oxidation, developing times must be increased according to the area of emulsion it has already processed.

7. Attach the hose from the cold water faucet to the tank. Allow the film to wash for 30 minutes. After washing add a few drops of wetting agent to the water in the tank, to encourage even drying.

8. Now remove a few inches of film from the reel and attach a film clip. Gently pull out the whole film and attach a clip to the other end. Hang up the film to dry in a dust-free area preferably overnight.

9. As soon as the film has fully dried cut the negatives into convenient strips and immediately protect them in storage envelopes.

Processing sheet film

Sheet film can be processed in a tank, right, or in batches of up to six sheets in a dish. Feed the sheets, one at a time, into a full tray of water at the same temperature as the developer. Pull out the bottom sheet and place it on top, and keep doing this until the whole stack has been rotated. Transfer sheets one at a time to the developer and keep shuffling. Do the same in the stop bath and fixer.

1. Unload individual sheet films from their holders in the dark. If you use film packs, open the pack in the dark, and detach each sheet from its backing.

2. Load each sheet into an individual film hanger, attaching all four corners. Enclose the hangers in a cage, which will hold them apart and prevent them from knocking each other.

3. Gently lower the whole cage into the tank of developer. To agitate raise the cage, tilt it at 45° for two or three seconds and return it to the tank.

Processing reversal film

Reversal processing can be carried out in any daylight developing tank, but it is best to use one with a transparent plastic reel. This is because part way through the four-stage processing sequence, below, the film must usually be exposed to light. By placing the reel in a white lined bowl of water under a lamp the whole film can be evenly fogged without risk of scratches or abrasion.

Processing film in a monobath

A monobath is a single processing solution which will both develop and fix a black and white negative in one stage. It consists of an active PQ type developer combined with a fixer component which has a long "induction period," meaning it only begins to work after the film has had time to fully develop. Monobath formulae are very critically balanced, but easy to use. Timing and temperature are relatively unimportant – both components are affected equally, so you simply leave the film in until no further changes are occurring.

In-cassette processing Using a monobath solution you can even process a 35 mm film in its cassette. The only equipment you need is a large coffee cup or beaker and a piece of ¼ in wooden dowel slotted at one end.

1. Develop in a concentrated MQ developer which also contains a weak halide solvent. This will give a contrasty negative image.

2. Rinse and then bleach in a solution of potassium bichromate and sulfuric acid. This removes the developed black silver negative, but without affecting undeveloped halides.

1. Cut off the shaped tongue at the beginning of the film, and loop about 1 in of film back over the cassette casing, retaining it with a rubber band.

2. Using the dowel as a key turn the cassette spool anti-clockwise to loosen the coil of film it carries.

3. Remove the bleacher stain in a clearing solution of sodium sulfite and sodium hydroxide. Expose the film to white light so that it is thoroughly fogged.

4. Develop in an MQ developer to blacken the remaining halides, forming a black and white positive image. Follow this by normal fixing and washing.

3. Lower the cassette into the coffee cup of monobath. Hold the cassette below the surface with one hand and rotate the spool fully one way, then the other, until the allotted time for processing is over.

4. Remove the film from its cassette and wash for five minutes.

Paper

Photographic printing paper carries a light sensitive emulsion similar in structure to film, but much slower, finer grained, and usually with color sensitivity limited to the blue end of the spectrum. These features make the paper convenient to handle in an orange safe-lighted darkroom. The majority of papers use halides of silver bromide (hence the term "bromide paper") which may be coated on a white or colored paper, a resin-coated paper base, translucent plastic, linen, or even on aluminum foil. The print surface may be calendered or coated to give a whole range of surface textures. You can also buy most types in a range of three or more grades or degrees of contrast, to cope with negatives of varying contrast. Like film, boxes and packets of printing materials should be stored away from damp, fumes and excessive heat. Stored in normal cool, dry room conditions you can expect them to remain fresh for two or three years. As with film, avoid fingering the emulsion as much as possible and keep paper well away from the "wet" areas of the darkroom until it is to be processed.
See: Paper processing

Resin-coated paper

The two most common bases for printing paper are: conventional paper, below left, consisting of high quality wood fiber usually with a "baryta" layer between paper and emulsion to improve whiteness, and the more modern plastic ("resin") coated paper, below right, which is laminated front and back with polyethylene before receiving its emulsion. The most important handling differences between these two types are due to the fact that resin-coated paper is virtually waterproof. This means there is much less carry-over of one solution into another, the time needed in each solution is reduced, and washing and drying times are dramatically cut. Resin-coated prints dry in a current of air without curling, and glossy prints dried this way have a fully glazed finish.

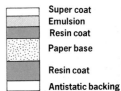

Super coat
Emulsion
Baryta

Paper base

Super coat
Emulsion
Resin coat
Paper base
Resin coat
Antistatic backing

Surface texture and weight

Printing papers are made with a wide range of surface textures including "velvet stipple," "silk," "rough luster", "semi-mat" and so on. Choice is largely a matter of personal preference – your retailer will have a sample book. Bear in mind that a bromide print on mat paper will not have intense black tones because this surface reflects some light in all directions from every part of the picture. The deepest tone you can produce will be a dark gray. Glazed glossy surfaced paper however, reflects light all in one direction. Provided you avoid viewing this mirror-like "hot spot," glossy prints resolve several extra gray tones down to an intense black. Dark areas of the picture have greater depth and detail. Printing papers are also made in various base thicknesses. "Single weight" is about the thickness of cartridge paper, "double weight" is about as thick as thin cardboard, and is used for large prints – say over 16 ins x 20 ins (40.6 x 50.8 cm) if creasing and buckling during processing is to be avoided.

Image color

Bromide paper, given full development, produces a silver image which is neutral black in appearance. However, "warm tone" papers, such as "Bromesko," have emulsions containing a mixture of silver chloride and silver bromide. Chloride emulsion produces a brown-black, warmer image. It also develops at a slightly faster rate than a bromide emulsion. Consequently if a chloro-bromide paper is given slight underdevelopment (or development in a slow acting warm tone developer) the print has a distinct brownish-black appearance. Full development in an MQ or PQ developer increases the silver bromide contribution and results in a more neutral black image. Within these limits you can therefore control image color by type and degree of development. Chlorobromide papers are often effective with subjects such as landscapes, portraits, and any low key image which is rich in shadow detail. More extreme changes of image color are possible either by controlled development of lith paper, or by color toning an existing black silver image.
See: Lith paper

Faint image

Becoming darker

Fully developed

Image formation

After exposure to the negative the emulsion on a sheet of printing paper still appears absolutely blank. For most of the first half of development no visible change occurs. The darkest subject shadows appear first as pale gray tones, gradually becoming darker as other lighter areas of the print also develop. By the end of the development period the deepest shadows will have a rich black density, while the brightest highlights remain substantially white paper.
The next processing stage – rinse or stop bath – simply halts development and reduces carry-over of chemical into the acid fixing bath. In the fixer the print appears to undergo little visible change, but remaining undeveloped halides are converted into complex, invisible silver salts. These by-products diffuse from the emulsion partly into the fixer and partly into the following wash stage. Washing also removes all remaining soluble chemicals, leaving the print with a permanent black and silver image.

Facilities for black and white printing

Producing prints calls for extensive handling of light-sensitive paper and processing in dishes and a darkroom is therefore essential. The darkroom can be a temporarily converted bathroom or a more permanently equipped room. The three most important basic features it requires are: light-tightness,

plumbing and electricity supplies and adequate ventilation. The best way to check how effectively your room is blacked out is to stand in the room on a bright day, allowing five to ten minutes for your eyes to adjust to the dark. Chinks of light will then be very apparent and can be sealed over with black paper or tape. Try

to organize your work area into clearly separated dry (paper, enlarger, negatives, power supply) and wet (dishes, chemicals, hot and cold water) zones. This is essential to avoid wet finger marks and chemical stains on prints, negatives and equipment. Equally you must adopt the discipline of rinsing

and drying your hands each time you change from a wet operation to a dry one. Good ventilation is essential, as you are likely to spend several hours at a time printing. It is particularly important if you are using a print dryer or film drying cabinet in the room.
See: Darkroom layout

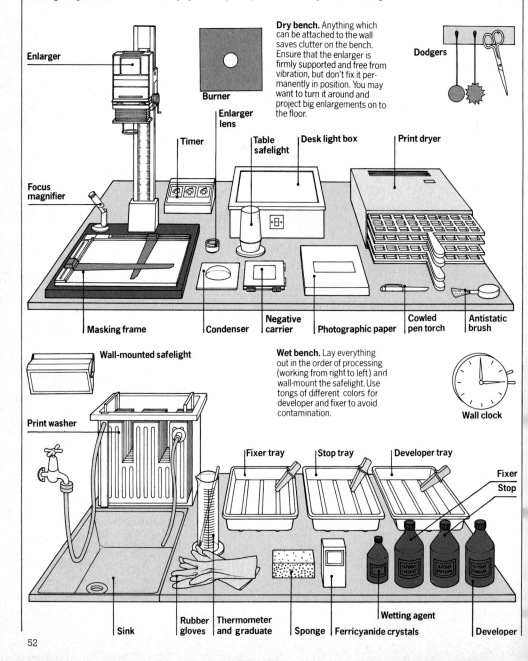

Dry bench. Anything which can be attached to the wall saves clutter on the bench. Ensure that the enlarger is firmly supported and free from vibration, but don't fix it permanently in position. You may want to turn it around and project big enlargements on to the floor.

Enlarger

Burner

Dodgers

Focus magnifier

Timer

Enlarger lens

Table safelight

Desk light box

Print dryer

Masking frame

Condenser

Negative carrier

Photographic paper

Cowled pen torch

Antistatic brush

Wall-mounted safelight

Wet bench. Lay everything out in the order of processing (working from right to left) and wall-mount the safelight. Use tongs of different colors for developer and fixer to avoid contamination.

Wall clock

Print washer

Fixer tray

Stop tray

Developer tray

Fixer

Stop

Sink

Rubber gloves

Thermometer and graduate

Sponge

Ferricyanide crystals

Wetting agent

Developer

Safelights

In choosing a safelight consider the following. Is its color appropriate for the color-sensitivity of the paper? Is it large enough to illuminate a sufficient area? Is the bulb no brighter than the manufacturers suggest for its distance from the dish or bench? The simplest safelights are just orange dyed 25 watt light bulbs, or you can use a red bicycle light.

Wall-mounted safelight

Table safelight

Safelights with inter-changeable filters.
These usually consist of a box or bowl shaped container for a 25 watt lamp, and accept a screw-on or slide-in colored glass screen.

Testing a safelight

When testing your safe-light remember that photographic materials are rather more sensitive to fogging when they already carry a latent image. Working in dark-ness take a sheet of paper and give it half normal exposure to an image under the enlarger. Place some coins on the paper, and switch on the safelight for rather longer than the maximum period the material would normally be handled, say five minutes. Now process the paper. If the coin outlines can be seen the safelight is unsafe.

Contact printing

Contact printing means printing negatives in face contact with light-sensitive paper. By care-ful arrangement of strips of negatives you can print a whole 35 mm or 120 film on one sheet of 8 ins x 10 ins (20.3 x 25.4 cm) paper. Try to contact print every film you shoot. By carefully examining the prints you can then decide which ones will be worth enlarging, and how these might best be cropped to improve composition. At the same time contact sheets form a catalog of all your photographs, helping you to locate pictures long after they have been taken. Note how most films have reference numbers ready printed alongside each frame.

Contact printing frame

Classifying negatives. You can write in black on the edge of a sheet of negatives with a mapping pen.

Contacting equipment. The cheapest way to contact print is simply to have a piece of glass slightly larger than the paper, using this to press the negatives into tight contact. You then make the exposure by switching on a white light, or using an even patch of light projected by the enlarger. As an alternative to the glass you can buy a hinged contact printing frame. This has glass with thin plastic grooves for positioning and holding each strip of negatives, and a foam plastic mat to back up the printing paper.

1. Raise and focus the enlarger until a patch of even light of sufficient size is formed on the baseboard. Stop the lens down between one and two stops.

2. Swing the safelight filter under the enlarger lens. Lay out a sheet of bromide paper, shiny side up, within the area of red light.

3. Lay out each strip of negatives until they cover the paper. Ensure they are all dull side downward and pictures are all the same way up.

4. Lower a piece of clean unscratched glass on to the negatives and paper, and take care not to disturb the nega-tives or leave finger marks.

5. If you have not written a reference number on the negatives, you can write on the glass with a spirit marker so that the reference will fall on the edge of the sheet.

6. Remove the enlarger lens filter for the required exposure time. This will be based on experience and judgment of average negative density.

53

Choosing an enlarger

The enlarger is like a low powered, vertically mounted slide projector. With it you can "blow up" the whole or parts of small negatives to make much more impressive images. You can lighten or darken local parts of a picture by shading, and you can create innumerable special effects. Choose an enlarger which gives the negative even illumination at all sizes of enlargement, and be sure the lens gives acute sharpness over the whole picture, even at wide aperture. Also look to the future and consider buying an enlarger which accepts 35 mm and roll film negative sizes.
A cheap enlarger with a locking clamp for moving the enlarger head is perfectly adequate, but the more expensive friction drive which can be wound up and down with a knob is easier to use and avoids disturbing the negative. It is useful if the enlarger head can be turned through 90 degrees so that really large prints can be made against the wall. A further advantage is an angled column which allows large enlargements to be made without the column getting in the way.
"**Auto-focus**" **enlargers**
Some enlargers are built on an "auto-focus" principle – as you raise or lower the enlarger to give a bigger or smaller picture the lens automatically changes its position to maintain a sharp image on the baseboard. These are more expensive but faster to use than conventional enlargers.

Large format enlargers
Large format enlargers offer a varying range of "enlarger movements". Mostly these are swings and tilts of the lens and/or negative, relative to the baseboard. Like camera movements, they allow the Scheimpflug principle to be applied when correcting, or creating, image distortions.
See: Special darkroom techniques/Scheimpflug principle.

Enlarger light sources.
Enlargers for 4 x 5 ins (10.2 x 12.7 cm) and similar negatives often have two alternative lamphouses. One uses the usual tungsten lamp and condenser system, top right. It gives hard, even light but needs a tall bulky lamphouse. The alternative is a "cold cathode" tubular fluorescent grid, bottom right, with a diffusing sheet instead of a condenser system. This provides soft even illumination, particularly good for minimizing retouching marks.

Focusing magnifier. This focusing aid stands on the easel and contains a mirror which reflects part of the projected image up to a small focusing screen. You focus the enlarger, examining the screen through an eyepiece which magnifies the image.

Easel. The enlarging easel or masking frame is a flat, white-faced board with a hinged frame which has adjustable metal strips. They hold the paper flat during exposure and, by protecting the edges through an eyepiece which magnifies the image.

Timer. An electric clock timer wired between supply and enlarger is ideal. It has an on/off switch for focusing and an adjustable timing dial usually ranging from 1 to 60 seconds. You simply pre-set the time required and press a button to start the exposure.

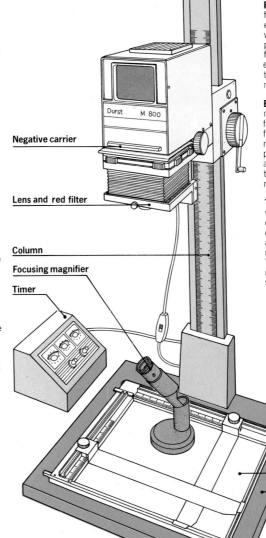

Negative carrier

Durst M 800

Lens and red filter

Column

Focusing magnifier

Timer

Easel

Baseboard

Enlarger lenses. Although it is quite possible to use a camera lens on the enlarger, it is more practical to choose a lens specially designed for the job. An enlarging lens has multi-elements computed to give highest quality when the subject (the negative) is closer than the image. Focal length is slightly longer than would be considered normal in a camera for the negative format – 65 mm for 24 x 36 mm, 100 mm for 6 x 6 cm, 180 mm for 5 x 4 ins. Physically the lens is constructed to be more resistant to heat, because

inevitably heat as well as light will be directed through it by the enlarger's condenser and lamp system. The lens, of course, requires no shutter and may not even carry "f" numbers as such – simply a series of x2, x4 etc. for each aperture, denoting halving or doubling of the exposure required. Apertures have positive, "click" settings easily felt in the dark. Often these ratios or "f" numbers appear in a red window backlit by illumination ducted from the main light beam.

Negative carriers. These consist of two metal plates with cut-out apertures to suit a particular format. They vary in detail but are all really of two main types – glass or glassless. Glass carriers may be essential for holding large format thin films, such as 4 x 5 ins film pack negatives completely flat. However, they introduce a

further four surfaces to be kept free from dust and scratches. Glassless carriers avoid this difficulty, holding the film flat by gently gripping it around the perimeter of the negative. Some negative carriers incorporate a system of sliding masks which enable the projected image to be cropped to size. This lessens the possibility of stray reflected light degrading the print.

Changing formats. Changing from a negative of one format to another in a 120/35 mm enlarger calls for three adjustments. First, the lens must be changed for another of different focal length. This allows the enlarger to give the same range of print sizes from the new negative format. Secondly, the negative must be changed to suit the new size. Thirdly, a substitute or extra condenser lens must be placed between lamp and negative, or else the lamp itself must be refocused. This re-establishes bright, even illumination of the whole negative image.

Electronic exposure measuring devices

Despite the popularity of test strips, electronic devices are also used for measuring enlarging exposures. There are three main types: a general purpose exposure meter fitted with an adaptor for use in the darkroom; a meter designed specially for enlarging work – either a color analyzer, or a similar self-contained unit for black and white work only; an electronic easel which both measures and times exposure, and holds the paper flat during exposure. All these devices automatically take into account enlarger light source, negative density, degree of enlargement and "f" number. However, they must first be calibrated for printing paper speed – usually by making one perfect print by trial-and-error and then programming the meter for this exposure time.

An overall meter assumes that highlight and shadow parts of a picture are approximately equal in area. The negative above is an example and can be read accurately without adjustments.

Meters which use an on-easel spot reading cell need to be carefully positioned. As shown here they should read from some area of the projected negative which is to print as a mid-gray tone.

Enlarging meter. Most enlarging meters make "on easel" spot measurements. The small measuring area is positioned to receive light from an image midtone, and the meter reads out exposure.

Electronic easels. These make an overall reading of the whole area to be printed, and set the exposure timer accordingly. Some types measure through the paper itself during exposure, automatically switching off the enlarger at the right time.

This negative has important tones which are small in area. An overall reading would be too influenced by the dark but unimportant background. The measured exposure time needs reducing by about 30 per cent.

Alternatively a spot reading meter can be used to take two readings – one from a highlight and one from shadow area. Exposure time is calculated for half-way between the two readings.

Assessing the negative

Having chosen the negative with the best picture content, check it over carefully before placing it in the negative carrier. Is it completely free of dust or fluff on both surfaces? If necessary, lightly wipe the negative over with an anti-static cloth or brush. Check that the picture has sufficient detail in important shadows and highlights. Try to decide which paper grade is likely to suit it best. Then having ensured that the negative lies absolutely flat in the carrier, switch on the enlarger and with the lens at full aperture check that the image on the negative is sharp.

Deep shadow area. Lack of detail here is acceptable because it contains no important subject information – it can be allowed to print black.

"Burnt-out" area. The sky, the opposite extreme to the sofa shadow, will print as white paper, but detail in this instance is relatively unimportant.

Darkest important shadow detail. The negative just manages to reproduce detail here in the shadow side of the girl's face.

Lightest important highlight. The exposure has retained sufficient detail of the plants and steps in the garden to convey the brightly lit exterior.

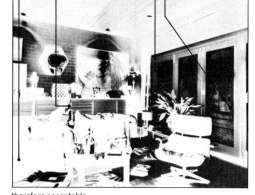

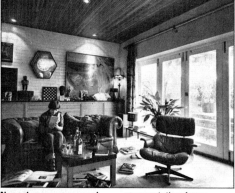

Normal exposure, normal development. Ideally the negative should show just discernible detail – not clear film – in the darkest important subject shadows. Similarly, brightest important highlights should not be solid black but contain some detail. Correct exposure is therefore a compromise. Often a brilliant white sky or a shadow under a dark chair can be allowed to appear featureless because these extremes are outside the range where the main picture elements lie, and solid white or black is therefore acceptable. Remember too that, unlike a color transparency, a black and white negative should appear rather low contrast to print well. In the case of an inherently contrasty subject, slight under-development of the negative may be helpful.

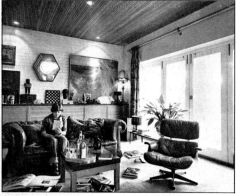

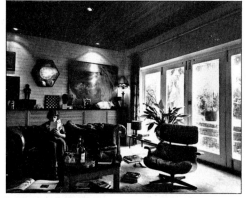

Under-exposure, over-development. Under-exposure tends to shift the range of tones in which detail is well recorded away from the shadows and toward the subject's highlights. Notice how "empty" the shadow areas (even important ones) have become. Highlights however have improved detail. The negative is more correctly exposed for the garden outside but fails to record important detail in dark parts of the room.

Over-exposure, under-development. Over-exposure will heighten shadow detail, often to an excessive degree, but makes delicate highlight areas merge and become featureless. Giving extra exposure when printing will not help, as the negative is so black here that highlight has been destroyed. All that will happen is that light parts of the picture will reproduce as a uniform gray.

Making a test strip

The idea of a test strip is to sample the projected image with a strip of paper, giving it a range of exposures, and then after processing decide the correct one for the complete enlargement. Try to position the test strip so that it covers a key area of the picture, and arrange that each band of exposure includes both highlights and shadow.

1. Cut a sheet of bromide paper to give a strip wide enough to allow four bands of exposure. Place it across a typical part of the image.

2. Remove the red lens filter and allow the whole strip to receive 5 seconds exposure.

3. After 5 seconds introduce an opaque card about an inch above the paper, shading one quarter of the strip. Hold it there steadily for another 5 seconds.

Placing the strip. Use a half or quarter sheet of paper for the test strip. If necesssary hold the ends down with coins.

Exposure bands. By making the bands horizontal (rather than vertical) each band predicts the appearance of the print across this wide negative tone range. Always aim to produce a test strip in which correct exposure is about the middle band. Darker bands then show how much subject highlight areas may have to be "printed-in." Similarly, lighter bands give information on shadow shading.

4. Now move the card along until half the strip is shaded from light. Keep it stationary while a further 10 seconds exposure is given.

5. Finally shade three-quarters of the strip for another 20 seconds. Switch off the enlarger and process the test strip.

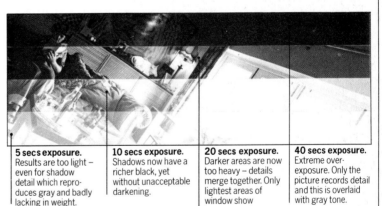

5 secs exposure. Results are too light – even for shadow detail which reproduces gray and badly lacking in weight.

10 secs exposure. Shadows now have a richer black, yet without unacceptable darkening.

20 secs exposure. Darker areas are now too heavy – details merge together. Only lightest areas of window show improvement.

40 secs exposure. Extreme over-exposure. Only the picture records detail and this is overlaid with gray tone.

A gray scale

This is a piece of film, right, divided up into segments ranging from clear film through four or five gray tones to almost black. By placing it over a square of printing paper in the enlarging easel and giving the exposure (typically 60 seconds) to a representative area of the image, you automatically produce the equivalent of a whole range of exposure times.

Printing through a gray scale. Give one exposure usually of 60 seconds (right). The segments simulate a whole range of exposures.

Making an enlargement

From the test strip you can decide the exposure time the picture requires, and whether the paper is the correct contrast grade for the negative. To be sure which areas of the enlargement will need local additional exposure or shading you should expose a complete sheet of paper, giving it the same time as the most promising band on the test strip.

1. Lift the hinged masking strips on the easel, carefully position the bromide paper shiny side upward, and relower the frame to hold it flat.

2. Give the exposure time suggested by test strip results. Remember, use the mains switch or timer to expose; swinging the red filter can jog the image.

3. Reopen the masking frame and remove the paper. Develop, rinse and fix the enlargement using the same processing procedure as for contact prints.

Assessing the enlargement

The enlargement can be judged as soon as it has fixed sufficiently. Is the enlargement generally too light or too dark? Keeping in mind that more exposure makes the picture darker, what change in exposure time is desirable? Would the picture look better on a harder or softer grade of paper, to increase or reduce contrast? Check sharpness closely, both at the center and in the corners of the print. Look particularly for grain pattern – if this, at least, is sharp the enlarger is properly focused. Are there any white specks or marks, perhaps caused by easily removable dust on the negative, paper, or enlarger condensers? Local areas may need to be made lighter or darker, so you must decide for what proportion of the exposure time they should be "dodged" or "printed-in."
See: Tests for permanence

Flat white area. This part of the negative contains garden detail which does not record here at the printing exposure required for the room. "Printing in" will be needed – perhaps through a shaped hole in a black card. Try doubling the exposure time over the garden detail, but do not spill your "printing in" too liberally over interior detail, or the result will look unnatural.

Dark tones and shadow. Dodging here would help reveal more detail. Try shading with the hand during one quarter of the exposure time. If over-dodged this area will look gray, flat and unreal.

Drying mark or scum on the negative. This causes a light patch on the print. Remove the negative and examine its surface closely. Scum on the back of the negative can be removed by gentle dry polishing. A drying mark on the emulsion can't be removed, you will probably have to spot each print.
See: Print retouching

White specks caused by dust. Specks may be lying on the paper surface during exposure; resting on the negative or cover glasses in the negative carrier; or lying on one surface of the large condenser lens above the negative. The marks can be retouched on this enlargement, but before you make another print, check the paper by examining the image on the masking easel. Specks on the negative or cover glasses will move when the negative carrier is shifted. If they remain they are probably on the lens.

Shading, "dodging" and "printing-in"

Local areas of the picture can be lightened by shading them from light during the exposure. You can simply block off the light with your hand (see right), or a piece of opaque card or, if an area well inside the picture needs shading, you may need a "dodger" (see right).

Other local areas may need to be darker, and you can effect this by "printing-in" (see right) which means using a card with a hole in it to give extra exposure time to a local area.

Shading. Hold your hand or a piece of card between the enlarger lens and the paper, so that it covers the relevant area. To avoid giving the shaded area a hard edge, keep hand or card moving.

"Dodging." To make a "dodger" cut a piece of card, the shape of the area you wish to dodge and tape it to a stiff wire. Hold it over the appropriate area and keep it moving to blur the edges.

"Printing-in." Make a hole about the size of a small coin in an opaque card. Expose the whole enlargement. Then expose again with the card in position so that only the area requiring it receives extra light.

Dodged area. This is the result of shading the dark left-hand settee area for one quarter of the print exposure time. Lightening the image has revealed much more information, but the limiting factor is the shadow detail and tone contrast contained on the negative. This is probably as much dodging as the image will accept without appearing false.

Printed-in area. Using a hole in a card, the window here has received light for twice as long as the rest of the print. As a result just sufficient detail has recorded to suggest the brightly lit garden. If still more printing-in were given the darkening of the window frames and external foliage would look very artificial, and you might become acutely aware of the shape of the printing-in hole itself.

Washing

Washing causes no immediate visual change, but it is vital for removing all by-products and processing chemicals from the emulsion and paper base. Ineffective washing eventually causes staining and bleaching of the print. Spray and siphon wash tanks are available, or you can use a wash/siphon device which attaches between the faucet and an ordinary dish. A large diameter tube with holes near the bottom can be used to form a wash tank out of a wash basin with running water, or you can just allow prints to soak, changing the water every five minutes for about half an hour. Prevent prints clumping together or floating on the surface. If you use resin-coated paper or a hypo eliminator between fixing and wash you need only wash for five minutes.
See: Tests for permanence

Wash tanks. The siphon wash tank works like an automatic water cistern. Water enters the sink-size tank from all directions through spray jets. When the water level has almost reached the top the tank empties itself and the cycle begins again. Auto print washers are similar to sheet film processing tanks but hold each print separately in a vertical plastic cradle. This prevents prints from sticking together. A continuous flow of water then circulates through the cradle, which on some models is automatically rocked.

This type of washer may also be fitted with a siphon. Resin-coated (RC) washers are designed to take advantage of the fact that only the emulsion layer contains unwanted chemicals. A typical model consists of a dish fitted with divider pegs to accept four or six prints horizontally. A wash spray creates a fast current of water across the emulsion surface. In general an efficient tank supplied with adequate water pressure washes paper based prints in 15 to 20 minutes and RC papers in two minutes.

Sinks and cascade washers. You can adapt any suitable sink for print washing by inserting a perforated tube, left, into the drain hole. This should be high enough to maintain a reasonable depth of water. A hose from the tap to the far end of the sink supplies wash water, which runs to waste through the perforations and the open top of the tube.
Cascade washers use a stack of several large dishes or sinks. Water enters the top unit, discharges into the second, and so on to the lowest level where it drains to waste. Batches of prints straight from the fixer are

always placed in the lowest unit and moved up to the next level before the next batch is added. Fully washed prints are removed from the top.

Drying and glazing

Once fully washed, prints are ready for drying. Surplus water can be removed and, in the case of resin-coated (RC) paper, the print is passed through a heated air drier or dried naturally. Glossy surface RC paper dries this way with a high glaze. Conventional paper based prints should be dried or, if they are glossy, glazed on a flat bed or rotary machine. Air drying produces curled prints, and glossy

paper dries with a semi-mat finish. Prints are glazed by using a squeegee to smooth the wet paper face down on to a polished surface such as chromium plated steel. The paper is held in tight contact with the surface by a tensioned cloth and heated until dry.

Flatbed glazing.
1. Wet glossy prints are laid face down on the glazing sheet and pressed into firm contact with a rubber squeegee. Soaking the print in glazing solution helps avoid bubbles and other marks.

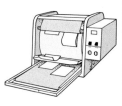

Rotary glazers. A rotary glazer squeegees, dries and delivers glazed glossy prints automatically. Wet prints are fed in at the bottom, face up, on to a cloth conveyor belt which wraps around a large part of the surface of a chromium plated drum. The drum has internal heaters and a motor which drives both drum and cloth in slow rotation. As the prints reach the drum surface a powerful roller below the cloth presses them into tight contact. Drying occurs as the drum rotates and dry glazed prints emerge from the front of the machine at the top. It is essential to clean the drum surface after use. RC papers must not be dried this way.

Air drier for resin-coated paper. The drier contains heaters and a fan, together with a simple conveyor belt. RC paper prints fed into the front slot are delivered dry 30 seconds later.

Flatbed glazer. This is an electrically heated box with a curved upper surface and a canvas type cloth lid. The lid lifts to accept a flat glazing sheet. Drying/glazing takes about ten minutes.

2. The glazing sheet is placed in the glazer and the spring-loaded lid closed. Check that the cloth and prints appear to have dried completely before opening the machine and removing the glazed photographs.

Making a giant enlargement

Prints several meters high can bring out undiscovered detail, and can drastically alter an environment. This is because you tend to observe the print from a point which is closer than the true distance (original focal length x degree of enlargement) so that the image begins to surround you. To make giant prints you need an enlarger which can give sufficient "throw" to form a really large image.

Choosing materials. It is possible to make the enlargement using several relatively small sheets of paper, slightly overlapped to cover the entire wall. After processing the mosaic is laid out, trimmed, and butt mounted on a common board. However you can buy paper in rolls 30, 48 and 52 inches (76, 122 and 132 cm) wide which will reduce the number of joins you have to make. This requires some management in processing. You will need to prepare a sink or a trough slightly longer than the width of your paper.

This will probably mean turning the enlarger head 90° and projecting horizontally along the length of a blacked-out room. The image is then focused on the far wall.

1. You need help to focus the dim, faraway image. Expose and process suitably large test strips, then tape up as many sheets of paper as necessary, allowing a small overlap. Dodge or print-in during the exposure.

2. Dilute the print developer to half strength, and double the timing. Roll each sheet evenly toward you into the solution, with the emulsion inside the roll. When you reach the far end carefully raise and turn over.

3. Begin drawing the end toward you, forming a new roll. Keeping both ends of the roll under the developer, wind the paper until you are back to the beginning. Repeat, checking the image with each repetition.

4. When the print is fully developed drain the roll and transfer it to a sink or trough of fresh acid fixer. Roll through this three or four times. Wash by filling a sink or bath with several changes of water.

5. Dry the print by laying it on layers of newspaper and leaving it overnight. Mount it on to smooth faced particle board as though you were pasting wallpaper on to a wall.

Machine processing

A number of machines are made to process black and white sheet paper automatically. All are quite expensive, but they save time and trouble, and do away with the need for the usual wet bench facilities in the printing darkroom. The two main types of bench-size machine operate different processes.

Resin-coated processor
In resin-coated paper a layer of polyethylene prevents solution from being absorbed into the paper base itself. It therefore processes, washes and dries very quickly, is undamaged by high temperatures, and carries over very little chemical from one solution to another. A machine processor for RC paper draws the exposed bromide print into a shallow trough of developer at 104°F (40°C). Here it develops fully in 18 seconds, passing on through further squeegee rollers and a water rinse into a trough of rapid fixer.

After only 15 seconds (for full archival image permanence) the print is surface washed and transported through an air drier. Total dry-to-dry time is two minutes.

Stabilization processor
This type of machine is designed for use only with stabilization papers such as Ektamatic. Bromide paper of this kind contains developing agents within the emulsion, so that when the print is drawn into a strong activator solution full development occurs in seconds. The paper then passes into a stabilizing solution of concentrated fixer and emerges, damp dry, about 15 seconds after entering the machine. The print therefore remains unwashed but is sufficiently stabilized to resist image deterioration for months.
See: Stabilization paper

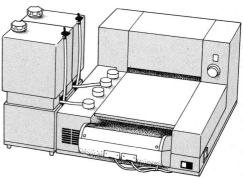

Printing resin-coated paper.
The Agfa RC black and white paper processor, above, stands on the darkroom bench and is connected to water, waste and electricity supplies. Each sheet of exposed resin-coated bromide paper is fed into the entry slot, where it is drawn through the first pair of motorized rollers. An infra-red sensing device measures an appropriate amount of developer which is drawn from a reservoir tank and passed over heated coils into the first trough. The paper is moved continuously through and out of the trough, the pairs of rollers

also acting as squeegees. Three further troughs contain a fast flowing stream of wash water, pre-measured and heated rapid fix, and water for final wash. The last set of rollers deliver the print direct into a mechanically linked RC air drier unit at the rear. Maximum print size is restricted only by the width of the roller transport system. The leading edge of a long print may be in the final wash while its far end has not yet entered the developer.

Designing the darkroom

Film – black and white or color – can be processed in any ordinary room providing you have some light-tight closet in which to load the daylight developing tank. But a darkroom for printing makes you independent of the camera shop's developing and printing service, and allows you to get just what you want from your pictures. You can take over the bathroom, but an attic, spare bedroom or closet under the stairs will be less disrupting, although absence of running water and drainage will mean that stages such as washing will have to be carried out elsewhere. Best of all, a room converted permanently for darkroom use can be designed and laid out with all necessary services. Here you can work for long periods in comfort, and leave all the equipment out ready for the next session. Whichever room you choose to be your darkroom, three factors must be considered. 1. Can the room be made light-tight, yet provide sufficient air circulation for the periods it will be in use? 2. Can a workbench be organized – preferably one which separates "dry" operations from "wet" processing stages? 3. Is there an electricity supply which can be safely wired to your enlarger, safelight and so on? Obviously in any small room where electricity and dishes of solution are present under dim or dark conditions safety is a particularly important aspect of design.
See: Black out

Darkroom under the stairs

As a darkroom, a closet under the stairs has the advantage of easy blackout, only the door edges need attention. Build benches of blockboard on 2 ins (6 cm) sq wooden supports, covering the top surface with plastic laminate. Locate the enlarger where the closet offers maximum ceiling height, and keep the adjacent area strictly for "dry" operations. Processing can be carried out under the sloping wall – you can sit down for this. Keep a pail of water for rinsing your hands.

As each batch of fixed prints accumulates in the hypo they are removed in a dry bucket to wash in a sink or bath outside. Paint the room in as light a tone as possible. Eggshell surface white is ideal, because it makes the room appear less cramped and helps the safelight give overall illumination. Some form of ventilation is highly desirable. A light-trapped louver panel in the door is the cheapest arrangement but it will need painting mat black, as will the edges of the door itself. Cover the floor with thermoplastic in sheet form. This is resistant to most chemicals and easy to keep clean.

Keep wiring in the darkroom to a minimum for reasons of safety and to avoid forming ledges where dust and dirt can accumulate. As far as possible arrange that switches are ceiling mounted, with pull cords. The white light (for mixing solutions, cleaning up and so on) should be impossible to switch on by accident. The enlarger can be plugged into a wall socket through the timer unit.

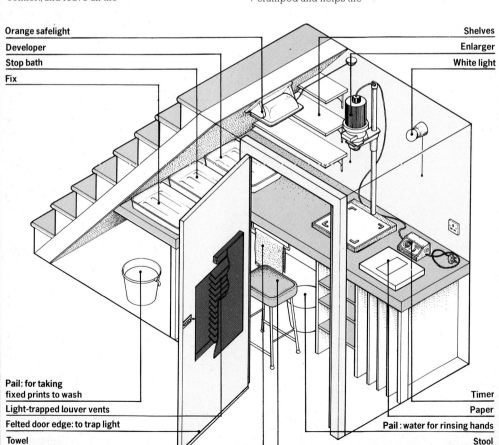

Orange safelight
Developer
Stop bath
Fix

Shelves
Enlarger
White light

Pail: for taking fixed prints to wash
Light-trapped louver vents
Felted door edge: to trap light
Towel

Timer
Paper
Pail : water for rinsing hands
Stool

Converting a room

Conversion of a spare room to a darkroom allows you to provide facilities for all stages – from film loading to final print mounting and spotting. Arrange the room so that each "bench" serves a particular function and the amount of walking from point to point is minimized. For example, film loading takes place adjacent to, but separated from, the sink; enlarging simply requires you to turn to reach the sink; print drying, spotting and mounting all take place where the window can be opened to introduce light and extra ventilation. Try to arrange that at all times there is a pattern of air flow, perhaps in through door louvers and out through a light-trapped electric extractor fan. For your wet bench use a large, flat-bottomed sink big enough to contain all dishes and the print washer. You can buy photographic sinks in various stock sizes – constructed of heat-seamed heavy duty PVC. Alternatively a suitable chemical-resistant plastic can be used to line a wooden frame of your own construction. Ensure that the sink – together with all benches – is really firmly supported and free from shake. A door-less light trap entrance (painted mat black) allows free access and greatly improved ventilation at all times. It does, however, take up very much more space. **See:** Light trap

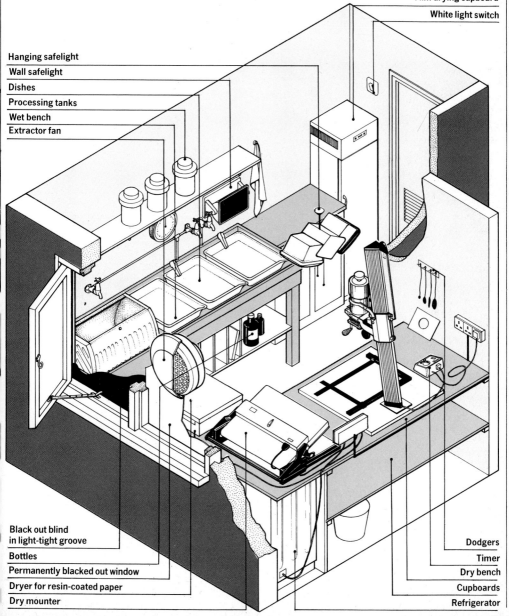

Film drying cupboard

White light switch

Hanging safelight

Wall safelight

Dishes

Processing tanks

Wet bench

Extractor fan

Black out blind in light-tight groove

Bottles

Permanently blacked out window

Dryer for resin-coated paper

Dry mounter

Dodgers

Timer

Dry bench

Cupboards

Refrigerator

The components of color

Three factors contribute to our seeing the world in color: a "white" light source, such as the sun or tungsten lamps; materials which reflect some wavelengths and absorb others, and so appear colored; the ability of the human eye to respond to groups of wavelengths as particular colors. Light itself is the source of all colors. Most white light sources such as the sun consist of a mixture of wavelengths. When light reaches a colored material only the wavelengths corresponding to this color are reflected, or transmitted if the material is transparent. It is easy to prove this by lighting a red rose in the studio and then placing a deep blue filter in the light beam. The rose immediately appears almost black because the only light it now receives consists of wavelengths it cannot reflect. The third factor, the human eye, imposes its own influences. For example, the eye's color sensitive receptors only respond to wavelengths between about 400 and 700 nanometers, the blue and red limits of the visual spectrum. Wavelengths outside this range – infra-red and ultra-violet for example – produce no response from the human eye (although the eyes of some insects have evolved to use this type of radiation). Furthermore the human eye's ability to distinguish colors also depends upon there being a sufficient quantity of light. Colors always look brightest in strong light, and appear to fade at dusk when increasingly we see objects only in shades of gray.

Splitting light

What we regard as "white" light is really a mixture of colors with differing wavelengths. By passing a beam of sunlight through a glass prism it is possible to split the light into its component colors because short wavelengths are bent more than longer wavelengths. The light beam therefore fans out into a band of recognizable colors – the visual spectrum – ranging from deep blue to deep red. If the band of spectrum colors are then directed through a second prism they recombine, again forming white light. If any color band is blocked off before it enters the second prism the reformed light is too incomplete to appear white and has a colored tinge complementary or opposite to the removed color.

Additive and subtractive formation of colors

Colors can be produced by adding or subtracting different wavelengths of light. A roughly uniform mixture of all the visual wavelengths produces white light. You can even take just three main areas of the spectrum – blue, green and red – and mix lights of these colors in different proportions to reproduce any color in the spectrum. This is important because it means color films need only have layers sensitive to these three primary bands to be able to record images of all colors. But just as all colors can be formed by adding primary colored lights, so you can start with white light and subtract various quantities of primary color. For example, to subtract only blue you would place a yellow filter in the light beam because this allows both green and red light to pass. To subtract only blue you would place a yellow filter in the light beam because this allows both green and red light to pass. To subtract green you use a bluish-red (magenta) filter, and red is subtracted with a green-blue (cyan) filter. So yellow, magenta and cyan are anti or complementary colors to blue, green and red respectively. This inter-relationship is vital for the understanding of color processing and printing.

Spectrum wavelengths

Visible light is just a small section of the enormously wide electromagnetic spectrum, ranging from radio waves to gamma rays. All these radiated forms of energy differ in wavelength (the distance between corresponding points on two successive waves) and this gives them very different properties. The wavelengths to which our eyes are normally sensitive, cover the band 400 to 700 nanometers. Conventional color films and panchromatic black and white films respond to about 350 to 700 nanometers, their sensitivity extending into the near ultra-violet. A nanometer is one millionth of a millimeter.

The nature of color film

Fundamentally a color film consists of three black and white emulsions. These are coated one on top of the other as a permanent, multi-layer structure, so arranged that the top emulsion responds only to the blue third of the spectrum, the middle one to the green third, and the bottom emulsion to the red third only. So blue, green and red parts of the image each record in one emulsion only. Other colors affect several emulsions to varying degrees – yellow, for example, will record in the green and red sensitive layers but not in the blue. In the early days of color photography it was common to make these three records with three separate exposures, process and dye the images, and then recombine them to give a full color picture. Today we can acheive this with one exposure, thanks to extremely accurate, controlled multi-layer emulsion coating. However, color films have to be "balanced" to a particular subject light source. For example, we accept someone's face as looking substantially the same color in daylight as when it is lit by a lamp in the studio. The eye's response is sufficiently adaptable to accept that both are "correct" even though the light bulb actually gives more red-rich white light than the sun. But multi-layer emulsions have a fixed, pre-set response and will only give accurate results when used with white light sources having a particular color mix. Hence, with the exception of some negative films intended for correcting when printing, color films are sold as daylight or artificial light types.

The visible spectrum. White light is a blend of colored light of differing wavelengths. A beam of sunlight passing through a prism-shaped block of glass, below, is split into the familiar rainbow colors of the visible spectrum.

Nanometers

400
450
500
550
600
650
700

Spectrum wavelengths. Light wavelengths are measured in extremely small units known as nanometers. The colors of the visible spectrum, above, range from 400 to 700 nm. Radiation outside this range, ultra-violet and infra-red, is beyond the sensitivity of the human eye.

Additive formation of colors. Spectrum colors can be reformed by mixing various proportions of primary colored light. If blue, green and red spotlights shine on to a screen other colors appear in overlap areas. The area overlapped by all primaries appears white.

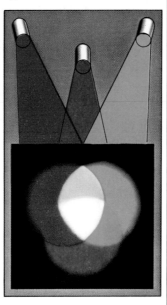

Subtractive formation of colors. Complementary colored filters, viewed against a white light source, will each subtract quantities of a primary color. Where two filters overlap, only one primary color remains to reach the observer. The central zone appears black.

The structure of color film.

Although they vary in detail, color films for general use consist essentially of three emulsions, each reacting to one third of the spectrum. The top emulsion, 1, is blue sensitive only. Beneath this is a second emulsion, 3, usually orthochromatic in character and therefore sensitive to blue and green. The third emulsion, 4, is a highly red-sensitive panchromatic type. By coating a yellow filter layer, 2, (destroyed later during processing) immediately below the first emulsion blue light is prevented from affecting the two other layers. The three emulsions are therefore effectively blue, green and red-responding. Coating these thin multi-layers accurately on to film base is extremely exacting.

1 2 3 4

Cross section of color film. The cross-section, above, shows the relationship between the layers of emulsion and the film base. The whole section measures no more than 0.17 mm, the emulsion itself measuring only .015 mm.

How color films work

Conventional color films are of two main kinds – those intended to give a color negative for subsequent enlargement on to color paper, and those designed to be reversal processed so that the film exposed in the camera forms a color transparency for projection. Both types are rather slow in speed relative to black and white films. Typically they range from 40 to 160 ASA. Most films are balanced for daylight, with tungsten light versions also available, particularly for reversal film. The diagrams on these pages trace the various stages color negative and color transparency film must pass through from camera exposure to production of a final, positive color photograph.

Color development. The first stage of color negative processing, below, is color development. This converts exposed silver halides in all three layers to black metallic silver. But by-products formed during this development interact with different color couplers incorporated in each of the emulsions – yellow couplers in the blue sensitive layer, magenta in the green and cyan in the red sensitive emulsions. The result is formation of simultaneous negative images in dyes of these colors.

Negative sequence

Exposing the image

Imagine that our subject is the figure in the colorful tee shirt, above. Each color in the image can be analyzed in terms of its blue, green and red content and in fact this is essentially what occurs when it is exposed on to the light sensitive film, above. Irrespective of whether the film is reversal or negative type the top, blue sensitive, emulsion records a latent image of all those parts of the image containing blue light. The center emulsion responds to green light areas, and the rear emulsion forms a latent image corresponding to red light zones. The next stage – processing – differs fundamentally between transparency and negative films, and in detail between the brands themselves.

Transparency sequence

Black and white development. The first stage in color reversal processing, above, is development in a fairly contrasty monochrome developer. This forms black and white negatives in each of the three layers, corresponding to their latent images. First development is a very critical stage of processing because it determines the amount of silver halide remaining for later conversion into color.

Fogging. The washed and hardened film, above, is usually fully fogged by holding the film spiral near a tungsten lamp. Some processes use chemical fogging agents incorporated within the color developer.

Color development. The color developer converts the remaining fogged halides to black silver. As with negative color processing it also forms yellow magenta and cyan dyes. The film at this stage appears totally black.

Bleach and fix. At present the color images are hidden by the accompanying black silver image in all three layers. The next stage, below, is therefore to bleach and fix away the black silver (without affected dyes), and at the same time fix the unexposed areas of the emulsion. This is followed by washing and drying.

Resulting negative. The finished color negative, below, shows an image in complementary colors and negative tones. Notice how red appears cyan, blue records yellow and white black. In addition the negative has an orange mask. This reduces contrast and improves final color print reproduction and exists in areas where magenta or cyan dye is absent.

Color paper

The structure of negative/positive color paper is broadly similar to color film, but it has no yellow filter layer and contains emulsions narrowly sensitized to blue, green and red. Some brands reverse the normal emulsion sequence – by forming the cyan image, which is visually the strongest, in the top layer, the image is made sharper.

Exposure and processing of the color print. Color paper should be handled in darkness or a deep amber safelight. Exposure is made to the color negative, left, by contact or enlargement after the processing of test strips which help you to check the exposure and color filtration. Filtration is controlled by "dialling-in" differing amounts of yellow, magenta or cyan via filter dials in the enlarger lamphouse, by inserting filters into a lamphouse drawer, or by giving different exposure times through three filters over the lens. The color paper is given a processing sequence of color development, bleach-fix, wash and stabilize similar to a color negative, but unlike a negative the paper has no orange mask. The result is a color positive.

Manipulating the image

Color printing by negative/positive methods presents a wide range of manipulative possibilites. You can shade or print-in to make parts of the picture lighter or darker, or print local areas through color filters to alter their color. Prints can be made from black and white negatives with color injected overall or locally, and you can make abstract pattern "negatives" from colored gelatin or colored inks and print these. Color photograms can give a kaleidoscope of brilliant effects. And by using a color transparency instead of a negative you produce a complementary print.
See: Shading/Printing-in/ Variations in processing/ Photograms

Bleach and fix. The film is next placed in a bleach bath which dissolves the silver negative formed in the first developer and the silver parts of the image formed in the color developer. Only the positive dye images remain unaffected, above. The film is then fixed, washed, and rinsed in stabilizer.

Resulting transparency. The finished transparency, above, carries a positive image which appears in correct colors. Notice how the three complementary dye layers give a full range of image colors by subtracting various amounts of blue, green and red from white light. Most color reversal films can be "pushed" in speed and then given carefully controlled additional first development time.

Resulting print. Most negative/positive color prints, above, are made on resin-coated paper of various surfaces, such as glazed glossy, semi-mat or rayon. All these accept hand or air brush retouching. Finished prints will last longest stored in albums, for the chemically generated dyes discolor and fade if left for long periods in direct sunlight.
See: Print retouching

Color film types

Apart from films for instant picture cameras, color films are supplied in all the popular sizes – sheet, roll-film, 35 mm and 16 mm. In performance they differ from their black and white counterparts in four ways. First, they can be divided into those which are processed as color negatives, and those reversal processed to give color transparencies. Secondly, color films are color balanced for use with one of three main types of subject lighting, either daylight, 3400K photofloods (Artificial light films, type A) or 3200K tungsten lamps (type B). ASA film speed is generally slower than that of black and white films although a few color emulsions of 400 to 500 ASA are available. Grain structure becomes apparent in the fastest materials. A few special purpose color films are designed for false color reproduction, photomicrographic work, and various darkroom processes.

Negative materials

Speeds range from about 25 to 500 ASA. The majority of color negative materials are balanced for daylight. Color casts produced when shooting under most other lighting can be corrected by filtering during printing. Some professional films are made in two versions – "S" for exposures of 1/10 second or shorter, and "L" for exposures 1/50 to 60 seconds. You can process these yourself.

Transparency materials

ASA ratings range from 25 ASA (Kodachrome) to 500 ASA (Anscochrome). You can process most of them yourself, but some non-substansive types such as Kodachrome must be sent away for elaborate laboratory processing. Transparency films can usually be "pushed" or cut back in processing, allowing ASA speed adjustment of up to four stops.

Special purpose films

Most special films are designed for particular functions but some can be used for visual effects. For example infra-red Ektachrome is a transparency film with emulsion layers sensitive to blue, green and infra-red wavelengths. Green grass is reproduced magenta, red paint films yellow, and there are other color distortions which give bizarre results. Aviphot Color Dupe Film is a color negative material intended for copying maps and so on. It gives images of high contrast, with strong color saturation and very fine grain, but it is extremely slow.

Instant picture color materials

There are two principal kinds of instant color print materials; peel-apart such as Polacolor 58, and integral such as Kodak PR 10 and Polaroid SX 70, described right. Each varies in composition but all are essentially self-processing multi-layer materials for use in a special camera or camera back with pressure rollers, which will produce a finished color print a few minutes after exposure.
SX 70 film
Although this material is released from the camera looking like a glazed blank card, it is really a

permanent assembly of negative material, receiving sheet, pod and a transparent plastic top. As shown below, it has the usual silver halide layers sensitive to blue, green and red respectively, but each has a complementary dye and a developer layer immediately below. After exposure alkaline reagents are spread between the negative and positive multilayers. The reagent seeps through all layers, activating each dye and its developer. These spread vertically upward. Wherever exposed undeveloped silver halides are

reached they are reduced to metallic silver, "locking in" the developer-carried dye in that layer. Only dye with developer which does not meet developable silver is free to accumulate in the image receiving layer, building up a positive colored image, which is eventually visible through the transparent plastic. White pigment spread with the reagent remains as background to this positive image, and obliterates the negative which is now obsolete.
See: Instant picture cameras

SX70 processing sequence. Exposure. The colors of the subject are picked up on three layers in the film which are sensitive to blue, green and red respectively. Each layer has a complementary dye and a developer layer.

The sheet is ejected. After exposure, a white pigment containing alkaline reagents spreads between the layers, activating the dyes and developers. An opaque timing layer keeps daylight from the developing film.

The function of dyes and developers. The dyes and developers filter up through the layers of the film until they are restrained by exposed silver – that is, the point where light has hit an appropriate layer.

The picture forms. Dye and developer which do not meet with developable silver accumulate in the image-receiving layer and build up a positive colored image. The reagent forms a brilliant white layer behind the dyes in the final image.

Color negative processing

There is little room for error in processing color negatives, but it is not difficult provided you are meticulous about timing and temperature. Equipment is no more complex than that required for monochrome processing, but you will need some extra containers. A typical processing sequence, C-41 for Kodacolor II, is shown, above right. Mix each solution carefully, following the manufacturer's instructions. Use a separate container for each solution, and stand them in a deep dish of water at developer temperature. Check that your wash water is within tolerances. Allow the last ten seconds of each processing stage for draining. When you have completed the bleach stage, you can do the rest with the lid of the tank removed.

Judging exposure

Color negatives are not easily judged by eye. The orange mask tends to make negatives look denser than they really are and the complementary image can really only be checked for color balance with an analyzer or by making a color print. Check exposure by looking for detail in shadows and highlights. Under-exposure is a more serious defect than over-exposure. Apply all the technical judgments – focus, lighting contrast, movement, marks or scratches – normally applied to black and white negatives. The top negative, above right, is correctly exposed; the one, below right, is under-exposed by two stops.

C-41 process for Kodacolor II

	°C	°F	Mins
1 Color developer	37.8 ± 0.2	100 ± 0.3	3¼
2 Bleach	24 – 41	75 – 106	6½
3 Wash	38 ± 3	100 ± 5	3¼
4 Fix	24 – 41	75 – 106	6½
5 Wash	38 ± 3	100 ± 5	3¼
6 Stabilize	24 – 41	75 – 106	1½
7 Dry			

Correct exposure

Under-exposed by two stops

Color transparency processing

Only "substantive" color transparency films such as Ektachrome and Agfachrome can be processed by the user. Non-substantive films like Kodachrome and Anscochrome must be processed by the manufacturer or professional laboratories. Obtain the correct kit of reversal processing chemicals for your film. Prepare solutions with the same care as for color negative. Extra stages are required for the reversal process – basically the film is developed as a black and white negative, then remaining silver halides are fogged and color developed. Finally silver is bleached and fixed, leaving a positive color image. Some processes fog the film chemically, others require you to expose the film to a bright light.
See: Color film: Basic principles

1. The first developer is the most critical stage of reversal processing. Temperature should be correct to within ½°F. Have all solutions at the correct temperature and work strictly according to the clock.

2. Some processes include a step at which the film must be fogged to light. Put the reel in a white bowl filled with water and place under a photoflood lamp for the required time.

3. Color development and subsequent stages can take place in white light with the tank lid off. Avoid contaminating one solution with another.

4. Many films, such as Ektachrome, have an opalescent, slightly unfixed appearance at the end of processing. This disappears when the film has dried.

Negative-positive color printing

Negative–positive printing in color differs from the same process for black and white mainly in that color filters are needed to control the color balance of each negative in order to produce the best possible print. Other differences include much less latitude in timing, temperature and agitation, and the absence of a choice of paper grades. The two main methods of color control are additive and subtractive filtration.

Subtractive principle

Yellow, magenta and cyan filters, each in a range of about seven densities, are used in subtractive filtration to control the amount of blue, green and red formed in the print. In order to make the print greener, for example, you add extra magenta filters. The color filters can be acetate sheets placed in a filter drawer between negative and enlarger lamp, or dial-in filters within a special color head.

Additive principle

This method uses only three primary colored filters (strong blue, green and red) on a rapid change holder under the enlarging lens. You give every print three exposures – one through each filter in turn – and control color balance by the relative length of these exposures. Accordingly, you lengthen green exposure time and reduce the time for blue and red if you want to increase green in the print. This system is cheap to set up but slow to produce prints, because of the number of exposures which have to be made. Shading, printing-in and local color changes are all more difficult with the additive than with the subtractive filtration method.

Color printing darkroom

You will need one or two extra items in your black and white darkroom before color printing can begin. The first of these is an enlarger lamphouse which allows color filtration. The most expensive color enlarger heads have "dial-in" filters, but you can manage with a simple filter drawer just below the lamp, or an attachment for additive filtration which will fit over the lens. Make sure also that the enlarger is really light-tight; stray light during exposure will lower the quality of your results. Change the screen in your darkroom safelight to one appropriate to the

paper you intend to use, or be prepared to work in total darkness. Color printing safelights are very dim, so it may be helpful to simplify your darkroom lay-out and reduce the risk of knocking into things. You need a bright, even light source equivalent to daylight to evaluate your processed test prints. This can be a fluorescent tube fitted over part of the sink, or else outside the darkroom. Dishes can be used for print processing but are difficult to handle in the dark and become contaminated. It is better to use a print processing drum which enables

you to carry out all processing stages in white light. You will need a mixing rod and measure to make up the various solutions from a kit, and storage containers for each stage. Use a plastic basin or deep sink filled with warm water to maintain solution temperature. Ensure that your thermometer covers the higher temperatures 85 to 105°F (30 to 40°C) used for color. If you can afford it, an electronic color analyzer will help you to save paper by predicting the filtration and exposure times.

Dial-in head. This type of enlarger head, below, contains three filters – yellow, magenta and cyan – which are lowered into the light as you adjust three dials. The exact degree of filtration is read from calibrations on the dials.

 Dial-in head

Color analyzer

Color analyzer. This instrument, above, is like an exposure meter wired to a light sensitive probe. It is usually positioned on the enlarger easel for measuring key areas. Alternatively it can be used with an image scrambler. Placed over the lens, this mixes up all the light from the negative enabling overall analysis. The analyzer makes readings and indicates which filter pack and exposure are needed.

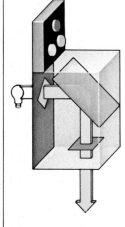

Filter drawer head. A cheap arrangement is to use a drawer, below, between lamp and negative which will accept a pack of filters. You need a set of about 22 acetate filters from which to make up a pack.

Chemicals. Keep separate containers for each stage of processing. Handle color chemicals, above, wearing rubber gloves. Beware contamination, which is easily caused by swapping container tops or failing to rinse the thermometer.

Processing drum

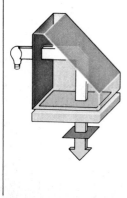

Filter drawer

Filters

Processing drum. Various types of processing drum are made for color prints. You load the drum, right, in the dark, then seal it and pour solutions in and out as you would into a film processing tank. Some tanks have motorized agitation; others must be rolled on a bench top.

Subtractive printing

Color printing calls for visual judgment of subtle color variations in tests and prints. Subtractive or "white-light" color printing has the advantage that once the filtration needed for a negative is established prints can be exposed quickly, and dodging or printing-in carried out in the same manner as for black and white. Set up and focus the enlargement in the normal way. Dial-in or make up an initial filter pack based on the paper manufacturer's recommendations, previous experience with the enlarger/film type, or, better still, measurements made with an analyzer. Using a half sheet of paper expose three or four test strips at different exposure times. After processing the strips check the most accurate exposure – it will almost certainly have a color cast. To remove this add filters which match the cast and adjust exposure time accordingly. Then test again using more closely bracketed exposure times. Mark each test with the filters used. After two or three tests you should be near enough to make the full print. Absolute consistency in processing tests and prints is, of course, essential.
See: Making a test strip/Dodging/ Printing -in/Enlargements

Test matrix

This consists of a diffuser to scramble the image light, and a color matrix and gray scale for contact printing on to the paper. From the patch which prints as neutral gray you can deduce how much filtration is needed.

Negative.
In enlarger

Diffuser.
Placed under lens to scramble image.

Matrix.
In contact with unexposed test strip.

Filtration.
Gray scale is placed over test strip to determine filtration.

Exposure.
To determine exposure, middle tear– drop should be just visible.

Neutral density

Adding or subtracting amounts of magenta, yellow or cyan filtration often results in the use of all three filters, below. This is unnecessary because equal quantities of each filter color produce gray, which merely increases exposure time. Simplify your pack by removing the lowest value filtration throughout. The re-settings, below, have the same color effect but allow a shorter exposure.

The subtractive method.
1. Compose and focus the image on the baseboard. Close the aperture about one stop. Now mask in the easel so that it will accept a test strip.

2. Measure the filtration needed with an analyzer. Alternatively, use paper batch recommendations and your previous notes. Set up the filters, then estimate test exposure times.

3. Process, remove print from drum and check in white light Assess the color cast. If the cast is slight you can check it by viewing the strip through filters of various types until the picture looks correct.

4. Reset your filtration. If tests were assessed through filters add filters complementary in color and half their strength. Eliminate any neutral density, to reduce exposure. Assess the new time. Re-test before printing.

Using test strips

The strips, right, show how progressive subtraction of color from an unfiltered test strip, near left, can produce a correctly exposed print, far right. The degree of filtration appears above each strip and the exposure times in seconds for each band are shown alongside. "M", "Y" and "C" indicate magenta, yellow and cyan filtration. Notice that as filtration is increased, so exposure must be increased.

0Y 0M 0C	75Y 50M	100Y 80M	130Y 80M
15	10	5	
10	5		
5			
2	2	2	2

Additive printing

For additive printing you can use an ordinary enlarger with a few inexpensive accessories. You need three gelatin filters, deep blue, green and red, and a device for introducing each of them one at a time without jogging the enlarger. A freely moving slide, rotating turntable or filter holder will do, but you must be able to identify each filter in the dark. The problem in printing is to find the combination of blue, green and red exposure times which gives correct color balance and density. There is no "neutral density" in additive printing. Test with a matrix device or make a test patch, below, based on analyzer readings or maker's recommendations. Process and examine the test. To reduce a given color either increase exposure through the filter of that color, or reduce exposure through a filter or filters complementary to that color. Local control of density must be carried out identically during each of the exposures. **See:** Test matrix/Color analyzer

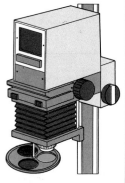

Rotating filter holder. The disk, right, is attached firmly to the enlarging lens mount. It swings to allow interchange of blue, green or red filters.

Making a test patch.
1. Enlarge the image to the required size. Mask down to a representative area about 3 ins (8 cm) sq. Check with an analyzer or data sheet for likely exposure times.

2. Suppose suggested times to be red 20 secs, green 20 secs, blue 10 secs. Put the blue filter in position. Switch off the enlarger, place a piece of color paper under the masking frame, and expose for 10 secs.

3. In the dark, and without moving the paper, change to the green filter. Use a piece of card to give equal width bands of exposure – 10, 20 and 40 secs.

4. Now change to the red filter and make another three exposure bands at right angles to the last set giving 10, 20 and 40 secs. Process the test and assess results.

Assessing the test patches

A checkered test patch, made as described above, shows the results of nine different exposure combinations. Other test patches could be made at the same time, each differing in their blue exposure. Correct color balance here appears to fall in the middle square. The full print would therefore be made giving 10 seconds blue, 20 seconds green and 20 seconds red. If a result is simply too light or too dark exposure times are all increased or decreased in proportion. For example, decreasing exposure by 30 per cent would mean changing the exposures given above to 7, 13 and 13 seconds respectively.

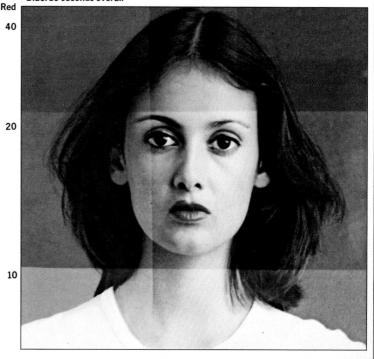

Blue: 10 seconds overall

Red

40

20

10

Green 10 20 40

Processing color prints

Whichever system you use for color printing, absolute consistency in processing is essential if you are to have any control over results. Use the kit of chemicals designed for the particular brand of color paper you are using. Most current papers are resin-coated and designed to be processed at fairly high temperatures, between 85 and 104 °F (30 and 40°C), over relatively short periods. A practical way of working is to use a daylight processing drum. It is a good idea to load the tank with paper and then pour in a warm water pre-wash. This will bring the tank up to the required temperature. If all chemical solutions are also ready at the right temperature little heat is lost during processing.
See: Color film: Basic principles

Machine processor. In the automatic processor, above, plastic reservoirs measure and feed quantities of heated solutions into the troughs through which the paper passes. A processed print emerges eight minutes later.

Using a daylight processing drum. 1. In the dark, curve the sheet of exposed paper gently, emulsion side inward, and load into drum. Close drum, switch on light and put on gloves.

2. Solutions must be ready at the correct temperature. Pour in the pre-wash and agitate by rolling the drum. After the required time, replace the water with color developer.

3. Continue the sequence: bleach/fix, wash and stabilize. Roll the drum continuously throughout each stage and discard the used chemicals.

4. On completion of the last stage, carefully remove the print from the drum. Mop off surface solution and feed the paper through an air dryer. Clean all your equipment.

Prints from transparencies

There are two main methods of making a color print from a color transparency. One involves making an internegative either by contact printing or through a camera, and then printing this conventionally. The other is to enlarge direct on to reversal color material such as Ektachrome RC paper F or Cibachrome A paper. This material is exposed using either additive or subtractive filtering methods, but remember that in this case increase in exposure lightens the print and the normal filter-change conventions for controlling casts are also reversed. The paper prints must be reversal processed using 8 or 9 stages similar to Ektachrome processing

Cibachrome
Cibachrome paper is unique in that dyes are pre-coated into the emulsion instead of being formed chemically. This gives exceptional color image brilliance. Processing simply removes unwanted color and requires a sequence using three solutions. The process takes about 12 minutes.

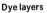

Transparency

Dye layers

- Blue sensitive/ yellow dye
- Green sensitive/ magenta dye
- Red sensitive/ cyan dye

1

2

3

Print

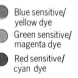

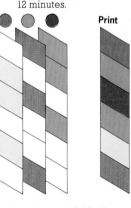

The Cibachrome process. When Cibachrome paper is exposed to a transparency the colors of the transparency are recorded by complementary layers in the paper – blue light is recorded by the yellow layer, cyan light by the yellow and magenta layers and so on. A black and white developer produces black silver images, 2, in the exposed areas of the three layers. The next solution is dye-bleach, which removes the dyes, together with the black silver, from all areas where the silver image is present, 3. After the fixing stage all remaining silver halide is dissolved. The colors of the original transparency are reproduced in the print by the remaining dyes.

The Sun through a wide-angle lens

You can make the sun's disk a much smaller element in a picture by changing from a normal to a wide-angle lens. This has the effect of removing it into the middle distance of a landscape, making foreground areas more dominant and their contents correspondingly more important. The intense brilliance of the sun, below, necessitated use of a small aperture, so that the landscape is lacking in detail. Note how even light colored objects, like clouds, begin to look dark when you have to expose for the colossal brightness of the sun.

See: Wide-angle lens/ Determining exposure

Warning. Avoid looking directly at the midday sun through a wide-aperture single lens reflex camera, and never leave a rangefinder type focal plane shutter camera pointed at the sun, focused on infinity. You may find a hole burnt through the shutter blind.

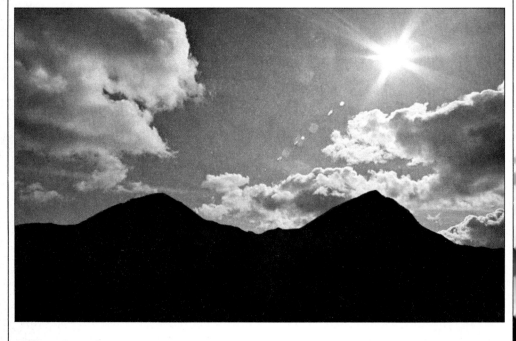

Leicaflex, 28 mm, Ektachrome X, 1/250 sec f16

Diffused weak sun

Mist or haze is often a characteristic of dawn or dusk. Weak sunlight combined with some under-exposure helps exaggerate rich sky colors, and haze gives tonal separation to silhouetted objects at varying distances from the camera. Sydney harbor bridge was photographed, right, from the shore, at early dusk. Although the sun was still very strong the presence of haze helped to retain its disk shape.

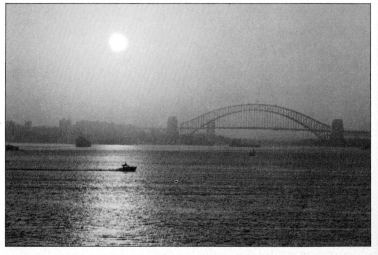

Leicaflex, 55 mm, Ektachrome X, 1/250 sec f11

Masking the sun by the subject

Using a camera – such as a single lens reflex – which allows really accurate viewing of the image, interesting relationships can be arranged between sun and subject. The sun's disk can be hidden behind quite small elements, so giving them tremendous emphasis. In this picture the sun was located so that it flares over the man's eye, and gives an iris flare spot on his ear. It was essential to view and compose the image at the actual working aperture.
See: Silhouette

Pentax Spotmatic, 55 mm,
Kodachrome X, 1/125 sec f8

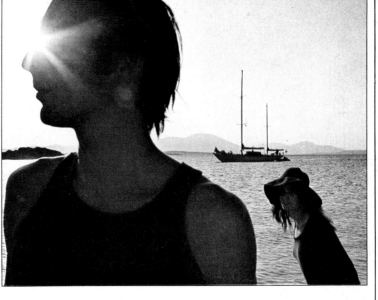

Sun behind clouds

Remember that some of the most dramatic cloud shapes occur in spring and fall, and dawn or dusk are often rewarding times of day. Generally it is best to measure exposure from an area of clear sky – this will underexpose dark clouds but allow the sun's rays to record as brilliant shafts of light. The picture below was taken after the sun had set behind the clouds. The sky is then often lit for another 30 minutes or so – a period which may be visually more interesting than sunset itself. It is particularly important not to overexpose a picture such as this, because delicate sun rays projecting from the cloud edge are easily merged with the sky.
See: Using weather/Determining exposure

Leicaflex, 135 mm,
Ektachrome X, 1/250 sec f11

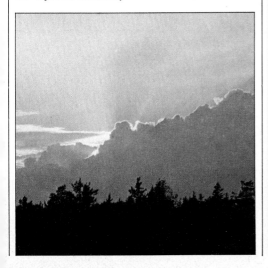

Using the sun's reflection

Water, ice, or a shiny surface such as a wet road all produce dramatic reflections when you photograph toward the sun. Often the sun itself can be excluded from the picture. This is the sort of situation where use of some form of lens hood becomes vital to eliminate overall flare. Including the sun in the picture below would have completely burnt out the sky and diluted the tonal contrast of the scene with excessive flare.
Olympus OM-1, 135 mm,
Extachrome X, 1/500 sec f11

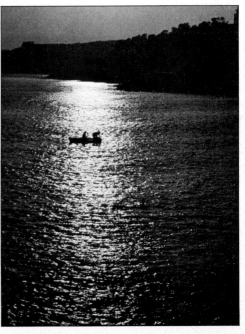

Lens flare

Any image containing a relatively intense source of light is likely to "flare" – spreading this light in size and shape. The effect is much more pronounced with old lenses and some very cheap cameras, because manufacturers today use special anti-reflective coatings on all glass surfaces to minimize flare. Despite this, when you include the unobscured sun in your picture some local light spread will still occur. Used knowledgeably, this enhances the feeling of intense – even blinding – brillance. The two controls are the size and shape of lens diaphragm used, and the degree of exposure given. The larger the aperture chosen the more circle-shaped the light spread will be. Smallest apertures usually create a multipointed star-shape, with flare extending in short radial lines from each point.
The top picture shows a large, circular patch of flare given by a long focus lens at widest aperture. Exposure was measured from a bright part of the sky. The intense heat and burning sun of the Australian outback is portrayed below by shooting toward the sun

to render most elements in semi-silhouette. The small, f22 aperture produces a strong star-shaped flare. Colored hexagonal patches here are formed by iris flare, see below.
See: Old cameras/ Lenses: varieties and functions

Nikon F, 200 mm,
Agfa CT18, 1/500 sec f8

Nikon F, 28 mm,
Kodachrome 11, 1/250 sec f22

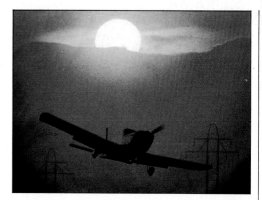

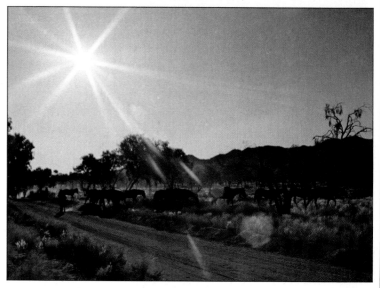

Iris flare

The more an intense point source of light is imaged off-center – even imaged just outside the frame – the more likely you are to find a sequence of "ghost" diaphragm shapes spread out in a line across the picture. The more elements used in the lens construction the more ghosts will be formed, and sometimes these take on the reflection color of individual surface coatings, as in the picture above. Of course, a direct vision or twin lens reflex camera will not allow any iris flare to be seen, and so you cannot exploit this effect creatively.
A special case of iris flare occurs where droplets of water thrown

into the air close to the camera form points of light – miniature "suns" – each reproducing one or more diaphragm shapes. The complex overlapping hexagonals and the general dispersion of the sun image itself all contribute to the general turbulence of this seascape. The lens was used at its smallest aperture and the 1/125 sec shutter speed just gives a degree of blur to the faster moving foam and spray.
See: Diffusing color/Low contrast

Leicaflex, 55 mm, High Speed
Ektachrome, 1/125 sec f16

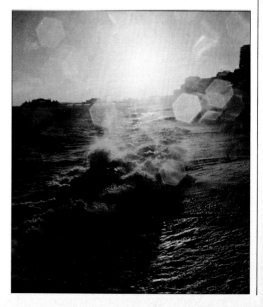

Exposure variations

The possibilities and problems which arise when including the sun in a photograph are summed up in the sequence on this page. All six pictures were taken within the space of two minutes. The only variation was in the shutter speed used – the first shot receiving about seven times more exposure than the last. This sequence also demonstrates the necessity of deciding which area of your picture you wish to be normally exposed. The exposure meter reading must then be taken selectively from this or a similarly-lit area. In conditions of extreme contrast such as these, other parts of the picture will inevitably show quite extreme under- or over-exposure.
See: Determining exposure/Modifying exposure/Shutter speed selection

All pictures: Leicaflex, 135 mm, Ektachrome X, various speeds f16

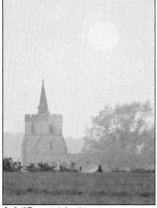

At 1/15 sec this landscape at sunset is transformed into a bright, daylight effect. Exposure was measured off the grass alone.

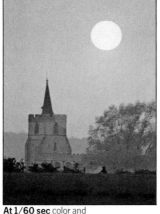

At 1/60 sec color and details in the dark foreground begin to become indistinct. The church still retains details and the sky reproduces with stronger color and better separation from the sun.

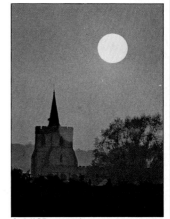

At 1/125 sec the foreground is uniformly black and the sun strongly defined against a rich sky color. This approximates the scene as I saw it. Exposure was measured from the sky alone.

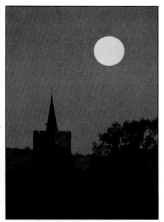

At 1/250 sec foreground and middle distance begin to merge but still show up strongly against the sky. An overall exposure reading was made of sky and sun.

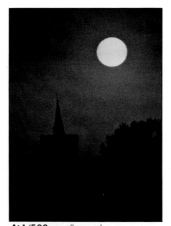

At 1/500 sec all ground based objects form a featureless silhouette. It is easy to see slight atmospheric squashing of the sun's shape, and some traces of haze across its disk.

At 1/1000 sec the skyline itself has practically disappeared and the sky has lost its color. In black and white this would easily pass as a moonlight shot.

Selecting time of day

Throughout the day sunlight steadily changes in its direction, height, color and quality. These changes have a fundamental effect on the appearance of a landscape. All the pictures of this water mill were taken during one day in winter. The building faced north east. Results prove how important it is to select the best time of day to give emphasis and mood to your picture.

7 am. First light, right, and the early morning mist blots out the building, leaving only the water and the river bank in the foreground. Although the rising sun has an orange cast most of the light filtering through the mist comes from the blue sky, giving cold colors.

8 am. The mist has mostly cleared, above left, but a blue haze persists. Patches of direct sunlight which reach the building through gaps in the trees are noticeably warm in color. The diffused quality of the light and the haze produces pastel colors.

10 am. The mist has gone, above right. The sun has risen further and moved to the left. Its hard light plus the clarity of the atmosphere produces a strong contrast, destroying some of the more subtle coloring. The buildings are now strongly emphasized.

12.30 pm. The sun has reached its highest point of the day, right. The tree shadow no longer breaks up the shape of the mill, and the hard oblique light across its boarded wall emphasizes texture. Some of the haze has returned, subduing the background.

2.30 pm. A radical change, above, as the sun has moved so that it no longer lights the side of the mill facing the camera. The buildings have become dark shapes against the lighter sky. Color is slightly warmer.

3.30 pm. At this time on a winter's day the sun is already low down in the sky, above right. The land mass contrasts with the sky and the water with its tint of orange, but the gentle quality of the lighting helps the film to record subtleties of color in the shadows.

4.30 pm. At early dusk, right, the sky has changed again – this time toward pink. Note its effect on the color of the mill building.

5 pm. At late dusk, below, rich color is found in the sky and its reflection. The mill building is barely separable from the dark, almost monochromatic land. Skyline silhouettes become a strong feature.
All pictures: Leicaflex, 35mm, Ektachrome-X, 1/15 sec to 1/125 sec f11

Photographing at dusk

The best time to take night pictures in color is at dusk. Faint traces of light still remain in the sky and you can achieve a whole range of effects – from near daylight to darkest night – by careful control of exposure. The two pictures, left, illustrate the extremes. They were taken within minutes of each other, at a time of day when the eye could clearly see the distant horizon against a lighter sky. The top picture was exposed for the brightest lit streets and houses. At 3 seconds at f11 other features submerge into the apparent darkness of night, the sky being sufficiently under-exposed to merge with the land. The lower picture was exposed for eight times as long to give the correct exposure for sky detail. Most buildings and lights are now over-exposed, but they retain sufficient detail for the picture to convey the atmosphere of an early dusk shot.

Leicaflex, 35 mm, Ektachrome-X (daylight): (above) 3 secs f11; (below) 25 secs f11

Unusual light sources

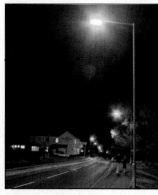

Color photographs, left, taken in streets lit by mercury-vapor or orange sodium lighting will never have a correctly balanced color appearance because these lamps do not produce a full range of light wavelengths. In the landscape, below, the buildings were floodlit by mercury-vapor lamps, but sufficient daylight remained in the sky for foreground and background to reproduce in more realistic color. To achieve this effect you can measure exposure from a building, then wait until dusk has advanced sufficiently for the surroundings to be 1½ to 2 stops under-exposed.

Pentax, 55 mm, Ektachrome-X (daylight): (top left) 4 secs f5.6; (bottom left) 3 secs f8; (below) 5 secs f8

Shooting by moonlight

To photograph a landscape at night looking toward the moon you must take account of high contrast in the same way you would if you were shooting into the sun. Often the result is a silhouetted skyline with no other detail. To give depth and interest to the picture, look for a reflective surface to use as a foreground. This might be wet pavement, a river or the gleaming tops of cars. **See:** High contrast/Shooting into the sun.
Nikon, 150 mm, Recording film, 5 secs f11

Exposure reading at night

To measure exposures at night you really need a high sensitivity meter such as a CdS or silicon cell type. This can be used in exactly the same way for night as for daylight work. If the instrument fails to respond to the subject under moonlight conditions try measuring from a piece of white card. The suggested exposure time should then be multiplied by six. As a less accurate emergency measure, point the meter directly toward the moon without using the incident light attachment. Exposure must then be increased about 20 times. Another method of calculation is based on the assumption that subjects illuminated by moonlight are only about 1/5000 as bright as they are under identical sunlight conditions. If you estimate that a landscape in sunlight would need, say, 1/1000 sec at f11, then with the sun replaced by the moon, exposure becomes 5 seconds.

Available light techniques

Taking photographs by available or "existing" light has the advantage of enabling you to capture the realism and atmosphere of the occasion. It means that you can work with greater freedom and remain more unobtrusive than with lamps or flashes. Of course, there are technical problems when the lighting is excessively dim, contrasty or uneven. Always try to choose a viewpoint to make maximum use of the best lit areas. Remember that by bracing the camera against a wall or steadying it on some other improvised support quite slow shutter speeds can be used. Light walls, covered tables, books and newspapers all provide natural reflectors to reduce contrast. Get used to using fast (including uprated) films, and provide yourself with a really sensitive exposure meter. When the need for brighter illumination is inescapable try placing your lights as close as possible to the existing sources. In this way you can help to preserve the direction and general lighting quality which gives so much of the character to this kind of subject.

Bottom left: Pentax, 35 mm, Tri-X, 1/30 sec f2.8

Bottom right: Wide-angle Rolleiflex, Tri-X, 1/5 sec f5.6

Below: Leica, 21 mm, Tri-X, 1/15 sec f4

Using room light

Most domestic lighting will produce photographs which are more uneven and have greater contrast than the original scene viewed with the naked eye. If you stand with your back to the only window a room will appear to be more flatly lit, and creative use can be made of any flare spot on a reflective facing wall, see below left. The portrait, below right, was lit by a single shaded domestic lamp, while the tatooist's shop, right, contained a mixture of fluorescent tubes and 100 watt bulbs. Using a wide-angle lens the camera was braced against a wall to give 1/15 sec at f4.

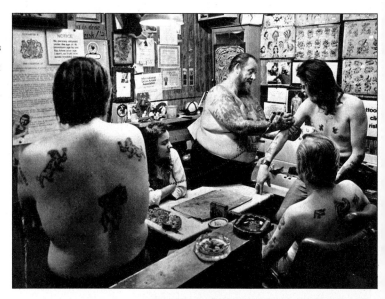

Using candlelight

Candlelight outdoors is a notoriously difficult light source, owing to its low intensity and extreme contrast. The candles, left, were positioned to illuminate each other as well as lighting the woman's face in an interesting way. A reflected light exposure reading was measured from the face, using an meter. The camera was used hand-held, the photographer's back pressed hard against a post.

TLR Rolleiflex, Royal-X (rated at 3000 ASA), 1/15 sec f3.5

Uprating film

One way to help solve the exposure problems when shooting under very dim conditions is to "uprate" the film, so that effectively you are underexposing. The film is then given increased development. Some films, especially fast film like Tri-X and HP5, respond better to this treatment than slower films, although uprating tends to give all films an exaggerated grain pattern and increased image contrast. Subjects which are flatly lit with soft, diffused illumination therefore lend themselves to this technique more than contrasty, harshly lit subjects. The latter often produce excessively hard negatives which are impossible to print. The picture, right, is a x 10 enlargement from part of a negative made on recording film (normal rating 1250 ASA) uprated to 3000 ASA and given 30 percent additional development time. Most fast and ultra-fast films can be "pushed" to between three and four times their normal ratings.

Lighting direction

The two fundamentals of lighting are direction and quality. Lighting direction can transform the apparent form and appearance of an object. First one set of surfaces and then another can be emphasized or suppressed. In the six pictures of the model church, right, lighting consisted of one flood alone. The same principles would apply if you were in direct sunlight outdoors. For picture 1 the lamp was close to and directly above the camera. This illuminates all visible surfaces but flattens shape and form. In picture 2 the lamp has been moved round to the left until light just grazes the wall with the two windows. The building now looks three-dimensional, yet detail is still visible throughout. For the third

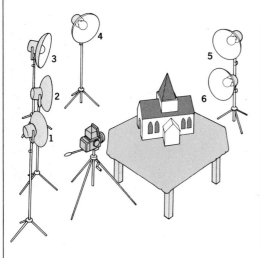

picture the lamp is to one side, directed slightly from the rear. The long wall and roof is now underlit and devoid of detail; extreme contrast exists between this and the strongly lit walls. Picture 4 shows the effect of moving the lamp more to the rear. The door wall and side of the spire are emphasized. All other surfaces merge into silhouette. In picture 5 the floodlamp points straight at the camera. Some flared detail has been recorded from light bounced off the studio wall behind the camera. Up to this point the lamp has remained at a constant height above the floor, but for the final picture, 6, it was lowered behind the model to give a "sunset" effect which simplifies the church to a silhouette.

All six photographs: Hasselblad, 80 mm, Plus-X, 1/10 sec f8

1

2

3

4

5

6

Lighting quality

Light quality means the harshness or softness of the illumination, irrespective of its direction or brightness. Both pictures below right, were lit from the left. A hard light source was used for the top picture and for the bottom picture a soft diffused one. Hard illumination is produced by any small, compact light source, particularly when it is some distance from the subject. In this case the source was a spotlight, but a match, candle or torch would have given similar quality. Shape and texture are dramatically exaggerated, but so also is contrast, and the shadow side is barely separated from the background. The lower picture, lit indirectly by a large floodlight, shows roundness of form as well as detail. Tonal separation from the background occurs on both the lit and shaded sides of the pears. Although both pictures are studio shots, the same differences in lighting quality can be observed in outdoor scenes lit by hard, direct sun and by daylight diffused by cloud.

Hard quality lighting. A small spotlight illuminated these pears from a position 90° to the lens axis.

Linhof, 100 mm, Plus-X, 1 min f11

Soft diffused lighting. For this picture the spotlight was replaced by a large flood unit about 3 ft (90 cm) in diameter.

Linhof, 100 mm, Plus-X, 75 secs f11

Simple studio lighting

Most of the principles of studio lighting are based on natural lighting in the world outdoors. We are used to seeing land-scapes, buildings, people illuminated by one sun rather than two, and from a direction above the lens-subject axis rather than below it. This does not mean that these are rules which cannot be broken, but complex and unusual lighting does tend to give a theatrical effect which can detract and work against realism. There are occasions when light itself is the main element in the picture, but in most cases lighting should be used to enhance qualities existing in the subject. In doing this it can empha-size some features and suppress others, sepa-rate elements or combine them, exag-gerate differences or show similarities. And the best way to learn about lighting is in the still life studio where everything is under our control and comparisons are easily made because elements can be changed one at a time. The main point to remember is that photo-graphic film is less able than the eye to record detail in both highlights and shadows of a scene. This means that as a rule you need to light the sub-ject in a less contrasty way than may appear correct to the eye. The photographic process will then increase this contrast so that the final photograph matches the effect you set out to produce.

Direct lighting

One lamp, such as a spot-light, directed from low down on one side of the subject, gives dark, dramatic shadows and exaggerated textures. The effect is similar to sunlight at dawn or dusk. Lines formed by shadow edges become strong elements in the composition. The spotlight here was at the same height as the doll's head, and directed from an acute angle to the wall.

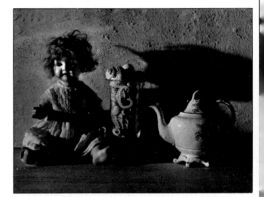

Using a reflector

A single spotlight used from a high, oblique position can pick out the subjects strongly and brightly illuminate the background. By position-ing a large reflector near the camera some of this light is redirected back into the frontal shadow areas, without forming a second set of shadows. Shapes and forms are emphasized, but the lighting of the scene is still full of contrast

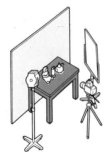

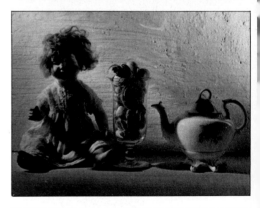

Bounced light

Instead of using one lamp direct, it can be turned away to light a large reflective surface, such as white card. This surface then illuminates the subject with even, diffused light. Shadows are few and soft edged, even when "bounced" lighting is directed from one side of the set. The resulting photograph can be full of detail without excessive flattening and loss of form.

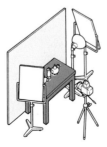

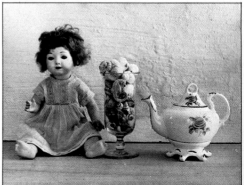

Main and fill – in light

When using two lamps set them up one at a time, deciding which shall be your main or "key" light. The main lamp may be a spotlight used to top light the subject – emphasizing form and giving strong tonal separation from the background. The second lamp, diffused or bounced, can be placed lower to help illuminate shadows thrown downwards by the main light.

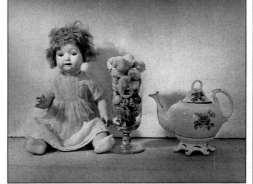

Direct and bounced light

Instead of a hard light source a flood or other diffused source might be used for the main light. It produces more gentle modeling. The second lamp can then be reflected off a suitable large area surface to give soft, overall fill-in. When the main light is frontal the resulting appearance is somewhat "flat" in black and white.

Lighting different areas

Two lamps can of course be used to light quite different parts of the the picture. For example, the subject may be lit by the main lamp plus reflector, and the background separately lit by a spotlight. The main light is a flood, high to the left, plus a large reflector on the right. The background is illuminated by a snooted spotlight from the extreme right.

Background control

Increasing the physical separation between subject and background makes possible a greater range of separate background "effects lighting". For example, spotlights can throw patterns on the background while the subjects themselves are lit separately with soft, frontal lighting. A large white surface below the lens will reflect enough light to give the effect.

Multiple lighting

The temptation when you have a lot of lamps is to use them all indiscriminately. Always try to use as few lamps as possible, building up one lamp at a time so that you can evaluate the contribution of each. Multiple lamps may be needed simply to raise the intensity of illumination. They may be used as a group to diffuse or bounce light. A range of lamps becomes really useful when you are shooting a subject which has distinct foreground, middle-distance and background. By lighting each zone separately you can pick out and balance the vital elements of the picture and add shape and atmosphere.

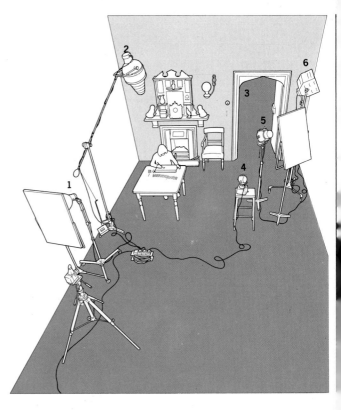

Illumination by the room-light only. 1/2 sec f11

Controlling light. Room light which looks attractive to the eye may be disappointing in a photograph because the photographic process exaggerates contrast and unevenness of lighting. This is the case in the picture, above left. Correct exposure for the wall light has recorded something of its warm glow, but details within the room which could just be seen by the eye are lost in gloom. Longer exposure which would light the room clearly would also "burn out" and destroy lamp detail. Extra lamps were introduced to rebuild the scene in more recordable form without destroying the impression that the wall lamp is the main light source. Photographic lighting units were built up one at a time, opposite, until there were six altogether. They included floods and spots, some bounced to give soft, even illumination or snooted to light local areas. The result, left, appears completely natural.

Hasselblad, 50 mm, Plus-X, 1/4 sec f11

Building up the lighting

When you build up an elaborate lighting scheme like this one, left, decide what function each lamp is intended to perform. Carefully introduce your lamps one at a time, with the other lamps turned off to begin with so that the effect of each can be seen in isolation. Then check with all the lamps on to assess relative brightness and influence on shadow formation. You can alter intensity by moving the light source nearer or further away. Always check lighting changes from the camera position. The first lamp introduced was

intended to give soft frontal detail lighting. A floodlamp, 1, was bounced off a large reflector board near the camera, and distance was adjusted until the meter showed that the subject required an aperture of f8. As the wall lamp alone required f11 this check ensured that the lighting balance would not be reversed, but simply reduced to a 2:1 ratio. A snooted flood, 2, on a boom stand lit the girl's hair, face and hands. Notice the weight on the lamp base to improve its stability. A floodlamp, 3, in the next room lit the door to a level measured as f11.

A miniature spotlight, 4, placed low to give a glancing light across the table adds texture and form to the pencils. These were rather flattened by the snooted flood, 2. Another light was needed to simulate shadows cast by the wall lamp. This was achieved with a spotlight, 5, slightly softened by bouncing off a small area of aluminum reflector board. Finally, soft illumination, 6, bounced off a wall to the right helped balance frontal lighting, 1.

All six below: Hasselblad, 50 mm, Plus-X, 1/2 sec f8

1. The frontal light used alone, left, gives details overall. Slight fall off in illumination from left to right will be compensated by bounced light, 6.

2. A top light, right, suspended just outside the top of the picture area is closely masked to illuminate the figure only. Notice how light bounced off the child's drawing paper illuminates the area of her chin.

3. A flood lamp, left, positioned in the room beyond the doorway reveals detail and gives shape to the door.

4. Miniature spotlights are particularly useful to highlight small areas. This one, right, was placed on a chair and focused to a narrow beam.

5. This shadow-forming light, left, was positioned the same height above the floor as the wall lamp. Shadows across the china ornaments then appear to be cast by the lamp.

6. The final touch was achieved with bounced side lighting, right, to give separation of forms.

Positioning the lights

Lighting a portrait head requires care. The direction of the light transforms shape and appearance. This is shown, right, by the extreme case of a single harsh spotlight used from various positions. Notice how features can be flattened or extended and the shape of the face changed from round to oval. Hard light is generally unflattering for portraiture, particularly when it comes from one side, unrelieved by a reflector. This girl has a symmetrical face which responds well to the top frontal lighting used in picture 1, right.

Hasselblad, 150 mm, Plus-X, 1/30 sec f8

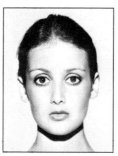

1. A lamp positioned about 1 ft (30 cm) directly above the camera lens gives no modeling.

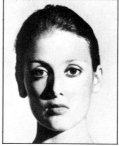

2. A lamp to one side, at 45° to the lens axis gives more shape to the head but throws an ugly nose shadow.

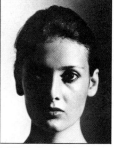

3. With the lamp at 90° one half of the face is unlit, while the other half has exaggerated skin texture and shadowed eye.

4. A lamp placed behind the model lights the back of the head at an angle of 45°. The unlit face is unrecognizable.

5. A lamp behind and above the model rim-lights the hairline and neck.

6. Here the lamp has been turned on to the white background, resulting in a silhouetted shape.

Dramatic effect

It is possible by means of dramatic lighting to inject extra life into a portrait. Shapes and textures can be exaggerated with loss of overall detail. Overdone, however, the effect is theatrical; key elements in the face are lost in extreme contrast. The small picture, below left, shows the model lit by soft frontal illumination. For the shot, below center, a harsh top light was used which emphasizes skin texture and makes the hair shine but obliterates the eyes and throws a heavy nose shadow across the lips. This could be the portrait of a blind man. The picture, below right, is lit from below, totally unlike "natural" lighting, giving an effect which is macabre and unreal. Note the ugly square shadow thrown upward from the nose. Use dramatic lighting with restraint. Often it will give the best results if the source is bounced or diffused.

Spotlight and flood for drama. The portrait, above, lit from the front with a diffused flood, is re-lit, right, by a single spotlight directed from high above the camera. In the picture, far right, this spotlight was pointed upward from below the camera. Rolleiflex, HP5, 1/60 sec f11

Profiles

Profiles are very revealing in terms of character and expression. They offer an interesting, rather under-rated approach to portraiture. Lighting plays a crucial role, as shown by the two pictures on the right. The first, near right, uses diffused side lighting and a background tone which merges with the back of the head. The second picture has the background lit to a tone midway between light and dark zones, revealing total head shape. Both pictures: Hasselblad, 150 mm, FP4, 1/15 sec f16

Silhouettes

Silhouette is one of the strongest ways of emphasizing shape, because of its simplicity and extreme economy of detail. It is also great fun to do. Character and expression can be summed up powerfully by the outline of a chin, nose or mouth. Where necessary, areas of detail can be made discernible by local lighting, but this should still be subordinate to a strong overall shape.

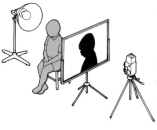

Using a white backdrop. The most convenient way to photograph a silhouette is to position the subject some distance in front of a white background. This backdrop is then evenly illuminated, perhaps with two or more floods, taking care not to spill light on to the sides of the figure. Avoid reflective surfaces behind the camera which could bounce illumination back to the face; wear dark clothing yourself. Take greatest care over positioning the subject. Slight rotation of the head radically changes a profile shape. Take your meter reading from the background alone and print on hard grade paper. Hasselblad, 150 mm, Plus-X, 1/60 sec f16

Lighting local detail. Instead of a solid silhouette some local area can be lit to reveal detail. This must be organized with care and restraint. Avoid hard shadows which would conflict with a simple silhouette shape and destroy it. For the picture above, the model's head could either have been turned into profile for a pure silhouette, or she could have looked to the front and additional light might have been introduced for face detail. Two floods were used behind the figure to light the background, and a spotlight well above the camera was focused on the face alone. Mamiyaflex, 80 mm, FP4, 1/30 sec f11

Using projected shadows. Another way of forming a silhouette is the traditional method of projecting the subject's shadow on to a screen. This gives a slightly softer "edge" to the shape. It is also the easiest way of working if you are limited to one light. For the picture above, the child was positioned just behind a screen of tracing paper stretched taut on a frame. At the far end of the room a floodlight directed to the screen projected his shadow on to the paper surface. As before, exposure was measured for the white area alone. Hasselblad, 150 mm, Plus-X, 1/125 sec f16

Lighting a large interior

Many lofty interiors tend to be underlit because there are large areas which receive little natural light. This means that when you give sufficient exposure to record shadow detail, windows are hopelessly burnt-out. More illumination is needed to reduce this contrast to manageable proportions, without destroying the illusion that the interior is lit naturally. It is sometimes enough to switch on all the available light or even open a door behind the camera to get the necessary fill-in, but lighting often has to be specially introduced. One approach, suitable for interiors without figures, is to set up the camera on a tripod, use slow film, stop the lens well down and give a long time exposure. During the exposure you walk around the interior with a floodlamp or flash-gun, illuminating the dark areas but making sure the light source never points toward the camera. The flood should be kept on the move all the time, "painting" the interior with shadowless light.

Linhof, 135 mm, Plus-X: (above)
6 sec f22; (below) 24 secs f32

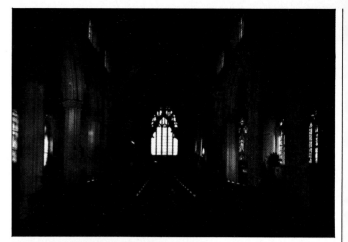

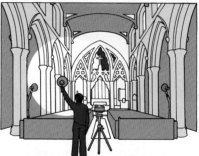

Painting with light. The photograph, above, was exposed correctly for the windows. For the picture, below, exposure was increased and during the exposure time the photographer "painted" the interior with a battery operated floodlamp, directed from the three vantage points, shown left. He wore dark clothing and moved continuously from one position to the next so that his own image did not record.

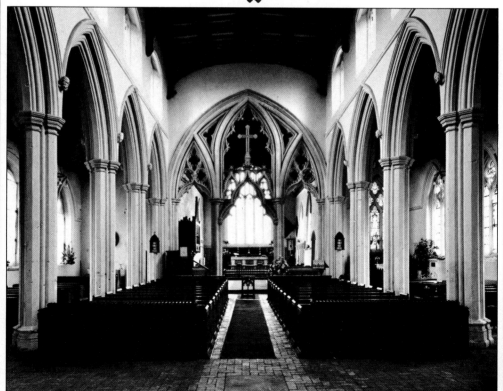

Photographing in museums

Modern museums provide good locations for the photographer. Most museum authorities will allow you to take photographs without having to ask formal permission. Even the use of supplementary lighting is frequently permitted. The main problems are the un-evenness of display illumination, unwanted backgrounds and reflections from glass. Dimness of lighting can be overcome by giving a long exposure using the camera on a tripod, but you may have to reduce the lighting contrast produced by spotlights or oblique daylight. The simplest solution is to have a sheet or a roll of white paper which can be arranged to reflect some illumination back into the shadows. This has the advantage over flash of allowing you to see exactly how the quality of lighting is altered. Should you need to photograph through a glass case, first clean the glass, then position the camera close to the glass surface. Avoid angles which give reflections of other objects, and choose a viewpoint which will eliminate bright parts of other displays, distant windows and fluorescent ceiling lights. Distracting backgrounds can also be avoided by hanging dark material behind the subject. If you want to blur the creases, get an assistant to keep this background on the move during the exposure. **See:** Balancing daylight and flash

4 x 5 ins (10.2 x 12.7 cm) view camera, 150 mm, Plus-X, 10 secs f32

Reflecting daylight to illuminate shadows. These stone figures were photographed in a museum from a viewpoint almost directly overhead. Overcast daylight from a low window on the left gave soft, oblique lighting. As the shadows were too dark to reveal detail, a large sheet of newspaper was suspended on the right to act as a reflector.

Photographing in the theater

Most photography of theatrical productions takes place under one of two distinct sets of conditions – during an actual public performance, or during a dress rehearsal or specially staged "photo-call". In the first instance you have to work using existing lighting, without being able to organize the actors, and from a set viewpoint within an audience. Obtain permission from the management first. Try to pick a camera position which is at least level with the stage and preferably slightly above it. The front row of the circle is ideal. It is essential to see the show through once, to make note of the best scenes and situations for photography. Stage lighting varies enormously; try to avoid extreme contrast and work when the set is fairly evenly illuminated. A sensitive spot meter or a through-the-lens meter is the best way of measuring exposure. Illuminated digital read-out is helpful in the gloom of the theater. Base exposure slightly more on highlights than on shadows, as the important detail of faces must not be lost. You will probably need to use a long-focus lens and work somewhere between 1/30 and 1/125 second at f3.5 on ultra-fast film. It is helpful to up-rate the film, but remember that the extra devel-opment further increases contrast. If you can work with the actors at dress rehearsal you will have much more control. You will be able to move your position around the auditorium for whole stage pictures and use house lights to soften contrast. You may be able to set up groups specially to suit the camera's viewpoint. For close-ups work on the stage itself, using stage lighting together with your own reflectors or a low powered flood or flash as fill-in. Alternatively, set up an improvised stage "studio" using your own familiar lighting, and work as you would for a portrait session. The pictures, right, were photographed in an on-stage studio using one large photographic flood and a white reflector board.

Rolleiflex, Tri-X, 1/30 sec f11

Masking down the light

The main advantage of working in the studio is that all light is controllable. You can insert devices into the light beam to produce various effects with located light. The picture, below, is lit by one flood with its beam restricted by a conical snoot. The girl was wearing a light patterned jacket but the limited lighting, helped by printing-in, has destroyed such unwanted detail. Masked down lights also allow you to project a patch of illumination on a background, to emphasize one face or object among many, or strengthen the effect of a lamp featured within the picture.
See: Multiple lighting

Rim lighting

Rim lighting – sometimes known as "profile lighting" – is a method of emphasizing an important edge-line by giving it a brilliant continuous highlight, usually contrasted against a dark background. In the studio this is created by a harsh light source positioned about 45° behind and above the sitter. Use barn-doors or a snoot to help shade the lens from direct light, and fit a lens hood. Generally it is advisable to reveal some detail in the rest of the face by using frontal light. This should be soft, shadowless and less intense than the rim light. Use your meter to compare the spotlit and shadow-filled sides of the face. A ratio of 4:1 is often satisfactory in black and white work.
See: Lighting equipment

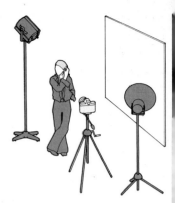

Using rim lighting for emphasis. To light the portrait below a 1000 watt spot was positioned at the rear left, about 3 ft (90 cm) higher than the model. Shadows were filled by a 500 watt flood bounced from a white wall.
Pentax, 135 mm, Plus-X, 1/60 sec f5.6

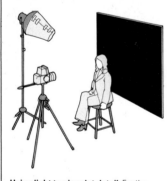

Using light to pinpoint detail. For the picture above a long snoot of black card was fitted to the front of a floodlamp. This was aimed at the subject from a position above and behind the camera, at a distance which just illuminated the face area. The girl was seated about 6 ft (1.8 m) from a black background with no other lighting present. Exposure was measured from the face alone.

Hasselblad, 150 mm, Tri-X, 1/15 sec f8

Rim light with one light source. With care you can achieve a similar rim light effect with one light only. Use a large reflector board quite close to the shadow side of the model, just out of frame. This will bring some detail into the face. When shooting outdoors using the sun as the rim light bring your model close to a white wall, or just poke the camera lens through a hole in a sheet of newspaper. This will then act as a reflector.
See: Shooting into the sun

Using flare

Lens flare can be used to good effect. It is a valuable way of simulating a blinding light, provided you can control your results. Also the light scatter caused by flare helps suppress ugly backgrounds, or at least lower the contrast of unwanted detail. The safest way of working is to check the subject through a single lens reflex stopped down to the diaphragm setting you actually intend to use. If possible have the camera on a tripod, because when shooting into the light the slightest variation of viewpoint makes a major change in the degree and extent of flare. Sometimes a gelatin ultra-violet filter positioned just in front of the lens helps to increase light spread. Consider also the use of "starburst" or other diffusion devices. Degree of exposure is also important. Try to arrange that the light source to be flared is about four stops over-exposed when exposure is correct for the rest of the picture. You will probably have to extend development time for the negative to compensate for its lowered image contrast. By shooting on ultra-fast film and printing on hard paper strong grain effects are produced, adding to a dramatic situation, as in the picture above.
See: Lens attachments

Dramatic effect with flare. This scene was staged in the studio. One 1000 watt flood was pointed almost directly toward the lens. The figures stared intently at a large sheet of reflective foil with a hole for the camera lens. Exposure was measured for the faces.
Hasselblad, 150 mm, Royal-X Pan, 1/125 sec f8

Using flash

The most obvious difference between flash and other forms of photographic lighting is its brief duration. How can you judge what is going to happen when the light lasts 1/100 second or less? Experience with studio lamps and daylight is useful, for the same basic principles of quality, direction and lighting balance still apply. There are several practical points to remember when using flash for the first time.

Synchronization
The shutter must be fully open at the moment the flash produces its maximum light. Guns which use bulbs must be triggered from the "M" synchronization socket on the camera shutter; electronic flash uses the "X" socket. Most cameras with focal plane shutters must be used at 1/60 second or slower, but effectively the shutter speed is the duration of the actual flash. Typically, this is 1/500 second with electronic flash or 1/60 second with bulbs. With

electronic flash particularly you have few problems with camera shake or subject movement. With all flash correct exposure is the setting of the correct lens aperture.

Judging exposure
Exposure depends upon the subject's distance from the flash, as well as its dark or light tone. For average subjects a simple scale of "f" numbers for different distances will suffice. It is also possible to use a self regulating flash, or take readings with a special flash meter.

Lighting quality
Most flash guns use a small bulb or tube as light source, backed by a polished reflector. Used direct, the lighting quality is as harsh as a spotlight. But bouncing it off a white surface or diffusing it produces soft illumination.

Color
Electronic flash and blue tinted flash-bulbs produce light which matches the color balance of daylight color film.

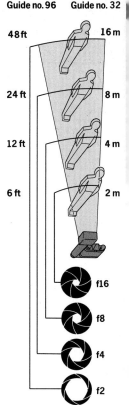

Guide no. 96 Guide no. 32

48 ft — 16 m
24 ft — 8 m
12 ft — 4 m
6 ft — 2 m

f16
f8
f4
f2

Guide numbers. The simplest way of calculating exposure is to use the guide number suggested by the flash manufacturer for the ASA rating of your film. You divide the flash-to-subject distance, either in feet or meters, into the appropriate guide number to find the lens "f" number required, as in the diagram, right.

Calculating exposure

Every electronic flashgun carries a small calculator disk so that you can read off apertures required for various distances, right. If you can afford a separate flash meter this is first set for your film speed, then placed by the subject pointing toward the flash. One flash is fired manually, making the meter needle register a reading which, after transfer to a calculator dial, indicates appropriate "f" number. Self regulating flashguns have their own light sensitive cell directed toward the subject. You set the ASA speed on a control dial at the back, then use the "f" number it suggests for the camera lens. The flash regulates itself to give a brief flash for close light toned subjects or a longer flash for distant darker subjects.

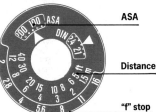

ASA

Distance

"f" stop

1. The basic calculator dial found on most flashguns relates flash distance to lens aperture. First set the ASA rating of the film you intend to use.

2. Then find the appropriate flash-to-subject distance on the distance scale – in this case 15 ft (4.5 m). Read off the aperture – in this case f8. If you are bouncing flash the aperture will need to be increased, in this case to f5.6.

Two flashes

Two flashes may be used to give a similar lighting effect to two lamps in the studio. One can be used for the subject, the other for the background. Usually one flash is used off the camera on a long lead while the other, mounted on the camera, gives diffused fill-in. A meter will take into account all the flash sources, but if you use a calculator work on the basis of the exposure which is needed for the main light alone.

Arranging the flash

The average small flash-gun gives lighting quality equivalent to a spotlight or quartz-iodine lamp. The same lighting principles therefore apply. You would not for example normally direct a spot-light flat-on from the camera position, yet the typical flashgun position directly over the lens gives just this lighting effect. Better results will be achieved using techniques two to six shown right.

1. Direct flash from the camera illuminates the subject like a searchlight. The hard flat-on light reveals outline, but destroys form and texture. Foreground is always much lighter than background.

2. A diffuser such as tracing paper placed over the flash-head scatters light and softens its quality, though it also reduces its intensity. Shadows are softer and the reduction of light with distance is less marked.

3. Here the flash-head is tilted upward to bounce light off the ceiling. The result is soft, even top lighting. With auto-flash keep the sensor pointing at your subject, not the ceiling.

Slave units

An accessory slave trigger unit can be plugged into the synchronizing lead of a flashgun. This reacts to light from another flash triggered from the camera, and instantaneously fires in full synchronization.

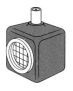

4. If you use the flash direct but detached from the camera you get hard side-lighting. Textures are exaggerated, but contrast becomes exceptionally hard unless a reflector is used on the shadow side.

5. One flash at full power off the camera provides the principal source of light while a flash on the camera, used at half power or heavily diffused, acts as fill-in.

6. One flash was held off the camera, with another illuminating the background. You can regulate subject/background tone by using half or full power, or by varying flash-to-subject distances.

Integrated flash

When the flashgun, below, is switched on, two extra contacts in the accessory shoe switch the camera automatically to a shutter speed of 1/60 sec irrespective of the speed already set. This linkage also controls the lens aperture and the level of illumination at the moment of exposure.

Canon AE-1 and Speedlite

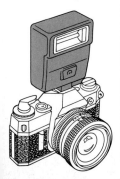

Freezing motion

Flashguns equipped with sensors ("computer" flashguns) regulate the amount of light falling on the subject by altering the duration of the flash produced. At small flash-to-subject distances, this duration may be as short as 1/10,000 sec. This enables high-speed subject movement to be arrested without the use of elaborate auxiliary equipment. In the picture, right, the bottle was held just in front of a white reflector card with the camera and the flashgun 3 ft (91 cm) away. Since the movement of the wine was entirely unpredictable, a large number of exposures were made in order to achieve the result shown here.

Hasselblad, 80 mm. Ektachrome-X, 1/60 sec f16

Lighting balance

Portable flash is a useful source for "balancing up" the lighting of interiors. The most common problem here is excessive contrast between brightly lit windows and darker interior detail. By firing a flash on, or near, the camera a more suitable balance can be achieved. Of course it is important not to overdo the flash, or the result will appear unnatural. Most of the technical skill lies in adjusting exposure to give a realistic balance of illumination, in which the interior reveals detail but light still apparently enters the room by the window. You must also consider the lighting quality of the flash fill-in. Hard lighting would form harsh shadows and make obvious the artificial light source. It is better to diffuse or bounce the flash to give soft, even frontal lighting with the minimum of shadow. Beware of reflections of the flash in windows and mirrors. A modeling light or flashlight near the flash head will help you to check this. Finally remember that the "daylight" color of the flash may not necessarily match existing daylight seen through the window, particularly early or late in the day. The flash may then require slight filtration.
See: Flash equipment/ Lighting interiors

Regulating the balance of light. The picture series, below, illustrates the ways interior/ exterior balance can be controlled. The flash was bounced off the interior of a white-lined umbrella positioned just to the right of the camera.

Hasselblad, 150 mm, Ektachrome-X.

1. The picture, left, was taken with daylight alone. Exposure of 1 second at f16 was averaged for the window and wall areas. Interior detail is under-exposed, yet longer exposure would severely "burn-out" the window.

2. A flash picture, right, was taken at a shutter setting of 1/60 second, at f16. This aperture is correct for flash but the shutter speed, too brief to record the daylight in the room, has grossly under-exposed the window. The picture appears to have been taken at night.

3. By giving ¼ second at f16, left, window detail is correctly exposed, as well as the flash illuminated interior. This 1:1 balance gives maximum information, yet the result is rather false and artificial.

4. For the picture, right, exposure time was extended to 1 second at f16. The window now gives the appearance of lighting the room. Notice how the diffused shadow formed by the flash is also less apparent.

Lighting an interior

The examples on the page opposite show how flash can balance daylight for pictures taken indoors, but most interiors also present lighting problems because of their overall depth. Daylight at windows is much brighter than in other parts of the room, and there are shadowy areas in the furthest corners. You must therefore be very careful in your choice of position for the flash fill-in. Once again the flash should be diffused and even, but placed to have greatest effect in the darkest areas of the room. In this way the fall-off in flash illumination is counteracted by daylight toward the window.

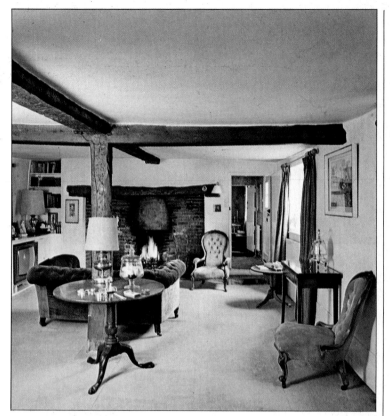

Balancing daylight and flash. For the picture, above, three flash heads were bounced off a large reflector to the left of the camera. The diagram, below, shows the lighting set up. Sheets of white card taped together formed a folding screen. The electronic flash heads directed into the reflector formed a brilliant patch of diffused light. A sheet of card, set up between the flash heads and the room, controlled the direction of light. The shutter was held open on "B" and the flashes fired manually. The exposure, measured for the table, was 6 seconds at f22.

Hasselblad, 40 mm, Ektachrome-X

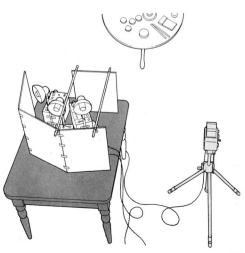

Using existing light.
The picture, above, was the best result possible using daylight alone. The room had only one window. Exposure was measured from the carpet/chair area in the mid-distance, and read 3 seconds at f16. Longer exposure would have resolved more detail in the shadowy corners, but would have "burnt-out" the area near the window.

Flash with daylight

When the brief duration of flash is combined with the continuous illumination of daylight all sorts of unusual effects can be achieved. Movement may be recorded as a mixture of detail and blur, and day can be turned into dusk or night. For these and similar techniques remember that the same basic principle applies: most shutter speeds affect daylight exposure alone, but aperture affects both daylight and flash.

The problem of recording movement is that a fast shutter speed freezes the action, but produces a fixed, static effect. Yet a slow shutter speed gives too much blur and abstraction. To combine the advantages of both these extremes try using the slow shutter speed in conjunction with an electronic flash. In the picture below the effect is of a sharp "flash frozen" image superimposed on a semi-abstract blur. Static objects remain blur-free and sharp. To make the most of this and other flash/daylight techniques choose a slow film and shutter speed in relation to subject movement. Similarly, try to use a camera with a bladed shutter. Unlike the focal plane type this allows you to use flash over the full range of shutter speeds. Beware of over-exposure. Choose a contrasty film and developer to compensate for the flattened highlight quality.
See: Flash equipment

1. Hasselblad, 150 mm, Plus-X, 1/30 sec f16

Turning day into night

Flash can be used outdoors to fill in or even eclipse daylight. Most flash is not powerful enough to light areas larger than, say, a full length figure at sufficient intensity. But provided you are not too ambitious some strange effects are possible. For example, the photographs of the gardener on these pages were taken within five minutes of each other, at mid-morning on an overcast day. Picture 1 accurately records the natural lighting conditions. No flash was used. The camera was about 10 ft (3 m) from the subject. In picture 2 the distance between camera and subject remained 10 ft (3 m) but an electronic flash with a guide number of 160 was attached to the camera. The photograph was timed to under-expose the daylight but to expose the flash correctly. Notice how the introduction of this frontal lighting has caused the shadow areas to leave the man's face. For picture 3 the shutter speed was increased. Background under-exposure now darkened the sky as well as the trees, and shadows formed by the flash can be seen on grass behind the figure. In picture 4 aerial perspective has been eliminated so that the gardener seems to be standing against a painted back-drop, while for picture 5 exposure was reduced so that flash provided the only effective illumination. With total elimination of background the gardener's out-line is lost and one has to piece together isolated bits of visual information such as the face, the trousers and the hand on the stick.
See: Flash techniques/Guide numbers/Sun: exposure variations

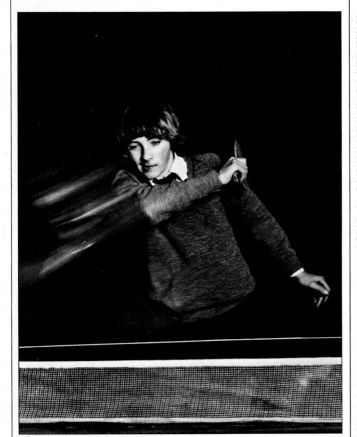

Using flash to capture movement. The action, above, was recorded by a combination of electronic flash and a relatively long shutter speed. Daylight caused the face and bat to record as blurred highlights while the flash recorded a hardcore of resolved sharpness. The meter exposure for the dull daylight was 1/15 second at f16. The electronic flash, 6 ft (1.9 m) from the subject, had a flash guide number of 96.

Shooting at f22 meant that both sources were under-exposed by one stop, but collectively the two light sources produced a fully exposed negative. A black background was hung behind the subject to accentuate the blurred highlights.

Rolleicord, 75 mm, Plus-X, 1/15 sec f22

2. 1/60 sec f16

3. 1/125 sec f16

4. 1/250 sec f16

5. 1/500 sec f16

Stained glass

The main technical problems here are: background; accessibility; and contrast. For true rendition of colors, below, pick weather conditions and viewpoints which give an even, slightly overcast sky background to the glass. Avoid direct sunlight, even if it reaches the glass obliquely, because it tends to emphasize unwanted shapes and colors behind the glass. If they cannot be avoided shoot at the widest aperture. A range of lenses and a camera offering "movements" will help you to fill the frame from various distances and angles. Take close-up local readings to average the exposures for darkest and lightest pieces of glass.

View camera, 210 mm, Ektachrome-X (daylight), 5 secs f8

Fireworks

Pictures of firework displays can easily be made to appear more impressive than the events themselves. You can hold the shutter open long enough to record several fireworks, or make several shorter exposures on to the same piece of film. Use the camera on a tripod. Rockets give better results than static set pieces. The picture immediately below, was exposed at f16 for a total of 18 seconds, during which three large rockets were set off. The lens was covered between rockets to avoid the recording of local light near the camera. The picture, bottom of page, is made up of two transparencies of single rocket bursts, sandwiched together in one mount.

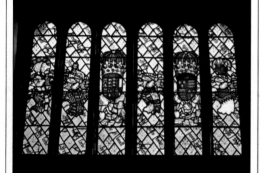

Stained glass detail. To capture detail you may need scaffolding or steps, right; the camera can be attached with a clamp to the top. Try to arrange that the camera back is truly parallel to the glass surface. Areas of the window immediately adjacent to the detail being recorded should be covered by black paper or cloth to eliminate flare. Do not stand on the ladder while making a time exposure – use either an extra long cable release or a delayed action shutter. The picture above was exposed from the top of a ladder.

Hasselblad, 80 mm, Ektachrome-X (daylight), 1 sec f11

Illuminated signs

You can make interesting pictures out of illuminated signs, and similar colored light sources at night. Consider the possibilities of showing them reflected in puddles, windows, or any polished surface. The picture, right, was taken some hours after a shower of rain in Piccadilly Circus, London. Exposure was measured from reflective parts of the sidewalk. Another technique is to blur the sign by moving the camera. For the picture, below, the camera was on a tripod. The meter read 2 seconds at f11 for the gas pump signs, but immediately this period had elapsed the camera was swung to the right before the shutter was closed.

Minolta, 55 mm, Ektachrome-X, 8 secs f16

Pentax, 55 mm, Ektachrome-X (daylight)

Lighting large areas

Often night scenes photograph with excessively high contrast and uneven distribution of light. This was the case in the picture below, photographed only by existing light. For the second version, right, the camera was left with the shutter open and a flash-gun was fired six times from different parts of the restaurant. It is important to keep yourself, and the flash, out of the lens's angle of view. Maintain a constant distance between the flash and the particular part it is illuminating.

Leicaflex, 28 mm, Ektachrome-X (daylight), 45 secs f22

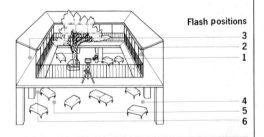

Flash positions
3
2
1
4
5
6

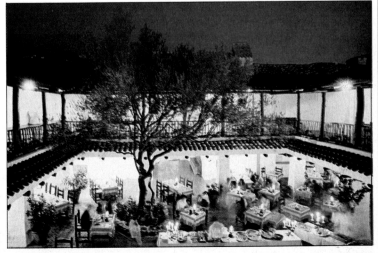

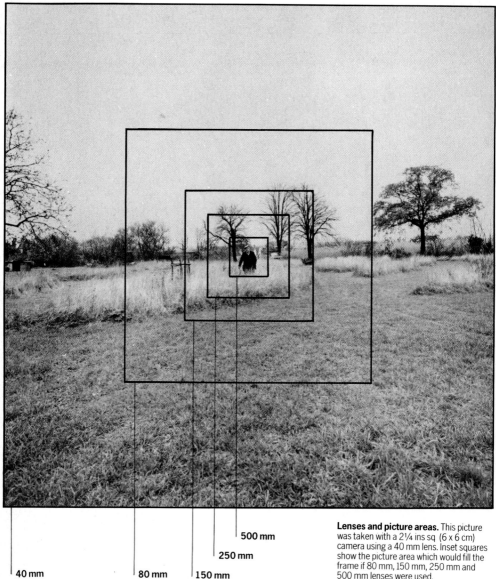

40 mm

80 mm

150 mm

250 mm

500 mm

Lenses and picture areas. This picture was taken with a 2¼ ins sq (6 x 6 cm) camera using a 40 mm lens. Inset squares show the picture area which would fill the frame if 80 mm, 150 mm, 250 mm and 500 mm lenses were used.
Tri-X, 1/250 sec f11

Changing lenses

With interchangeable lenses of different focal lengths you can extend your range considerably. The most immediate advantage is that you can include a greater or lesser amount of the subject without having to change camera position. The 2¼ ins square (6 x 6 cm) camera was set up on a tripod and a picture was taken using a 40 mm lens. The result is shown in its entirety, above. If the lens was changed to 80 mm the viewfinder would be filled by the area outlined, above. The longer lens has a narrower angle of view (in this case 46° instead of 92°)

and therefore gives a more magnified image. The image could be enlarged still further through a lens of 150 mm. The man and his immediate surroundings now appear closer, but the lens picks up much less of the original scene. 250 mm and 500 mm lenses produce similar effects. In fact for a distant subject the image size changes in direct ratio to focal length. Since the camera and the man remain static, therefore in every photograph the figure's size remains the same in relation to his background. This ability to include more or less of a scene

just by changing the lens is particularly useful when you cannot position the camera at an ideal distance. However, bear in mind that the image can change in two ways. First, depth of field becomes increasingly shallow as you change to lenses of a longer focal length, even though the "f" number remains constant throughout. Secondly, some extreme wide-angle lenses introduce their own distortion of image shape at the edges and corners of the picture.

Magnification with lenses

Image magnification varies according to focal length. You might argue that everything could be shot with a wide-angle lens and the required picture area enlarged from the negative through the enlarger. To show just how different the result would be, the picture, below right, is from a whole negative taken with a 500 mm lens. The one, below left, is enlarged from the center of the 40 mm lens negative. Immediately you can see that depth of field is much shallower with the long-focus lens. The degree of enlargement given to the 40 mm negative has also increased its graininess destroying fine detail. The result is an image which has been flattened in tone, even though perspective and scale remain the same in each picture.

Changing viewpoint

The size of objects relative to one another in a photograph depends both upon their actual size and on their relative distance from the camera. If the camera is much closer to a figure than it is to the background, figure size will be exaggerated while the background recedes. If both elements are a long way from the camera this effect is diminished. By using interchangeable lenses and shifting the camera position it is therefore possible to alter perspective in a photograph. As the diagram, right, shows, a close viewpoint and 40 mm lens can give the same figure size as a distant viewpoint and 500 mm lens. The first picture, however, will include a great deal more background, rendered small in scale. Its close camera viewpoint produces a much steeper perspective so that the man seems to loom strangely out of his surroundings.

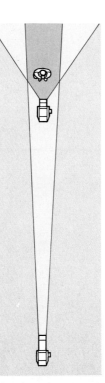

Viewpoint and perspective.
This picture was taken from a viewpoint only 6 ft (1.8 m) from the figure, using a 40 mm lens. Compare the steep perspective with the shot directly above it which was taken with a 500 mm lens 70 ft (21 m) from the figure.
Hasselblad, Tri-X, 1/250 sec f11

Close-up equipment

To take close-ups you need equipment which will increase the distance from lens to film. Alternatively, you can add another lens element, a close-up attachment. The trouble with both these methods is that the lens is being used under conditions for which it was not designed, and so image quality deteriorates. A macro lens, which is specially corrected for close-up conditions, will give a sharper image. Even reversing the standard lens will improve the result.

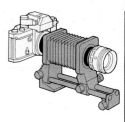

Normal and macro camera lenses. The normal lens, top, allows you to focus subjects down to about 2 ft (60 cm). A close-up lens attachment is cheap and convenient, but the strongly converging type needed for really close work seriously upsets lens quality. Center and corners of the picture cannot both be resolved sharply. For best results use a special macro lens, above.

Reversing the lens. Some systems allow the normal lens to be reversed for use when the subject is closer to the lens than the lens is to the film.

Extension tubes. You can buy extension tubes above, in a set of three, each of a different length. They can be used all together, or in any combination, but they are not as adaptable as bellows, above right.

Bellows and bellows attachments. For highest quality close-up work use a macro lens on a bellows unit. This allows continuous focusing adjustment and may even offer movements. You can get a slide-copier attachment which fits on the front of the lens. This enables you to make selective enlargements from transparencies. Large format monorail cameras can be fitted with an additional bellows for extreme close-up work.

Close-up techniques

The term "close-up" is a generalization covering anything from a head-and-shoulders portrait to images the same size as the subject (a 1:1 reproduction). The term "macro-photography", applies to pictures larger than subject size, up to a magnification of about 10 times (x 10). For larger magnification than this the subject will usually have to be photographed through a microscope, a technique called "photo-micrography". The main technical problems in close-up and macro-photography are the difficulty of focusing a sharp image and the very shallow depth of field which obtains under these conditions. There are also problems of lighting and extra exposure. The pictures, right, illustrate by how much you have to increase the lens-to-film distance when you come very close to your subject. Beyond 1:1 reproduction the lens must be closer to the subject than it is to the film, the opposite of normal working conditions.
See: Exposure for close-up/Lighting for close-up

1:05. Here the image on film is half subject size. Distance ratios of film to lens and lens to subject are shown below.

Nikon, 55 mm macro, Ektachrome-X, 1/2 sec f11

1:1. In this picture the image on the film was the same size as the subject. Using bellows the lens was twice its focal length from both film and subject.

Nikon, 55 mm macro with bellows, Ektachrome-X, 1 sec f11

1:3. This image is three times subject size. With the bellows at almost maximum extension the lens is much nearer the subject than the film.

Nikon, 55 mm macro with bellows, Ektachrome-X, 4 secs f11

Choosing subjects

Macrophotography is often associated with studio work under artificial light, but you will discover that many day-to-day objects, which may be unappealing from a normal viewpoint, produce the most interesting pictures. You could profitably expose a whole film on half a cabbage. Examine the color, pattern and texture of small areas of your surroundings. The picture, right, is of a small patch of frozen water found literally at the photographer's feet.

Pentax K2, 50 mm macro, Ektachrome-X, 1/60 sec f5.6

Long lens with bellows

To get maximum image magnification you should use a short-focus lens with the bellows fully extended. However, this means working very close to the subject. If you use a long-focus lens with bellows, magnification is not quite so great, but you are able to work further away which makes lighting the subject much easier. The eye, left, was taken with a long-focus lens because a short-focus lens would not permit even lighting.

Hasselblad, 250 mm, High Speed Ektachrome, 1/60 sec f16

Photographing flowers

Flowers make good subjects for close-ups provided you can overcome the problems of shallow depth of field and the likelihood that they may move. This picture was taken in a garden using a card as background. Fill-in light was provided by another card used as a reflector.

Cards as backgrounds and reflectors. Background card doubles up as a windshield for the flowers, left. Another white card reflects sunlight into the shadows for extra detail.

Pentax 6 x 7, 105 mm, Ektachrome-X, 1/30 sec f16

Measuring exposure

It is much easier to measure exposure for close-up and macro-photography if your camera has a built-in meter. This solves the problems of measuring light from small areas and allowing extra exposure for extension rings or bellows. Using a separate meter you may have to measure from a larger area, or from a substitute subject under the same lighting. It may even be necessary to attach an accessory probe, below. The exposure shown on the meter must be increased whenever the subject is closer than about five times the focal length of the lens. Work out the magnification (image height divided by subject height), add one, and square the result. This is the factor by which you must multiply exposure time, so for an image the same size as the subject give four times the normal exposure.

Using a fiber optic device. Some meters allow a plug-in probe like this fiber optic device which pipes light to the cell. The probe is so small that it can be brought close in without casting shadows.

Controlling local light

Museums are full of interesting detail for close-up photography. If you cannot carry a light source around with you use a pocket mirror to redirect existing light. This stone head only ¾ in (20 mm) high, below, was fixed to a stone wall. It was lit by sunlight through a window at its rear, which gave only a silhouette effect. Direct light was blocked off from the head with a sheet of card and a mirror was propped up reflecting the sun to give hard side light. A page torn from a notebook was used to lighten shadows on the right.

Hasselblad, 80 mm with extension tubes, Plus-X, 1/30 sec f5.6

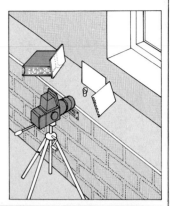

Photographing coins and medals

The best way to photograph a coin is to lay it out on a contrasting plain background, with the camera mounted above it. If you use very oblique, soft light from a flood you will get depth in most of the surface detail. To exaggerate the design use a spotlight, adding a white card reflector to relieve the deepest shadows.

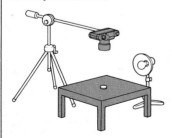

Lighting for coins and medals. The medal, right, was lit by a floodlamp positioned just above the table surface, and about 4 ft (1.2 m) away, above. A lens hood keeps direct light away from the lens.

Pentax, 50 mm macro, Plus-X, 1 sec f11

Shadowless backgrounds

Plain, shadowless backgrounds are excellent for factual records of small subjects. Place the subject on a light box, either a transparency viewing box or a "box" improvised from a sheet of glass, white card reflector and floodlamp, below. Mask off the glass just outside the picture area to reduce flare. Subjects with very open structures can be lit by reflecting the lightbox illumination back with white card positioned close to the camera.

Reversing a tripod. Some tripods allow the center column to be reversed. You can then place the subject on a table or the floor and support the camera above it.

Ring flash

A ring electronic flash gives complete frontal lighting. This is ideal for recording detail within a complex enclosed subject which would throw complicated and confusing shadows if it were lit with any kind of side light. Used very close to the subject a ring flash will form soft, central shadows as the light begins to reach the subject obliquely from all round the lens.

Pentax, 135 mm, Plus-X, 1/60 sec f22

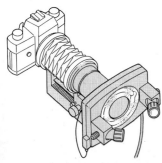

Photographing a botanical specimen. The plant, below, was set up on a light box. Additional lighting came from a diffused floodlight directed from above.

Hasselblad, 150 mm with extension tubes, Tri-X, 1/15 sec f32

Endoscopes

An endoscope allows you to put a camera lens into places where there would normally be insufficient space. It is a tube containing a series of small lenses which relay the view from the end of the tube back up to the camera body. The endoscope, therefore, replaces the normal camera lens, giving an image similar to that seen through a periscope. You can use it for taking pictures inside complex machinery or intricate electronic equipment.

Modelscope. The endoscope, above, has a right angle mirror near its tip. Designed for photographing models of buildings or exhibition displays, it gives a viewpoint equivalent to scaled down eye level.

Photography with a microscope

A huge variety of everyday substances can be photographed through a microscope. With comparatively little equipment you can transform the contents of an average dustpan into a sequence of colorful photographs. In addition to a good camera all you need is a basic microscope-camera adaptor, a microscope lamp and a few accessories such as tweezers and glass slides. A single lens reflex with through-the-lens metering is ideal. You can get special exposure meters if your camera does not have a through-the-lens meter, but this is laborious. If you use a direct vison camera, you will need a separate focusing eyepiece.

Microscope and microscope lamp.
For photomicrography a simple microscope and a microscope lamp are quite adequate. The principal components of both are shown, right.

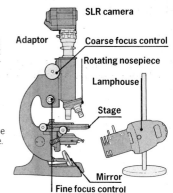

SLR camera
Adaptor
Coarse focus control
Rotating nosepiece
Lamphouse
Stage
Mirror
Fine focus control

Foam rubber: magnification x25

Hydra (stained): magnification x25

Human ileum, small intestine (stained): magnification x40

Hypo crystals: magnification x25 (polarized light)

Vorticella, unicellular pond animals (stained): magnification x100

Coin detail: magnification x25

Euglena, primitive plant-like creatures (stained): magnification x100

Paper fibers: magnification x25

Movie film, crowd scene detail: magnification x100

Setting up a photomicrograph

Position your camera over the microscope's eyepiece using either an adaptor or a camera stand. Direct the lamp beam on to the center of the mirror. For low magnifications, less than x60, remove the sub-stage condenser if you can and use the concave side of the mirror. Adjust the mirror angle to direct the beam on to the subject. This allows a wide field of view to be evenly illuminated. If you have a through-the-lens system the best way of working is to attach your camera body to the microscope. However, if your meter only works with the lens attached to the camera body, focus the lens on infinity, set the widest aperture and then attach the camera to the microscope. Whichever method you adopt, focus with the microscope focusing controls – not with the camera controls – and adjust exposure by changing the shutter speed, not the lens aperture. For your first test exposures follow the camera manufacturer's instructions and make a record for each frame of the ASA film speed, the shutter speed, the type of subject and the light source. Compare your record with each test result and make a short table which relates the system of illumination to the correct film speed setting required, as determined by the first test. With experience you should be able, by using this table, to obtain about 85 percent of frames which are acceptable first time.

Mounted insect's wing: magnification x25

Lighting and focusing.
1. Direct the microscope lamp from a distance of about 10 ins (25 cm) on to the center of the flat surface of the mirror. The image above is unevenly lit. Adjust the mirror until the field of view is evenly illuminated.

2. Hold a pencil at the lamp condenser and focus the sub-stage condenser to obtain a sharp silhouette image of the pencil on the specimen. The sub-stage condenser is correctly set at this point.

3. Stop the sub-stage iris down slowly until the field of view just begins to darken. Open the lamp iris until it reveals the entire field. The picture, above, was shot before the lamp iris was sufficiently open.

Using polarized light

In some specimens polarized light reveals otherwise invisible structures in brilliant color. Compare the picture of a section of rock photographed in ordinary light, below, with the same section, right, in which the light is polarized. Magnification is x25, right, and x10, below. You need two polarizing filters; one between the light source and the stage, and the other between the eyepiece and the film. Set up the illumination so that there is a clear bright field and rotate one filter until the field becomes dark. You then insert the specimen. **See:** Polarizing filters

Bright field

A bright field is created by transmitting light on to the subject from below, using the mirror unless your microscope has a built-in lamp. A bright field is suitable for translucent and transparent specimens, but not for thick or opaque subjects. The specimen may be a specially cut thin section, like the reproductive body of the fern, below, or else a three-dimensional subject.

Setting up a bright field.
The light from the lamp is condensed, above, by the concave mirror. It passes through the specimen and fills the objective aperture.

Dark field

When you look at certain specimens with bright field illumination it is difficult to see them clearly. Specimens of this kind, microforms of aquatic life, for example, will be seen more clearly with dark field illumination. This is created by shining the beam from the lamp obliquely across the specimen, usually from above the stage. Like the copper salts, below, the specimen will glow brightly against a dark background. Provided the magnification is restricted to x60 or less, the effect is striking and easily achieved.

Setting up a dark field.
Bring the lamp as close to the microscope as possible and arrange it so that its beam illuminates the specimen from a high angle. Turn the mirror so that light does not enter the objective from directly below.

Flash techniques in photomicrography

Aquatic and other living subjects tend to propel themselves with surprising speed out of the field of view. To capture their images on film you must use a flash of very short duration. Flash is also useful for arresting movement when a structure moves relatively quickly on an otherwise slow moving animal. The photograph, right, shows the fast-moving, hair-like antennae and legs of glycimerus, a shrimp.

Adapting a flashgun. You can modify an electronic flash head to incorporate a low voltage tungsten filament bulb. This makes alignment of the flash much easier. Use a shade to direct the flash at the mirror.

Essential equipment

Image quality in photo-micrography depends primarily on the quality of the objective (microscope lens). For photography the instrument should have a focusing sub-stage condenser and iris. With a removable sub-stage condenser and a mirror with one flat and one concave face you can achieve a wide range of magnifications. It is also useful to have several objectives of different strengths. Finally, the illumination source is important; it must have a high intensity lamp and be fitted with a focusing condenser and iris.

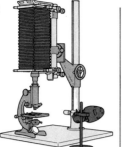

Adapting an enlarger. The diagram, above, shows how you can use an enlarger baseboard and column to support a large format camera over a microscope. You need to bolt a plate on to the enlarger head bracket after removing the enlarger head. You then fix the camera to this plate using the normal camera retaining screw. A special lens panel fitted with a light trap instead of a lens must be fitted to the camera to make sure that no stray light reaches the film. The camera can be raised and lowered on the enlarger column, so extra magnification can be achieved with extended bellows, above.

Fitting camera to microscope.
A camera body is fitted to a microscope with a special adaptor, above. It is best to get an adaptor which will take macro extension tubes.

Calculating magnification

In photography the image seen through the eyepiece is projected on to the film. The degree of magnification of the image on film is called the projected magnification (M_p), and is given by the equation:

$$M_p = \frac{objective}{power} \times \frac{eyepiece}{power} \times \frac{d}{250}$$

The projected distance (d), above, is the distance (in mm) from the eyepiece to the film plane. For a x10 objective, a x6 eyepiece and a projected distance of 100 mm the M_p will be x24. When a print is made the magnification on the print is referred to as the total magnification (M_t) which is the product of the magnification on the negative and the enlarging factor (E): $M_t = (M_p) \times (E)$

So if an image at x25 on a negative is enlarged five

times, the total magnification (M_t) on the final print will be x125. From this you can determine the actual size of the structures in your pictures:

$$Actual\ size = \frac{image\ size}{magnification}$$

Numerical aperture
All modern microscope objectives are engraved with their numerical aperture (NA), which is used as a measure of the ability of an objective to resolve fine detail. A simple rule to remember is that total magnification on a print or transparency should not exceed 1000 times the NA of the objective. For example, a x10 objective has an NA of about 0.25, so the maximum possible magnification is x250.

Collecting subjects

You can buy ready prepared micro-specimens, but it is much more interesting to prepare your own. You can collect most microforms of biological material quite easily, particularly aquatic and insect life. You can also prepare slides of crystal growth for photographing by polarized light. It is much easier to cut sections of soft plant tissues than it is to prepare thin sections of rock, but the results you get from the latter are well worthwhile.

Buying prepared slides.
You can buy a very wide range of prepared sections and other micro-specimens such as the stained paramecium (x100), pictured below.

Storing slides. Store your prepared micro-specimens in a micro-slide box, left. Slides are laid out in trays with projecting edges so that each tray can rest on the one below without damaging the specimens.

Preparing your own specimens

Micro-crystals are easy to prepare. Dissolve about 4 grams of sodium thiosulfate photographic fixer, in 10 milliliters of warm water in a test tube. Place one drop of the solution in the center of a glass slide. If you warm it gently, the solution will evaporate and crystals will begin to form. Observe and photograph using the polarizing set-up (p 111). Another subject which is easy to prepare is microscopic pond life. Fill a jar with stagnant water and use a small pipette to transfer single drops to glass slides. Use dark-field illumination.

Crystals. The micro-crystals, above, are formed when a solution of sodium thiosulfate is allowed to evaporate. Details of the crystals can only be seen when the slide is viewed between crossed polarizing filters. Other chemical substances produce different crystal forms.

Making a section. The hand microtome, above, is fixed to the edge of a table so that you have both hands free to cut the section. The specimen is held in place by embedding it in wax.

Mounting a section. When a thin section has been cut it can be mounted on a glass slide. You make a permanent slide by covering the section with a cover glass and cementing it in place with mounting medium.

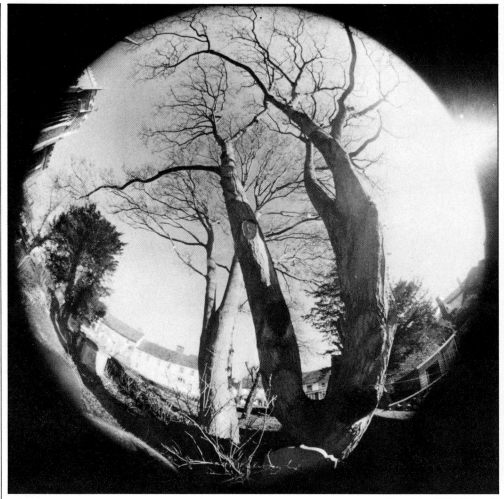

Nikon, 6 mm, Tri-X, 1/125 sec f11

Fisheye images

A fisheye is an extreme type of wide-angle lens, usually designed for 35 mm format cameras, although a few are made for 2¼ ins sq (6 x 6 cm), or movie cameras. The widest angle fisheyes form a circular image in the normal picture area, above. Others encompass the full rectangular format, right. Most fisheye lenses consist of ten or more elements, the front ones having a characteristic exaggerated diameter. The most distinguishing feature of these lenses is the way only radial lines are reproduced straight; all other straight lines in the subject appear curved, an effect which is particularly startling in enclosed spaces. However, the optics are so unlike human vision that the lens tends to dominate every subject and the distortion can become monotonous.
See: Lenses: varieties and functions/Lens attachments

Pentax Spotmatic, 18 mm, Tri-X, 1/125 sec f11

Applications

The most important characteristics of an ultra wide-angle lens are its wide angle of view, its great depth of field, and its degree of image distortion. The picture, below opposite, was taken with an 18 mm lens and the one, above right, with a 15 mm lens. Results are very different because the 15 mm lens is designed to give "correct" representation of vertical and horizontal lines. Even so, parts of the picture at the edges and corners tend to be elongated in shape. A corrected ultra wide-angle only gives a "correct" image if the lens and subject planes are parallel, right. The steep diminution of scale between foreground and background objects makes small interiors seem vast. The figures, near right, for example, are standing only six ft (1.8 m) apart. You can also make lines in the subject converge steeply or curve into new shapes by careful choice of viewpoint. The portrait, far right, shows the typical distortion at small lens-to-subject distances.

All pictures: Pentax K2, 15 mm, Tri-X, various exposures.

Types of ultra wide-angle

The shorter the focal length of a lens the greater is its angle of view. However, the shorter the lens the more difficult and expensive becomes the correction of optical errors – particularly curvature of line. The shortest "corrected" ultra wide-angle for 35 mm cameras is about 16 mm. The fisheye design disregards the need for linear correction and allows 35 mm format lenses down to about 6 mm (a 220° angle of view).

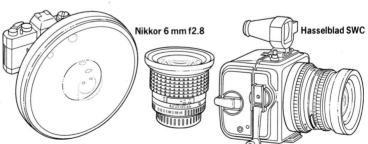

Nikkor 6 mm f2.8

SMC Pentax 20 mm f 4

Hasselblad SWC

Fisheyes. The shape and performance of fisheye lenses impose special constraints. Filter attachments may project into the picture; the photographer may even find his own hands and feet have intruded. The front elements of wide aperture extreme fisheyes are large and heavy. There is little internal space for diaphragm or focusing mechanism.

Wide-angles. Linearly corrected ultra wide-angle lenses for 35 mm format cameras range in focal length from about 21 mm down to 15 mm. Because the latter is approaching the extreme limits of design maximum aperture may be limited to about f8. Good quality lenses of this type are very expensive.

Camera housing. The ultra wide-angle lens of short focal length would normally need positioning close to the film unless designed as an inverted telephoto, which artificially extends the lens/film distance. This design allows space for a single lens reflex mirror. Some models have minimal depth, and abandon a reflex system for a direct vision finder.

Applications

Next to the standard lens the wide-angle is probably the most useful lens to buy. It enables you to include the whole of a cramped subject from a close viewpoint, a particularly useful facility for interiors. It provides greater depth of field for the same "f" number than lenses of longer focal length. And it offers wonderful opportunities to exaggerate depth within a picture and manipulate scale – even to the point of distortion and caricature. A wide-angle lens can emphasize space and emptiness in a landscape, and convey involvement and closeness within a group of people. Technically a wide-angle design is a short focus lens with exceptional covering power. A standard lens for a 35 mm format camera cannot for example be used on a 2¼ ins sq model as a wide-angle – the picture edges would fade off into a circular vignette. A wide-angle lens must therefore be specially designed, including features which allow sufficient rear space for a SLR mirror system, even though its short focal length would normally dictate positioning close to the film.

Vivitar 28 mm f2.5

Increasing the angle of view

A major advantage of a wide-angle lens is its ability to include more of the subject from a given position than can a normal or long lens. This means that subjects the eye would normally scan (notably interiors and landscapes) often look less cramped and are therefore more accurately portrayed by a wide-angle than by a normal lens. The shot, immediately below, was taken with a normal lens (180 mm on a 4 x 5 ins view camera). Viewpoint therefore had to be chosen with extreme care to give an impression of the whole lobby when only a part could be included. The picture, bottom, was taken with a 65 mm wide-angle from the same viewpoint.

MPP, 180 mm and 65 mm, Plus-X, 1 sec f22

Increasing depth of field

A wide-angle offers greater depth of field than the longer, normal angle lens. This is an advantage when great front-to-back sharpness is required, or the lens is focused by distance scale alone. It is sometimes a disadvantage when you wish to focus critically or selectively. A wide-angle lens was chosen for this landscape to give impact and emphasis to the foreground, and stress the remoteness and isolation of the houses. The exaggeration of scale – diminution of rock size from foreground to background – is mainly the result of the extreme closeness of the nearest rocks. Only a wide-angle would allow their inclusion together with the houses, and render the whole scene sharp throughout.

Pentax Spotmatic, 28 mm, HP4, 1/125 sec f16

Increasing the illusion of depth

Since the wide-angle includes parts of the subject very close at hand, dramatic scale values are incurred which give an extra illusion of depth. This is particularly apparent in subjects with strong linear elements, providing you choose your viewpoint with this in mind. A wide-angle lens and low viewpoint were used for this shot. Sufficient detailed information is provided from the nearest buildings to describe the whole. Depth of field extends almost through-out the picture.

Hasselblad, 40 mm, Tri-X, 1/250 sec f16

Manipulating the picture elements

Small changes of view-point make major changes to the relation-ship of foreground/background objects when using a wide-angle lens. People close at hand loom out of the picture and quite small detail becomes enlarged and prominent. Consider your foreground with great care. For the picture below, the photographer moved in close up with a wide-angle lens to give a sense of intimacy, an impression that the viewer was right there within the group. Tight cropping further helps this feeling.

Leicaflex, 21 mm, Tri-X, 1/250 sec f11

Distortion effects

Shape distortion to the extent of caricature can be used intentionally as a major element in a picture. The subject needs its strong ele-ments placed near the edges of the frame, and shape change can be further emphasized by a plain background. The portrait below intention-ally uses distortion for effect, to exaggerate the figure shape, contrast the head with the body and emphasize the costume. In a restricted area the wide-angle may be your only means of getting a full figure shot.

Olympus OM-1, 21 mm, Tri-X, 1/60 sec f16 with flash

Applications

A normal or standard camera lens is so-called because the image it produces relates most closely to normal vision. It is not easy to draw parallels between eye and camera, because of the eye's poor periphery vision, its constant scanning, and absence of a hard edged "frame." However, the size relationship of items at different distances within a photograph are less at variance with normal eye vision with this lens than when recorded by wide-angle or long-focus lenses. The normal lens usually has the widest aperture of the series and is slightly less expensive than lenses of other focal lengths.

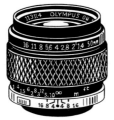

Olympus 50 mm f1.4

Construction of the normal lens. As the prime lens of any camera system the normal lens is likely to have the most sophisticated means of correcting aberrations, and so offer the widest maximum aperture of the range. This is likely to be between f1.4 and f2. Angle of view is 43° or 47° (55 mm or 50 mm lenses on standard 24 x 36 mm format). The lens is usually constructed from 6, 7 or 8 elements.

Normal angle of view

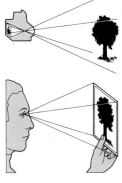

Because of the indeterminate edges to the eye's field of view we cannot categorically claim to see with a 47° angle of view. But a scene photographed with a normal lens, then enlarged to about 10 ins (25 cm) wide and viewed at normal reading distance of about 12 ins (30 cm), closely re-creates the appearance of original size and correct distance between objects, as in the diagram, right. The same effect would occur with wide-angle and long-focus lenses, too, if enlargements were each examined from the "correct" distance, that is to say focal length multiplied by degree of enlargement.

Matching size and distance to reality. An 80 mm lens was used for the picture, below. It was then enlarged by a factor of 2.5 times, and if you view the page from 2.5 x 80 mm, which is 200 mm or 8 ins, the size relationships of figure to houses closely match reality.

Converters and lens sets

If your camera accepts interchangeable lenses and you want to acquire a wide-angle and long-focus as well as your normal lens the best purchases are undoubtedly other focal lengths by the same maker. This will ensure that the same standards of acceptable quality are adopted, and the glasses and lens coating match others in the series, giving the same color bias (if any). All external controls will also follow the same pattern. Cheap lens brands tend to adopt lower standards of image quality, but if you want to save money it is possible to buy a "converter" supplementary lens system. This usually attaches to the front of a normal lens and may take one of two forms, converting it either to telephoto or to wide-angle/fisheye. Some telephoto converters are designed to fit between lens and camera. Since aberration corrections built into the normal lens are inevitably compromised by this conversion, image quality may suffer. Sharpness toward the corners of the picture will show most deterioration, and image contrast may be reduced. There is often considerable change of "f" number, a telephoto converter reducing the light by two or more stops. An alternative if you are buying a new camera is a zoom lens which includes the normal focal length within its range. Quality varies – and it is best to buy the same make as the camera. Zoom quality and focal length range are improved year by year. You cannot, however, expect a very wide maximum aperture, and the lens is larger and more expensive than a normal lens.

Advantages of aperture

The limiting factor to the maximum permissible aperture a lens can offer is image deterioration. The design must therefore maintain the quality standard set for the whole lens/camera system, yet produce an impressively wide maximum aperture. At this end of the "f" number scale small changes in figures produce significant differences in illumination. Relative to f2.8, f2 gives twice, f1.4 four times, and f1.1 six times the image brightness. In practical terms this means that you need only half the amount of flash or tungsten lighting equipment for an f1.4 as for an f2 lens. Similarly, focusing an SLR camera is much easier under dim lighting conditions, like those above, when using the wider aperture lens. This lens also allows exceptionally shallow depth of field. Sometimes the ability to halve or quarter a time exposure by changing to your widest aperture lens is the only way to make a shot possible.

Large aperture for low light levels. The picture, above, taken in an extremely dimly-lit restaurant, shows the light-gathering properties at full aperture of a typical large aperture normal lens. Shallow depth of field made focusing very critical. Uprating the film gave a shutter speed of 1/15 second – the extreme limit for handholding the camera without support.
See: Depth of field/Shallow depth of field/Selective focusing/Uprating film/ Holding the camera

Pentax K2, 50 mm, Tri-X rated at 1600 ASA, 1/15 sec f1.2

Applications

A long-focus or tele-photo lens, typically 135 mm for the 35 mm camera, completes the set of basic lenses. Since it has a narrower angle of view than a normal lens, the view through a tele-photo is similar to that through a low-powered telescope. Long lenses are especially useful in two situations: first, when space is to be compressed and objects massed one against the other with little variation in scale; and, second, when you need to fill the frame but cannot get suf-ficiently close to the sub-ject. Remember that cam-era shake is much more pronounced through a long lens. A good rule is that the slowest reasonably safe shutter speed for hand-held shots is the nearest fraction of a sec-ond to the focal length of the lens in millimeters. For example, 1/125 sec-ond for a 135 mm lens, or 1/250 for a 200 mm lens.

Depth of field is also shallower than with a normal lens, set to the same "f" number. The widest aperture offered by a long-focus lens is often one or more stops smaller than a normal lens offers – a factor that can be a handicap in poor lighting conditions. **See:** Lenses: varieties and functions/Depth of field/Changing lenses

Pentax 135 mm f3.5

Compressing space

The long-focus lens per-mits you to enlarge parts of distant landscapes to fill the frame. But as can be seen in the picture, right, it also compresses the apparent depth of the scene. This is because its distant viewpoint dim-inishes differences in scale between fore-ground, mid-distance and and background. Haze and other light-scattering effects also tend to re-duce image contrast overall, and limit the tone variations that normally give atmospheric per-spective. Of course, this compression can be used creatively to isolate inter-esting patterns. In this case the camera position was carefully chosen to place the various ele-ments of the landscape into horizontal bands, like a geological model. Note how each band contains its own items of interest – the shimmer-ing sea, the shadowy cot-tage and the shapes of the mountains beyond. **See:** Changing lenses

Leicaflex, 135 mm, FP4, 1/60 sec f16

Massing effects

With a long-focus lens you can photograph massed objects some distance away. The compression of space and lack of any strong variation of scale gives a cramped appearance to the crowd, below, and this is taken further by filling the frame completely. For all we know this was quite a small group, but because it bleeds off all four edges we can imagine it continuing well outside the frame. The same massing effect occurs in long-focus pictures of, say, football games where the players appear almost on top of each other, although they are really spread well apart. Similarly it can be used to emphasize claustrophobic subjects, such as the density of traffic on a highway.

Pentax, 135 mm, Plus-X, 1/250 sec f4

Filling the frame

A large, bold image can emphasize the point you want to make in a picture. Simplicity is best achieved by filling the frame completely with the subject and excluding the unwanted peripheral elements. For pictures of animals or candid shots of people the very presence of the photographer is likely to influence the subject unless the photographer can move out of the way and change to a long lens. The rhinoceros, below, was taken from 20 ft (6 m) away. The foreground contained a number of posts and railings, but the narrow angle of view of this lens enabled them to be excluded from the picture. The long lens is a useful aid to composition. Its angle of view is so different to that of the eye, that it teaches you to see patterns and shapes within a new, much smaller frame.
See: Selective focusing/ Depth of field
Nikon, 135 mm, Tri-X, 1/250 f11

Portraits

In the early days of photography all long-focus lenses were known as "portrait" lenses. This is because filling the frame from a distance is more flattering to the face, particularly the nose and ears. The distance of the camera from the model helps to reduce self-consciousness. The two pictures, right and far right, illustrate how camera distance changes the apparent shape of a face. The photograph, right, was taken from a position about 12 ins (30 cm) from the model's face, using a 21 mm wide-angle lens. The hair, which is nearly twice as far from the camera as the nose, appears to be receding; the nose is exaggerated in size and the whole face looms into the frame. For the picture, far right, the camera was moved away until it was about 7 ft (2 m) from the girl. A 135 mm lens replaced the wide-angle and this restored the image size. The model's hair is now only one twelfth further away from the camera than her nose and there is consequently much less distortion of scale. The head reverts to its normal shape and depth of field is reduced by the long-focus lens. The rule is to keep well away if you wish to flatter your model.

Both pictures:
Leicaflex, Plus-X, 1/125 sec f11

Applications

Extra long-focus lenses for 35 mm cameras range up to 800 or 1000 mm (31 or 40 ins) in focal length. They are effectively high quality telescopes, which give an angle of view of between 2° and 3° This type of lens is often used to enlarge detail from a great distance when the subject is otherwise inaccessible. The technical limitations of the long-focus lens increase with focal length. Risk of camera shake in hand-held shots limits you to 1/500 or 1/1000 second, depending upon lens design. Depth of field is extremely shallow; maximum aperture is usually f5.6 or f8.

Telephoto design. Almost all extra long-focus lenses are of telephoto design. This means that the distance between lens and film is less than the focal length – typically 60 per cent. Despite this, lenses of 500 mm or more are extremely bulky and heavy. Maximum aperture is kept small, to minimize aberrations and reduce what would otherwise be excessive lens diameter.

Mirror design. The folded up optics of the mirror type long-focus lens makes a shorter lens than the telephoto, and the mirrors are also much lighter than their glass equivalents. The whole unit is much easier to handle and hold steady, but the design does not allow stopping down by aperture.

Mirror lens effects

At first sight the image given by a mirror lens appears identical to that of a telephoto lens of the same focal length. But any small bright highlight rendered out of focus does not spread into the usual disk of light; instead it forms a characteristic ring shape, below. This is a silhouette of the front lens element with its centrally placed mirror. Inability to stop a mirror lens down means you are unable to avoid this strange effect by increasing depth of field.
See: Pinpoint light patterns

Nikon, 500 mm mirror, Tri-X, 1/1000 sec f8

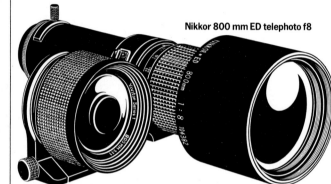

Nikkor 800 mm ED telephoto f8

Vivitar 800 mm mirror (solid catadioptric) f11

Magnification

For distant subjects the size of image is proportional to the focal length of the lens. This means that when you change from a normal 50 mm lens to a 500 mm extra long-focus you increase an image to ten times its former height. 1000 mm doubles this again. Equally, the effect of camera shake on the image is increased ten or twenty fold. As extra long-focus lenses are generally used at great distances from the subject, atmospheric conditions – mist, dust, rain, mirage effects – have a considerable effect on image quality and contrast. Any air pollution will be much denser than it would be if you were shooting from a closer viewpoint to get the same size image with a normal lens. By increasing development slightly you can improve the image contrast of extreme long lens negatives. It is not advisable to use these lenses to take photographs through windows. However clean and unscratched the glass may appear its presence is sufficient to ruin image quality.

Capturing detail with extreme long-focus lenses. The top picture of Buckingham Palace, London was taken from the top of a monument about 150 yds (137 m) away, using a 50 mm lens. For the lower picture, taken from the same position, a 500 mm lens was used. Image height is ten times as great.

Nikon, Tri-X; (top) 1/125 sec f16; (above) 1/500 sec f5.6

Lens supports

Almost all extra long-focus lenses
need some form of firm support to
avoid shake. Most lenses of
500 mm or longer have a screw
thread in the lens barrel for direct
tripod mounting; the camera body
is therefore supported by the lens,
right. You need a really firm,
braced tripod. In windy conditions
you can make this more stable by
leaning sandbags against the legs
or suspending them from the
bracing struts. Some 1000 mm
lenses have a further support
socket near the lens hood. To this
you can attach a monopod to a
tripod foot, right, once the lens is
set up and aimed.

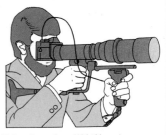

Follow-focus lens. With this system you
focus by squeezing a spring-loaded
pistol grip instead of rotating the lens
barrel. A detachable shoulder harness
further aids steadiness.

Applications

The zoom, or variable focal length lens offers several technical and visual advantages. To begin with you can just take out one lens instead of two or three of varying focal lengths. And within the limits of its zoom range you can continuously vary the size of the image – enlarging or reducing it until the right parts of the subject exactly fill the frame. This is particularly useful in sports and journalistic photography where some small but important action may suddenly take place any distance from the camera. Secondly you can zoom the lens while the open shutter is actually making the exposure – either keeping the

Nikkor-Auto 43-86 mm f3.5

camera itself still or panning. This gives a whole variety of interesting streaky effects.
See: Zoom lens construction

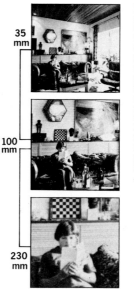

35 mm

100 mm

230 mm

Lens coverage. As technology advances, more and more zoom lenses are coming on to the market. At present most are designed for 35 mm and smaller format cameras. Common focal length ranges are from long to very long, from wide-angle to normal, or a modest range either side of normal. The longer ranges which are available, such as 35 mm to 100 mm and 100 mm to 230 mm are especially useful. With two such lenses you can cover the whole range from wide-angle to long.

Steady zoom

For this technique you need a slow film and/or dim lighting conditions so that by stopping down you can expose the film for about 1/4 sec. Have the camera on a tripod and focus the subject at the zoom's longest focus setting. Then as soon as the shutter is heard to open move the zoom control throughout its range. Make sure the center of interest is composed exactly in the center of the frame. This will be the only really sharp part of the picture

and all lines will radiate from this zone. If possible try to choose a complex background with plenty of points of light – these will form the most dramatic streaks.
The three children in this shot, screaming on cue, appear to be hurtling toward the camera at breakneck speed. The streaks in the top half of the picture come from light filtering through a row of trees.

Pentax Spotmatic, 85-210 mm zoom, FP4, 1/2 sec f16

Zoom and pan

Complex streaking effects occur when zooming is combined with panning during the exposure. The moving object which is being panned records with lines radiating from its center, while the background has oblique horizontal streaks. The technique needed is similar to that required for straight zooming-during-exposure except that zooming fast at shutter speeds of 1/15 – 1/30 sec is likely to be more convenient,

because such speeds allow the camera to be panned hand-held. Be prepared to take numerous versions of your picture.
The technique was used at a stock-car meeting to capture the prevailing air of excitement and confusion. The light streaks radiate from a point outside the picture area.

Pentax Spotmatic, 85-210 mm zoom, FP4, 1/2 sec f16

Stepped zoom

Several exposures made on the same piece of film using a zoom lens at different, equally spaced focal length settings produce a set of super-imposed images. Use a plain background and remember that the pictures expand from the center point of the frame. A meter reading from the face suggested 1 sec at f22. The three superimposed exposures were each ½ second.
See: Determining exposure

Pentax Spotmatic, 85-210 mm zoom, FP4, ½ sec f16

Projected zoom

If you project a transparency using a zoom lens, you get a similar effect to stepped zoom. The image on the screen is copied using an ordinary camera, giving three super-imposed exposures. The projected picture edges also enlarge in steps, so that borders overlap images.
See: Projected images

Nikkormat, 55 mm, FP4, 1/4 sec x 3, f16

Pre-marking on a screen
The projection technique enables the juxtaposition of images at various zoom settings to be tried out and lightly pre-marked on the screen.

Zoom and tilt

Under studio conditions the almost accidental effects achieved by panning on a moving subject can be controlled to create images to order, and the same effect can be reproduced again and again. Zooming and tilting the camera at the same time enables static objects to be recorded with comet-like blur trails giving an illusion of movement. The picture began as a large, high contrast negative carrying white lettering on a black background. It was set up on a vertical light box facing a camera with extension bellows and zoom lens, and mounted on a firm tripod. Next the amount of upward camera tilt needed to shift the lettering downward from near the top to below the bottom of the frame was checked and a stop device fitted to prevent movement beyond this point. Measured exposure was 1/2 sec at f16. The lettering was aligned near the top of the frame, the shutter opened on "B" and after 1/2 sec the camera tilted slowly upward over a period of two seconds to the stop position. During this movement the lens was zoomed evenly to its maximum focal length.
See: Simulating movement

Pentax Spotmatic, 85-210 mm zoom, Tri-X, 1/2 sec f16

1. The negative was taped along all four edges to ensure flatness, and the surrounding areas of the light-box masked with black paper to avoid light leaks which would have degraded the image.

2. In order to leave your right hand free to zoom the lens, hold your cable release between thumb and index finger. You can then just operate the tripod tilt head with your little finger.

3. The principal problem was to synchronize all three operations: firing the shutter, tilting and zooming. A firm grip on the lens is essential to achieve smooth, even and gradual zoom.

Applications

Attaching a shift lens to an SLR camera gives it rising or cross front movements like those found on a view camera. The unit consists of a wide-angle lens (28 or 35 mm) on a mount which can be racked left or right of center. You can rotate the mount 90° to convert this to an upward or downward shift. With an ordinary lens you may have to tilt the whole camera to include the top of a tall subject from ground level, and this produces converging verticals, near right. With a shift lens you hold the camera with the back vertical, then rack the lens upward. This enables you to get the verticals parallel, far right.
See: Camera movements

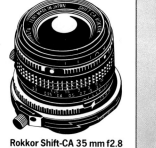

Rokkor Shift-CA 35 mm f2.8

Nikon, PC-Nikkor 35 mm,
Tri-X, 1/125 sec f11

Side shift

Conventional use of the shift lens is for large architectural subjects, but it can be applied on a smaller scale to produce distortions in close-up photographs, right. The top picture was taken with the shift lens centered in the mount and fitted with a x3 close-up lens. For the picture, lower right, the lens was displaced to the left; notice the severe distortion on the left hand side of the picture. In photographs of interiors containing mirrors or other reflective surfaces you sometimes get an unwanted reflection of the camera itself. With a shift lens you can set up the camera to one side of your original viewpoint with the film plane parallel to the reflective surface. Re-center the image by using the shift movement horizontally. The camera will no longer appear in the field of view. The range of movement in lenses of this type is relatively limited.

Both pictures: Nikon F, 35 mm shift lens with x3 close-up lens, Tri-X, 1/125 sec f16

Anamorphic attachments

Anamorphic lens attachments are made primarily for wide screen movie photography. They compress a wide angle of view on to standard width film. If projected through a normal lens, the image would appear distorted, but an anamorphic attachment fitted to the projector produces the wide screen effect familiar to movie goers. If you use an anamorphic attachment with a stills camera, you can create interesting distortions, below center and below right. The image size given by your normal lens is unaffected in one dimension, but compressed to half its normal width in the other.

Using an anamorphic attachment. To avoid vignetting the image, an anamorphic attachment must have a larger diameter than the camera lens, left. You can either hold the attachment in front of the lens, or better still support it on a bracket attached to the tripod. No special increase in exposure is needed, but these attachments do upset the image quality of the main lens, which you should use well stopped down.

Anamorphic effects. For the picture above a normal 80 mm lens was used alone. The anamorphic attachment was added and arranged to compress the image in the horizontal plane, right. Then the attachment was rotated through 90° to compress the image vertically, far right.

Hasselblad, Tri-X, 1/30 sec f16

Effects with an additional lens

You can hold all sorts of optical devices, such as a dental mirror, a spectacle lens, a magnifying glass or a condenser lens, in front of all or part of the scene when you expose a picture. A single lens reflex camera is essential so that the effect of each attachment can be checked. Choose a subject with plenty of contrast and bold, simple shapes, right. Try holding lenses at different distances and at various oblique angles in front of the main lens. Examine carefully the effect of stopping down.

Rolleiflex, HP3, 1/15 sec f11

Fisheye converters

There are two principal kinds of fisheye converters. One is a multi-element lens system which fits over the prime lens of the camera. This produces the same kind of image as a fisheye lens. The other type of fisheye converter, the bird's eye attachment, works on the basis of reflection from a convex mirror. For convenience this is arranged facing the normal camera lens at the end of a clear glass tube. You therefore get a circular fisheye image, right, with the camera and photographer always at its center.
See: Fisheye images

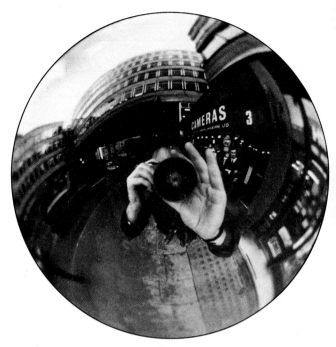

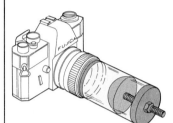

Using a bird's eye attachment. For the picture, right, the camera was pointed at the sky, stopped down to get maximum depth of field and focused halfway between the nearest and furthest points of view.

Nikon F, 50 mm with bird's eye attachment, Tri-X, 1/60 sec f11

Two point focusing

A half lens allows you to image close and distant elements of a subject sharply at the same focus setting in situations where you cannot get sufficient depth of field. Since the attachment consists of a half-circle of glass, it produces a line across the center of the picture. You need to adjust your viewpoint and, if possible, rotate the half lens until this join is disguised by alignment with some suitable part of the subject. The less you stop down the lens the more indistinct the glass edge will appear. You may also have to contend with blurring in the center of the picture where the two halves of the image meet, as in the background behind the postcard, far right. The best way to disguise this is by organizing your viewpoint so that the images merge in an indeterminate area, such as the grass, far right.

Using a half lens. For the picture, above left, it was impossible using a normal lens to focus both on the scene itself and on the post card. A half lens was therefore attached to the camera with the close-up area in the bottom half of the frame. The postcard was moved in front of the half lens until it was in focus, and as shown in the picture, above, it was then possible to resolve the image on the postcard and the scene in the distance at the same time.

Nikon F, 50 mm, Tri-X, 1/125 sec f5.6

Prism lens

Prism lens attachments give you a group of three, four or more multiples of the center part of the picture. They therefore work best with subjects in which the main element is strongly contrasted against a relatively plain background. Always rotate the attachment until the outer images move into the most satisfactory relationship with the center.

Soft focus attachments

Soft focus and diffusion attachments vary enormously. Some produce intentional lens aberrations, others scatter light with a series of molded concentric rings. The principle is to overlay a sharp image with one in which light areas are smudged and spread. A few attachments give overall soft focus; others give greatest effect around the edges. You can achieve soft focus by smearing transparent grease around the edges of a U-V filter to suit a particular composition. You can also control the degree of soft focus by the amount you stop down. Try to arrange the subject in a way that will bring out highlights – edge-lit forms, catchlights in the eyes and so on – as these will glow when shot with a soft focus attachment.

Effects with a soft focus attachment.
The device, above, pushes clear plastic leaves into the light beam entering the lens, to give a diffused vignette. You rotate a ring to move the leaves inward and thereby control the image area affected. By stopping down you can determine whether the transition from a diffused to a sharp image appears gradual or sudden. For the picture, below left, the leaves were part extended; they were extended more fully over the lens, below right.

Both pictures: Pentax, 55 mm, Plus-X, 1/125 sec f6.3

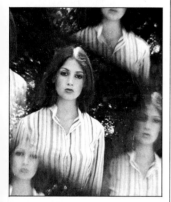

Creating prism effects. A five facet prism lens attachment was held over the lens for the picture, above.
Pentax, 135 mm, Plus-X, 1/125 sec f11

Wide-angle attachment

A wide-angle attachment is designed for use over a normal lens. It forms a cheap, usually inferior, alternative to a real wide-angle lens. When you use such attachments over lenses of other focal lengths you introduce severe aberrations, giving a result similar to that shown below. Experiment with a spectacle lens or a magnifying glass to achieve similar results.

Hasselblad, 150 mm with attachment, Plus-X, 1/125 sec f5.6

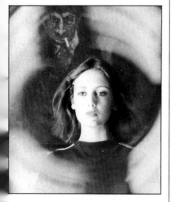

Rotating the prism lens. If you use a prism lens with a clear central facet, the outer images rotate around the center image as you turn the attachment. For the picture, above, it was rotated about 30° during a 2 second exposure. Note how the gap left in the blurred extra images is positioned so as to allow the figure on the painted background to record.

Shallow depth of field

Photographic images need not always be sharp throughout. By carefully limiting your zone of sharp focus to the most important picture elements you can give them special emphasis. And the existence of an out-of-focus background, or foreground, often simplifies and gives the illusion of depth in your photographs. The simplest way to produce shallow depth of field is to shoot at a wide lens aperture. This is quite convenient under dim lighting conditions, but for pictures like the one below, shot on a brilliant beach, a filter may be needed. Depth of field may also be reduced by changing to a long-focus lens or using a larger for-mat camera. A single lens reflex is essential for critical work – be sure to check the image at the actual "f" number to be used for taking the photo-graph. Notice how an out-of-focus figure may lose its detail but still read clearly as a simplified shape. Make sure, how-ever, it blends with the sharply focused center of interest.

Shooting through foreground

A picture is often made more interesting when it contains a slight element of mystery. Compare the two photographs of the bird, below. The top one offers plenty of detailed information, presented in a rather clinical manner. The lower picture leaves much more to the imagin-ation, presenting the bird in an apparently natural situation. This was achieved simply by changing viewpoint so that part of a hedge pro-truded into the picture a few inches in front of the lens. Use of a wide lens aperture turns this veg-etation into vague shapes from which appears the sharply recorded bird of prey. Similar techniques are useful in landscape photography. Often just lowering the camera viewpoint will allow a dull foreground to be gently obscured by grass at your feet.

Both pictures: Leicaflex, 135 mm, Tri-X, 1/125 sec f3.5

Using a filter to reduce depth of field. For the picture, above, the meter indicated f8, too small an aperture to give shallow depth of field. A x5 neutral density filter was used to allow f3.5 for 1/1000 sec. Hasselblad, 80 mm, Tri-X

Selective focusing in close-ups. The lizard, left, was photographed at 1/500 second at f3.5 to help freeze sudden movement. Working close-up drastically reduces depth of field Here accurate selective focusing strongly separates the animal from its background. Pentax, 50 mm macro lens, Tri-X

Selective focusing

You can create very different images from the same viewpoint by using a large aperture and simply changing focus. The shallow depth of field obtained with a large aperture enables you to render just one element of a picture sharp, leaving the rest blurred. This is a very flexible compositional device. For example, you can bring an interesting foreground element into sharp focus against a blur which merely hints at the nature of the background, above right. Alternatively, you can draw attention to a feature in middle distance and use fore- and background blur to establish the context, center right. And by blurring foreground and middle distance you can frame a background element and give depth to your composition, below right.

All pictures: Pentax, 50 mm, FP4, 1/250 sec f2.8

Reflections in mirrors

Mirrors provide a useful way of dividing your picture elements into two distance zones – objects and their reflections. Focus on the true distance of the image rather than the reflection and stop down until the required degree of sharpness is obtained. By altering your angle of view you can make image and reflection appear close together or far apart.

Shooting into a mirror. The picture, right, was shot looking obliquely into a large mirror. By focusing on the middle distance and stopping well down the whole scene was combined and rendered sharply.
Leicaflex, 28 mm, Tri-X, 1/15 sec f22

Deliberate defocusing

It may seem rather strange to render an entire image out of focus, but compare the two semi-silhouette pictures, below. The defocused image, top, focused on half the distance between lens and camera, has an attractive plastic shape, caused partly by the white background eating into the edge of the figure. For pictures where simplified shapes are more important than detail check out the appearance of the subject at various "wrong" focus settings. Notice how highlights broaden into circular patches of light.

Both pictures: Pentax, 55 mm, Plus-X, 1/60 sec f2

Determining exposure

Giving correct exposure means allowing the right amount of light to affect the emulsion, so that after processing, the whole range of image tone values – from important dark shadows to important bright highlights – is recorded. In practical terms, exposure is controlled by setting combinations of lens "f" number (light intensity) and shutter speed (time) to suit the particular subject conditions and the ASA rating of the film. An exposure meter is simply a light measuring instrument which can be directed to receive light from the subject, or the source illuminating the subject. Programmed with the film's ASA rating it then reads out, or automatically sets, the combinations of "f" number and shutter speed which will give correct exposure. There are at least three ways of meter reading the picture: overall, highlight and shadow, or incident light. Used intelligently all of

them should give the same final exposure settings, but each one offers practical advantages over the others for particular subject conditions. For example, it is easiest of all to arrange that the meter "sees" the whole of the picture area in the same way as the camera itself. However this overall reading is only accurate if lightest and darkest subject tones are approximately equal in area. Separate readings taken of the brightest important highlight and darkest important shadow, which are then averaged, makes the best compromise between the picture's tonal extremes. This method also warns you when the subject has excessive contrast and may need more fill-in lighting. Incident light (light from the source rather than the subject) can be measured by attaching an incident light adaptor to your meter, or it can be read by bouncing it off a gray card toward the meter.

Calculator dial. Many hand-held meters carry a calculator dial which translates your light reading into an aligned series of "f" numbers and shutter speeds. You must decide the best one to use in terms of depth of field, blur and so on.

Shadow reading. Reading from the darkest area, circled top right, gives good shadow detail, but at the expense of gross over-exposure of the more brightly lit areas.
Highlight reading. Exposing for the brightest part of the scene, circled middle right, causes loss of detail in the shadow areas.
Average reading. Taking the average of the shadow and highlight readings, bottom right, gives good mid-tone detail and acceptable coverage of highlight and shadow areas.

Taking readings

First of all it is important to recognize the conditions under which errors will occur. Subjects with extensive back-lighting or light backgrounds will be under-exposed by an overall reading or carelessly directed highlight and shadow readings. Very dark and light-absorbing subjects, or very light and reflective subjects may be inaccurately exposed by an incident light reading.

Overall and highlight/ shadow readings. To read the subject overall, the meter should match lens angle of view. For highlight/shadow readings bring the meter in close to both areas in turn.

Incident reading. Point the meter with incident light attachment toward light source. Alternatively, measure directly off white card, then increase exposure x 6.

Gray card reading. A variation of incident light measurement. Meter reads direct off mid-gray (ideally 16 percent reflectance) card which simulates subject mid-tone.

Using a hand-held meter

The advantage of a separate, hand-held meter is that it can be used with all your cameras. It is flexible enough to take any type of reading, and with the aid of attachments can be used for various dark-room functions too. By getting to know the cap-abilities of one instru-ment in all situations you can achieve remarkable exposure consistency. Most meters have a cell arrangement giving them an angle of view which approximates that of a standard focal length lens (about 40°). This is intended for overall readings from the camera position, but will not, of course, match the picture area if a wide-angle or long-focus lens is used. Shadow and highlight readings are made by bringing the meter sufficiently close to these parts of the sub-ject to fill its field of view. Sometimes, in candid portraiture for example, this is physically difficult to carry out. You can then measure from substitute surfaces – the back of your hand for a face, the grass at your feet for a distant field. Always make sure the substitute is receiving the same illumination as your actual subject. For incident light measure-ments a clip-on or sliding white plastic dome makes the acceptance angle of the measuring cell much wider and, by absorbing some light, compensates for the fact that the meter is now used pointing toward the light source. Light received is equivalent to a reflected reading from a gray card, or a reading from a white card divided by six. In all cases aperture and shutter setting informa-tion is read from the meter's calculator dial.

Holding the meter. When taking local readings beware of casting shadow from the meter itself. Hold the meter at a slight angle, or use a larger substitute surface which can be read from further away.

Range switch. To register large variations in readings, most meters divide light levels into a high and low range. Rocking the button, above, changes the scale and alters needle movement.

Alternative exposures. Some meter calculators carry alternative setting arrows which indicate readings for over- or under-exposure. These enable you to compensate for special situations.

Narrow angle attachment. An optical accessory which attaches over the cell to narrow its angle, and so allow spot readings, see right. The device includes a viewfinder for accurately pointing the meter.

Using a built-in meter

Having a meter built into your camera saves time and bother. Meter read-out can be linked direct-ly to lens aperture and shutter speed controls, without going through the time wasting stage of reading off figures or consulting calculators. This is particularly help-ful when lighting con-ditions are changing unpredictably or rapidly. The majority of built-in meters today operate behind the lens of a single lens reflex. Most measure exposure at full aperture to minimize disturbance to view-finding; others operate at the working aperture and may even measure the light actually falling on the film during the exposure. A few meter/camera links are entirely automatic, with or without indicating what speeds and "f" numbers are in use. Others expect you to pre-set one of these variables. You then adjust the other with the meter switched on until a mov-ing needle or lighted diode signals that correct exposure is set. Choice of pre-set "f" number is likely to be based on depth of field considera-tions, but on other occasions subject/camera movement is the most important factor, and then speed should be pre-set.

Discover whether your particular internal meter makes overall, spot, or intermediate center-weighted readings. Some offer two systems with a selector switch to suit subject conditions, for example overall for evenly distributed tones, spot for backlighting. The most practical way to measure incident light with an internal meter is to read off a gray card. If your internal meter allows only overall readings, local readings of highlights and shadows can still be made, by bringing the camera to the relevant area. Since the meter func-tions with the whole range of interchange-able lenses its angle of view automatically varies with each lens change. It also takes into account the light losses incurred in using bellows, ex-tension rings, and the majority of filters.

Alternative exposures. Most diode or moving needle displays have plus and minus positions which can be used when under- or over-exposure is to be given intentionally.

Using a spot meter

The spot meter is a battery operated hand instrument with an eye-piece giving a direct view of the subject. A small superimposed circle or dot denotes the measuring area of an internal cell with a narrow 1° angle of view. This allows accurate readings of small areas without approaching close up. Normally the meter is used to average shadows and highlights.

Spot readout. A number will appear which must be translated into shutter/lens settings. Some meters give direct "f" number readout for a pre-selected shutter speed.

The principles of contrast

Contrast refers to the range of gray tones a photograph contains. The fewer grays and the more intense the black and white appears, the more contrasty the picture is. To a lesser degree we are also influenced by the distribution of the tones – a photograph in which lightest and darkest values are adjacent to each other appears more contrasty than one in which other tone gradations separate these extremes. Four main factors control final picture contrast: the subject itself, the lighting, the film and its development, and the printing and presentation.
As in the picture, right, the subject may itself consist of strongly contrasting areas of dark and light tone.
Lighting creates contrast between the areas it illuminates most brightly and the darkest shadows it casts. Harsh oblique light can form intense contrast across a textured surface even though this is itself all of one tone.
A high contrast film, or even one of medium contrast if overdeveloped, will increase the contrast of the image.
The grade and type of paper and enlarger, and the way the final print is mounted and lit can radically change the appearance of contrast in the final image. In some cases these controls can be exercised to counteract difficult subject conditions, for example reducing development to improve a negative of a harshly lit scene.

High contrast subjects

Some subjects inherently look more contrasty than others, even though the lighting may be diffused, frontal and therefore virtually shadowless. A dark horse seen against white snow, a white face framed in a dark shawl, the traditional black and white pattern of a tudor house, above, – all these subjects offer strong contrasts within themselves. Soft, even illumination reveals this contrast pattern more effectively than hard lighting which often introduces conflicting and confusing shadows.

Rolleiflex, Tri-X, 1/30 sec f8

Using hard lighting

Strong oblique lighting from a source such as a spotlight or direct sunlight can turn a flat and apparently featureless surface into a wealth of textures and contrast. The picture below shows how hard light can pick out parts of a building all on one plane, and totally suppress other parts. Very careful selection of the right time of day is essential for this kind of picture. The "moonface" portrait was side-lit by one spotlight only. The extreme contrast between the half of the face lit flat on and other areas totally unlit must be closely considered at the time of shooting. Remember that when printed on to hard grade paper both these areas will reproduce stark and featureless, with texture and gradation limited to the narrow zone between the two.

Nikon F, 35 mm, FP4, 1/250 sec f16

High contrast lighting. The face, below, was illuminated by a vertical slit of light created by restricting a spotlight beam with two pieces of black card. Exposure was measured from the forehead between dark and light zones.
Nikon F, 50 mm, Plus-X, 1/125 sec f16

Using silhouettes

The most extreme form of contrast is the silhouette – shape devoid of form. Dramatic shapes photographed from a viewpoint which places them against a light toned background are given tremendous strength and emphasis. Similarly any object seen on a distant skyline has exaggerated importance. By arranging the key elements of a picture in this way and then exposing for the light toned background, unwanted detail can be darkened and merged. In the picture, right, however, a time was chosen when the distant house was still sufficiently lit by the setting sun to separate out from the foreground silhouette. This helps to preserve the feeling of depth without in any way destroying the drama.
Leicaflex, 35 mm, Ektachrome HS, 1/125 sec f5.6

Using pushed film

The over-development of fast film not only uprates its effective speed but also increases negative contrast, creating an image with a peculiarly strong quality of line. To get this working well subject lighting should be essentially soft and diffused. Exposure must be accurate, for there is little room for error. The portrait, above, was lit by one large diffused flood, using Royal-X Pan rated at 2000 ASA and overdeveloped by 80 percent. It was essential to expose correctly for the skin tones so that full detail was recorded. Then on the final print facial creases and lines reproduced as strong but simple shapes.

Hasselblad, 150 mm, Royal-X (2000 ASA), 1/125 sec f5.6

Darkroom techniques

Once the shutter has been fired and the image exposed, there is nothing you can do in the darkroom to alter viewpoint, lighting direction or quality. But the photographic process easily allows you to step up the contrast of the image, simply by reducing the number of gray tones and making the white and black appear very intense. As a general rule try to produce an original negative which has slightly lower contrast than you are aiming for in the final print. This will allow more control when you increase contrast at the printing stage.

Printing

A condenser enlarger, particularly one with a point light lamp, gives greater printing contrast than a diffused light type. A hard grade bromide paper or even lith paper will probably be needed. Ensure that the print is given full development. Local dodging or printing-in allows control over unevenness, or correction of areas which would otherwise disappear or be too assertive.

Similarly, you can apply a bleaching or reducing chemical to the final print to give extra brightness to some selected part of the image. For an extreme overall contrast boost make an intermediate, purely black and white negative.

Presentation

The actual print surface finish greatly influences the degree of image contrast. Glazed glossy paper appears deeper black than mat surfaced paper. This is further enhanced if the finished print is lit obliquely by spotlight, preferably in darkened surroundings. For the most dramatic contrast of all try making a large black and white transparency, and display this on a light box in a totally darkened room.
See: Enlarging equipment/Black and white paper/Special darkroom techniques/Black and white reversal film

Low contrast subjects

A low contrast subject is one in which the pervading tone values are gray, with little evidence of strong black or white. Tones graduate rather than contrast, and although the resulting picture may be either high or low key it relies more on delicacy of atmosphere than dramatic change. Distant views on hazy, overcast days, right, and still lifes with soft frontal lighting and minimal light/dark interchange are typical low contrast subjects. Notice too how a long focus lens contributes to a lowering of image contrast. Its narrow angle of view means the lens is often used from a distant viewpoint so that the amount of moisture or dust laden air between camera and subject is much greater than normal. The gentle tone gradation of the image itself must be followed through with techniques which result in a negative containing a wide range of tone values. This in turn requires sympathetic controls in printing.

Leicaflex, 135 mm, Tri-X, 1/15 sec f8

Reducing lighting contrast

Natural lighting may have more contrast than is necessary for your picture. Of course, if you are shooting a vast area such as a landscape there is little you can do to improve the lighting except wait for more favorable conditions and, if possible, match the choice of film to the prevailing light. For closer subjects you may be able to adjust position so that lighting is more frontal, or use another light source or a reflector to illuminate shadowy areas. If the main lighting is harsh it can be diffused with tracing paper.

Pentax, 105 mm, FP4, 1/60 sec f5.6

Positioning a reflector. In this portrait of Stanley Spencer contrast was reduced by using a large reflector on the left hand side. This returned some of the daylight from the window to the shadow side of the head.

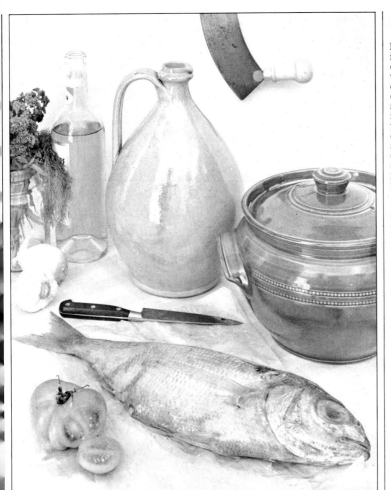

Darkroom techniques

Because tone gradation is so important in low contrast images it is vital that the negative contains a wide range of grays. Tones can be subtracted during printing but never added. If you start with an over-contrasty negative and struggle to print it by dodging or printing-in on soft grade paper, the result is likely to be an image with burnt out highlight areas and degraded shadow. Aim for a negative which is correctly exposed on medium speed film and normally developed. This will then print well on all grades of paper.

Printing material
Printing low contrast negatives calls for subtle control of density. The result should be delicate and of normal density. Try to reveal detail without resorting to contrast. It may be helpful to print on to a mat faced bromide paper (such as document paper) in which the darkest tone is no more than a dark gray and the overall image is light in quality. Sometimes it is helpful to use a two-bath print developer – a soft working type for the midtones, alternated with a more contrasty type to add body to the shadows. Do not fall into the trap of assuming that if any negative is printed on to a soft enough grade of paper, the result will have the delicacy you require. The most successful pictures achieve their effect mostly by careful lighting and negative exposure in the first instance; printing is then reasonably straightforward using normal or even a hard grade paper.
See: Special printing techniques

Using shadowless lighting

In the studio shadowless, even lighting is usually created by diffusion or reflection. This may mean positioning a large piece of diffusing material between light source and subject, or surrounding the set with mat white "bounce boards" or similar reflective surfaces on to which various lighting units are directed. In a room with a low ceiling and white walls these alone may form excellent reflectors. Alternatively a "tent" of muslin or white paper can be built to enclose the subject completely, leaving only a small hole for the camera lens.
See: Painting with light

Nikon, 55mm, Plus-X, 1/2 sec f16

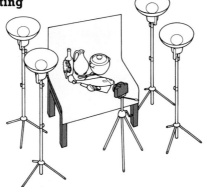

Shadowless still life. The still life above was lit entirely by reflected light, using four lamps. One flood was positioned either side of the camera, and the others left and right of the set. All were directed on to the white studio ceiling and walls.

High and low key

The terms high or low key refer to the dominant prevailing tones – light or dark – used in a picture. A high key photograph consists mostly of white with light tones and some middle tones, whereas a low key photograph is composed predominantly of black and dark tones. Though purists may disagree, it is often effective to have small areas of black or white present in high or low key pictures respectively. This counterpoint allows prominence to be given to a particular element within the picture and often emphasizes rather than destroys the prevailing key. A high key photograph is often concerned with delicacy and lightness, and is popular for portraits of young children, nudes, atmospheric landscapes and so on. Low key pictures tend to be mysterious, dramatic and somber. Both high and low key photographs depend for success upon the right choice of subject, background and lighting, followed through by appropriate darkroom technique. It is impossible to create a particular key just by making a light or dark print from any negative. The result will appear weak or heavy.
See: Enlargements

High and low key landscapes. In the picture, top right, the delicate structure of the pier is the only dark tone between white surf and hazy sky. The negative was slightly overexposed to record maximum shadow detail, then printed light on hard grade paper. The castle, right, was photographed on a heavily overcast day, making conscious use of the driveway as foreground.

Top right: Rolleiflex, Tri-X, 1/500 sec f8.

Right: Hasselblad, 50 mm, Tri-X, 1/125 sec f11

High key subjects

Potential high key subjects include snowscapes; seascapes; portraits in which background, clothing and often hair are light in tone; landscapes comprising sand dunes, white cliffs and so on. In the landscape, right, the fact that snow was still actually falling made the ruined abbey appear much more delicate than its normal dark tone. The atmospheric perspective, open foreground and even, shadowless lighting, threw the tree and horses into sharp contrast. Look out for fortunate combinations of light foreground and background which give overall delicacy of this kind. A few small bare patches of earth in the immediate foreground were shaded slightly during printing.

Rolleiflex, FP4, 1/30 sec f8

Processing and printing for high key

Although the crucial elements of high key work are concerned with subject and lighting, the special treatment must be carried through in processing and particularly in printing. The aim in processing is to produce a negative with all its highlight tones well separated, yet softly graduated overall. A fine grain developer or dilute general purpose developer will do this well. At the printing stage try to use as soft a paper as possible without making the image flat and dull. Judge exposure for delicacy of highlight detail. You will probably then find that the darkest tone is no more than deep gray, but this can appear quite dark in contrast with its surroundings. Print on a white based paper, preferably with a mat or semi-mat surface. Remember that prints always dry a little darker than they appear when wet; a high key photograph must never look gray. The pictures below show how easy it is to destroy a delicate image by over-printing. The top print was given 15 seconds exposure under the enlarger. The bottom version received only 9 seconds, and during this time the basket above the baby's head was shaded for 2 seconds to reduce its importance.

High key lighting techniques

Lighting for a high key picture should be full and soft. Try to avoid harsh or strong shadows of any kind. In daylight choose a day when the light is diffused and general surroundings contribute to the feeling of delicacy. In the studio, work with plenty of light walls or reflector boards, including if possible a white reflector on the floor. Typically the modeling light is a diffused source placed near the camera. Other lamps are then bounced or strongly diffused so that they fill in the slight shadows formed by the main light without forming additional shadows themselves. Unless it is close to the figure, the background will probably have to be lit separately. Its tone can be lifted till it is only a shade darker than the lightest subject tones.

High key in the studio.
For the picture above, the furniture, backdrop, carpets, model's clothes and the model himself were all selected with high key in mind. The aim was to concentrate attention on the man's face and on the book. A large flood was bounced from a white wall and ceiling behind and to the left of the camera to give the main light. Three other floods were directed on to the ceiling to form a large, even canopy of soft, diffused light. The exposure was measured from the face. Medium speed film was chosen so as to give a good range of well graduated gray tones.

Hasselblad, 60 mm
Plus-X, 1/15 sec f11

Low key lighting and exposure

A low key photograph must be deliberately organized, lit and exposed. Use dark clothing, dark surroundings and highlights which occupy relatively small areas of the picture. Lighting may be soft or hard, but should be directed from the side or rear rather than from the front, and should illuminate only the important elements. Choose a medium speed film and judge exposure with particular care. For the picture, left, readings from the lit side of the girl's face and the bed cover below her foot were averaged in calculating exposure.

Low key portrait. The portrait, left, was lit by a single flood bounced off a white-lined umbrella well to the left of the camera, above.
Pentax, 28 mm, FP4, 1/5 sec f8

Using the weather

Weather conditions just before or after a storm, or at dawn or dusk on an overcast day, can produce marvelous low key landscapes. Remember that effect can be gained from emphasizing small light areas, and make full use of these in the composition. For example, the main subject can be shown against a dramatic sky or a reflection in a somber lake. Large underlit areas can subdue unwanted detail and simplify the image. In this picture the foreground below the castle was a discordant array of streets and houses.

Rolleiflex wide-angle, Tri-X, 1/60 sec f16

Processing and printing low key

It is important to avoid under-development of a low key negative. Under-development gives lack of contrast with murky, poorly separated shadow tones. Correct development in a general purpose fine grain developer such as D76 is generally effective. At the printing stage remember the importance of good rich blacks. A white-based bromide paper is likely to give the best reproduction of dark tone values. The quality of the contrast will depend upon the original subject conditions, but the golden rule is to give the paper full development so that rich blacks are formed. Various tone adjustments of particular areas are

Nikon, 135 mm, HP5, 1/125 sec f8

possible at the printing stage. The foreground of the castle picture, below opposite, was deliberately printed-in to hide the houses and the sky darkened to increase its dramatic appearance. The two pictures, right and below, show how a landscape can be transformed by sympathetic printing controls.

Printing control. The small image below is a straight print, given 8 seconds exposure. The larger print received 14 seconds, plus a further 6 seconds over the sky alone.

Sunlight

Apart from being the principal
light source for photographs, the
sun can exercise great influence
over the subject. Under hazy con-
ditions, particularly at dusk or
dawn, it projects dramatic beams
of light above the clouds, showing
them as dark, indeterminate
masses. (Exposure for the picture,
right, was taken from the light area
of the sky.) By contrast, at high noon
in bright clear conditions the spot-
light effect of direct sun gives
subjects short, intense shadows.
The harsh shapes in the picture,
below, are strongly evocative of
the brightness and heat of
Mediterranean sunlight. Exposure
was taken from an average of
doorway and wall.

Right: Pentax, 200 mm, Plus-X, 1/250 sec f16
Below: Nikon, 85 mm, FP4, 1/250 sec f8

Overcast skies

In winter, overcast weather con-
ditions are sometimes accom-
panied by weak, hard sunlight
from a low angle. Individual planes
and surfaces are picked out loc-
ally in sharp relief. Distant
elements merge together, as in the
picture, right, where the sea dis-
solves into a leaden sky. This sort
of weather gives an excellent
opportunity to concentrate interest
on harshly lit foreground, simpli-
fying background detail which in
this case on a clear day would be
seen as a mass of promontories
and islands.

Exploiting bad weather. Water, land and
sky merge into one in this misty scene,
which was photographed just after a snow
storm. The cold wet atmosphere is
enhanced by the weak lighting.
See: Shooting in snow

Leicaflex, 50 mm, Tri-X, 1/125 sec f11

Rain and cloud

Explore the visual possibilities of all forms of weather and lighting conditions. Notice the glow of light on wet pavements and other smooth surfaces, below, when the sun reappears after a rain shower. Look out for that short period before or after a storm when the sky is dramatically dark, except for a clear band in the distance which throws horizon detail into sharp relief, right. Make use of the patchy lighting given by sunlight and clouds, below right. This can change a landscape radically from one moment to the next.

Right: Pentax, 50 mm, Tri-X, 1/60 sec f11
Below: Rolleiflex, Plus-X, 1/125 sec f8
Below right: Canon F-1, 135 mm, Tri-X, 1/125 sec f5.6

Mist and fog

Fog or mist, particularly sea mist, distinctly separates foreground from distant objects by atmospheric perspective, below and right. When all the principal elements are distant the whole picture will appear to be on one flat plane.

Below: Pentax K2, 105 mm, Plus-X, 1/60 f8
Right: Nikon, 85 mm, Tri-X, 1/125 sec f3.5

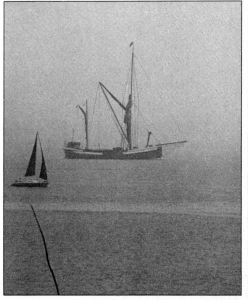

Black and white reproduction of color

Virtually all black and white films used for general camera work today are "panchromatic," which means they are sensitive to all colors; in other words the brightness or darkness of colors as seen by the eye is fairly accurately reproduced in tones of gray. Blues, however, record slightly lighter and yellows and greens slightly darker than might be expected. For more exact reproduction use a yellow filter over the lens – this will darken blue and, for example, make clouds stand out more clearly against a clear blue sky. The rule to remember is that a color filter lightens the black and white reproduction of objects its own color and darkens complementary colors. As you can see from the examples, below, a red filter makes all red parts of the original scene record very light in tone. Compare these with the green filtered shot in which reds appear almost black. Objects which were black, gray or white should appear unchanged regardless of the filter.

Polarizing filters

Polarized light is light reflected at an acute angle from a surface such as polished glass. By using a polarizing filter it is possible to block this light, without affecting the unpolarized light from other parts of the picture. The filter itself appears gray and therefore has no effect on color. Both pictures, below, were photographed through a plate glass window. For the lower picture a polarizing filter over the lens was rotated until the reflections completely disappeared.

Without filter

Yellow filter

Without filter

Red filter

Green filter

Polarizing filter

Filter forms

There are two principal forms of color filter. You can buy them as glass disks of the correct diameter to clip or screw on to the front of the camera lens, or, more cheaply, as thin sheets of gelatin. You can use the latter either uncut in a special filter holder, right, or you can trim them with scissors to fit your lens. Circular outlines printed on the packet show you where to cut. Take special care to protect gelatin filters as it is impossible to remove fingerprints, raindrops or other marks. Unless a filter is very pale you need to increase exposure slightly to compensate for loss of light. A filter factor – x2, x3, and so on – is usually quoted. Multiply exposure by this amount.

Further uses for polarizing filters.
A polarizing filter can be used to suppress any source of polarized light. This may be an acute reflection from smooth surfaces such as glass, plastic, water, or gloss paint (but not metallic surfaces), as well as light from a clear bright sky. The filter is therefore particularly useful in color photography for darkening skies and improving the saturation of colored objects with reflective surfaces. It is also helpful when copying paintings behind glass, photographing objects in show cases and so on. Two polarizing filters rotated one against the other form a variable neutral density filter.
See: Neutral density

Color film characteristics

No two color films are exactly
alike. Each manufacturer uses
patented dye forming chemicals,
so that although color pictures of
different brands may appear
satisfactory when they are seen in
isolation, pictures of the same
subject photographed with
different makes of film vary
dramatically in color and contrast
when they are compared side by
side, right. Some transparency
films are better than others at
reproducing "warm" colors, some
give excellent color brilliance;
others are best with subtle tones
and colors. Films such as
Kodachrome 25 are noted for
fine grain, but are slow in speed
(25 ASA) and cannot be user-
processed. Other, much faster
films show a distinctive grain
pattern. Color negatives are
carefully prepared to give best
color rendering when printed on
the same manufacturer's color
paper. Whenever possible keep
to one brand range and get to
know each type of film. Some films
can be "pushed" or "cut" in ASA
speed, if given compensatory
processing, with some loss of
quality and variation of grain size.

All pictures: Pentax K2, 50 mm

Kodachrome 64/64 ASA

Perutz C19/50 ASA

Fuji R100/100 ASA

GAF 500/500 ASA

Determining exposure

Exposure measurement
techniques which are successful
for black and white will work
well, as a general rule, for color.
However, color film has less
exposure latitude. Under-
exposure of color negatives is
more detrimental than over-
exposure, whereas the reverse is
true with transparency films.
An over-exposed transparency
looks pale, with bleached colors,
while slight under-exposure tends
to make its colors stronger.
Avoid taking an overall meter
reading of scenes where the most
important subject is small in size.
For the backlit color slide picture,
right, an overall reading
suggested an exposure which
would have made the girl's face
much too dark. Exposure was
made from a spot measurement
taken from the face area alone. If
you have a separate meter, try
using an incident light reading as
a means of ensuring that your
transparencies are not over-
exposed. For the shot, right, the
meter would be held with its
incident light attachment just in
front of the girl's face, pointing
toward the camera.

Long exposures
The performance of all films is
radically altered when very long

or extremely short exposure
times are given. With color film
this reciprocity law failure also
affects the appearance of color,
giving it an unpleasant cast. Most
color transparency and
unsophisticated color negative
films perform normally when
given exposure times between
1/1000 second and 1 second.
Outside this range the ASA speed
effectively becomes slower and a

pale color correcting filter may
be needed. Check with the film
packing slip. Sophisticated color
negative films, used by
professionals, are made in two
forms – type L for exposures of
1/10 second or longer, and type S
for 1/10 second or less.

Nikon, 35 mm, Ektachrome-X,
1/250 sec f8

Color accuracy

It is tempting to look around for subjects with bright, fully saturated colors as soon as you put your first color film in the camera. Fully saturated color or hue means a color of great purity, like the colors in the color circle right, with relative freedom from white, gray or black. In practice, however, too many strong colors have a discordant and confusing effect. Colors may be de-saturated by surface reflections from the subject itself, light scatter from atmospheric conditions, lens flare, even the color balance of light and film. Underexposure begins to introduce gray and black whereas over-exposure has the action of bleaching and diluting color. The very dyes used in color films have serious deficiencies – try recording fluorescent display lettering, for example. Do not strive too hard for absolute purity and accuracy. Use color subjectively. Remember that unlike black and white photography you can now explore the use of color contrast as well as tone contrast. Use this in a restrained way to give emphasis to the most important item in the picture. Or you can work in similar hues and tones, which combine to make a picture of harmonized colors. Alternatively, use a single dominant color.
See: Lens flare/Harmony/Contrast

Light and pigment. When photographers and painters discuss color the issue may become confused by the fact that each has a different concept of primary colors. Photographers are used to the additive effects of light, where red, green and blue are primaries, and the addition of red and green produces yellow. Painters deal in pigments where primaries are red, yellow and blue, and the overlapping effect of red and green gives brown.

Color circle. The disk, below, shows the classic color circle based on the spectrum and marked with divisions relating to pigments. If you were to cut out and spin the disk the colors would appear to blend into white. The pigment primaries, red, yellow and blue, are located opposite the secondaries, green, violet and orange. Maximum color contrast occurs between a color and its complementary. Conversely, you are most likely to achieve color harmony in a picture using colors closely positioned within the circle. Warm colors lie in the half circle containing red and yellow, cool colors in the other half. The disk shows only fully saturated colors, as far as they can be reproduced here by the printer. Often, of course, you can base an image essentially on one color, using it in variegated tints and shades.

Color contrast

The appearance of color is greatly affected by its surroundings. A pale colored subject photographed against a complementary colored background seems to have its saturation increased. Similarly, a neutral gray changes its appearance according to background, appearing slightly bluish green against red, and magenta against green. Compare the different looking gray patches in the two lower panels, below. Now cut two small holes in a piece of white card and compare the grays alone. Compare the blue patches in the same way.

Effect of color

In picture making color is the most important single element which will evoke an emotional response. Most people are prepared to say whether or not they "like" a color. The eye is very responsive to direct color comparisons and relationships, although much less reliable in remembering exact subject shades and tints. Of course a color photograph tends to describe the original scene leaving much less to your imagination than the more abstract qualities of black and white. This means that you have to make subtle use of subjective aspects of color composition to put over the right mood and emphasis.

Hot and cold colors

All colors have emotive associations. Hot colors such as red, orange and yellow, are related to fire, sunlight, body warmth. Blues and greens are associated with the cold – water, winter, ice. This change of mood is very noticeable, for example, at sunset when the warm orange light alters to a dark, bluish tinge as soon as the sun has dropped below the horizon. Try to use the right color theme to strengthen the mood of your picture – the warm orange glow of a cottage interior, the cold blueness of bleak rock formations, and so on.

Strong and muted colors

Strong, discordant color can be impressive, but it easily confuses the image, often destroying subject form. If you are working with a scene full of saturated colors try to control the relative areas of each, a small area of red, for example, picked out against a larger area of green. Muted, desaturated colors are often more evocative than strong colors. Rain, or mist, or just the atmospheric perspective created by selection of a distant viewpoint, soft lighting and long-focus lens, all help to subdue otherwise strident coloring. Once you restrict your image to a narrow range of subject colors all the various shades and tints contained within it become very important, though they might otherwise have passed unnoticed. Description of shape and form in terms of tone gradation is therefore more powerful.

Using a color theme to emphasize mood. The harmony of autumnal color in the landscape, above, is strengthened by the restricted use of brown, green and yellow. Each of these colors is de-saturated and muted, helped by the softness of the lighting. Correct exposure is very important here. Over-exposure would destroy the subtlety of green and yellow coloring; under-exposure would darken the brown.

Hasselblad, 150 mm, Ektachrome-X, 1/125 sec f5.6

Using a single dominant color. The picture, right, is almost monochromatic, using one dominant hue. Imagine this picture in black and white and consider how color contributes to the mood and atmosphere. Exposure was read from the brightest part of the sky to record the rocks and vegetation as simple silhouettes.

Hasselblad, 80 mm lens, High Speed Ektachrome, 5 secs f16

Pattern and harmony

Nature is the best source of color, harmony and pattern. All three are frequently combined in subjects such as trees, foliage, worn timber, corroded metal, stones and sand. In such subjects numerous variations of tint and tone occur in what appears superficially as all-over color. In the picture, right, the harmony of the leaf shape is overlaid with a pattern formed by the wave-like shapes of the gaps between the foliage. The juxtaposition of two warm colors strengthens both and gives variety. By exposing for the leaves alone detail and color in the shadows are suppressed and the shape and color of the leaves is emphasized. Pictures of this kind are limited in that they lack a center of interest.

Daylight for pattern and color. This group of maple trees was photographed in a woodland clearing using diffused daylight. Top lighting has helped to pick out the brilliant color and shape of the leaves.

Pentax, 50 mm, High Speed Ektachrome, 1/60 sec f8

Harmony through viewpoint

By careful choice of viewpoint you can arrange that everything in the picture area is of similar color. Monotony is avoided by using lighting and differential focus to pick out the main element. Notice the unifying effect of color in the picture below, and the way it helps convey the texture of the stone.

Using top and back lighting. This detail from a cathedral tomb was top and back lit by daylight. Exposure was for the shadow.

Bronica, 150 mm, Ektachrome-X, 1/2 sec f4

Harmony through filtration

Sometimes you can bring subject colors into a more harmonious relationship by creating an image with an overall color cast. You can also warm up cold colors. The easiest way to do this is with a pale color filter over the camera lens. The filter always has greatest effect on the light colored parts of the image.

Using a color filter. A diffused daylight shot using a CC15Y gelatin filter. Rolleiflex, Ektachrome-X, 1/60 sec f11

Complementary colors

Pictures with strongly contrasting or complementary colors can have great strength, provided they are kept simple. Avoid complicated compositions, and choose well saturated colors placed adjacent to each other. Vary the area of each color to heighten the effect. The red huts occupy only a tiny area of the landscape, right, but dominate the picture because of their strong position on the horizon and their color contrast against the foreground field. The flower shot, below right, is also restricted to three strong colors, this time linked by a similarity of pattern. With such complexity of detail hard lighting would break up the colored areas too severely. Diffused daylight is ideal. Notice how the yellows are made stronger by the presence of the complementary color, violet.

Using viewpoint to emphasize color. A distant viewpoint isolates the huts, right, and by shooting at wide aperture foreground detail merges into an area of flat color. In the picture, below, a high viewpoint suppresses form, thereby emphasizing color and pattern.

Pentax, 55 mm, High Speed Ektachrome, 1/60 sec f8

Contax RTS, 50 mm, Perutz C19, 1/60 sec f8

Discordant colors

Combinations of colors which clash violently have a certain shock effect. The trouble is that color juxtaposition is so strong that it detracts from the picture's content. In the picture of the sculptor Henry Moore, right, his daughter's dress, the shutters and the wall almost destroy the faces. Unity and emphasis is maintained by careful use of the various shapes and proportions, and accurate framing. This picture would be totally different in black and white, where green and violet would reproduce in similar tones of gray.

Exploiting discord. Taken separately the colors of the dress, house and shutters, right, are unremarkable, but together they make a strong startling composition. Train yourself to perceive interesting juxtapositions of color. The picture, right, was shot against the north wall of the building, using slightly overcast daylight. Shutters were closed in other windows to darken unwanted interior detail.

Pentax, 55 mm, Ektachrome-X, 1/125 sec f5.6

Emphasis through color

A tiny speck of strong contrasting color attracts the eye to a key element in a picture. Careful use of shutter speed is essential to get the correct balance between elements like the window, right, and the surroundings. Calculate exposure to give rich color to your small area of contrast, and in a case like this, right, wait for daylight to fade until the right visual relationship occurs.

Leicaflex, 21 mm, Ektachrome-X, 1 sec f4

Color with silhouette

The simplicity and economy of the black and white silhouette has its color equivalent in the shapes formed by flat, dark areas of color. When you combine both black and white and color silhouettes, as you can with color film under certain conditions, the result is a two dimensional pattern which is graphically very strong. The picture, below, was exposed for the sky overhead, thereby recording the intense color of the cloud while merging all ground details into black.

Pentax, 135 mm, Ektachrome-X, 1/125 sec f5.6

Balancing color

It is worth taking trouble to put harmonious colors together – either in the studio, right, where everything can be selected and arranged, or outside where you must wait for the right conditions to occur. The principles involved in putting colors together are inevitably subject to individual taste, but in general avoid clashes of strong color. Remember that shades and tints are as important as the colors themselves. Less saturated hues can be combined with greater freedom than intense colors. You might decide to choose a color key for the whole setting which contrasts with the main element, but results in a balanced color scheme overall.

Pentax, 55 mm, Ektachrome-X (type B), 1/30 sec f4

Increasing color saturation

You can achieve maximum saturation of colors in a photograph partly by visual organization of the picture presented to the camera, and partly by technical choice and manipulation. Obviously you start with a subject which has strongly saturated colors. Arrange colors close to each other to make use of simultaneous contrast, but do not overload the picture with a confusion of discordant tones. The simpler the color areas the better. Notice, left, how the colors in the clown's ruff appear stronger than the red and blue in the hat, which competes with other shapes and colors. Keep the lighting even and for mat surface colors, diffused. Colored materials with glossy surfaces appear more pure if lit with a hard light source, provided glare and other reflections are avoided. Choose a color film which offers maximum color saturation. In negative/positive color photography print on dye-bleach material. Use lenses totally free of grease and scratches and have a lens hood on the camera to minimize flare. Try to use lights of the precise color temperature to match the film, without the need for filters. Under-exposure of user-processed color transparency film followed by "pushed" extra development helps increase saturation, but should not be used with contrasty lighting because the result will be excessively hard.

Nikon, 50 mm, Kodachrome, 1/125 sec f4

Choosing the subject

Make a point of looking for subjects with muted colors. It is surprising what an extraordinary range of subtle tints and tones can be recorded by modern color films. You could easily disregard these old railroad locomotives, right, as unsuitable subjects for color photography. Yet the somber mixture of rust and gray paint is highly appropriate for the atmosphere of the scrap yard, and the repeated colors blend well with the pattern of shapes. Soft overall lighting allowed the recording of maximum color detail throughout.

Pentax, 135 mm, High Speed
Ektachrome, 1/60 sec f16

The effect of weather

Mist, rain and other adverse weather conditions are generally considered unfavorable for photography. Yet they can produce interesting pictures if you are prepared to experiment. The picture, right, was taken when heavy mist was drifting through the woods. The diffusion of mist mutes colors and flattens contrast. Subject form is difficult to identify, and the whole scene has a two-dimensional quality For atmospheric pictures under these conditions it is important not to lose the delicate shadowed areas by under-exposure.

Leicaflex, 135 mm, Ektachrome, 1/10 sec f11

Shooting in snow

The heavily overcast conditions during or just after a snowstorm usually give color pictures a strong blue cast. You can make the cold color contribute to the mood of the picture, as in the picture of the water mill, left. Instead of the conventional sparkle and texture of sunlight on snow, this picture is pervaded by a feeling of stillness and intense cold. Choose a viewpoint at an angle to the direction of snowfall. Trees and buildings are then delineated by a dark edge where they are protected from the lighter snow.
See: High key

Pentax, 55 mm, Ektachrome-X, 1/60 sec f4

Using a gauze screen

Bright subject color values can be muted in a photograph by image diffusion of one form or another. For the portrait below, a gauze veil was stretched and hung a few inches in front of the model's face.

The camera lens was focused on the gauze. The face can still be read but has lost form and contrast. Colors are de-saturated, and detail is broken up as it would be in a tiled mosaic. Try this effect shooting through various materials.

Rolleiflex, Ektachrome-X (type B), 1/15 sec f8

Using condensation on glass

Both the pictures, below, are of the same subject. For the picture, right, the camera was outside, while the picture, left, was shot through a steamed-up window, the camera being focused on the glass. The de-saturated, diffused colors give a romantic effect.

Both pictures: Leicaflex, 50 mm, Ektachrome-X, f4, (left) 1/30 sec; (right) 1/125 sec

Diffusion through movement

One unusual but effective way of muting color is to smudge it by moving the camera during exposure. The edges of colored shapes become diffused and eaten into by adjacent lighter colors or tones. Decide what sort of movement you should give; rotating the camera smudges the picture more at the edges than in the center. Panning and tilting give horizontal and vertical effects. For the picture, right, the camera was moved vertically in the hand.
See: Panning

Pentax, 55 mm, Ektachrome-X, 1/5 sec f16

Using over-exposure

Over-exposure burns-out highlight details and dilutes color. The more you over-expose the more mid-tones become affected, and eventually shadows and other dark areas. Controlled over-exposure therefore gives you a high key, de-saturated color image which has a delicate and dream-like appearance. Make sure the important parts of the scene are also the darkest, and try rendering the image slightly out of focus. For the picture, right, the meter reading was based on darkest important shadows. Further exposures were made opening the lens one stop and two stops. Shutter speed was eight times that recommended as "correct."

Pentax, 55 mm, Ektachrome-X, 1/4 sec f11

Using tungsten film in daylight

Tungsten light type color transparency film is balanced to give correct color reading in 3200 kelvin studio light (for 3400 kelvin photofloods use type A film). Daylight has more blue, less red, content so pictures taken on this film in daylight have a strong blue cast. You can make warm colors such as yellows and reds become suppressed and subdued. Whites show a blue tinge and cold colors generally are emphasized. Your result has a slightly macabre, unreal appearance. When it is also slightly underexposed the effect is very like moonlight. The same result is possible shooting on daylight film with a blue filter, which is normally used for shooting in tungsten light on daylight film.

Rolleiflex, Ektachrome-X (type B), 1/125 sec f8

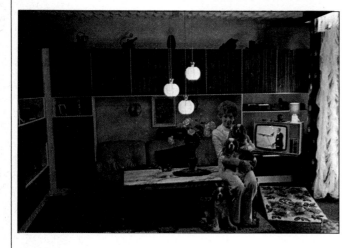

Using daylight film in tungsten light

The opposite effect occurs when daylight film is exposed with studio or domestic room lighting. Warm colors are strengthened, whites appear orange and cold colors become darker. In the picture, left, the room was lit mostly by three 60 watt lamps, with daylight coming through a large window on the right. The white curtain and nearby carpet therefore appear in their correct color. Color televison also records correctly on daylight type film. **See:** Photographing a TV screen

Leicaflex, 28 mm, Ektachrome-X, 1/2 sec f16

Using infra-red film

With infra-red Ektachrome you can transform everyday scenes into a make-believe world where foliage is magenta and people have yellow lips and waxen faces. All vegetation rich in chlorophyll reflects infra-red and therefore prints as magenta. Sunlit plants in spring appear bright red. Most familiar red painted objects record as yellow, although skies remain largely undistorted. The film is intended to be used with a yellow filter, right, although interesting effects are also possible using a deep green filter. **See:** Infra-red film

Leicaflex, 135 mm, infra-red Ektachrome, 1/125 sec f5.6

Incorrect processing

If you process a reversal color transparency film as a color negative the subject appears in complementary colors and reversed tones. Unlike a normal color negative there is no overall orange mask and contrast is greatly increased. With care, this technique can be used for special nightmarish effects. A landscape, for example, appears with magenta grass and black clouds in a yellow sky. In this case, right, the technique has been used simply to distort color and increase contrast.
See: Color processing

Rolleiflex, Ektachrome-X processed as color negative, 1/250 sec f8

Normally processed transparency

Print from the negative, right

Transparency processed as negative

Using video

Anyone with access to closed circuit color television equipment can modify and distort his color photographs electronically. The original subject, or a conventional color transparency or print of the subject, is set up in front of a color television camera. By means of the color balance and registration controls to the three primary color circuits you can change or offset the colors with the same ease as adjusting a TV set. The final picture is displayed on a high definition monitor, then copied on to daylight color film.

Video transformation. An Ektachrome transparency similar to the one above, is ducted through a TV channel and the three composite images made to offset. The result, left, is photographed from a TV monitor.

Leicaflex, 50 mm, Ektachrome-X, ¼ sec f8

Color casts

Light can be filtered in various ways to produce a color cast. For the picture, right, thin red curtains were pulled across the windows to bathe the room in warm color. Similar effects are possible by photographing the sitter in a small room with red walls.

Nikon, 50 mm, Ektachrome-X, 5 sec f2.8

Reciprocity failure

Most daylight type color films are designed to be given exposure times of 1/10 second of less. If an exposure is much longer than this it will affect ASA speed and color balance. The picture, right, though correctly exposed, is typical of the distortion produced by extra-long exposure.

Leicaflex, 28 mm, Ektachrome-X, 1½ mins f11

Color correction filters

Correction filters, below, are very useful whenever color film balanced for one type of lighting must be used for a subject lit by another. You may, for example, have type B color film in the camera but need to take some pictures in daylight. In this case use an orange (No.85B) filter over the lens. Similarly a blue filter (No.80A) corrects daylight type film for use with 3200 Kelvin tungsten studio lamps. In all cases using the filter reduces image brightness, so you must give extra exposure – typically ½ to 1½ stops, according to the filter used. Of course, if you have a through-the-lens meter this automatically takes the increase into account by reading through the filter too. Remember it is not possible to use a correcting filter after exposure, for ex-

ample by binding it up with an off-color transparency, because this gives a result with tinted highlights. Sometimes you have to take color pictures with mixed lighting, such as an interior illuminated by daylight with tungsten lamps "filling in". If the mixed color is not satisfactory, you can filter one of the light sources so that it matches the other. Large sheets of blue or orange acetate filter are made for the purpose. In the case described above you might use blue filters over the lamps and then shoot on daylight type color film.

Filter correction for daylight pictures.
The picture, left, was exposed on Ektachrome-X (type B), the correct film for tungsten lighting. Color is correct within the windows of the building but everything else is strong blue. The picture, above, was shot on the same film but with an orange correction filter over the lens. Interior lighting appears orange, but daylight is now the correct color and the effect is much more natural. The lens was opened up one stop.
Both pictures: Pentax, 28 mm, Ektachrome-X (type B), 1/60 sec f4 and f5.6

Filters for color effects

A pale color filter is often useful for generally "warming up" or "cooling down" the colors in a photograph, even though film type and lighting are compatible. This is useful for intensifying the mood or atmosphere of a picture, to strengthen some hues and suppress others. Deep color filters, below, can be used to give a strong overall effect, right, similar to looking through colored glass. You can achieve a similar result by binding up the gelatin filter with a normal unfiltered transparency.

Konica, 50 mm, Kodachrome II, 1/125 sec f11

Graduated filters

Some filters affect the color of only part of the image. Graduated filters, below left, affect only half your picture, and have a diffused boundary between clear and colored glass. They are useful for tinting the sky in a landscape, left. Here the straight horizon makes it easy to disguise the change of color. The wider the lens aperture the more indistinct the edge line

Darkening sky with a half filter. The picture above was taken through an orange-brown graduated half filter. This was arranged so that the tinted half of the filter affected only the sky. The graduated change to clear glass corresponds with the horizon. Notice how cloud detail is improved by under-exposure, relative to the unfiltered picture, above right. Both pictures: Pentax, 55 mm, Ektachrome-X, 1/125 sec f8

will appear. Of course, the colored half of a graduated filter also darkens the image, so try to arrange that it corresponds to a lighter area of the picture. You then measure your exposure from the unfiltered areas. A similar effect can be achieved by holding a piece of gelatin so that it covers only half the lens.

Color spot filters

Color spot filters, below, are part filters with a clear central hole. They have a soft graduated effect from the edges inward – the corners of the picture being most strongly colored, right. The image is greatly affected by lens aperture and focal length. Stopping down and/or use of a short focus lens forms a noticeably circular unfiltered patch in the center. Generally it is best to use such filters at wide aperture to give romantic, atmospheric images. Measure exposure as if no filter is being used.

Nikon, 85 mm, Ektachrome-X, 1/250 sec f4

Dual color filters

With a dual color filter, below, you can produce an image with a two color effect. The filter can be rotated so that the division of colors runs vertically, horizontally, below, or at an angle, right. The wider the lens aperture and the longer its focal length the more graduated will be the color transition across the image. Both halves of the filter are usually designed so that they require the same exposure increase factor.

Right, Pentax, 50 mm, Ektachrome-X, 1/4 sec f2.8
Below, Leicaflex, 50 mm, Ektachrome-X, 1/125 sec f5.6

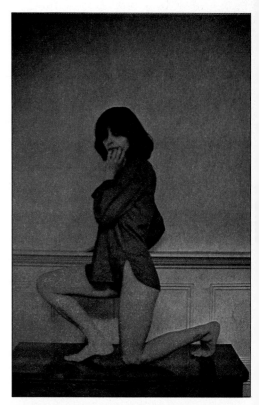

Diffraction filters

Some special effects filters contain no color, but produce color effects by refraction or diffraction. This is accompanied by spread of light and sometimes by multiple image effects, below. With a single lens reflex camera you can observe exactly how the filter influences the image. For the most dramatic effects choose subjects which have small intense highlights against a dark background. Night scenes like the one above are ideal. Notice how the Hoya colorburst filter expands the chain of lamps into an interesting curtain effect, each row repeating the lines of the original. You can combine two or more filters. The picture, right, was taken with a colorburst and a three-band prism filter, and for the shot, below right, a vario-starburst filter was added to the above combination.

Top: Pentax, 28 mm with colorburst filter, Ektachrome-X, 10 secs f11
Above: Leicaflex, 50 mm with colorburst filter, Ektachrome-X, 1/125 sec f11
Center right: Pentax, 55 mm with colorburst and three-band prism filters, Ektachrome-X, 1 sec f5.6
Right: Pentax, 28 mm with colorburst, three-band prism and vario-starburst filters, Ektachrome-X, 3 secs f8

Combining filters

You can get composite effects by combining color and special effects filters. You need an SLR camera so that you can view the filtered images; in some cases the relationships between the filters is crucial. It is also much easier to get the right exposure if you have a through-the-lens meter. But remember that as you add filters the picture becomes increasingly fragmented and abstract, and eventually image sharpness deteriorates. For the photograph, right, a purple/yellow dual color filter was combined with a colorburst. In the shot, bottom, a vario-cross filter was used with colorburst and half red filters. A spotlight reflected off a plastic mirror background helped to give intense highlights. For the building, below, a colorburst was used with a vario-cross filter. Foreground streaks are moving cars.

Top: Pentax, 28 mm with dual color and colorburst filters, Ektachrome-X, 1/125 sec f8
Above: Pentax, 55 mm with colorburst and vario-cross filters, Ektachrome-X, 2 secs f8
Right: Pentax, 55 mm with vario-cross, colorburst and half-red filters Ektachrome-X, 1/60 sec f5.6

Filters for infra-red film

Infra-red Ektachrome film is intended to be exposed through a strong yellow filter. Without this the result has very cold colors; green vegetation appears purple rather than the magenta or red normally produced by the film. The effect of shooting through a deep red filter is a strong overall yellow cast. The picture, directly below, was taken on unfiltered Ektachrome-X.

Ektachrome-X: f11
Unfiltered infra-red Ektachrome: f16
Filtered infra-red Ektachrome: f8

Ektachrome-X

Infra-red without filter

Infra-red with yellow filter

Infra-red with red filter

Holding the camera

A correct grip is essential if you are to have maximum control over the camera. For the SLR, right, the left hand supports the lens and adjusts the lens housing while the right hand controls the shutter release and the film wind. The mechanics of photography, like those of driving, should become second nature and leave you free to concentrate on composition and focusing.

Supporting the camera.
Most people can hand-hold a camera with a normal lens steadily enough for shutter speeds of 1/60 sec or faster. Some of the stances, below, allow you to work down to about 1/15 sec without shake. With long lenses camera support becomes more critical. You get the most stable support by leaning against a solid surface, below. Avoid the rigid bone to bone contact of elbow and knee; instead brace your knee against your upper arm, below left.

Handling the TLR. The normal TLR position, for portraits and so on, is at waist level, center, but for moving subjects use the sports finder, below left. In crowds, when you cannot hold the TLR at eye level, you can invert the camera and use it like a periscope, right.

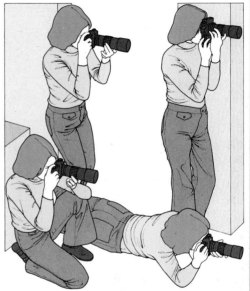

Shutter speed and movement

The definition of a moving subject depends on the direction and speed at which it is moving and its distance from the camera. The series of pictures, right, illustrates how you can adjust definition by altering the shutter speed. The slower the shutter speed the more blurred and undefined the image will become, while a very fast shutter speed will "freeze" the moving subject and give overall definition to the image. If you want a sharp image, you must use a faster shutter speed for a subject moving straight across the frame than for a subject moving obliquely.

All pictures: Nikon, 50 mm, HP4

1/500 sec f5.6

1/250 sec f8

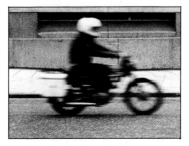

1/125 sec f11

1/60 sec f16

Arresting movement

Fast shutter speeds – say 1/250 sec or shorter – usually eliminate problems of camera shake. Speeds of 1/500 – 1/2000 sec allow you to freeze subject action beyond the perception of the eye. Squabbling seagulls appear suspended in the air like plaster casts, and water flowing down a waterfall looks like blocks of ice, Of course, to work at these shutter speeds you will need fast film and a wide aperture lens, particularly if lighting conditions are not brilliant. Often results have very little depth of field, as shown in the picture below, which was photographed at 1/2000 sec at f 2. Sometimes you can help matters by choosing a viewpoint which makes the most of the lighting and keeps the subject all on one shallow plane. This happened in the photograph of the thrown water, below, exposed at 1/1000 sec at f 2.8.
See: Sport/Water/Action sequences/Stroboscopic flash/Flash with daylight

Shooting while moving

This picture was taken from the back of another car while both were traveling at about 40 mph. The camera was mounted on a tripod firmly secured to the floor. Since results are difficult to forecast a practice run is advisable. A series of shots were taken with the shutter at 1/15, 1/30 and 1/60 sec. Notice how blur increases near the edges of the picture where movement is most oblique to the lens. For best results choose a road lined with trees, or buildings which will provide plenty of highlight and shadow in the background.
See: Moving the camera

Selective movement

Shutter speeds between about 1/30 and 1/250 sec are the most commonly used for hand-held work. The resulting image of moving subjects is similar to the eye's response to the scene – often a mixture of blur and frozen detail according to the speed, distance and direction of the movement. The bicycle picture, taken at 1/125 at f 4, shows how the nearest raindrops are elongated by blurring, whereas those in the background are shorter and sharper. Similarly the slower moving parts of the bicycle itself separate out from faster parts (further localized by the slight horizontal panning given during exposure). Notice too in the lower picture how the stationary little girl stands out strongly from her fast moving companions. This was photographed at 1/30 sec at f 16.
See: Moving the camera/Simulating movement

Removing crowds

Approximately the same number of people were passing in and out of this museum entrance in both the pictures, right. The one on the left was exposed for 1/15 second at f11 and the one on the right was given five seconds at f22 using a x20 gray filter. During the time exposure nobody has remained long enough in one spot to record. Obviously this is a very useful technique for photographing public buildings and monuments.
See: Architecture/Neutral density filters

Leicaflex, 135 mm, Plus-X, (near right) 1/15 sec f11; (far right) 5 secs f22

Photographing a TV screen

Some special moving subjects – such as projected movie film or television – rely on the human eye's inability to separate out rapidly presented still images. These subjects record in a very different way when briefly clipped by the camera shutter.
A television image is

completely reformed 30 times per second (25 times in U.K. 625 line systems), so that photographing the TV screen picture at shutter speeds shorter than 1/30 or 1/25 sec will show part of the image missing. If possible use 1/8 or 1/15 sec so that several complete scans are superimposed.

Pentax Spotmatic, 105 mm, Tri-X, 1/25 sec f8

Following subject movement

If you use a fast shutter speed to freeze a fast moving subject you may get a disappointing picture, because so much of the action itself – movement against background, for example – has been lost. You can choose a slower shutter speed and show the moving subject against a sharp background, but this tends to make the background too important. Instead, try panning with the subject, moving the camera in a horizontal arc and firing the shutter at the same time. Provided this is done at the right speed the photograph will record the image of the moving subject clearly separated from a blurred background. It is difficult to lay down rules for this technique. Much depends upon the true speed and direction of movement relative to the camera. Close objects appear to move faster than objects further away and focal length also influences the speed of pan. For most sports events shutter speeds between 1/30 and 1/125 second work well. Choose a viewpoint which gives a mixture of highlight and shadows in the background, as this will produce a stronger pattern of blur. Use a camera which gives you a good view throughout the action, and if it is a large format type mount it on a tripod with a pan and tilt head.

Holding the camera for panning. Adopt a firm stance and swing your body from the waist upward. Pre-focus the lens, frame up the subject when it is still some way off and begin to pan smoothly. Release the shutter as the subject passes, continuing to pan in one continuous action.

Panning with a moving subject. In the picture of the cyclists, below, movement is oblique to the camera. You should pan fairly slowly in such circumstances, but since subject-to-lens distance is changing all the time, either stop well down, or pre-focus on the road and expose when the subject reaches this point of focus. The picture, bottom, was one of a series taken at the start of a veteran car rally. The street had been cleared and the cars passed at regular intervals, so the problems were considerably simplified. It is on occasions like this, just as you start a magnificent panning shot, that you are likely to find a large truck crossing your field of view.

Leicaflex, 50 mm, Tri-X, 1/30 sec f16

Leicaflex, 50 mm, Ektachrome-X, 1/125 sec f11

Camera movement

You can obtain a variety of image abstractions by moving the camera in a different direction from that in which the subject is moving. Results are not predictable, but the highlights or brightest parts of the image will be elongated and overlaid on the darker areas. The picture of the procession, above, was taken with an exposure of one second. The hand-held camera was moved in a direction 45° upward halfway through the exposure.

Leicaflex, 28 mm, Plus-X, 1 sec f16

Auxiliary viewfinders

One or two otherwise excellent camera designs are unsuitable for panning and other controlled movement. The normal single lens reflex finder is no good because the image disappears from view while the exposure is taking place. The image on the focusing screen of a twin lens reflex (or non-pentaprism SLR), is reversed left to right. When you pan the viewfinder image will shift, disconcertingly, in the opposite direction to the subject movement. The best type of finder is a wire frame or one which gives direct vision. With these you can observe action and movement clearly, even before the subject enters the picture area. Most twin lens reflexes have a "sports finder" which folds out of the hood, and auxiliary frame finders can be attached to the accessory shoe of SLR cameras.

A homemade auxiliary finder. You can make an auxiliary finder for a 35 mm SLR camera with two 35 mm cardboard transparency mounts. Simply stick two mounts together, above, and cover one with opaque tape. Punch a hole in the tape just big enough to make a peep sight. Use more tape to fix the device to the top of your camera. Arrange it so that the image coincides as closely as possible with the image shown in the conventional finder.

Viewpoint for action shots

Find out which are likely to be the main areas of action in the event you are photographing and choose your viewpoint with great care. Try several positions before deciding where to work, and look for an angle which will give you a simple background to figure shapes, below. A ground level viewpoint emphasizes vertical separation of the figures, but can give a complicated crowd-filled background. Use shallow depth of field to separate crowd from players; the pattern of faces, right, adds to the chaos of the scene.
Right: Nikon F, 400 mm, Tri-X, 1/250 sec f4
Below: Nikon F, 200 mm, Tri-X, 1/500 sec f4

Capturing the moment

A good sports photo-
grapher needs ultra fast
response to the action in
front of the camera. Use a
motorized SLR or view-
finder camera and fit a
sportsfinder. The motor
drive minimizes the wind-
on delay after each shot.
Fast shutter speeds mean
you must use wide aper-
tures. This, together with
the long lens demands
accurate focusing. Some
lenses offer trigger oper-
ated focusing, or you can
pre-focus on some fixed

object where you know
the action will occur.
See: Auxiliary view-
finders/Follow-focus lens

Below: Nikon F, 180 mm,
Kodachrome 64, 1/500 sec f8
Right: Nikon F, 135 mm,
Tri-X, 1/125 sec f4
Bottom: Nikon F, 180 mm,
Tri-X, 1/1000 sec f11

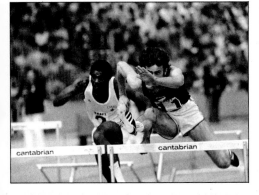

Showing speed

Speed in a still photo-
graph has to be shown by
means of symbols – blur,
shape elongation – and
by framing and compo-
sition. An excessively fast
shutter speed may some-
times destroy the feeling
and excitement of speed
events. You must decide
whether to show the
action from a participant's
or spectator's point of
view. The motorcycle
shot, right, was taken
from a moving car. It gives
a realistic impression of
participating in a race.
The picture, below, simu-
lates a spectator's im-
pression as the partici-
pants flash past. It was
photographed at a rela-
tively slow shutter speed,
panning the camera and
zooming at the same time.
See: Zoom and pan

Above: Nikon F, 35 mm,
Tri-X, 1/60 sec f11
Left: Nikon F, 80-200 mm,
Tri-X, 1/30 sec f4.5

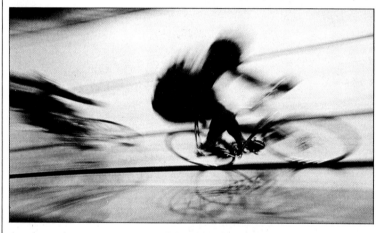

Freezing action

In some areas of athletics,
notably gymnastics, right,
it is important not to blur
the picture. You need to
show the precise attitude
of the contestant at a
crucial moment in the
performance. For indoor
events this means using
widest aperture and
pushing the film speed to
allow the shortest poss-
ible exposures.

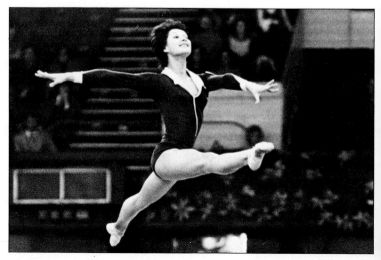

Nikon F, 180 mm, Tri-X uprated,
1/250 sec f2.8

Photography away from the action

Sport photography is often concerned with recording fast and sometimes violent action, but there are many opportunities for taking pictures outside the main arena. Competitors preparing themselves for an event or recovering afterwards make good subjects for portraiture. Keep your camera ready for quick reaction shooting, but remember these are likely to be tense or emotional moments for the sportsman, when he may least welcome your attention. A camera with automatic exposure control will enable you to work quickly and unobtrusively before the opportunity passes.

Left: Nikon F, 105 mm,
Tri-X, 1/250 sec f4
Below: Nikon F, 55 mm,
Tri-X, 1/250 sec f5.6

Photographing sequences

To take a series of pictures in fast sequence, or to take a slow sequence over a long period of time, you really need a motor driven camera with enlarged film capacity, above right. This enables you to work for longer periods before reloading. Electric wind and shutter release also allow fully automatic operation of the camera for surveillance work or time-lapse recording. To back up the system you need a battery pack or domestic current adaptor. A film loader is useful for filling the bulk film back cassettes; and you will require a suitable enlarged processing reel and tank to accept the long lengths of film.

Contax 250 exposure unit

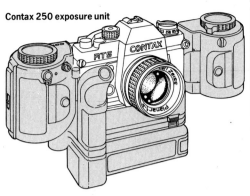

Hasselblad 70 mm bulk magazine

Equipment for action sequences. A 35 mm SLR camera with motor drive, battery power unit, and 250 exposure film back, top, is excellent for long sequences. You can use the whole shutter speed range for single pictures, or the faster speeds for sequences of up to four per second. The film back holds 33 ft (10 m) of 35 mm film. A motor driven 2¼ ins sq (6 x 6 cm) SLR, left, with bulk film magazine containing 100 ft (30 m) of 70 mm double-perforated film gives 500 exposures, at over one per second. **See:** Camera systems

Automatic camera

Specialized motor driven cameras are made for surveillance work, recording of instrument dials in the operator's absence and so on. The unit is fixed in a permanent position and therefore requires no viewfinder. Electrical release of the camera shutter is triggered by pedal switch, radio, time switch or movement of the subject.

Instrumentation/surveillance camera. This compact 35 mm camera has a spring motor which takes 50 24 x 24 mm pictures at up to 6 per second at one winding. An electrical solenoid releases the shutter.

Loading and processing bulk film

Manufacturers supply cassette-loaded film in lengths of up to 36 exposures only. Roll-film comes in lengths of up to 24 exposures. This means you must load the enlarged cassette for motor drive film backs yourself from a tin of bulk film, usually containing 100 ft (30 m). Once loaded, the cassette drops into the magazine back and feeds film across to an identical cassette which acts as a take-up spool. Most backs have a built-in knife to cut the film at any point so that a sequence can be processed and the remaining film rethreaded and used later. Long lengths of film will not fit normal daylight processing tanks so you need a special enlarged tank, or a machine processor as used by professional laboratories.

Loading cassette film. The large cassettes for 250-exposure magazines are generally loaded from a bulk film roll using the jig, above.

Processing bulk film. The enlarged reel, above, is designed for processing bulk lengths of film. The reel loads from the center outward, using the wind-on loading jig. Processing can then take place in a deep tank.

Time-lapse recording

An electrically triggered and timed motor driven camera allows you to record very slow sequences as well as fast ones. By fixing a constant period of time between exposures – seconds, minutes, hours or even days – you can make comparative pictures showing changes which normally occur too slowly for the eye to appreciate. Suitable subjects include the growth of plants, movement of clouds, patterns of traffic at an intersection, and the progress of corrosion. The camera itself may be just one part of an elaborate chain of equipment. For example, to record plant growth in a greenhouse you might use an interval timer, a daylight excluding blind, two floods or flash units, a motor drive camera and a bulk film magazine which allows an appropriate number of exposures. At long, preset intervals, the timer activates the window blind and switches on the lights. It then triggers one exposure and the film wind-on, extinguishes the lights and uncovers the window again to allow the plant to continue growing naturally.

Photographing plant growth. You can set up a camera – in this example a 2¼ ins sq (6 x 6 cm) SLR – to give a series of comparative time-lapse color pictures of a plant growing. The interval timer, operating from domestic current, also powers the motor drive.

Motor drive techniques

There are two distinct ways of using motor drive. With the control set at single shot the motor drive merely winds on the film instantaneously after exposure. The alternative is continuous exposure. Settings usually range from one to four exposures per second; the camera will keep firing as long as you keep your finger on the shutter release. You might think that at its fastest automatic setting, a motor driven sequence will give at least one definitive dramatic picture. This is not always so because even at four frames per second, exposing at 1/250 second, only 1.5 percent of any time period is actually recorded on film, while the remaining 98.5 percent is taken up with transporting the film. The larger the picture format the worse this ratio becomes. It is best to use the continuous exposure settings for short fast bursts when something dramatic is about to happen.

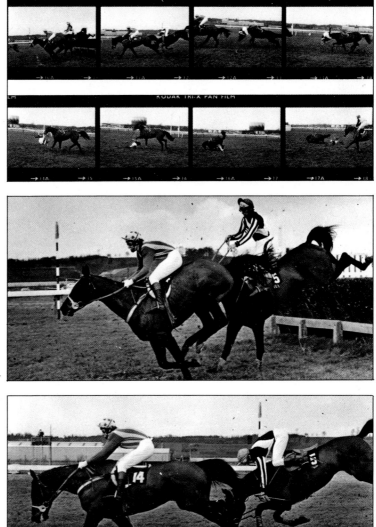

Action pictures with motor drive. The pictures, right, were enlarged from a long sequence, part of which is shown above right. The motor drive was already set to continuous exposure, so when the drama began, the photographer kept his finger pressed to the shutter release. The viewpoint was well back from the track which was unfenced at this point. Calamitous as the incident might seem, both horse and rider were unhurt.

All pictures: Nikon, 85 mm, Tri-X, 1/500 sec f5.6

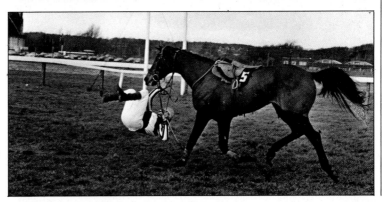

Stroboscopic photography

You can take multi-image photographs of moving subjects by using a pulsed, stroboscopic lamp, right. This has a variable control which allows you to set a flash frequency to suit the subject's speed and direction. If the flashes are fast and the subject moves slowly you get a greater number of overlapping images.

Using a stroboscopic lamp. For the picture, right, a bank of eight stroboscopic lamps was set up in a blacked out studio and wired to fire in unison at 15 per second. They were arranged to the left of the set, shaded as much as possible from the black background. The exposure of f16 on Tri-X was read by a flash meter, from a single pulse. This exposure applies only if the subject is in a different position for each flash. For the picture, below, two lamps were used, one on either side of the subject, firing at two flashes per second.

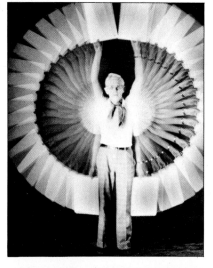

Stroboscopic lamp. Units of this type can produce from 1 to 20 flashes per second. You may need several units, linked to a synchronizing control box, to produce enough light for photography.

Left: Nikon F, 35 mm, Tri-X, 3 secs f11
Below: Hasselblad, 80 mm, Tri-X, 3 secs f8

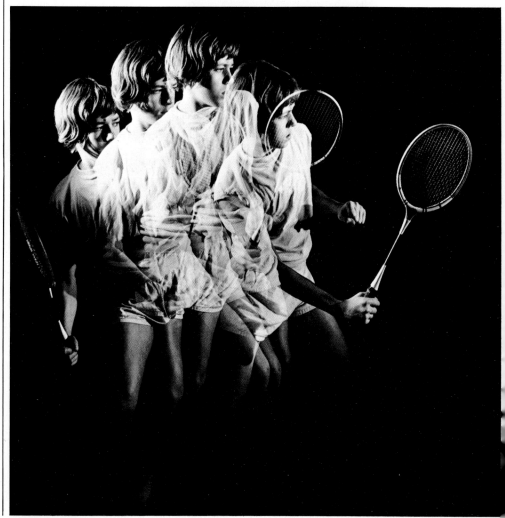

Physiograms

A physiogram is a pattern re-
corded photographically by a
moving point source of light,
usually attached to a swinging
pendulum. You can arrange this
by masking down a flashlight to
give only a spot of light, and sus-
pending it on black cord from a
high ceiling in a darkened room.
The camera rests on the floor, lens
upward. Another arrangement,
right, uses a mirror to save space.
While the flashlight swings you
hold the shutter open and steer
the pendulum in various new dir-
ections by gently pulling one or
more draw strings. Make tests to
establish exposure. If you are
shooting color use a range of
strong filters over the lens or the
flashlight to vary the color of the
lines traced.

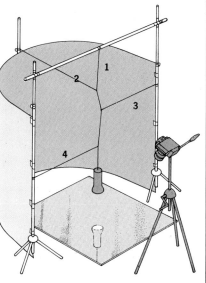

Constructing a set for physiograms.
The set-up, above, uses a mirror on the
floor to allow almost full floor-to-ceiling
height for pendulum swing. You must take
care to image the reflection only. The
flashlight is suspended on a piece of cord,
1, the movement of which is controlled by
strings 2, 3 and 4.

Time and motion

You can measure the
direction, speed and
timing of a moving object
by applying the tech-
niques used for physio-
grams. For example, a
small light attached to a
piece of machinery will
trace out its exact motion.
If the lamp is made to
flash at a known rate the
photograph will record
broken lines, so by
counting the gaps you
can assess how long the
action took, where accel-
eration occurred, and so
on. Lamps attached to
the hands of a machine
operator allow you to
record the exact hand
movements and the time
needed to do a job.
Tracks can be separated
out by attaching a dif-
ferent colored lamp to
each hand and shooting
on color film. Keep a low
level of ambient light to
record just sufficient
detail of the work bench
and other static objects.

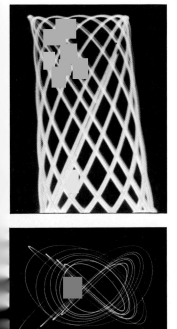

Engineering physiogram patterns. The
pattern, top, was produced by a swinging
flashlight using a two point pivot and a
single exposure of 20 seconds at f11. For
the picture, above, the pendulum was
tugged sideways to give a figure of eight
effect. Brightest tracks denote slowest
movement. Two exposures were made for
a total of 45 seconds at f8. The complicated
three point pivot physiogram, right, was
given three exposures for a total of 55
seconds at f16. Printing on to lith paper has
increased contrast.

All pictures: Pentax, 55 mm, Plus-X

Using the picture area

Composition is concerned with the arrangement of picture elements so that they have a unified effect. Regard the frame of film as you would a sheet of paper or canvas. Decide the best shape and proportions to suit your subject. If it is a simple linear form like the picture below, decide how this should interact with the frame edges. How does it divide up the picture space? A viewpoint can sometimes be chosen which will divide the image into two complementary areas, each with a linked point of emphasis, right. Some subjects contain their own frame – still life objects in a box, for example, or views through doors or windows.

Below: Hasselblad, 80 mm, Tri-X, 1/250 sec f16
Bottom and right: Nikon, 50 mm, HP4,
1/125 sec and 1/30 sec f5.6

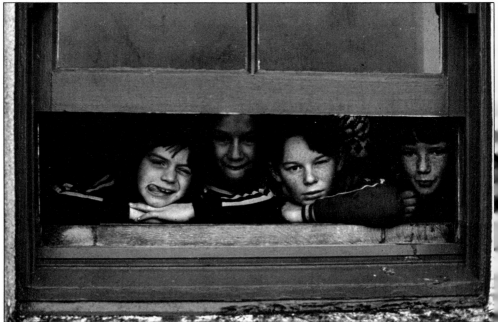

Judging the moment

Still life, landscape and other
static subjects allow every aspect
of the picture to be considered at
length. However, you will fre-
quently be confronted with tran-
sient situations where juxtapo-
sition of people, objects and set-
tings changes from one moment to
the next and photography is the
perfect medium to capture these
events. You can choose which
moment to record but this calls for
lightning decisions on composition
and often facial expression. Of
course, pictures can be cropped
to different proportions, lightened
or darkened, and changed in
contrast during printing. But all of
this is detail relative to the
decisions made when the camera
shutter was pressed. Consider the
permutations of position the
squabbling ducks, top, above and
above right, could adopt from one
moment to the next. The running
boy's foot, right, was off the ground,
and his placing relative to mid-
distance and background figures
looked this way, for one decisive
moment only. You must therefore
consider many things at once.
First, select the most promising
viewpoint and lighting, then com-
pose approximately within the
frame. Watch the massing and
placing of shapes and forms as
they interweave and change in
the viewfinder. React fast when the
right moment occurs and do not
allow the technicalities of the
medium to come between you
and the subject.

Bird series: Pentax, 35 mm, Plus-X,
1/60 sec f8
Right: Nikon, 50 mm, Tri-X, 1/125 sec f2.8

Varying camera height

Every camera tends to impose its own viewpoint. A direct vision or pentaprism reflex encourages you to shoot from eye level; a TLR camera from chest level; and an old fashioned box camera from waist level. It is easy to drop into habits of use, with the result that all your pictures have a certain similarity. Often by standing on a chair or crouching or lying on the ground you can get a more interesting, relevant composition. In this picture of garden produce, below, all the interest lies spread · across the floor. A high viewpoint emphasizes this plane, and causes vertical uprights to converge toward it. In the picture, bottom of page, the crazy old vehicle with its worn tyres and high, beaten-up chassis was depicted more effectively from ground level viewpoint.

Below: Pentax, 28 mm, Tri-X, 1/30 sec f5.6

Bottom of page: Rolleiflex, Plus-X, 1/250 sec f8

Using the foreground

Including foreground can have a major influence on the appearance of a landscape or building. The larger the main element of your picture the more opportunity there will be to vary viewpoint so that the right foreground is introduced. In the pictures of Chartres Cathedral, below, the apparent environment has been changed from country to town just by moving a few hundred yards. Bear in mind however, that foreground is still only an adjunct to the main subject and should not compete too strongly. The top picture uses willow trees to block out every-

thing but the cathedral itself. The building dominates because of the way it breaks the skyline. In the lower picture a strong lead-in is given by the converging lines of bridge and roofs in an otherwise confused town-scape. Decide which sort of foreground best suits the mood of your picture.

Both pictures: Leicaflex, 50 mm, Plus-X, 1/60 sec f11

Change of direction

These pictures of the fountain and lily pond, right and below, illustrate how different a scene can appear when photographed from opposite viewpoints. In the picture, right, the pond is of indeterminate size, and the scene appears mostly on one plane with no indication of the way the land drops away. The picture, below, shows how enclosed the pond really is, and how it forms only a part of a much larger and very three-dimensional landscape. In a situation like this it is always worth walking around before taking any pictures to see how change of direction alters your interpretation of the scene. Notice the effects of light, foreground/background relationships, lines and shapes. When you are shooting a subject, such as a building in a landscape, try taking at least six pictures from different directions, making the subject as different as possible in each photograph.

Leicaflex, 28 mm, HP5: (right) 1/125 sec f16; (below)1/250 sec f16

Shape

There are various ways of emphasizing shape in a composition. You can strengthen the outline of a subject by contrasting it against a plain and simple background such as sky or water. Outlines can be emphasized further, and internal detail suppressed, by back or side lighting. In the studio you have more control than you do outdoors, and a figure can be dressed, posed and lit to form an exaggerated shape. Camera viewpoint can be established first and the model then directed from the focusing screen. Another important factor is the way the subject shape relates to the picture shape. By tight cropping and very careful composition you can make each line relate to the others and to the edges of the frame. Remember always that the simpler the picture content the stronger its shapes are likely to be. Decide which shapes are important, then eliminate all unnecessary detail.

Emphasizing shape. Strong side-lighting and exceptionally calm water at dusk emphasize the shape of the boat, top. In the studio, the poses of the models, arrangement and close-cropping help accentuate shapes, above and left. All pictures: Hasselblad, Tri-X: (top) 80 mm, 1/125 sec f8; (above) 80 mm, 1/15 sec f5.6; (left) 50 mm, 1/8 sec f11

Simplification by tone

Atmospheric conditions may eliminate unwanted detail from distant views and form silhouettes. Where these shapes occur at different distances they are separated by aerial, or atmospheric, perspective and appear as contrasting areas of flat tone. In the landscape, right, early morning mist shrouds the ridges – the greater the distance, the lighter the tone. The vertical lines of the church are contrasted with the contours of the hills.
See: Aerial perspective

Leicaflex, 200 mm, CT 18, 1/60 sec f11

Lighting for shape and form

Lighting is fundamental to the visual representation of form. Although a photograph is a flat piece of paper the solidarity of the subject can be conveyed powerfully by gradation of tone. Lighting for depth and volume ranges from harsh oblique light which might suit the stark shape of a modern building, to a gentle, diffused quality for the rounded form of a nude. Carefully controlled backlighting is an excellent way of showing the folds and curves of a translucent form, below left. The lily was lit by a flood placed behind it at the top left with a reflector at the bottom right. Side-lighting is the best way to emphasize form in sculpture, below right. Here the statue was lit by overcast daylight from a window.

Below left: Bronica, 80 mm with extension ring, Plus-X, 1/8 sec f11
Below: Pentax, 135 mm, Plus-X, 1/15 sec f5.6

Observing everyday objects

Do not limit your search for shape and form to objects of accepted beauty. Learn to recognize the visual potential of ordinary everyday items. This old washbasin was lit by diffused light from a low narrow window. White walls close by acted as reflectors. Viewpoint was chosen with great care to give maximum symmetry.

Pentax, 55 mm, Tri-X, 1/5 sec f8

Using shadow

Shape can be reinforced strongly by shadow. This applies both to shadow within the subject itself, and shadow cast on other surfaces such as the background. In some extreme cases the shadow gives more information than would a direct view of the subject itself. However, the inherent danger of dramatic shadow is that it confuses the true shape and form of the subject. So when you use hard lighting consider carefully its height and direction relative to camera viewpoint. Empty black "spaces" will probably need some gentle fill-in. In black and white photography a dark shadow line cast on a light background may dominate subject outline which the eye clearly distinguishes by color. The picture, right, uses shadow to strengthen subject form. It was lit by oblique daylight.

Hasselblad, 80 mm, Plus-X, 1/60 sec f16

Types of perspective

Perspective is the most effective way of giving a three-dimensional illusion to a photograph. Depth is particularly important when the main subject interest is in the mid or far distance of the picture – by using linear perspective you can "lead in" to this area. Make use of converging lines, right, and diminishing size, below.

Remember also the value of aerial perspective – the illusion of recession by atmospheric effects, which usually gives progressively weaker tones from fore to background.

Both pictures: Pentax, 55 mm, Tri-X: (right) 1/250 sec f16; (below) 1/30 sec f16

Perspective with lens and viewpoint

By judicious use of viewpoint and lens focal length you can make full use of the convergence of lines toward the central vanishing point. With manmade landscape in particular it is possible to use these linear perspective effects to build up a symmetrical composition, right. Use a camera like an SLR which allows you to observe the actual image without parallax error – this is essential for critical alignment of foreground and distance. Since total symmetry can be monotonous include small elements to break the pattern.

Leicaflex, 28 mm, HP5, 1/60 sec f16

Movement and perspective

Any object moving obliquely to the camera viewpoint during exposure creates blur lines. These are traced out in directions that obey the same rules of perspective as the lines of the subject itself. Static camera shots of lights on moving vehicles, right, and shots of roadside lights photographed as you travel along the highway at dusk will form streaks radiating from a central vanishing point. The effect is particularly helpful for creating depth in night shots which otherwise tend to register as flat silhouette.

Leicaflex, 28 mm, Plus-X, 1/2 sec f3.5

Dynamic line

The most dynamic forms of composition make use of diagonals and acutely angled lines, rather than horizontals and verticals. You can use perspective to powerful effect by choosing a lens and viewpoint which create strongly converging or radiating lines, even when the subject itself consists mostly of right angled structures. The best technique is to move in close to the subject and adopt as oblique a viewpoint as possible. Then use a wide-angle lens to include the whole area you need. Extreme wide-angle and fisheye lenses also add their own characteristic linear distortions. A clear sky can be filled with diverging lines if the sun is spread by means of a starburst filter, or if a line of multi-internal lens reflections of increasing size is allowed to spill across the frame. In the picture, left, a near-ground level viewpoint was chosen and the picture was shot steeply upward.
See: Shooting into the sun/Iris flare

Hasselblad, 50 mm, Tri-X, 1/250 sec f16

Aerial perspective

Even when a landscape offers little linear perspective, depth can be conveyed expressively by atmospheric conditions which separate objects at different distances as differences in tone. The effect of atmospheric, or aerial, perspective is most noticeable when objects are placed at distinct, well-spaced intervals like the ridges of a series of hills, left. Mist, smoke or the haze which often occurs at dusk or dawn has a light-scattering effect. Light from the furthest parts of a landscape travels to the camera through a greater volume of haze than light from features which are relatively near. Therefore the greater the distance the lighter the tone. This effect is enhanced if a long-focus lens is used to bring distant images apparently closer to those in the foreground.

Hasselblad, 150 mm, Tri-X, 1/30 sec f11

Texture

The tactile qualities of a subject
are conveyed by the texture of the
photograph. Rough and irregular
or smooth and shiny, texture
revealed in a photograph tells us
how a surface would feel if we
were able to touch it. Texture is
therefore often a vital element
when we wish to show subject
depth and form, whether it be a
portrait face, a landscape, or a
still life close-up. The picture,
right, conveys the feel of a piece
of crumpled paper.

Use of light to convey texture. Lighting is
the key to texture photography. The best
lighting direction is usually oblique to the
surface, whereas quality of lighting
depends upon the subtlety of the subject
texture itself. Complex, rugged surfaces
respond well to diffused, directional
lighting; smoother textures can be
emphasized by harsh lighting. For the
picture, right, the surface was raked by a
single flood from the left. The light was
placed some distance from the subject to
reduce unevenness across its surface.

Sinar, 180 mm, Plus-X, 1/5 sec f22

Natural lighting for texture

The same principles of lighting for
texture apply when you work with
natural light outdoors. This often
calls for patience, waiting for
weather conditions to produce the
right quality of light, and choosing
the time of day to give correct
direction. The close-up, left, of a
weathered wooden structure at
the seaside was lit by harsh after-
noon sunlight. Light shines across
the wood grain, revealing its rough
and eroded surface. Shadowed
gaps and protrusions give a strong
compositional structure to the pic-
ture. The tire tracks, below, were
backlit by soft, evening sunlight.
Left: Leicaflex, 55 mm, FP4, 1/125 sec f16
Below: Pentax, 55 mm, Tri-X, 1/60 sec f16

Pattern

Pattern is a compositional arrangement which helps to strengthen a single motif, and can bring order out of confusion. You can discover pattern in a simple tree shape or a complex collection of buildings. Be very selective with your viewpoint and lighting; pattern is sometimes the product of strong lighting across a textured surface, or an arrangement of interestingly related shapes responding best to flat illumination. The picture, right, for example, relies for its interest on the angles and shapes of the fern leaves. It was taken within the shadow of a building where soft, even lighting and a dark background emphasized the repetitive shapes. Harsh lighting would have created a confusion of shadows here.

Leicaflex, 55 mm, FP4, 1/125 sec f16

Viewpoint and lighting for pattern

With all three-dimensional subjects, camera position determines how various elements and planes align and relate to each other. In a photograph of a stairwell, for example, only minor adjustment of camera viewpoint is needed to change the structure of the picture radically from a symmetrical spiral to an abstract pattern of curves. The picture, right, was seen first because of the light and shade on the factory roofs. Low harsh evening sunlight emphasized the texture of walls facing in one direction, silhouetting other walls and roofs against the sky. But to make this pattern work a viewpoint and lens focal length had to be chosen to relate nearest and furthest elements in the best possible way. For the picture of the bottles, lower right, complete symmetry was avoided by a close, slightly oblique viewpoint. This, and the reflective bounce lighting, gave some variety in the relationship of necks and bottles.

Above: Leicaflex, 135 mm, Tri-X, 1/500 sec f16

Right: Pentax, 35 mm, Plus-X, 1/60 sec f16

Controlling emphasis

You can strengthen a composition by placing emphasis on one particular area. For example, you can restrict emphasis to foreground, mid-distance, or background. In each case you would use the other zones to suggest environment and to help give an impression of depth. In the picture, top right, evening sunlight emphasizes the snowy mountain peaks, casting foreground and mid-distance detail into deep shadow. However, the emphasis of the scene would be reversed if the picture were taken at dawn, as the foreground would then be lit against a silhouetted mountain range. In the picture of farm buildings, center right, the mountains provide no more than a backdrop. Low cloud, flat lighting and aerial perspective all help to suppress their shapes. The strong forms of building, trees and figure occur in the mid-distance. The wide foreground, devoid of detail, helps to convey the remoteness of the farm. The center of interest in the portrait, right, is clearly in the foreground. The only other elements, the fire and hearth in the mid-distance, are reduced in importance by defocus. Without them however, there would be no sense of environment and little depth.
See: Aerial perspective

Emphasizing specific areas.
Under-exposure of foreground and mid-distance, top right, help to concentrate interest on the background. A distant viewpoint and long-focus lens flattens perspective, center right, and helps place the mid-distance building within its physical surroundings. Shallow depth of field and local lighting, right, help emphasize foreground.

Top right: Nikon, 28 mm, Tri-X, 1/60 sec f4

Center right: Pentax, 135 mm, Tri-X, 1/125 sec f5.6

Right: Pentax, 105 mm, Plus-X, 1/60 sec f4

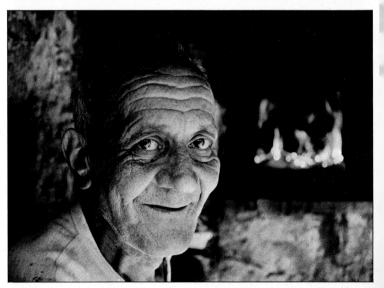

Relating planes

Sometimes the interest in a scene extends right through from foreground into background. All the elements may be related, or may form a diminishing pattern, but it is still necessary to provide compositional stop points either in foreground or background, or both. This sort of scene allows a strong impression of depth to be given by variation in scale. The picture, above right, conveys a complete activity; foreground, mid-distance and background display three distinct phases of the action – before, during and after respectively. The children's slide itself is the link, and this is helped by its being one tone. The heightened linear perspective obtained through the use of a wide-angle lens exaggerates the closeness of the foreground figure and the remoteness of those in the background. The two children on the slide in the mid-distance are a vital compositional element. Without them the greater part of the picture would be featureless and foreground and background would appear unrelated. In other situations you can choose a viewpoint which relates foreground to background without the interference of middle distance. This may allow direct comparison between a small, close detail and a larger distant element. The picture, below right, relates the shapes and pattern of the ruined wall to Lincoln Cathedral in the distance, at the same time blotting out the more modern town buildings which lie between the two. The soft lighting and similar tone values make the cathedral appear to be almost on the same plane as the wall. A distant camera viewpoint, long-focus lens and small aperture also help to fore-shorten depth. The manipulation of foreground and background in this way is commonly known as false attachment.

Continuous emphasis. The interest in the picture, above right, is carried throughout foreground, mid-distance and background.
Leicaflex, 28 mm, Tri-X, 1/60 sec f16

False attachment. Foreground and background appear to be connected to each other, below right, without intervening middle distance.
Hasselblad, 150 mm, Tri-X, 1/30 sec f16

Simple framing

You can add an extra element to your composition by framing the main subject within a foreground or background shape. One way of doing this is to shoot through a window or dark veranda, right. This provides new picture proportions and helps to give depth and balance to the composition. It can obscure unwanted detail, and fill empty skies or foregrounds. You can also place your main element in the foreground so that by exposing for a much brighter background a strong, interesting silhouette is formed. Framing often requires precise alignment between foreground and background, so check for parallax.

Minolta, 35 mm, Ektachrome-X, 1/250 sec f8

Composite framing

The two pictures, right and below, show how you can frame one image within another. For the tea party, below, the three figures and table were grouped carefully within the gap between flowers and creeper. The womens' black dresses contrast with the wall, allowing the figures to dominate over the foreground detail. In the portrait, right, the mirror gives a halo shape around the head. Both relate to the shapes of table and swan, linked through body and hands.

Right: Pentax, 28 mm, recording film, 1/125 sec f2.8
Below: Bronica, 150 mm, Tri-X, 1/60 sec f16

Framing to emphasize the main subject.
Both photographs, above, give the main subject strong emphasis by framing it, but they achieve this in opposite ways. For the picture, top, a university professor was carefully silhouetted against related window shapes and the architecture beyond. In the picture, above, light timberwork and an under-exposed interior create a strong black rectangular frame behind the main element.

Top: Hasselblad, 80 mm, Plus-X, 1/125 sec f11
Above: Leicaflex, 28 mm, Ektachrome-X, 1/60 sec f5.6

Arranging still life

Still life is a general term covering inanimate objects, usually put together in the studio. This sort of subject allows you complete freedom of arrangement, lighting and viewpoint. Try to choose items that have some form of visual link, such as similar shapes, colors or materials. Keep the number of objects and their arrangement as simple as possible. You can build up the composition piece by piece watching on the focusing screen as a painter would consider his canvas. The relationships of objects one to another and to the picture edges are of critical importance, as are the placing and appearance of shadows and the choice of background tone and pattern.

Found objects

Objet trouvés, or "found objects" frequently make excellent still lifes. Odd collections of items sharing a mantlepiece or showcase, an eccentric window display, below, shells or driftwood from the seashore, and even slow moving animals, right, can all be used to make interesting compositions. Such subjects need the right lighting and framing to make them into something unique and interesting.

Right: Nikon, 50 mm, Tri-X, 1/250 sec f4
Below: Pentax, 85 mm, Tri-X, 1/125 sec f8

Lighting and pattern in still life. The picture above was simply lit by diffused daylight from a large skylight above. The light tones of the ceramics and the wooden base reflect light into the shadow areas. The pictures, below and bottom right, show how quite ordinary objects can be made interesting by arrangement and lighting – in this case using a single, harsh spotlight. Both pictures make dramatic use of pattern and repetition. A puzzle element is introduced in the right hand picture by casting a shadow from a cup hidden behind the jug. Consider the potential of eggs, glassware, books, wooden kitchen utensils and so on.

Above: Hasselblad, 150 mm, Plus-X, 1/15 sec f16
Both pictures, below and right: MPP View camera, 180 mm, FP4, (below) 1/2 sec f22; (right) 2 secs f32

Countryside

Country landscapes are more difficult to photograph well than they may appear. Whether your intention is to capture mood, detail, or a general expanse of land, you must plan your shot carefully. Open spaces usually contain a great deal of information, and you will have to be selective if you want to give an impression of the whole. Find key elements – a building, a river, or trees on a hillside – and position them in dominant positions relative to their surroundings. Try to convey the feel of the particular season of the year. Choose the best time of day for lighting the ground formation, and a viewpoint from which lines or tones relate foreground to background. Hedges, fences and stone walls provide useful lines. Use recession of shapes and patterns to give depth through a change of scale.

Above: Hasselblad, 150 mm, Plus-X, 1/250 sec f5.6

Left: Pentax, 135 mm, FP4, 1/60 sec f3.5

Hasselblad, 250 mm, Tri-X, 1/125 sec f8

Industrial landscape

Manmade landscape in industrial areas is often photogenic because it abounds in powerful shapes and patterns. The corrugated iron structure of the cement works, left, was covered in a fine layer of white dust which subdued almost all local color and concentrated interest on the interplay of curved and angular forms. A long focal length lens added further to the abstract qualities of the picture by isolating and compressing space.

Flowing water

The appearance of moving water in a photograph is greatly influenced by the length of the exposure. You can never quite predict how much the image will blur, as this depends upon the direction and speed of the water as well as the shutter setting. If you have a tripod it is worth taking two or three pictures at different shutter speeds, then choosing the result which best sums up your impression of the scene.

Changing the appearance of water. The picture, below, was taken at 1/4 second at f16, and the picture right at 1/250 second at f2. A shutter speed of about 1/5000 second would be needed to freeze detail in the falling water.
Pentax, 28 mm, HP4

Still water

Smooth, still water forms a superb mirror for the sky. The best conditions occur at morning or evening when there is no wind, or on sheltered stretches of water which are free from ripples. Effects are particularly striking if the main land mass is in shadow. Avoid having both reflection and sky competing equally for attention. An extra element, or appropriate proportioning within the frame, will help break excessive symmetry of composition.

Nikon, 28 mm, FP4, 1/125 f11

Choosing subjects and angles

Architecture is full of excellent subjects for photography, but it is a field which needs considerable thought. A knowledge of architectural styles and an appreciation of the atmosphere is essential, together with an awareness of practical considerations. The light may be best for a particular facade on just a few days in the year and the photographer should know when these will be. The function of the building frequently determines the way it should be shown – a cathedral interior, for example, is characterized by soaring arches and vaulting and this effect can be ruined by cropping. Do not limit yourself to grand structures. Ordinary houses and streets offer as many opportunities and often a great deal more freedom for interpretation. Viewpoint is of great importance. The square-on, frontally lit view of the house, right, emphasizes the extraordinary symmetry of its architecture and setting. The picture, below right, uses line, tone and shape to lead to an appropriate focal point. A range of lenses and a camera capable of movements are useful in the manipulation of shapes and lines.

Above right: Pentax, 55 mm, Plus-X, 1/125 sec f11
Right: Nikon, 28 mm, Tri-X, 1/30 sec f16

Avoiding the obvious

Wherever possible you should give a personal interpretation of a building or environment. Try to avoid the obvious pictures of well known sights which have been taken so often before. The unusual angle of the picture, right, adds interest to the often-photographed baptistry at Pisa. Try and relate a building to its surroundings. Search out detail which reflects your own reaction to the place. This Montreal barber's shop, center right, provides a souvenir of the city very different from, say, the relics of Expo '67 or the Olympic Stadium.

Right: Nikon, 28 mm, FP4, 1/250 sec f8
Center right: Leicaflex, 50 mm, Ektachrome-X, 1/30 sec f5.6

Pattern in architecture

Architecture is full of patterns which may be determined by building materials; local methods of construction; the building's actual use; or by time-honored designs characteristic of a building's function. The mosaic decorating the hotel window, above, is a modern embellishment around a traditional design. Try to find a pattern which sums up a locality, then choose camera angle and lighting to present it in an interesting way. The different tone values on each face of the buildings, right, provide depth, while the receding planes give variety to an otherwise severe pattern of windows. The picture is tightly cropped to suggest that these structures continue endlessly.

Above: Pentax, 135 mm, Tri-X, 1/250 sec f5.6
Right: Leicaflex, 250 mm, Tri-X, 1/250 sec f8

Urban landscape

The shapes and lines of city architecture lend themselves to dramatic images. Take your camera whenever you visit a city for the first time; watch for the complex mixture of styles and patterns which people who know the city may take for granted. Simplify your images as much as possible; select viewpoint carefully and plan the day so as to make best use of the lighting, below. Remember the value of archways and windows for framing; use lead-in elements to link foreground to background and place important features on the skyline. The severe lines of modern architecture, right, offer you strong geometric shapes which can be contrasted with buildings from other periods. Above all, try to convey the atmosphere of a particular building or street or district.

Right: Leicaflex, 28 mm, Plus-X, 1/125 sec f8
Below: Leica, 21 mm, Tri-X, 1/250 sec f11

Urban contrasts

You can often make a strong visual statement about a place by drawing comparisons and showing contrasts. These can range from the simple relationship of young and old parts of a city, to the comparison of complete life styles. The brash cut-price supermarket can be contrasted with the traditional family store, below; homes which are loved and cared for can be contrasted with decay and neglect. Decorations and embellishments, crafts and occupations, transport, recreation and entertainment are valuable themes.

Top: Nikkormat, 50 mm, FP4, 1/125 sec f8
Above: Pentax, 135 mm, HP4, 1/250 sec f5.6

People in cities

Cities and buildings are essentially to be lived in, and people will give vitality and atmosphere as well as scale to your urban shots. Sidewalks, plazas, shopping centers and stations are intended to be busy with people and may appear sterile when empty. However, try not to let individual characters dominate the scene. Choose a distant viewpoint or arrange that nearby figures are seen from the rear or shown in silhouette. Blur can sometimes be allowed to separate moving figures from stationary ones.

Pentax, 35 mm, Tri-X, 1/250 sec f11

Urban detail

Another approach to the city is to photograph some of its human touches and idiosyncracies without actually portraying people themselves, left. Worn steps, the much fingered door, names over bell-pushes, papers through mail boxes can say a lot about the occupants. Graffiti, advertisements and public signs suggest attitudes and lifestyles. A cheerful window can belie the drabness of a neglected building. All these commonplace details are strengthened if they are used in sequence. Try a series of doors or windows. Choose viewpoints which make the most striking similarities and contrasts. You can do this by identical positioning in the frame, or by repetition of shape, scale or color scheme.

op: Nikon, 50 mm, Plus-X, 1/125 sec f4
bove: Pentax, 55 mm, FP4, 1/60 sec f8

Top left: Pentax, 135 mm, Tri-X,
1/250 sec f5.6
Left: Leicaflex, 50 mm, FP4, 1/125 sec f4

Portrait basics

You cannot photograph portraits without taking character into consideration as well as appearance. Your picture should convey the mood of the sitter – vivacity, introspection, humor, arrogance and so on. Successful portraiture calls for a combination of technical know-how, an interest and response to people, and understanding of the inhibitions which the camera may impose. Try to ensure that the subject wears clothes which suit him or her. Choose a background appropriate to the clothes, and the tone of face, but avoid plain black or white unless this is essential for a low or high key effect. Remember that a long lens and distant viewpoint help to suppress forward projections such as the nose. It also prevents the subject from feeling crowded in with equipment. Focus always on the eyes. Light to give only one set of shadows and go for a simple arrangement which allows the sitter some freedom of movement. Try to sort out your technical calculations in advance, so that when shooting you can concentrate fully on the subject's expression.

Capturing a spontaneous expression. When he took this picture of actor Tom Courtenay the photographer was talking to him from the camera position. Expression was therefore generated spontaneously. The lighting consisted of one electronic flash with umbrella reflector about 2 ft (65 cm) directly above the camera.

Bronica, 180 mm, FP4, 1/60 sec f16

Expression in portraits

An interesting and characteristic expression is essential to a good portrait. Provided depth of field and lighting allow the sitter reasonable flexibility of movement you can keep the camera on a tripod, use a long cable release, and carry on a natural conversation. To make the subject look to the left you move to the right of the camera; to make him or her look up you stand tall, and so on. In this way the issuing of instructions becomes unnecessary. Your general manner is of great importance. Discover the sitter's interests and try to put him or her at ease; minimize photographic technicalities and make the environment as comfortable as possible. Electronic flash helps here, with its freedom from heat and continuous glare. To change view-

point rotate the sitter's chair, keeping it sufficiently distant from the background to avoid casting a shadow. Minimize your lighting changes, shoot plenty of film as wastage is bound to run fairly high and above all enjoy yourself. The atmosphere of the session will inevitably affect the results.

Portrait series. For this series of portraits one diffused electronic studio flash was positioned slightly above the camera, either full frontal or moved to one side with a corresponding reflector.

All pictures: Hasselblad, 180 mm, FP4, 1/60 sec f11

Informal portraits

Informal portraiture away from the studio allows you great scope for adding touches of local environment. At the same time you cannot afford to be quite so concerned with details of lighting and composition. You must choose the moment which captures expression and momentary pose together, as in the portrait, right. Be prepared to make rapid decisions on the use of existing shapes and lighting to form an image which is interesting and strong. This usually involves compromise relative to the controls you would normally exercise in the photographic studio. Sometimes by working in close-up and using existing light, below, it is possible to achieve a result similar to studio conditions, but with the bonus that the sitter is more relaxed.
See: Lighting for portraits

Pentax, 35 mm, Tri-X, 1/125 sec f5.6

Natural lighting for informality.
The portrait of this artist, left, reveals his contemplative mood during a break from work. It was lit by strong, diffused light from a small window to his right. The blunt personality of inventor Percy Shaw is well conveyed by this full face portrait shot in natural lighting.

Left: Pentax, 135mm, Tri-X, 1/60 sec f8

Above: Bronica, 80 mm, HP4, 1/60 sec f5.6

Using familiar surroundings

People generally feel more relaxed and at home among familiar surroundings, and their own environment yields information about their personality. Mrs Watt's achievement was the growing of plants. She was posed in her parlor, above, and photographed from a high camera position with soft, even lighting from reflected daylight to reveal plenty of detail in the cups, certificates and pot plants. Her concern for the bird in the cup helped to keep her mind off the photography. The extrovert personality of dress designer, Mary Quant, right, is well captured in this informal portrait taken in her own living room.

Above: Hasselblad, 60 mm, Tri-X, 1/60 sec f5.6

Right: Hasselblad, 40 mm, Plus-X, 1/60 sec f11

Backgrounds for portraiture

A portrait is more than just a good likeness; it should capture the personality of the sitter. Think carefully about background, whether you are photographing in the studio or at the subject's home. A plain background tends to isolate the figure and contributes nothing to the portrait. The simple chair and painting setting used, right, adds an historical interest to this family group; the viewer automatically starts to compare faces, styles of clothes and so on. The portrait was lit by daylight in the studio. Background should relate to but not dominate the sitter. For the portrait of Julian Bream, below, the guitarist was photographed at his country house. He is an enthusiastic gardener, so the inclusion of flowers was important, but notice how the open doorway deliberately emphasizes and separates the figure from the background.

Right: Hasselblad, 80 mm, Royal-X Pan, 1/60 sec f5.6

Below: Nikon, 85 mm, Plus-X, 1/30 sec f11

The working environment

The best setting for a portrait may well be the sitter's working environment. Writer Enid Bagnold, above, works in a study filled with the mementos of a busy life. The main problem with a cluttered setting like this is how to separate the figure from the surroundings. Soft frontal fill-in flash illumination directed toward the subject was the answer in this instance. The portrait of Selwyn Lloyd, right, was taken at the Palace of Westminster. The setting is simple but strongly identifies Selwyn Lloyd with his office as Speaker of the House of Commons. The portrait was lit by electronic flash.

Above: Hasselblad, 60 mm, Tri-X, 1/60 sec f16

Right: Hasselblad, 80 mm, Plus-X, 1/60 sec f11

199

Character in close-up

The emotions and moods reflected in the human face are subtle, fleeting and varied. Expression is most directly communicated by the eyes and mouth. You can simplify a portrait down to the bare essentials such as a characteristic grin, right, or the delicate relationship of hand to face, below, but do not crowd the sitter. Apart from creating self-consciousness, a close viewpoint gives uncomfortably steep perspective.

A good technique is to use a 2¼ ins sq (6 x 6 cm), or larger, negative to include head and shoulders, and then enlarge part of the image. Alternatively, use a long-focus lens and attach an extension tube.

See: Using lenses: the long lens

Right: Nikon, 200 mm, Tri-X, 1/60 sec f11

Below: Hasselblad, 80 mm, Tri-X, 1/60 sec f5.6

Unusual viewpoints

Do not become con-
ditioned by convenience,
the height of your tripod
or the design of your
camera into photo-
graphing everyone from
chest or eye level. Keep
an open mind about
viewpoint. The picture of
the painter Graham
Sutherland, right, was
taken looking down from
a balcony in order to
show his way of working
and the contents of his
sketch book. A low
viewpoint in the portrait,
below, allows use of the
oblique carpet pattern
and the line of the wall
to draw you toward the
shapes of the girl and the
chair. A white sheet was
pinned over the front
door to extend the plain
background and flash
was bounced from the
white ceiling.

Right: Bronica, 80 mm, FP4,
1/125 sec f8

Below: Hasselblad, 50 mm,
Plus-X, 1/60 sec f11

Babies

Babies make excellent subjects because they are expressive and not self-conscious. Do not try to pose them. A young baby will feel most contented in the care of its mother, right, or with familiar toys, but you will need patience and guile to capture a character-istic expression. Babies quickly feel uncomfortable under intense hot lights, so keep the session brief. The pictures, right, were taken with electronic flash using an umbrella reflector and a modeling lamp. Keep to a lighting scheme which allows freedom of movement and view-point without constant adjustments.

All pictures, right: Pentax, 55 mm, Plus-X, 1/60 sec f11

Children

From the age of about 18 months, when they can first walk and run, children become great exhibitionists and actors. In rapid succession they can be inquisitive, puzzled, absorbed, happy, sad and bored. In all these emotions they hold nothing back in terms of facial expression, left, because they are not self-conscious. Try observing children behaving naturally. They will soon forget the camera and the situation will take off by itself. You must be able to make quick decisions and work fast – there will be little time for changing focus or exposure. As children enter their teens they become more self aware, often shy and introspective. Try to convey these moods in your pictures. For the photograph, opposite, the space left around the child, the gentle illumination – daylight from an attic window – and the subdued tonal range echo the girl's posture and appearance.

Right: Hasselblad, 40 mm, Tri-X, 1/60 sec f4

Left: Pentax, 135 mm, HP4, 1/250 sec f8

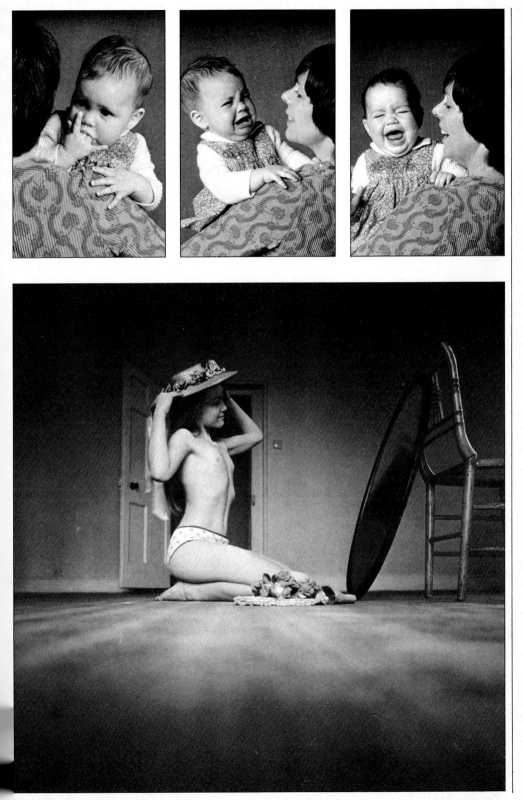

Shooting on sight

Watch for details in the lives of the people around you. A candid picture can capture a relationship, right, or a reaction, below. Try carrying your camera set to stops which are approximately correct, say 1/250 second at f4 for 400 ASA film and focus it at about 8 feet (2.5 m). If a situation suddenly develops in front of you, below right, expose one picture immediately, then take others at the proper settings. Sometimes you can pre-set the controls accurately. Take a reading from the back of your hand as an equivalent to the subject's face. Estimate how many yards he is from you and set this on the focusing scale. You can then raise the camera, turn and take the picture instantly. If the subject is moving steadily you can focus on the ground and wait until he reaches this point. You can also shoot from the hip or through a gap in your coat – the method used to obtain the picture, below opposite.

Mirro-Tach 90° attachment.
This attachment looks like a telephoto lens. It is in fact a mirror which pushes over the normal camera lens and allows candid pictures to be taken at right angles, through a hole at the side of the lens barrel. The "lens" at the front is a dummy.

Above: Pentax, 85 mm, Tri-X, 1/250 sec f4
Left: Nikon, 135 mm, HP4, 1/250 sec f5.6
Right: Leica, 90 mm, Tri-X, 1/250 sec f8
Below: Pentax, 50 mm, FP4, 1/60 sec f8

A composite face

The more you involve yourself in portraiture the more fascinating the study of human features becomes. You can investigate through your photography national or family similarities; character-revealing traits; the shape and proportions of basic types of faces and the effects of aging. For example, try making a series of portraits of all the members of one family, lit, posed and printed to allow direct comparison. You can even combine images into composite portraits like the one, below, which mixes the features of three artists, Henry Moore, Pablo Picasso and Francis Bacon. Each was originally a head and shoulders portrait taken looking straight into the lens and lit by soft frontal daylight. The Henry Moore negative was set up in the enlarger and the position and separation of the eyes carefully traced on to the easel. First the printing paper was exposed to this negative and

given 4 seconds exposure (10 seconds would normally be correct). It was then returned to the box while the second negative was set up so that the eyes occupied exactly the same position. This negative was then exposed on to the same sheet of paper and given 3 seconds exposure. The third image was exposed in the same way. The result is an interesting unreal face in which the characteristics of all three individuals can still be discovered.

Arranging groups

People with similar interests are often photographed in groups. As a rule they enjoy it because the group gives them a sense of communal identity and makes otherwise shy individuals feel self-possessed. It is important to try to show the activities of the group or the occasion that has brought them together. The group's members may have some form of uniform, or at least dress for a particular sport or occasion, such as a wedding, and if this is the case they should be photographed in the appropriate clothes. Try to set your photograph against a background which adds information about the people, such as the view of the valley behind this Welsh village choir, right. If you are organizing a formal group like the one photographed below, arrange people in rows but give them some focal point, perhaps center front. You can then have one row of people sitting, one row standing, and if necessary another row standing on chairs. Try to have the tallest people at the back. Raise the camera as high as possible so that everyone's face is clearly seen. Gaps in the foreground can be filled with instruments, sports equipment, shields, cups and so on. Individuals can be left to position themselves for an informal group picture, but, even so, try to compose the shot with one person forming the center of interest, and make sure there are no inappropriate gaps. The best lighting for groups is even, diffused sunlight. Avoid shadow patterns from trees or buildings and direct sunlight which either casts hard shadows on one side, or dazzles everyone and makes them screw up their eyes. Direct your group and give them clear instructions as to what they should do: all shout or all sing, or all look at the camera or at each other. Take plenty of pictures because there is almost certain to be someone with his eyes shut or looking away.

Above: Hasselblad, 80 mm, Tri-X, 1/30 sec f16

Right: Nikon, 85 mm, Tri-X, 1/125 sec f8

Composite groups

A group portrait can be constructed from a series of individual portraits. These are most effective if they have a common theme or link – in this case the chair. You can take a number of shots of each member of the group, and thereby create a final composite which contains a characteristic likeness of every individual; this is almost impossible to achieve in a conventional group portrait. You can construct groups from people who are difficult to assemble in one place, members of a large dispersed family for example. It is best to use one simple prop like the chair on this page. Mark the floor so that you always get the prop in the same position and make another mark for positioning your tripod. Keep the lighting as simple as possible and always use the same exposure.

All pictures: Hasselblad, 60 mm, Royal-X, 1/60 sec f16

Self portraits

Self portraiture is a great challenge, which calls for patience and one or two technical aids. You can photograph yourself alongside the camera in a mirror, then print through the back of the negative to correct the image and trim off the reflection of the camera. Alternatively, prop a mirror up behind the camera, focus the lens and use the mirror to pose yourself. If your camera does not have a delayed action device, expose with an extra long cable release.

Programming your own face.
The self portrait, right, was taken by a "Print-Me" computer read-out machine. You stand in front of a television camera, check your position with the image on a monitor, then press a button to transfer the picture to a digital computer. This analyzes tone values, and converts them into an assortment of letters and symbols which are printed out in ink on to paper.

Taking your own picture.
For the picture, below left, the photographer posed using a mirror propped behind the camera. If you are unable to manage this you can go to an automatic booth which uses a single electronic flashgun to produce the harsh result, below right.

Pentax, 50 mm, Tri-X, 1/30 sec f8

Recording a family trip

Vacations for most people provide the year's main opportunity for taking photographs. You can produce a visual log book of your travels, but unless you take great care this can result in a succession of static posed shots. It can be more interesting to try to combine people with places, and to choose angles, details and effects of light which record memories and impressions. The best approach is to carry a lightweight direct vision camera with a built-in meter at all times. You are then ready to record the scenes, incidents and nuances of atmosphere – however fleeting – that will evoke strong memories

at a later date. It is important to keep equipment to a minimum, but it is well worth carrying a small flashgun, because this can light even a large interior. Do not make the mistake of only shooting in bright sunlight. Some of the most evocative shots can be taken after dusk or in bad weather. The pictures on this page are a selection of scenes from one family trip.
See: Direct vision cameras/ Lighting large areas/Using the weather

All pictures: Pentax, Ektachrome-X

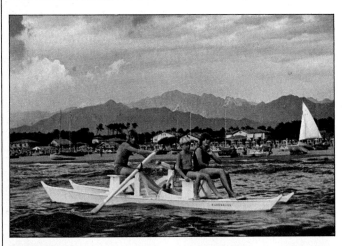

People and events

Ceremonies and celebrations of all kinds offer great scope to the photographer. Decide whether you want to treat the subject formally or informally. When you want formal shots you must yourself behave formally, get the attention of your subjects and tell them where to stand, sit, which way to face and so on. Also take great care with the setting. For the picture of the Lord Mayor of London, center right, the dress, the items of regalia and the background were meticulously arranged. Informal shots of special occasions demand a completely different approach. You can gain your subject's attention, as in the shot of the priest, right, but have your camera pre-set and pre-focused so that you can take the shot immediately, before the subject becomes self-conscious. You can strike a balance between formality and informality if the subject warrants it. The setting for the group of English morris dancers, below right, evokes the historical traditions behind their dance, but the pose itself suggests the vigor and fun with which they perform. If an event is occurring in a grand setting, such as Caernarvon Castle, below, timing and viewpoint – in this case high on the castle ramparts – are paramount.

Top: Pentax, 28 mm, Kodachrome-X, 1/60 sec f5.6
Center: Hasselblad, 80 mm, Kodachrome-X, 1/60 sec f11
Above: Leicaflex, 28 mm, Ektachrome-X, 1/250 sec f5.6
Left: Hasselblad, 40 mm, Ektachrome-X, 1/250 sec f11

Setting up a studio

A studio is an area in which to take photographs under the most controlled conditions possible. In its simplest form it may be part of the garden – stretch a sheet on a clothes-line as a backdrop and use the sun as a spotlight, either direct or diffused by muslin. Mobile studios can be set up in large tents and you can even convert an old trailer or bus. Greenhouses and conservatories can be adapted with light-diffusing drapes to form daylight studios. But for complete control the studio needs to allow the exclusion of all light except sources introduced by the photographer. Ideally, the room should offer sufficient space for a full length figure to be photographed without recourse to a wide-angle lens. This requires a camera-to-background distance of at least 12 ft (3.6 m) and therefore, allowing for lights, camera space and photographer, a minimum room length of 15 to 18 ft (4.5 to 5.4 m). The studio's width should be at least half its length and the ceiling as high as possible. High ceilings allow high camera viewpoints and provide a surface which can be evenly lit to give soft overall "bounce" lighting. Room shape should be as simple as possible. Remove or box in alcoves, fireplaces and base boards to allow yourself more versatility. The window can be shuttered or covered with a blind. It may be useful as a light source or background, but if the view outside is unattractive diffuse each pane with tracing paper. Walls and ceiling should be given a mat, washable white finish; colored surfaces will produce a cast in color photography. The floor should be non-slip, dust free and firm, as vibration causes camera shake.

Electricity

The room will need plenty of electrical outlets. Decide which walls are most likely to be used as backgrounds and distribute your outlets around the remainder. Alternatively you can have one heavy duty outlet supplying a distribution box on a long cable. All lights can then be plugged into the distributor so that only one wall is disfigured by an electrical fitting. Check carefully that your full complement of tungsten and flash lighting will not overload the circuit. This is especially likely to occur on domestic premises. Remember that lamp wattage divided by supply voltage equals amps drawn. Check with an electrician if your total lighting is close to the limit. Another useful electrical appliance is a ventilator or air conditioner. Air quickly becomes hot and stuffy in a room full of tungsten lamps.

Backgrounds

The simplest background is the wall itself. Provided it is well behind the subject a white wall can be made to appear any tone from white to near-black, depending on how it is lit. Small still lifes can be set up on a suitable table, right. For full length figures, and any shot in which the floor becomes part of the background, a curved continuous surface is useful. Rolls of paper 9 ft (2.7 m) wide are available for this purpose. You can put the roll on the floor near the camera, then run the end of the paper backward and up the wall, taping it almost at ceiling level. Better still, use a roll-hanging wall bracket as described on the page opposite.

Studio accessories

The studio also needs space for props, set-building materials and reflector boards. The latter consist of hinged wooden frames about 6 ft (1.8 m) tall, covered on one face by white paper or painted plywood. They can be brought in close to a set to reflect light back into shadows, or to act as main light bounce boards. Plenty of boxes and wooden blocks are useful for supporting and raising objects or equipment. A small platform can be useful for the subject or camera. If space permits you can build a structure from miniature scaffolding to form a camera rostrum. You will need a cupboard to store props, such as antique and picturesque junk, pieces of well textured wood or stone, clothing, drapes and miscellaneous rolls of material. You will also need to store essential tools – hammer and nails, saw, tacking gun, adhesive tape, electrical screwdriver, clamps and supports, aerosol paint, modeling clay, pins, string, and so on. Finally, try to keep one corner of the studio as a dressing room. Have a mirror and sufficiently strong lighting for the model to get ready for the camera.

Still life table

Small still life objects can be set on a table, using as background a large sheet of paper raised and attached to the wall behind, but this restricts lighting opportunities because there is no room for a lamp at the rear. A free-standing table with an attached adjustable background support allows for lighting from all directions. A more sophisticated still life unit can be constructed with flexible, translucent plastic shaped in a curve. You can light this from the front or from the rear, so that small objects appear to float on a white or color filtered background without any shadows.

Adaptable still life units. The folding wooden table, above, has two uprights, drilled to carry a background paper support bar at any convenient height. The skeleton frame, below, holds a thick sheet of translucent plastic, curved to shape by a number of G-clamps.

Constructing backgrounds and sets

Rolls of paper, usually 9 ft (2.7 m) wide give you a choice of background color and tone and are free from seams and creases. The best way to use them in the studio is to hang one or more rolls on brackets almost at ceiling height. You can then pull down the free end to cover wall and floor. After use a chain system allows you to wind up the roll again. Alternatively you can support rolls of paper between a pair of poles braced between ceiling and floor. A complete background support for one roll can even be constructed on castors, allowing it to be moved about the studio. You may want to build sets which simulate the corner of a room, a window and so on. These can be constructed from timber "flats," like reflector boards, clamped together with doorway or window units. The front surface can be covered with pasted and painted wallpaper. Make sure that everything is well propped up from behind, and remember to leave sufficient space for lighting.

Coving. When a large object such as a car is to be photographed in a confined space, a continuous background may be required which will turn the angles at the corners of a room into gentle curves. Coving can be constructed, below, from plaster on a timber frame and the whole surface painted. The result is a huge area which can be lit to give the impression of infinite space.

Studio flash

Electronic flash for use in the studio operates from house current, and incorporates modeling lamps in each head to show the exact direction and quality of the lighting. There are two main types. Self-contained floor standing units use a power-pack which either forms part of the head or of the base. The more powerful console units have a large power-pack feeding through long cables up to six flash heads, which can be mounted on ordinary lighting stands. The console allows power selection for each head, and connects by a trigger synchronizing lead to the camera. Since both types of unit also have photo-cell slave triggers they can be fired in conjunction with one another.
See: Slave unit

Using a flash meter. In many ways a flash meter functions like an ordinary incident light exposure meter. The cell is covered with a white plastic hemisphere, and the meter is held at or near the subject pointing toward the camera. Some meters have their own synchronizing lead to the flash unit; you press a button on the meter itself to fire the flash. Other meters are switched on and left pointing at the subject while the flash is fired by hand, using the test button on the lighting head. The flash causes the meter needle to rise and

Equipping a studio. A studio should be versatile and simple. The one, above, has room to hang backgrounds and construct sets of varying complexity. Paper rolls 9 ft (2.7 m) wide are supported on expanding poles braced between floor and ceiling. The ends of the paper can be stapled or taped to the floor. The "flat" shown under construction is built from plywood on 2 x 2 ins (5 x 5 cm) wooden battens, and includes a frame with glassless windows. It is supported by an adjustable prop, held down by a floor weight. Carpet or plastic tiles can be placed across the floor to turn the studio into a room interior. Boxes, clamps, supports and plinths are useful for holding still life objects and lights. Larger platforms can be used for models to pose on. A step ladder is needed to renew background paper rolls or even support the camera. Two large white-painted flats can be hinged together to form a free-standing reflector screen.

register with a figure on a scale. When related to ASA speed this indicates the "f" number required for the flash. The meter must be reset after each light reading.
See: Incident light meter

Simulating daylight

Provided you are not too ambitious, you can produce some realistic outdoor or location effects in the studio. In this way you avoid the distractions and inconveniences of working away from base, and have complete control over every element. Observe natural daylight carefully and build up a similar effect with your studio lights. This need not be complicated, as the picture, right, shows. The patch of light on the wall is created by a spotlight shining through a window-shaped cutout diffused with tracing paper. This also picks out the key color element – the red wine. Shadow detail is gently illuminated by bounce light off a reflector. Notice how the candle is placed in a tonally strong position to accentuate the bright flame. The rest of the illusion is created by a careful choice of props which harmonize in tone and color.

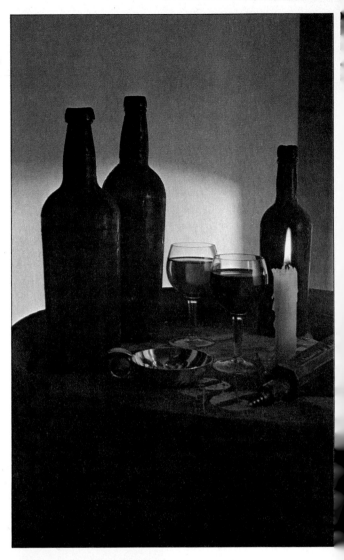

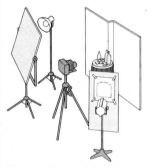

Strengthening candlelight with a studio lamp. To strengthen the candlelight, right, two exposures were given – 10 seconds with the candle as the only source of illumination, then another ½ second with the studio lamps switched on.

4 x 5 ins (10.2 x 12.7 cm) view camera, 180 mm, Ektachrome-X (type B), f16

Candlelight

Pictures can be taken by candlelight alone, which on type B color film reproduces with a characteristically warm cast. A single candle gives very high contrast lighting. This can be avoided by using candles in groups, or adding a little auxiliary studio lighting. The picture, far left, is a combination of 3 seconds at f8 for the candle, plus ¼ second using a flood filtered by orange acetate to illuminate the background. The portrait, left, was exposed by candlelight alone for 2 seconds at f2.8 spreading the highlights with a cross hair starburst filter.
See: Using candlelight

Both pictures: Hasselblad, 80 mm, Ektachrome-X (type B)

Daylight studio

The soft, even illumination given by diffused sunlight can be excellent for color. Look at the detail in the complex shapes of the flowers, left. The picture was lit by two windows above it and to its left, and by a silvered reflector used on the right to fill the shadows. The bottles, below, were arranged close to a tall, north facing window in a light toned room.
See: Reducing lighting contrast

Above left: Hasselblad, 80 mm, Ektachrome-X, 1/30 sec f5.6

Below: MPP, 210 mm, Ektachrome-X, 1/10 sec f16

Infra-red in the studio

You can create strange, macabre effects using infra-red Ektachrome film, although results are always difficult to predict with accuracy. Subject reds reproduce yellow, skin goes greenish, and many black materials appear maroon. You expose this transparency film through a yellow filter using daylight or flash. A deep green filter gives further interesting distortions. The effect can be made even more sinister by distorting the shape of the subject with an extreme wide-angle lens and using colored acetate over the lights. Bear in mind that the film is also very contrasty: the relative brightness of shadows and highlights will be greatly exaggerated.
See: Infra-red film/Special processing for infra-red

Leicaflex, 21 mm, infra-red Ektachrome, yellow filter, 1/60 sec f16

Creating nightmare with infra-red.
This girl was wearing red toweling and had her hands spread over black cloth. She was lit by two electronic flashes. The one low on the right was covered by orange acetate.

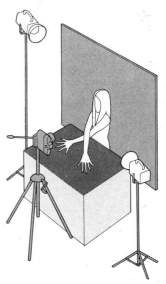

Reflective surfaces

Materials with polished, highly reflective surfaces are very difficult to light. In a still photograph confused reflections may interfere with the shape of a shiny object; the camera and the studio may be mirrored in the photographed surface. One way to solve the problem is to use a matting spray to diffuse reflections. This makes the material appear to have a satin rather than a polished finish. Another answer is to light through large diffusers hung around the set, or to surround it with large areas of white paper and bounce lights off the walls and ceiling. Place all equipment well back from the set to keep reflections small, and use a long-focus lens.

Glass

Good lighting should show the essential qualities of a material. In the case of glass this involves both its transparency and surface smoothness, as well as the shape and form of the particular object. As you can see from the displays in any good glass store, backlighting is a fine way of showing shape and delicacy through silhouette. In photography you need to go further and introduce roundness of form with controlled, reflected highlights. Notice in the picture, below, how a dark edge line has been introduced in each glass of wine. This is because dark areas at the base and left side of the set are refracted by the liquid.

Adding reflections

You can read quite a lot from a reflection appearing on a subject in a photograph. For example, close examination of the eye highlight in a close-up portrait usually reveals whether the light source was a studio lamp or the sun. Umbrella reflector flash-heads are easily recognized. In a similar way you can fake reflections to imply surroundings – an environment which does not in fact exist. Shapes to suggest windows can be set up in front of the main light. You can project color slides of scenery on to a screen to one side of the set. By keeping other lighting dim you can make these shapes appear realistically in the reflective surfaces of your subject.

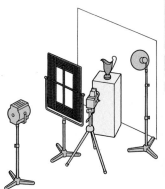

Photographing polished metal. The pile of kitchen equipment, above, was laid out on white paper 9 ft (2.7 m) wide, stretching forward about 10 ft (3 m) to the camera. Most of the studio ceiling was used as a bounce board for lighting. Direct light spill from these lamps to the set was prevented by diffusers.

MPP, 210 mm, Plus-X, ½ sec f32

Lighting glass to display shape and quality. The glasses and bottle above were set up about 4 ft (1.2 m) in front of the white studio wall. Two floods lit the wall evenly while a third flood, directed on to a white reflector board on the extreme right gave the glasses vertical highlights. A wide strip of black paper hanging on the left created the dark edge lines.

MPP, 180 mm, Plus-X, ¼ sec f16

Faking reflections in the studio. Apparently natural lighting through a window, suggested by the reflection in the jug is really a studio creation. A large sheet of translucent plastic diffusing material was marked out with narrow strips of black paper in the shape of window bars. This was hung in front of the main light source just outside the picture area to the left.

Hasselblad, 80 mm, Tri-X, 1/15 sec f11

Using a light tent

One of the best ways of producing soft, even lighting, free from shadows, is to build a light tent with your subject inside it. This is basically a cubic or conical enclosure made of plain white diffusing material. You simply drape seamless muslin from some simple external frame so that it surrounds the set completely, like a tent. Leave a hole big enough for the camera lens to look in . You then arrange various lights around the outside to illuminate the interior evenly. If subjects appear too "dead" and unnatural, sheets of gray paper can be placed inside the tent to give more controlled shadows and reflections.
See: High key

Moving the light source

You can often create a shadowless effect by "painting" a still life subject with a moving lamp during a time exposure. For this you need a studio which can be completely blacked out. Set up the camera and subject and stop the lens well down. Decide at what distance you will position the lamp, and measure exposure. Switch out the light, open the shutter, then methodically paint illumination over the subject. Keep the lamp moving slowly at a constant distance from the left of the set, over the top of the camera, to the extreme right.

MPP, 180 mm, Plus-X, 15 secs f45

Constructing a light tent. The light tent, above, was made by hanging muslin from a suspended hoop. A 2 in (5 cm) hole was cut out for the camera lens.

Shadowless close-ups. Small subjects photographed close up, right, are difficult to light from the front because of lack of space. You can of course use a ring flash, but there is a simpler way to produce flat, frontal lighting using a thin sheet of glass and a snooted spotlight. The glass is set up at 45° between camera and subject. Light from the spotlight reflects down on to the subject, with the camera lens also looking down this light beam.
See: Ring flash

Pentax, 50 mm macro, Plus-X, ½ sec f16

Light trails with flashlights

You need to work in a blacked out room or outside at night, using a dark background, a model who is prepared to stay still, and some small colored light sources. The camera is arranged to make two exposures on the same piece of film. One exposes the model, using flash or tungsten lighting; the other is a time exposure during which colored lights are moved around the background.

See: Flash techniques/ Photographing fireworks/ Recording trails of light

Rows of color.
Flashlights covered with colored acetates form small, mobile lights. Tape them together to draw several lines at once.

To form a simple background. Light your model by an electronic flash held above the camera. She must remain absolutely still during a time exposure while an assistant moves an array of colored torches in several complete circles behind her. Torches should be held so that the row is at right angles to the direction of movement. Hasselblad, 80 mm, Ektachrome X, 1/60 sec and 10 secs, f16 both times.

To create background and foreground. Use the same procedure, but with the assistant walking three times behind the model moving the torch array in a wave pattern at various heights. This must be repeated in front of the girl, right, taking care not to pass in front of her face. Hasselblad, 80 mm, Ektachrome X, 1/60 sec and 20 secs, f16 both times

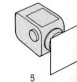

Sequence of exposure.
The easiest exposure routine is as follows, see right. 1 Mount the camera on a firm tripod and hold the shutter open on "B" but prevent light entering the lens with a black card. 2 Remove the card and make the flash exposure, using the open flash button on the head. 3 Cover the lens while the assistant and his torches get into position and begin tracing out patterns. 4 Expose long enough for the number of patterns required. 5 Cover the lens and close the shutter.

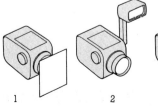

1 2 3 4 5

Pinpoint light patterns

This is a method of creating a background of nebulous, overlapping disks of light. You need a backdrop containing many bright highlights – perhaps a window covered with black paper pierced by many irregular holes, or crinkled aluminum foil lit from the front by a distant spotlight. The background must be some distance behind the main subject so that light specks are completely out of focus and "spread" when the lens (used at widest aperture) is focused on the subject itself. A pierced window screen background was used, right and above. The model was lit with one floodlight adjusted

in distance until, looking through the camera, a good visual balance was established between face and light disks. **See:** Depth of field/ Circles of confusion

Pinpoint light sources with masks

Out-of-focus light specks always spread into circular disks, matching the shape of the lens diaphragm. If you cut a simple shape from thick black paper or foil, placing it just in front of a wide aperture lens, ideally held in place with a filter holder, all out-of-focus highlights take on this new shape. Any part of the image rendered sharply however shows no change (note the highlights in the girl's eyes). These three pictures used the pinpoint light source method, above, but with masks of different shapes placed directly in front of the lens. For these shots a through-the-lens meter read exposure off the

model's face. **See:** Depth of field/ Circles of confusion

Circular masks. To make a circular mask use a compass with a scalpel blade instead of a pencil. Be sure to cut cleanly.

Masks of any shape. To make other shapes, use a template first drawn on paper, or look out for shapes of appropriate size in magazines.

View camera facilities

The large format monorail camera has several unique practical features. Its range of bellows allows you to use the lens close to the focusing screen or racked well forward for focusing on very close subjects. Its camera movements are unrivaled by any other design. The focusing screen is large enough to measure, and mark in wax pencil, exact image sizes, special proportions, page lay-outs and so on. Individual exposures can be processed separately to give just the development required, and you can check each result as you go along.

Using shift movements

Parallel movements of the front and back of the camera have the effect of shifting the position of the image on the focusing screen. Rising and drop front move the picture vertically; cross front shifts it horizontally. Shift movements are most often used to produce parallel vertical or horizontal lines in architectural photography. You must use a lens which has ample covering power because it is forming an image from an off center position. If your lens normally only just covers the picture format these movements will produce poor definition or vignetting

Marking the focusing screen. You can use cross and drop front for special effects. The girl, below, was photographed five times on one sheet of film. The position of her head was marked each time on the focusing screen, above, and the lens was shifted appropriately.

Sinar, 180 mm, Tri-X, each 1/60 sec f11

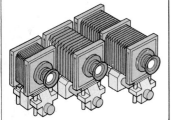

Using the bellows for focusing. The illustrations, above, show how you can use the bellows to vary the distance between lens and film to facilitate focusing. The front and back standards, carrying lens and focusing screen, can be offset or tilted relative to each other to give a variety of camera movements.

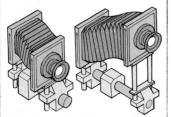

Shift movements. Shift movements can be made at the front and back of the camera. The lens panel remains parallel to the focusing screen but no longer centered on it, above. This gives cross front, left, rising front, right, or drop front. Shifting the front one way and the back the opposite way allows offsetting by several inches.

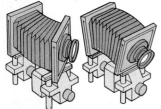

Swinging and tilting. Swing movements, left, and tilt movements, right, of the front and back of the camera are made from pivots positioned either just above the monorail or level with the lens. You can swing the lens one way and the back another to give extreme convergence.

Keeping verticals parallel. Drop front, near right, and rising front, far right, enables you to photograph objects, from high and low viewpoints respectively, without tilting the camera and causing vertical lines to converge. The picture below was photographed without using movements. The one bottom right was shot from a higher viewpoint, showing more of the lid, but using drop front to avoid tilting the camera.

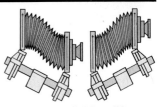

Sinar, 210 mm, Plus-X, 1/5 sec f32

Using swing and tilt

Swinging or tilting the back of the camera, near right, alters the distribution of depth of field and also the shape of the image. For example, you can position the back so that the part of the film receiving the image from a close subject is further from the lens than the part receiving a distant subject. This greatly increases depth of field. Swinging or tilting the lens, far right, helps control depth of field, according to the Scheimpflug principle. It also improves image coverage when you are using extreme shift movements.
See: Scheimpflug principle

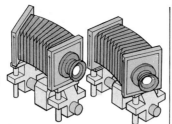

Image coverage with swing and tilt.
Swing and tilt movement of the camera back makes no extra demands on image coverage, since the lens remains centered on the film. However, any use of swing or tilt front which directs the lens off center requires ample lens covering power.

Matching sharpness to the subject. With swing front or back you can maneuver the zone of sharpness so that it suits the subject. The picture above was shot without camera movements; sharpness is limited to a narrow horizontal band which cuts across the main area of action. In the picture below, exposed at the same aperture, the back has been swung until the bottom left corner of the film is further from the lens. The zone of sharpness now runs diagonally along the area of action.

Both pictures: Sinar, 180 mm, Tri-X, 1/8 sec f5.6

View camera techniques

Although a view camera is large and unwieldy, it offers certain special advantages. For example, architectural photography and still life studio work often call for movements beyond the range of a small camera, even one fitted with a shift lens. If you intend to make maximum use of the camera's movements a lens of good covering power is essential. This is independent of focal length – the lens must be constructed and its aberrations corrected so that it can be used well off center and still deliver a full image. The lens below left, lacks the covering

power needed to produce a complete image when the camera back is shifted to any great extent, above right. When buying a lens always check the limits of its (circular) covering power by checking a distant subject at maximum rising or cross front.

Photographing to a lay-out

You may want to build up a very carefully considered arrangement in front of the camera to fit a sketched lay-out, say for a page in a mail order catalog. The large focusing screen allows you to overlay a tracing, then place each subject element so that it occupies just the right position in the picture. Another way is to darken the studio and, with a flood behind the focusing screen, project the design on to the background. The view camera is also very useful for copying, since it allows you to use a wide range of emulsions of various contrasts and color sensitivities, and to process these individually. The large negatives are ideal for retouching, blocking out with photo-opaque, masking and so on.
See: View camera/Architecture/ Still life/Shift lens/Negative retouching/Masking

Still life with food

Food is well worth exploring as a still life subject. The shape, pattern, color and texture of fruit, fish and fowl, or even manufactured foods can all be built into very satisfactory images. Start with as wide a variety of shapes as possible, selecting from vegetables, meat, cheese, fruit, seafood and so on. Use food only of the finest quality. Grouping might be formal and mannered, or in apparent disarray. You can add figures and environment to build up an idea such as a gastronomic banquet, country cooking, a picnic and so on. The people you show may have grown the food, or cooked it, or are about to eat it. Choose the setting carefully, so that it does not compete with the foods themselves. Props, such as dishes and cutlery, should be appropriate to whatever atmosphere you are trying to create. Use a large or medium format camera on a tripod. Avoid any form of parallax error – you need to be able to check the juxtaposition of items with great accuracy. Build up the picture bit by bit, showing variety but grouping items within a unifying, overall shape. Consider framing everything within a table, tray, or some form of container. In general keep to simple, diffused lighting. **See:** Still life/Parallax

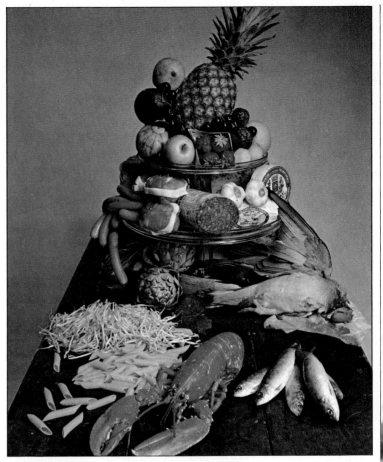

Setting up a still life food shot. The foods above were arranged in the studio on an old kitchen table and a two-tier glass cake stand. The backdrop was gray paper. Three electronic flash units lit the set from behind a stretched muslin frame on the right and there was a large white reflector on the left.

Enhancing the appearance of food. Foods often require cosmetic treatment, such as color dyeing, glycerin coating for shine, or induced condensation. Here the picture was set up with empty bottles, then the real bottles and glass were brought from the refrigerator to the warm studio just before the picture was taken. It was lit by diffused electronic flash with a mirror arranged to give fill-in.

Linhof, 120 mm, Ektachrome-X, 1/60 sec f16

MPP view camera, 180 mm, Ektachrome-X, 1/60 sec f22

Cookery photographs

Photographs of food cooking or recently cooked must be faithful as well as attractive. Tricks can be used to make a photograph, as in the picture of crêpes suzettes, above, but the end result must be a realistic portrayal of the way the food would look if cooked, prepared and served in the orthodox way. Cooked food generally looks best against dark, especially red and brown, backgrounds, but bear in mind that most food is seasonal. Cold food and white wine look good in a light summery setting. Keep lighting simple, and avoid complex shadows.

Photographing crêpes suzettes. The recipe for crêpes suzettes was followed except for the substitution of methylated spirit for Grand Marnier. The spirit produces a longer-lasting brighter flame, but records the same color as Grand Marnier. A cookery expert made sufficient crêpes for at least eight shots, 1.
A dark background was needed to set off the flames, so a sheet of dark flame proof laminate with a hole cut for the gas burner was used for the background. The set, 2, was kept scrupulously free of grease. When it had been composed some experiments were made with lighting arrangements.
An exposure of 4000 joules at f32 was given by the flash meter. At f5.6 an exposure of 30 seconds was needed to record the flames in the pan. Experiments with increasing amounts of methylated spirit – applied to wadded cotton underneath the crêpes – eventually produced a 30 second burn. The modeling and other lights were extinguished and the pan with crêpes, sauce and methylated spirit was set alight, 3. With the shutter set on "B" the flash exposure was made in order to record the crêpes before they burned. Then with the shutter still open the lens was opened to f5.6 for the long exposure.

Sinar, 240 mm, Ektachrome, 30 secs f32 and f5.6

Double exposures

Photography is a powerful medium for creating illusions, because people tend to regard photographs as authentic. You can make backgrounds appear through people, cause objects to fade out in mid-air, or superimpose one image on to another. Most of these effects are achieved through double-exposure, which means either exposing two images on top of each other, or exposing two images side by side. You can usually bypass the double exposure prevention mechanism, if your camera has one, by depressing the rewind button when you wind on after taking the first image. Check this with a length of scrap film first.

Remember it is always the light parts of one image which show through on the other. Dark areas tend to be lost. You might, for example, want to show a ghost-like figure through which background detail can be seen. Set up the figure and background normally but divide the exposure into two halves. After the first half of the exposure the figure is removed, so that during the second half some background is recorded over the figure area. If the figure wears a white dress, as in the picture on the right, this will "burn out" most of the second image, whereas background will record quite strongly in places covered by darker skin

and hair. If your camera will not allow double exposure use slow film, the minimum amount of light and stop down the lens fully so that exposure times extend to several seconds. Using the camera on a tripod you can then hold the shutter open on the "B" setting simply covering the lens with black card while the model moves away. Another surreal effect, of the type shown below, can be achieved by making a double exposure. During the first exposure you mask one half of the lens; for the second exposure you mask the other half. In between you rearrange the subject – in this case the model walked out of the picture.

Superimposing images.
The girl was positioned with the doors open and a darkened room behind her. After 2 seconds exposure the lens was covered, the doors shut and the girl removed. Then another 2 seconds were given.
Rolleiflex, Pan-F, 4 secs f16

Using a mask. The picture on the right was photographed using a simple masking device made from an old film holder with two sheaths. The girl was arranged in the chair, then the

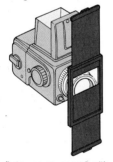

first exposure was made with the bottom sheath in place, above. Next, the top sheath was replaced and the bottom one removed, below. As soon as the girl had moved away the the second picture was taken, using the same exposure.

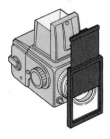

Hasselblad, 50 mm, Plus-X, total ½ sec f16

Simulating movement

Static objects can be made to appear mobile, simply by shifting the camera during exposure. For this to work well, choose a light-toned subject against a dark, uncomplicated background. Most tripods allow smooth pan or tilt camera movement, but for the picture, right, a slow electric turntable, below, was used. Exposure measured for the statue was two seconds so the shutter was set on "B". Two seconds exposure was given, then the panning motor was switched on and after a further second or so the lens was shut.

Spatial illusions

It is often necessary to create the illusion that an object is suspended in space. Although this may be achieved by retouching the final image, there are several ways of establishing such an effect at the time of shooting.

Movement by suspending objects. The camera has only one eye. Given the right viewpoint, it cannot see how objects presented to it are supported. You can set up a loaf of bread which appears to hover, or a model aircraft which flies through clouds. This can be organized by mounting the item on a horizontal metal rod which is pushed through background paper and clamped to a lighting stand. The support will be concealed by the subject, but make sure when you light the picture that the support forms no tell-tale shadow.

Suspending objects on a glass shelf. Objects supported on a horizontal sheet of glass will appear to float in space if they are photographed from above. The glass should be well above the background, which can be lit separately. Be careful to avoid reflections from the glass surface – if necessary surround the camera lens with black card. Remove all dust or marks from the glass and check this again just before exposing. Several sheets of glass can be supported in spaced out layers on notched wooden rods. Arranging objects on each shelf allows a three-dimensional table-top composition to be built up.

An image which defies gravity. Using the glass shelf technique you can build whole compositions on a horizontal plane, which are then photographed to appear vertical. The main purpose of this is to make liquids and solid objects appear to defy the laws of gravity. A simple "shelf" and a picture frame laid on a piece of wallpaper may be enough to convince the observer that he is looking at a vertical surface. Once again remember the importance of light for sustaining the idea; make it appear to come from an appropriate direction and height.

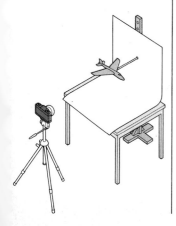

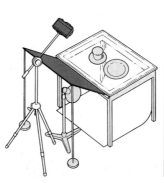

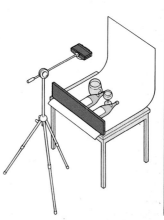

Approaches to fashion

Fashion photographs have to
satisfy two basic needs – to show
what a garment looks like, and to
associate it with the right mood
and atmosphere. Sometimes this
can be achieved with a very direct
image using simple lighting, right.
Alternatively you can build up an
interesting setting, using props
and additional models, below.

Both pictures: Hasselblad, 80 mm,
Ektachrome-X, 1/60 sec, (right) f16 ;
(below) f22

Lighting for detail and atmosphere.
The picture, right, typifies the detailed
objective approach to fashion required for
much mail order catalog and advertising
photography. Use of a plain background
and soft directional lighting shows the
texture and hang of the garment with
great detail. The picture was lit by electronic
flash used with a white-lined umbrella.
The picture, below, sets out to add
atmosphere and liveliness by means of
colored light and diffusion. It was lit by a
combination of flash and tungsten lamps.

Right: Hasselblad, 80 mm, Ektachrome-X,
1/60 sec f11
Below: Hasselblad, 80 mm, Ektachrome-X,
1/30 sec f1J

Ring flash for fashion

Lighting for fashion is as transient
as fashion itself. Ring flash, or at
least a flash placed as close as
possible to the lens, is frequently
used nowadays. The resulting flat
lighting and rim shadow on a
closely positioned background,
below, gives a cut-out appearance.
Most ring flashes are intended for
close-up work, so you may have
difficulty finding one powerful
enough for full length figure work.

Leicaflex, 50 mm, Ektachrome-X,
1/60 sec f4

Jewelry

You can use the human body as a jewelry display stand, right. This sort of shot is best lit by bounce flash directly above the lens. Otherwise you can construct a still life set-up like the one below.

Right: Hasselblad, 80 mm, Ektachrome-X, 1/60 sec f11
Below: Linhof, 210 mm, Ektachrome-X, 1/10 sec f16

Locations for fashion

The fashion photographer needs to know a wide range of suitable locations – interiors and exteriors, town and country. Sometimes a totally incongruous location can be used to give a surrealist effect, but for the most part you need to consider how the setting will suit the type of garment, color scheme and composition. The field, above, was chosen to emphasize the casual, outdoor appeal of the clothes. Hence the informal pose and use of a wide-angle lens to emphasize the grassy foreground.
Leicaflex, 28 mm, Ektachrome-X, 1/125 sec f11

Hair

Hair needs very careful lighting. The picture, left, was taken in the studio using diffused daylight from a large window, with a white reflector close to the back of the head. The location, above, was chosen for its harmonious color relationship with the hair.
Left: Mamiyaflex, 105 mm, Ektachrome-X, 1/15 sec f5.6
Above: Nikon, 50 mm, Ektachrome-X, 1/125 sec f4

Make-up for fashion and portraiture

Make-up is vital for fashion photography and it can also enhance a studio portrait. Make-up for photography needs to be more exaggerated than everyday make-up. Study the face carefully and bear in mind the camera angles you will use. Your aim is to accentuate the eyes, the bone structure and the mouth, and to balance the face by shading. As against round faces, long faces need more chin shading and the blusher applied higher on the cheeks. When you choose colors and tones remember that hair and eye color must blend with the make-up. Photograph make-up with a soft-focus attachment, or else over-expose a little. The make-up will then reproduce smoothly and appear like real skin, and blemishes will not be recorded. Use a hair band to keep hair away from the face.

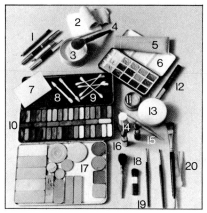

Make-up kit
1. Eye pencils
2. Head band
3. Loose powder
4. Brush
5. Moisturizer
6. Creme eye shadow
7. Mirror
8. Eye shadow applicators
9. Cotton swabs
10. Eye shadows
11. Foundation
12. Mascara
13. Sponge
14. Nail varnish
15. Lip brush
16. Lipsticks
17. Rouge and toners
18. Rouge brushes
19. Make-up brushes
20. Tweezers

Making up the eyes. After applying the foundations, powder the whole face with translucent powder. Then begin on the eyes. First use a dark eyeshadow to outline the eyes, below. Exaggerate the outer corners of the eyes, but follow the overall shape. Then apply a bright highlight, above the lashes and below the brow, bottom left. This, more than anything, helps to make the eyes the dominant feature in the face. Next, brush on a dark shader to amplify the socket line, bottom right.

Moisturizer and foundation. Always use a moisturizer before applying make-up. This softens the skin allowing you to apply make-up smoothly and easily. Foundations make the skin look smooth and cover up marks and blemishes. It is best to work with two foundations, above. Use a pale one – lighter than the skin – on the center of the face: forehead, nose, upper lip, chin and below the eyes. Then apply a darker foundation – matching the neck color – to the sides of the face and forehead.

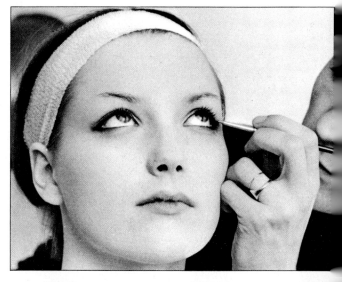

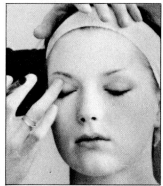

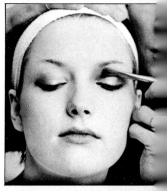

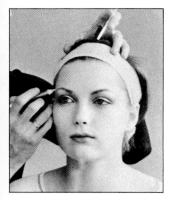

Eyebrows, lashes, cheeks and lips.
Use a pencil to lengthen and emphasize the eyebrows, left. Then powder the eyelashes so that they will not stick together when you apply the mascara, below left. Next, shade the cheeks by applying blusher to the area under the cheekbones, below. This will emphasize the bone structure and add color to the face. Now start on the lips, right. First, define the outline with a lip pencil. This should be darker than the lipstick so that the shape of the lips is emphasized or corrected. Then use a brush to apply lipstick over the whole of the lips. The outline will show through. If you want a more luscious effect apply gloss over the lipstick.

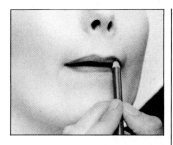

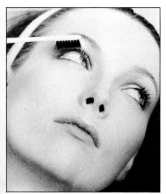

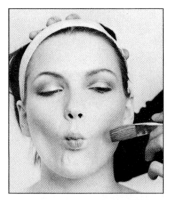

The final effect. Without make-up, below, the model is undeniably photogenic, but for the portrait or fashion photographer there is little shape or tonal contrast – the elements which a photographer can develop by using lighting, pose and viewpoint. When the model is made up, right, her bone structure is emphasized and attention is automatically drawn toward her eyes, the rest of her face seeming smaller in comparison. The face now has a well-defined shape, a dramatic area of emphasis and a high degree of tonal contrast.

Hasselblad, 150 mm, Tri-X, 1/125 sec f8

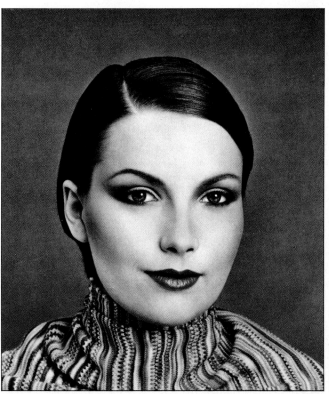

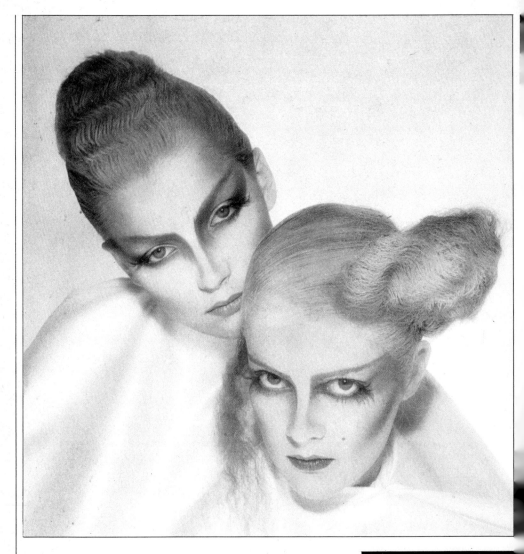

Make-up as art

The model's face is the important factor in portraiture and fashion photography, and the make-up is used to emphasize and regularize it. But make-up can itself become the important element, while the face becomes secondary, a canvas on which the make-up is painted. You can paint with make-up in two ways. You can take your model's features and exaggerate them to a level of hyperbole where they bear no relation to reality (The girl in green above, is the girl on the previous page.) Or, you can ignore the lines of the face completely, right, and treat the model as a pair of eyes, a nose and a mouth around which you can unfetter your imagination. In the picture, above, line is the most important element. The upward

sweep of the eye make-up is strengthened by the toning on the cheeks. Theatrical hairspray was used to blend the hair in with the monochromatic effect of the make-up. Because a translucent pastel appearance was required, the make-up was deliberately strengthened, so that the picture could be over-exposed by two stops. The make-up, right, again uses lines, but this time they disregard the model's features, spreading downward to broaden the face and portray a macabre, wistful sadness. The face was framed in black velvet.

Above: Hasselblad, 150 mm with soft focus attachment, Ektachrome-X, 1/125 sec f8
Right: Hasselblad, 150 mm, Ektachrome-X, 1/125 sec f11

Settings for nudes

Romantic settings are very effec-
tive, though they generally involve
a certain amount of contrivance as
in the carefully constructed flower
picture, below. A more natural
pose, bottom left, can be uninter-
esting against a plain background,
so an exotic setting was chosen to
emphasize the figure. Among
the attractions of nudes is shape,
and this can be emphasized by
contrasting the curves of the
human body with something man-
made and angular, right. There is
also great potential for humor in
nude studies. This was achieved
with the minimum of props in the
bathroom shot, bottom right.

Right: Pentax, 50 mm, Ektachrome-X,
1/60 sec f16
Below: Hasselblad, 150 mm, Ektachrome-X,
1/60 sec f11
Both pictures bottom: Hasselblad, 80 mm,
Ektachrome-X, 1/60 sec, (left) f5.6,
(right) f16

Nude composition

The nude provides innumerable opportunities for composition, and you do not need many props. Look for simple elements like the light cast by a skylight on a blank wall, left. This is used to create an image which has atmosphere and a subtle eroticism. The curving line of the girl's body follows through into the patch of light to convey a degree of movement. The window frame and the reflections, bottom, combine with the wistful pose to produce a romantic moody composition. Eroticism is again subtle, and is helped by the contrast between the ravaged paintwork and the young skin. Always remember the potential of close-ups, below.

Top left: Pentax, 55 mm, FP4, 1/30 sec f4
Above: Pentax, 85 mm, FP4, 1/60 sec f5.6
Left: Nikon, 50 mm, FP4, 1/60 sec f11

Lighting for nudes

Lighting quality and direction are of key importance when you are portraying the nude figure. Decide what function your lighting should perform in the picture. You can use a restricted light with a dark background tone to give a low key effect and an element of mystery. Or you can use rim lighting to emphasize the contours of the body and the velvet texture of the skin. You may occasionally need harsh spotlighting to emphasize the outline and shape of an isolated part of the body pictured in close-up, or to create interesting shadows. The picture below, uses lighting from both sides to show shape, texture and roundness of form. Diffused daylight from a window on the right is balanced by a reflector, close to the left, and well to the rear of the model. Notice how this lighting picks out even slight indentations made by finger pressure on the skin. The photograph, center right, uses wholly frontal diffused lighting and a dark background to place emphasis entirely on shape. In the picture, bottom right, the shadow cast by direct sunlight shows shape devoid of form or texture and distorts the human figure. The photograph right, is an example of the effects which can be achieved by projecting a color transparency on to a figure against a white studio wall.

Right: Pentax, 135 mm, Tri-X, ½ sec f5.6
All pictures below: Hasselblad, 150 mm, Plus-X, (below left) 1/30 sec f8;
(below right) 1/60 sec f3.5;
(bottom right) 1/125 sec f11

Using one projector

We are used to viewing transparencies projected on to a screen, but projected images themselves can be photographed. The technique opens up a whole range of special effects. As a simple example, you can project an image on to a conventional white screen and photograph it obliquely to distort its shape. Judge exposure by averaging the meter readings for lightest and darkest parts of the image just as though you were copying a photograph, but take care the meter does not read its own

shadow. A short time exposure may be necessary, so have the projector firmly supported and mount the camera on a tripod. Exclude light from the room, and if you are shooting in color use tungsten type film. Visual possibilities are further extended by projecting on to other objects, either flat or curved, right and below.
See: Viewing transparencies

Re-photographing a transparency. The drawing, left, shows how you can photograph a transparency projected on to any surface, in this case a curtain of white textured material. By using a long focus lens (135 mm, for example) the camera may be positioned sufficiently far back for it not to block the projector beam. Most modern slide projectors use lamps which have a color temperature suitable for tungsten light color film. Tests will show whether any corrective filtration is at all necessary.

Using a flat surface. Here the image was projected on to the blackboard. A masked down flood picked out the wall.
Nikon, 135 mm, Ektachrome (type B), 1 sec f11

Using a curved surface. In this picture a transparency of a girl was projected on to a lace curtain draped against black paper.
Nikon, 135 mm, Ektachrome (type B), 1 sec f16

Using a three-dimensional surface. The projector lens was racked forward to focus a small image on to this plastic cup.
Pentax, 50 mm macro lens, Ektachrome (type B), ¼ sec f16

Using two projectors

Photographing projected images becomes much more interesting if you can use two projectors. These should be of the same make, or at least use the same lamp. Both machines should project separate images which are superimposed on a common screen. In this way the light parts of one image show up in the dark areas of the other. Where necessary you can mask off the light beam of either projector so that overlap only occurs where it is wanted. With this technique you can form interesting pictures or vignettes.

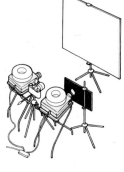

Superimposing images. A close-up of a child's maze was projected on to a transparency of a silhouette. The light beam from the maze projector was vignetted to prevent its image extending outside the head shape. Leicaflex, 135 mm, Ektachrome (type B), ¼ sec f8

Multi-projectors

The more projectors you have available the greater the flexibility to create combined images. Zoom lens projectors are particularly useful because you can adjust the size of each image element quickly and with precision. However, projectors with ordinary lenses can be positioned to give correct size; they should be individually supported on stools or small tables. Build up one element in your picture at a time. Mask off unwanted images by means of a shading device mounted fairly close to the projector lens. If one element is too bright relative to another use a neutral density filter over the projector lens, or reduce the lens aperture with a black cardboard stop. Individual projectors can be fitted with color filters or diffusion devices, thrown out of focus or moved during exposure. Work on a reasonably large screen size, about one meter wide, so that your equipment is not too cramped. Bear in mind that every projector creates a small amount of light spill from ventilators and slide gate and this light can build up in the studio until it begins to dilute the image on the screen. For the best results use as few projectors as possible.

Building multiple images. The picture, bottom right, was constructed from the four transparencies below. Each was projected separately and the four were superimposed on the screen. The sunset and the rainbow were both 35 mm direct color transparencies. The studio shot of the mug was 2¼ ins sq (6 x 6 cm). The floodlit buildings were a transparency of a black and white print. Notice how every picture has a black background or is predominantly low key.

Setting up projectors. The arrangement of the projectors was as shown below. Room was allowed for setting up masks and hand shading individual projector beams during the exposure. A long-focus lens enabled the camera to be placed well back behind the array of projectors.

Masking the projector beam. Projector beam masks can be cut from black card, or you can use your hands as a shade. A mask close to the projector lens gives general shading, whereas a shaped mask further from the lens has a local effect. The shading device should be kept on the move throughout exposure to soften shadow edges.

The final result. First the buildings, sunset and rainbow were projected and combined, with unwanted overlaps shaded out. The three images were shaded in one corner of the screen to allow plenty of space for the mug.
Leicaflex, 135 mm, Ektachrome (type B), ½ sec f11

Effects with water

Water offers almost as many visual possibilities in the studio as it does on location. A shower spray or garden hose can be used to simulate rain; shot in close-up with studio electronic flash the fast-flying droplets record sufficiently blurred to look real. A shallow tray of water can be used to fill the foreground of a shot with a reflection of the main subject. Objects, or photographs of objects, can be placed under water in a sink and shot looking down through gently disturbed water to distort shape. But whenever water is used in close proximity to electrical equipment special safety measures must be taken. Wrap electronic flash gear in clear polythene; make sure the leads are off the floor and keep lights and camera well separated from wet areas. If you cannot work in a bathroom or shower-room, cover the floor with plastic sheeting and have some container such as a child's wading pool to catch the water.

Simulating a river. The picture, below, was set up in a large wading pool. It was filled to a depth of about one foot (30 cm) with warm water. The girl's head was supported on foam plastic and the water liberally strewn with petals and flower heads. Illumination was soft and diffused and the camera positioned to show some light reflected from the water surface itself, giving a high key picture. Hasselblad, 80 mm, Plus-X, 1/60 sec f11

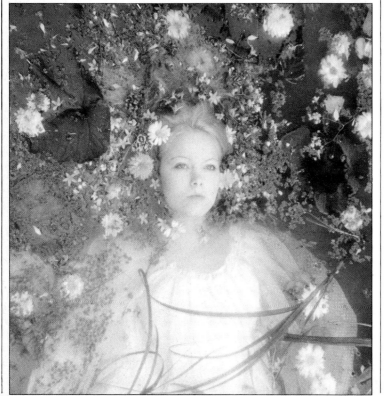

Weather effects

You can improvise a whole range of weather effects in the studio, or you can use special equipment. Most of the machinery can be hired from firms servicing film and theater productions.

Wind
For close-ups, a hair drier or domestic fan on full power is often sufficiently powerful. But for larger sets, where perhaps garments and hair on a full length figure must be blown, you need a floor mounted "wind machine." This is a variable speed fan unit, with blades heavily screened by wire guards.

Mist
A block of solid carbon dioxide ("dry ice") placed in a pail of water will generate a heavy mist which gradually climbs over the sides of the bucket and forms a layer a few inches deep across the studio floor. A mist generator performs the same function: it douses solid carbon dioxide in warm water when a handle is pulled.

Mist generator

Snow
You can buy ground up polystyrene or make it by feeding packing pellets through a grinder. To create a full scale blizzard gently tip the material off a flat sheet into the air flow from a wind machine.

Cobwebs

Cobwebs can be spun from a simple machine comprising a small fan with a centrifuge on the end of its shaft, below. You fill the centrifuge with a thin mixture of rubber solution. When you switch the fan on the solution exudes slowly from slots and is wafted by the air stream into long thin strands which attach themselves to whatever surface or object the machine is facing.

Cobweb spinner

Simulating cobwebs. It took two large cans of rubber solution to give this cellar its coating of fake cobwebs. Fine dust blown from a garden syringe thickened their appearance and added a gray coating to the table and floor. The picture was illuminated by two electronic flashes, one around the corner on the right; the other bounced above and behind the camera.
Hasselblad, 60 mm, Tri-X, 1/60 sec f11

Smoke

Smoke is difficult and slightly dangerous to handle indoors. You can, however, use a fog generator which produces smoke in a controlled manner by electrically heating a small quantity of oil. Small amounts of smoke can be introduced from a cigar or pipe. Outside, a bonfire can be prepared up wind of the set. Damp it down with green vegetation to increase the smoke. The most controllable outdoor sources of smoke are smoke bombs. These look like small roman candles and are pushed upright into the earth, singly or in clumps, burning for five minutes.

Fog generator

Using smoke to diffuse light. Smoke is excellent for diffusing unwanted background detail and creating aerial perspective. This tree house, right, was sunlit from above and behind. Shafts of sunlight are picked out in smoke generated by four smoke bombs upwind of the background trees.

Bronica, 80 mm, Tri-X, 1/30 f8

Front projection units

With a front projection unit, right, you can combine a figure in the studio with a background which has been photographed on a previous occasion. For this, you need a special screen, designed to reflect back light narrowly along its original path. A semi-reflective mirror is mounted in front of the camera lens at an angle of 45°, with a small projector below it for the background transparency. The projected image is reflected from the mirror down the studio to the screen. From the camera viewpoint the shadow cast by the figure is always hidden. The background image will not record on the figure as long as the model wears non-reflective clothing. The model should be lit separately by carefully regulated studio lighting.

Front projection set-up. The picture, right, was taken with a front projection unit with the screen and lighting arranged as shown above. Notice the masking screen carefully positioned to prevent the light spilling onto the projection screen.

Combining images. The background for the image, right, was made by projecting a transparency on to a sheet of torn white paper and re-photographing it. The resulting transparency was projected, and the subject positioned in front of the screen.

Changing the background. With a front projection device, you can quickly take shots of the same subjects against a variety of backgrounds. The girls, below, were transported from the seashore to the depths of the countryside in seconds.

Camera and projector unit. The unit, left, fits on to a tripod and consists of a projector with flash tube and modeling lamp, a semi-reflective mirror, and a mounting for the camera. Because camera and projector are mounted on a single unit, they are always accurately aligned, so shadows formed on the screen by figures in the studio cannot be seen by the lens.

Oblique front projection

If you use a projector to front project backgrounds in the studio the main subject will cast a shadow. Projecting from one side eliminates the shadow, but distorts the background image. You can correct this distortion by preparing a ready-distorted slide. This is made by projecting a slide square-on and copying the projected image obliquely. This slide, re-projected at the same angle, gives a distortion-free background. The projector must be fitted with a lens of the same focal length as that on the taking camera.

1. Project the background slide square-on to the screen. Position the camera obliquely, stop down and copy the image on to artificial light color film.

2. Project the copy transparency from the first camera position. You may held a simple "stop" (a small hole cut in a piece of black paper) stuck behind the lens to get sharpness right across the screen.

3. Set the camera square-on to the screen. Balance the strength of light on the model to match the projected image. Be careful to prevent stray light falling on the screen.

Projection sequence. The original transparency, below left, was copied at an angle, below, to produce the background for the final image, right.

Constructing a system

You can improvise a front projection system using a glass beaded movie screen for the background, a sheet of semi-reflective glass in front of the camera and a slide projector at camera level, but at right angles to the lens axis. Arrange the mirror to reflect the projector light beam to the screen. Adjust the camera until, seen through the mirror, its lens coincides with the reflection of the projector lens. Set up lamps to illuminate the model from the right direction and at sufficient intensity to relate him to the projected image. Use boards to prevent his light reaching the screen directly. Prevent ghost reflections from reaching the camera by hanging a black cloth to one side of the mirror opposite the projector.

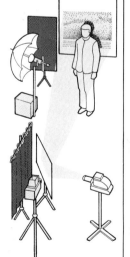

Improvising front projection. Project a slide on to a highly reflective screen via a half-silvered mirror. The camera is set up square to the screen.

Back projection

Another way of simulating backgrounds in the studio is by back projection, using a pattern-free, translucent screen, which does not show a "hot spot" when illuminated from behind. You can buy special back projection materials, but thick stretched tracing paper will also work. Reverse the slide in the projector, which is set up square-on to the screen center, far enough behind to fill it with a normal lens. Ensure that no other light reaches the back of the screen and that studio illumination does not reach the front of the screen. If it does, dark areas will be diluted and the image will appear gray and flat. Keep lamps well to the side and use large black boards to shade the screen. Place the model as far forward as possible. Back projection usually requires much more space than front projection.

Projecting from behind. For this you need plenty of space. Back project the image on to a translucent screen and place the model well forward.

Negative developers

Development of film must be carried out with the same care and attention to detail as the actual taking of photographs. One of the occupational hazards of photography is that the entire results of a hard day's work can be spoilt by using the wrong solution, time or temperature, or just by switching on a light. The first visible action of development is to form black silver in those areas of the emulsion which correspond to highlight areas of the image. Gradually mid-tone areas appear, and then some shadow detail. Meanwhile highlights have increased in density so that overall contrast builds up, together with grain. This means that if you have intentionally under-exposed the film and intend to compensate by "pushing" its speed with extra development you inevitably increase your negative contrast. The technique will be satisfactory if your subject was lit by fairly low contrast lighting, but with a contrasty subject lit with harsh lighting subsequent over-development may produce an unprintable, hard, grainy negative.

Fine grain developer

The most commonly used developer for small and medium format negatives is a normal contrast, fine grain type such as D-76 or ID-11. This uses metol and hydroquinone as developing agents in a fairly low alkaline solution. The developer is rather slow in action but its reduced energy lessens the silver's tendency to clump into comparatively large grains. Remember, however, that fine grain is a relative term and no fine grain developer will compensate for a coarse grain film. There are many other proprietary brands of fine grain developers which use mixtures of high and low energy developing agents. All of them aim to avoid the clumping of grains without reducing the emulsion speed.

High definition developer

A high definition developer gives a normal or soft gradation image concentrated on the surface of the film. This minimizes the slight loss of detail that occurs as a result of image diffusion within the emulsion. The developer is intended for use with slow or medium speed thin emulsion film.

High energy developer

This type of developer is designed to bring out the maximum film speed. Several formulae are similar to those of rapid developers, below. Emulsion grain is accentuated although its final appearance tends to be less noticeable than in a faster film

developed with normal fine grain developer such as D-76 or ID-11.

Rapid developer

You can develop in 30 to 45 seconds by using a concentrated, highly alkaline developer formulated specially for rapid results. You can reduce this to 4 to 5 seconds by working at a temperature of up to 85°F (30°C). The great problem here is to develop your film evenly. It is best to process only a small area using a powerful spray.

Extreme contrast developer

This type of developer is based on hydroquinone and is intended for ultra high contrast films, like Kodalith. A combination of locally exhausted developer at the edge of dark areas of the negative and fresh developer from light parts produces a boundary between black and white which is very sharply defined.

Two bath developer

This is a technique for producing negatives with maximum image shadow detail, but without excessively dense highlights. It is particularly useful for interiors with bright windows and important dark areas where no extra lighting is available. You use two solutions – normal fine grain developer such as D-76, and either plain water or a 1 per cent borax solution. The film is developed for about two-thirds its normal time, then transferred without rinsing into the second solution. Here it must remain without any agitation. Developer which is still in the highlight areas of the image quickly becomes exhausted and development stops. In the shadows the chemicals remain active for longer, enabling details to continue development.
See: Black and white processing/ Choice of solution

Mixing chemicals

Popular photographic chemicals – developers, fixers and so on – are sold ready weighed, as concentrated liquids or pre-mixed powders. Liquids are quicker and simpler to prepare for use, but are more expensive. Solutions which are less commonly used may have to be made up from individual chemicals, working from a written formula. Notice whether the formula quotes chemicals in crystal or anhydrous (monohydrate) form. Anhydrous means that the chemicals come as a dried powder in which the concentration of chemical is greater than it is in crystals. You therefore need less. Weigh out each of the chemicals first using a chemical balance, below. Line both scale pans with pieces of paper of equal size. Do not allow chemicals into contact with brass and other contaminating metals. Dissolve each chemical separately; use water at about 120°F (49°C) to dissolve crystal, and at 70-80°F (21-27°C) for most anhydrous chemicals.
See: Preparing chemicals

Chemical balance. This laboratory-style balance is the ideal method of measuring precise quantities of chemicals. The smaller weights in the range must be handled with tweezers.

Storing solutions

Solutions should preferably be stored in dark bottles away from bright light. Keep them well filled as air in the bottle causes oxidation. If a bottle gets to be half empty, transfer the contents to a smaller bottle. The problem is solved if you use compressible plastic bottles. All bottles should be of glass or strong plastic with tight stoppers. Metal caps or ordinary corks are not suitable. Information on labels should include the name of the solution, the date of preparation, and how much it has been used.

Reticulation

The regular pattern in the picture, right, is the effect of reticulation–overall wrinkling or puckering of the gelatin of the negative. It can be caused by a cold developer suddenly followed by a warm fixing solution. Modern films have built-in resistance to reticulation, but the effect can sometimes be produced by developing at temperatures between 105 and 115°F (40 and 45°C).
Try reticulating already processed, unhardened negatives with a 10 per cent sodium carbonate solution. You soak the film in the solution at about 120°F (49°C) until the emulsion wrinkles, then wash in cold water.

Distorting the emulsion

Really hot water will melt emulsion, but it usually breaks up the image as well. For results which you can control print on to Agfa Auto-reversal sheet film. Keep the image small as it will expand a lot later. Process in normal M-Q or lith developer which will form a negative image that eventually becomes detached from the film base. Line images give striking results.
See: Stripping film

. Enlarge your original on to uto-reversal film. Develop for short period to lift the edges f the emulsion slightly. Use a heet of perforated plastic to ansfer film from tray to tray.

2. Carefully lower the film into a stop bath, then transfer it to the fixer to clear. Keep the film level when moving it from tray to tray, or the emulsion will slide off into the solution.

3. Wash the film carefully and transfer it to a sheet of absorbent paper. The emulsion can now be creased and stretched, but take care not to tear it.

4. Slide the film on to a fresh sheet of paper. It must be allowed to dry naturally, or air bubbles will form under the emulsion. Contact on to line film if the print lacks contrast.

Improving sub-standard negatives

When an important black and white negative turns out too dark or too light, so that it is difficult to print, it is sometimes possible to improve the quality by some form of post-processing treatment. Generally this can be divided into intensification of a weak image or reduction of a dark one. The limiting factor is the amount of information the original negative contains. An under-exposed image, for example, will have very little shadow detail, and where this does not exist it cannot be intensified. There is also an inevitable risk that the negative might be accidentally damaged during after-treatment, perhaps by over-reduction, so before you begin you should make the best possible print from the negative. If accidents occur you can at least re-photograph this print.

Intensification
This means building up the image which is already on the negative. It is easier to improve an under-developed image than one which is under-exposed. Chromium and uranium intensifiers can be bought ready to use. Negatives must be thoroughly fixed and washed before treatment. Chromium intensification involves bleaching and then re-developing the image in ordinary MQ/PQ developer. The picture, above far right, shows its effect. Uranium nitrate intensifier works as a single solution.

Reduction
Reducing the density of a negative is usually carried out chemically by dissolving away some of the silver of the image. This also increases the appearance of grain. Farmers reducer is most suitable for negatives which are over-exposed and flat, since it increases contrast. The negative is treated in a solution of 1.6 grams of potassium ferricyanide and 33 grams of hypo crystals made up to 1 liter with water. Assess the progress of reduction by removing the negative at frequent intervals. Finally wash the film. The picture, far right, was produced from the picture, near right, in this way. Persulfate reducer (2.5 percent ammonium persulfate, with the addition of one drop of sulfuric acid per liter) makes a better reducer for negatives which are over-developed and therefore need less density and contrast.

Before treatment

After treatment

Processing special films

Several special types of film are made for use in the darkroom or for purposes such as copying, rather than for direct photography. They are almost all sheet film.

Direct duplicating film
This is a slow, orthochromatic film giving direct image reversal, below left. It is used for making negatives of continuous tone negatives and can be processed normally.

Lith film
Lith film has an extremely high contrast ortho emulsion. Process it in lith developer and you will get dense blacks and clear whites, below center. It is used mostly for copying, or for converting continuous tone images to line.

Autoscreen
Expose and process as you would conventional lith film. Autoscreen forms an image consisting of fine dots of varying sizes. For clarity it is shown, below right, enlarged three times. it is intended as an intermediate material in the making of photo-silkscreens or lithographic printing plates.
See: Copying prints and transparencies/High contrast

Contour line film

Also known as equidensity film, this carries a double emulsion, one giving a negative image and the other a slower, direct positive image. Given correct exposure, normally to an image under the enlarger, both highlights and shadow record as black. Because of a "gap" between the response of the two emulsions only a mid-tone records as clear film. The result is similar to that given by direct solarization. Several sheets can be used for posterization.
See: Black and white film types/Solarization/Posterization

Direct duplicating

Lith

Autoscreen

Stripping film

Stripping film contains an extra gelatin coating between emulsion layer and base. After normal processing this gelatin is easily melted by placing the film in warm water. The emulsion therefore floats off as a thick membrane and can be attached to another negative, or laterally reversed, or creased and attached to a sheet of clear film. An adhesive is provided for this purpose. Stripping film is normally only available with a high contrast emulsion. It is used mainly by printers.

1. After development, non-hardening fixing and washing, the emulsion membrane is floated off its base in warm water.

2. The emulsion is attached to a clear sheet of unexposed film, fixed to make it clear. The sheet is hung up to dry.

Multiple negatives

By combining two or more negatives when printing you can produce an image which is unlike anything actually seen by the camera lens. The simplest multiple negative technique is to take two negatives and sandwich them together in the negative carrier. The image carried on one negative then prints through in subject shadow areas of the other negative. Alternatively, the paper can be exposed to each negative in turn. The details of one image then record in the subject highlight areas of the other image. Although, with tests, two separate exposures take longer to make, this technique gives you much more freedom to maneuver images. Thus there is scope for individual vignetting, printing-in, dodging and adjustment of size.

Register board

The equipment, right, which you can make yourself, is used for aligning sheet film negatives while contact printing. This is especially useful for posterization, opposite. Take a negative and a sheet of unexposed film, for example, and punch holes through the pair of them with a paper punch. The holes can then be fitted over the pins on the registering board.

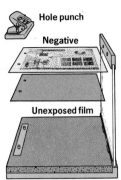

Hole punch

Negative

Unexposed film

Register board

Sandwiched or separate negatives. Both prints, below, were made from the two originals shown, right. Printing them sandwiched together in the negative carrier gave the result, below left. Printing them in turn produced the picture, below right.

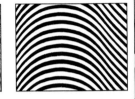

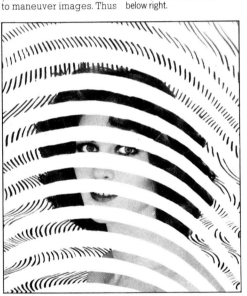

Two enlargers

The most flexible way of printing two negatives separately on to the paper is to use two enlargers. The paper is moved from one baseboard to the other between exposures.

Surrealism with two enlargers. The picture, far right, was produced from two negatives each printed through a different enlarger, near right. The handful of eggs was exposed and then a mask was used to print the face.

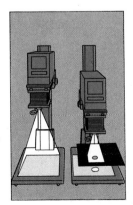

Posterization

Posterization or tone separation means turning a normal, continuous tone photograph into an image consisting of clearly distinguished areas of flat tone. These usually consist of black, white, and two or three tones of gray, bottom right. The technique involves printing the original continuous tone negative image on to three high contrast films, giving under-, correct and over-exposure. The first film therefore records deep shadows only in solid black. The second merges shadows and mid-tones as black, and the third is completely black except for highlights. These "separations" are then printed in turn on to one sheet of continuous tone (normal contrast) film so that each piece of image information records as a separate gray tone. This posterized negative is then printed conventionally.

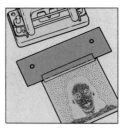

1. Take a negative 2¼ ins sq (6 x 6 cm) and attach it to a strip of film which has been punched to fit the register board, opposite.

2. Place a piece of lith sheet film under the negative, and make a test strip.

3. Punch holes in three sheets: of 4 x 5 ins (10.2 x 12.7 cm) lith film, and place the first on the register board underneath the negative.

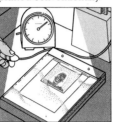

4. Take the exposure time which recorded the subject shadows as black, say 5 seconds. Now print on to the three sheets of lith film giving exposures of 5, 10 and 20 seconds respectively, and process in lith developer.

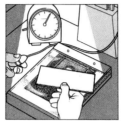

5. Contact print one of the lith separations on to a test piece of continuous tone sheet film. Process in normal print developer. Discover the exposure time needed to give a pale gray tone.

6. Using the register board print each separation in turn on to one sheet of continuous tone film, giving the same exposure in each case. Process, dry and enlarge on to bromide paper.

A. The original continuous tone negative.

B. Contact printed on lith film, giving 5 seconds exposure.

C. Contact printed on lith film for 10 seconds.

D. Contact printed on lith film for 20 seconds.

E. The final print shows the full range of tones.

Bas-relief process

This is a darkroom process which changes the familiar photographic image into what appears to be a low relief sculpture, lit from one side. The result, while physically flat, looks similar to the metal low reliefs often formed on plaques and decorative panels. Best results are often achieved from pictures which are sharp throughout, and contain mostly strong, simple shapes. The original subject lighting should be soft and even. Landscapes, still life and portraits are all likely to form interesting "relief" images – you can even transform a head shot into what appears to be a coin. Similarly handwriting and pen and ink sketches can be made to appear pseudo-three dimensional. The technique is essentially the preparation of a same-

size film positive, bound slightly out of register with the original negative. The sandwich is then printed conventionally. You need an enlarger with a glass faced negative carrier, and some medium contrast, non-color sensitive sheet film. Make sure the negative

you intend to work from is free from scratches and spots, as these may finally appear as gouges or holes in your bas-relief. Any size of negative is suitable, but medium or large formats are easier to work. Make sure the enlarger projects an even circle of light on

the baseboard, as used for contact printing. Prepare print developer at half its usual strength or be prepared to use normal MQ type negative developer.
See: Processing sheet film/Enlargements

1. Contact print your original negative on to a sheet of normal contrast sheet film. Expose and develop to form a positive slightly lower in overall density but similar in contrast to the negative.

2. Register the positive and negative, emulsion to emulsion, then offset one to the other so that boundaries of tones just show narrow dark/light lines. Tape the two films tightly together.

3. Insert the sandwich between the glasses of the enlarger negative carrier (you may have to trim the positive film to fit). Now enlarge in the normal manner, preferably on to hard grade paper.

Varying the effect
The original photograph is shown on the left. Note the soft, even lighting and generally simple shapes. The first bas-relief, made by this technique, below left, had the two images offset left and right. Notice how edges are emphasized. Flat, featureless surfaces appear unchanged

whereas fine detail seems to be pushing up through the paper as if embossed. For the bottom right enlargement the two images were rearranged with offsetting top to bottom. You can in fact form dozens of versions by varying the offsetting – either by degree or direction. If the film positive is made denser than the original

negative the final print appears predominantly negative in tone values. If the two films are exactly density matched the edge-lines formed by offsetting dominate the whole image, which consists of little more than black, white and mid-gray. Make sure both films lie flat and in firm contact within the enlarger carrier.

"Pen and ink"

This technique converts a normal, full tone range photograph into an image resembling a pen and ink or scraper board line drawing. You can make the result white line on black, or black line on white. Either way all the original tone values are replaced by an intricate "drawing" which outlines each boundary of light and dark areas.

The process

Choose a negative which gives a perfectly sharp print, and be careful to avoid dust and debris at every stage. If you choose a small format negative, it is more convenient to begin by enlarging it on to 4x5 ins film to produce a positive, using this to make a new negative. The resulting negative/positive sandwich produces a black line on a clear background when contacted on to film, so a further film contact is made to obtain a suitable negative for enlargement.
See: Processing sheet film/Enlargements

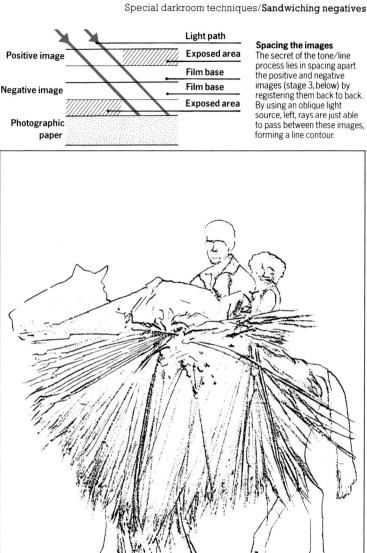

Light path

Positive image
Exposed area
Film base

Film base
Negative image
Exposed area

Photographic paper

Spacing the images

The secret of the tone/line process lies in spacing apart the positive and negative images (stage 3, below) by registering them back to back. By using an oblique light source, left, rays are just able to pass between these images, forming a line contour.

1. Enlarge the original negative to a convenient size. Expose on to a continuous tone sheet film, such as Ilford N8.31.

2. Process, then contact print this positive on to another sheet of the film. Make its density and contrast similar to the positive.

3. Register both sheet films – negative and positive – back to back. (Viewed from directly above they should appear a gray featureless rectangle.)

4. Contact print this "sandwich" on to line film, using a harsh oblique lamp. Revolve the pack on a turntable throughout exposure. Process and enlarge.

Solarization

Solarization, or the "Sabattier" effect, is the technique of partially reversing the image by means of fogging to white light part way through development, then completing the development time. The partly developed image, together with the by-products of development, cause the fogging light to have greatest effect in the least exposed parts of the emulsion. Along the boundaries of the fog and image induced tones a lighter edge line appears.

Solarization sequence. Exposed film, 1, (shown here greatly magnified) is partially developed, 2, fogged by white light and then fully developed, 3. Shadow areas severely affected by the fogging exposure, become almost as dense as the highlights which have been partially protected from the fogging by the halides blackened during the pre-fogging development. The clear edge line is the result of exhausted processing by-products which retard development, along the boundary between original image and fogging density. This appears as a black line on the print, 4.

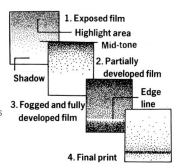

1. Exposed film
Highlight area
Mid-tone
2. Partially developed film
Shadow
Edge line
3. Fogged and fully developed film
4. Final print

Print solarization

It is quite easy to solarize a paper print, although it is difficult to repeat the process with exactly the same result. If possible choose an image which has strong linear elements. Structures against a sky background, strongly lit textured surfaces, signs and shapes are ideal. The picture should be sharp throughout. Test for exposure and then expose a print on a paper grade harder than you would normally use. Give the paper half its normal development time, then switch on the white light for a second or so. Ensure that it evenly illuminates the developer dish. Now complete the normal development without agitation. Fix and wash normally. The print will have an overall gray appearance, with partially reversed tones and edge lines, below. By printing on single weight paper you can contact print it back on to a sheet of hard grade bromide paper to give a cleaner, reversed tone result.

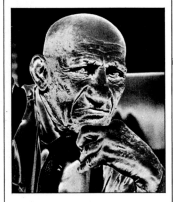

Film solarization

Solarizing a negative allows you to make final enlargements in which edge lines are more apparent and you avoid the overall gray appearance which characterizes solarized paper prints. You can solarize original camera exposed film, but it is easier and safer to work from an existing negative. Use a moderately contrasty sheet film such as Ilford line film. Test for correct exposure and then contact print your original negative on to a sheet of the film. Place it in a tray of print strength developer for half its normal development time and

agitate. Then use white light to fog the film for the same period as the contact exposure, and continue development without agitating. The longer the fogging time relative to image exposure time the greater the reversal effect. This produces a solarized positive on film. Wash it and dry it, and then you can contact print in the conventional way back on to a piece of the same film to form a negative. Cut the negative out of the sheet of film so that it will fit in the enlarger carrier to make prints.

1. Contact print the original negative on to a sheet of line film, after testing for correct exposure. Develop for half the normal time.

2. Place the developer tray on the enlarger baseboard. Fog the film for a period equal to the exposure used for contact printing.

3. Replace the tray in the sink and allow remaining development time to elapse.

4. The processed, dry positive is contact printed on to another sheet of the film to give a negative suitable for enlarging.

Degree of solarization. It is not easy to predict with any certainty how an image will appear when it is solarized. If you want strong edge line effects try to make the tone produced by fogging closely match the adjacent tone of the image. By fogging the first stage positive, light subject areas appear reversed in the final print. The length of exposure to white light determines the appearance of the result. The print, right, was given considerably shorter fogging exposure than the print below. You can also make a double solarization by solarizing the positive and the negative stage with tone boundaries forming double lines. Another way of working is to start with a bromide print, then make a copy of this and solarize the negative.

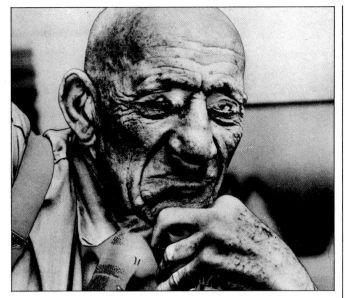

Masking

A negative is sometimes too contrasty or too flat to print well on any grade of paper. Chemical intensification or reduction may help, but if the negative is valuable it may be worth trying correction by contrast mask first. A contrast mask is a weak positive or negative image on film which is registered and bound up with the original negative. The two are then printed together. The effect of a mask carrying a weak

negative is to increase the contrast of the combination. More often, however, the problem is one of too much contrast in the original negative, like interiors recorded without supplementary lighting. This calls for a mask with a weak positive image. The original negative is contact printed on to a sheet of continuous tone film, preferably one which can be handled under bright safelighting. If

possible, make the mask image slightly unsharp by printing it through the back of the negative, using an oblique light source and rotating the sandwiched images during exposure.
See: Tone/line effect

Flashing

You can reduce print contrast by giving a brief exposure to weak white light between image exposure and processing. First expose correctly for shadows and mid-tone areas, then diffuse the enlarger lens with a sheet of tracing paper and re-expose for a further 10 per cent of the correct time. Flashing helps increase highlight detail without affecting shadow areas.

Contrast reducing mask.
The picture, right, shows the result of printing from the negative directly below to achieve detail in the window. The required printing exposure results in a total lack of detail in the figure. An under-exposed and slightly under-developed positive mask was therefore made, below bottom. The mask was registered with the negative, below and an enlargment made on slightly harder grade paper. About twice the previous exposure time was found necessary.

Enlarger attachments

Most of the optical special effects attachments used over the camera lens can also be used on the enlarger. The main difference in result is that whereas on the camera, diffusers, anamorphic lenses, starburst attachments and so on spread brightest highlight areas of the image, on the enlarger they spread the shadows – the light passing through thinnest parts of the negative. They also tend to lower the overall contrast of the image, so that a harder grade of printing paper is necessary.
See: Lens attachments/ Anamorphic lens

Diffuser. A diffuser, which is a disk of clear glass inscribed with concentric lines, will produce a soft focus effect when used directly beneath an enlarger lens. However, you can achieve the same effect more cheaply by stretching a piece of nylon stocking, preferably black to prevent light from scattering, over a simple frame made from a cardboard box with a hole cut from its base. The picture, right, shows how this spreads the dark areas of the image.

Using patterned glass

The image reaching the enlarger baseboard can be modified by supporting a sheet of textured or patterned glass about one inch (2.5 cm) above the paper surface. To create the effect, right, glass with a concave ribbed design was placed so that the ribs were at an angle to the axis of the picture. This had the effect of spreading the shadows in the direction of the ribs. Glass placed directly on the paper surface simply produces lines across the image. If you hold the glass nearer to the enlarger lens, the image will become extremely blurred and almost unrecognizable.

Baseboard distortions

The normal arrangement for enlarging is to have negative, lens panel and enlarging easel all strictly parallel to one another. If you tilt the baseboard at an angle the printing paper will be slightly nearer the lens at one end than it is at the other. Nearer parts of the image will then be slightly smaller and more brightly illuminated than parts further from the lens. The picture will be elongated, just as it would if you used a slide projector pointing obliquely at a screen. Occasionally this distortion can be useful for creating caricatures. Tall thin people can be made to look even taller and thinner or, if you turn the negative 90° in the carrier, shorter and fatter. Focus carefully on the center of the paper and stop the lens well down to gain maximum depth of focus. The end of the paper nearer the lens needs less exposure than the further end, so shade the image progressively.

Flat baseboard. The print, above, was made conventionally, with the baseboard horizontal. Exposure time was 12 seconds.

Tilted baseboard. The top of the picture, right, several inches nearer the lens than the bottom, received 8 seconds exposure. The bottom received 12 seconds.

Curving the paper

You can give an image a melted, distorted appearance by bowing and corrugating the printing paper. Use the red filter under the enlarger lens to see how the paper must be curved and twisted to stretch interesting parts of the picture. Choose a negative with a plain background, otherwise the result may be confused. Tape or pin the paper firmly to blocks or other supports to keep it perfectly still during exposure. Use mat paper, as glossy paper may reflect light from one part of the undulating surface to another.

Creating distortion. Bromide paper is twisted and taped to a block of wood during exposure, above, in order to distort the printed image, right.

The distorted print. Even with the lens fully stopped down, depth of focus has not quite covered nearest and farthest parts of the image, right.

Baseboard correction

Baseboard tilt can be used to cancel out a distorted image on a negative. For example, a picture of a tall building may have unwanted converging verticals, below, either because it was photographed using a tilted camera without movements, or the camera's rising front or lens coverage was insufficient to allow full correction. By tilting the enlarging easel so that the top of the building is further from the lens than the bottom, the image is improved, bottom. Verticals are now almost upright but the building is elongated. Depth of focus is also insufficient. A better picture, right, can be made by tilting both the negative carrier and the baseboard, using the Scheimpflug principle.
See: Camera movements/ Scheimpflug principle

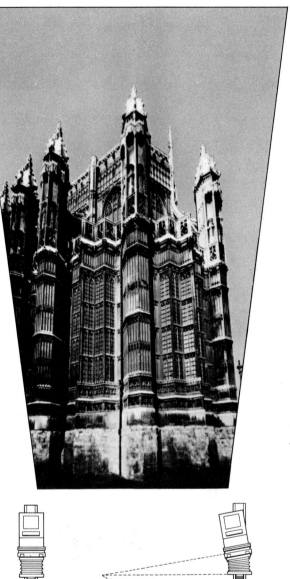

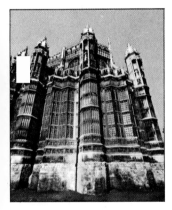

Partly corrected image. The baseboard was tilted alone at about 70° to give the print, above. Converging lines on the negative are "corrected" but depth of focus no longer covers the image and the appearance of the building is even now by no means normal.

Scheimpflug principle. If your enlarger will allow independent tilting of the negative carrier you can tilt carrier and baseboard as shown above. This allows maximum correction of converging verticals, with minimum loss of depth of focus.

Vignettes

A vignette is a picture without defined borders, whose edges merge into the background. The term is often extended to include hard edged shapes and pictures which shade off into black as well as white. Vignetting takes place during printing exposure and is basically an extreme case of dodging or printing-in. For example, to produce the effect, right, you shade the image through an oval hole in a black card during the entire exposure time. If you want soft edges hold the card several inches above the paper surface and move it gently. Generally this effect works best with a subject which has a fairly plain toned background.

A soft edge. The picture, above right, was shaded throughout exposure so that it merged into a light surround.

Using a black surround. Controlled fogging gives a vignette, right, which merges the image into black.

Making vignettes. 1. Compose and focus the image on the enlarger easel. Support a piece of black card about 3 ins (8 cm) above this surface. Mark out a shape of suitable size to enclose the figure.

Creating shapes for vignettes. All kinds of shapes can be cut for vignettes and masks. You can trace round one image to make a shape for vignetting another; you can draw round objects, or use pictures from magazines. Always use opaque card with a black surface to avoid light reflections.

2. Cut the shape cleanly out of the card with a sharp knife. Attach the oval firmly to a thin, strong piece of wire to form an oversized dodger.

3. Test for exposure, then expose a full sheet of paper for the required time. Switch off the enlarger, remove the negative and replace the carrier.

4. Support the oval card about 3 ins (8 cm) above the paper. Switch on the enlarger again for about twice the image exposure time. Rotate the oval gently throughout to blur the shadow of the wire.

Adding texture

You can add texture to a print in various ways. One approach is to print on to a surface textured bromide paper. But it is also possible to add the appearance of texture to the image itself, by sandwiching the negative with one of several texture screens which you can buy or make yourself. The effect is most pronounced in plain mid-tone areas of the picture.

Textured screens. The examples, above, illustrate three commercially made texture screens, gravel, tapestry and drawn cotton. Most patterns are available in 35 mm and 2¼ ins sq (6 x 6 cm) formats. The picture, right, was enlarged from a 35 mm negative sandwiched with the gravel texture screen.

Making a texture screen

You can make your own texture screens out of under-exposed, slightly under-developed negatives of regular all-over patterns, like the matting, below right, or semi-transparent materials used in direct contact with paper. The image must be sharp and evenly lit. Under-expose by about three stops on very fine grain film and cut development by 30 per cent. Another approach is to under-expose ultra-fast film to an even tone (unsharp overcast sky, for example) to make a coarse grain screen.

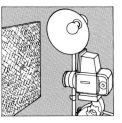

1. Find a suitable textured or patterned surface. This can be quite small if you have a macro lens. Bear in mind what size of detail will look best on your finished print.

2. Under-expose by at least two stops, then under-develop to produce a "ghost" negative. If possible, bracket your exposures to give a choice of screen densities.

3. Superimpose screen and picture negative, emulsion to emulsion. The pattern should in no way overwhelm the image. Try to use a glass negative carrier to keep them in complete contact.

Printing methods. The visual effect of a texture screen varies considerably with magnification. Both prints below were made using the same 2¼ ins sq (6 x 6 cm) texture screen, left. The picture, below left, was made by sandwiching the screen with a 2¼ ins sq

(6 x 6 cm) negative so that the pattern appeared relatively small. For the picture, below right, two exposures were made. The picture negative alone was exposed normally and then replaced by the screen negative at an increased magnification.

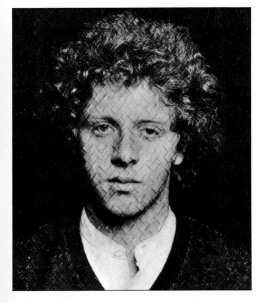

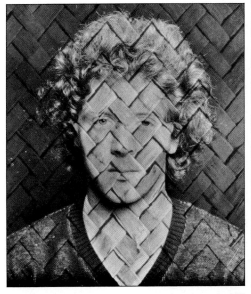

Step-and-repeat images

One way of making a multiple image print from a single negative is to give a series of exposures, shifting the paper between each one, right. Choose a negative of a subject photographed against a plain, light-toned background. Decide how many images you want and how they should be spaced, parallel or fanned out, and with equal or decreasing gaps. It will help to trace out on a piece of paper how the image shape might look when related in different ways. Then work out what distances the printing paper must be moved between each successive exposure.

1. Tape a ruler to the baseboard and use a spare print of the correct size to make a series of aligning marks, so that you can register the edge of the printing paper at each exposure.

2. Carry through the sequence of exposure and paper shift, first on a test and then a full print. During each exposure shade as much of the background as possible.

Rotating easel

To make the print, right, the negative which produced the print, below, was given two-thirds normal exposure, then rotated on a phonograph turntable before the enlarger was switched off. The center of rotation, having least blur, will be given greatest emphasis, and can be positioned in

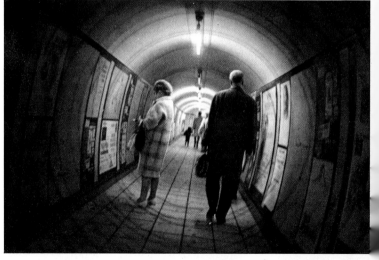

the center, to one side, or even outside the picture area. In making this print the figure of the man was held back during exposure to prevent a dark band forming near the center of the image, and the edges of the picture were "printed-in" to intensify and enhance the "tunnel" effect.

Continuous rotation. If you omit the static exposure, and simply let the paper spin with the enlarger switched on, a pie-shaped image will result, far right. The negative printed normally produced the picture, near right. A high contrast negative with a large amount of detail will give the best result.

Zooming

You can make a simple image on a light background appear to be moving toward the camera by zooming the enlarger. Give about half the correct exposure time, then crank the enlarger slowly to the top of its column and switch off. A different effect is produced by an autofocus enlarger, since the image remains sharp when zoomed. An autofocus enlarger was used to produce the print, right, from the portrait, below. An exposure was made with the enlarger low down on its column, and then, without turning the lamp off, it was raised in five stages.

Using removable masks

You can combine two or more images by placing a mask on the enlarger baseboard. The mask can be a piece of thick card cut into segments which are lifted and replaced in turn to expose the paper to a succession of different negatives. A more complex effect can be achieved by covering the paper with an ordinary jigsaw – a simple wooden one is best, since the individual pieces are large enough to be handled without disturbing the remainder. To produce the print, right, a number of test prints were first made to determine the exposure for each negative. Each piece of the puzzle was numbered and a check list kept to ensure that the same piece was not lifted more than once. A piece of adhesive tape was stuck to each piece of jigsaw, so that it could be moved without disturbing the print.

Merging images

By making multiple exposures under the enlarger you can construct photographs which appear convincingly "real", though they are printed from parts of several different negatives. You must shade each exposure carefully to make sure that the dark areas of one image do not coincide with vital parts of another. If this shading is even slightly inaccurate, exposure will build up in the areas where images merge and will destroy the illusion. Make a test print of each negative at the correct degree of enlargement and standardize development time so that all parts of the final image show the same density.

Fogging to join images

In multiple exposures you tend to get unwanted dark areas where images overlap and these can be turned to good effect. Totally black areas can be produced either by extreme over-exposure to parts of the negatives themselves, or by a masked exposure to white light. With the second method you can make exposures in the normal way, using a guide tracing as shown, below left, but you add a mask of the desired size to protect the latent image from the fogging exposure.

Masking for fogging. The picture, below, was printed from two negatives and a transparency. Seven image exposures and a fogging exposure were made. The three

archways and superimposed skulls were repeat-printed using the technique described on p 256 and the transparency was projected obliquely on to the baseboard to elongate the verticals of the building. On completion of the image exposures, a piece of black card was used to mask off the archways. With the tracing as a guide, a layer of instant coffee granules was spread over the upper image to produce an irregular edge line and a mottled effect on the image. A white light, switched on for about fifteen seconds, fogged all the unmasked areas. The print was then processed normally.
See: Baseboard distortions

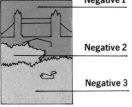

Negative 1

Negative 2

Negative 3

Registering the images. The three negatives which combine to make the picture, top, were selected for their similar perspective and angle of view. Using one enlarger, each negative was projected in turn on to a sheet of white paper, cut to the printing paper size so that a guide tracing could be made, above. Correct exposure times were then determined by test prints. The tracing sheet was substituted for the printing paper before each exposure to check degree of enlargement, focus and position. The shading was done with masks cut to the appropriate shapes from a sheet of black card.
See: Montage/Shading, "dodging" and printing-in

Progressive development

With resin-coated (RC) photographic paper you can combine some images without the problem of registering them. RC paper absorbs relatively small amounts of processing solution, because its base is coated with polyethylene. Full development is fast – typically one minute – after which time the image does not darken appreciably. This property, combined with its exceptional stability when wet, allows developer to be applied locally to each image immediately after exposure. As soon as the image has emerged the next one can be positioned exactly, and the process repeated. This method works for most multiple images, and is especially good for those which require a large number of exposures, below. However, you cannot allow images to overlap to any great extent, nor can you make fogging exposures. Conventional bromide paper could be used in this way, but its greater absorption often produces curling and over-development.

Exposing for progressive images. The "wallpaper" effect of the print, below, is achieved, using one negative, by multiple exposure and progressive development. The negative was projected on to the baseboard and a mask fixed just beneath the enlarger lens to give a soft edge to the images. One exposure was made in the center of the paper and developer applied to the area with a cotton swab. Once the image had emerged, the second image was positioned using the red filter. It was exposed and developed in the same way. This process was repeated to cover the whole sheet – a total of about 30 exposures.

Warning. With this technique you will inevitably get developer on your hands. To avoid electric shocks it is vital that you use the red filter to control exposure times. Do not use the enlarger switch or any kind of electrical timer.

259

Variations in paper processing

The processing of bromide paper should be a strict routine without variations. Keep to recommended times and temperatures. Removing a print from the developer too soon gives weak blacks; excessive over-development stains the paper yellow and flattens highlights. Within limits, however, it is possible to vary the appearance of an image by choosing a special developer and strictly controlling its action. By developing prints in special warm tone developer, for example, you can produce images ranging from black to a reddish color. Developers of this kind work best with warm tone chlorobromide papers, opposite. The basic principle is to over-expose the print, then curtail development. To get strong color with this method, print on a paper such as Bromesko, giving extreme over-exposure and then under-developing in a diluted warm tone solution. You normally have to use a grade harder than usual, to avoid loss of contrast. Two bath development is a routine which gives improved image quality in prints from over contrasty negatives. You give the first part of the development time in a low contrast developer such as Kodak Soft Gradation. This produces a flat image with mid-tone and highlight detail. Once the image has appeared, you transfer the print to double strength print developer just long enough to build up the full weight of tone in the shadows.
See: Black and white processing

Selective processing

Normal processing routines can be extended in several ways for visual effect. Instead of trying to give even development in a dish you can apply developer in an uneven spray, or swab it on with pads of cotton. If you expose your paper to a negative of a landscape, follow this by weak exposure to white light, and then develop with swabs soaked in diluted developer. The picture will appear to have been taken in foggy weather conditions. Developer can be applied to an exposed print with an embossed roller, or even with the palm of your hand. For both these techniques use concentrated developer. You can adjust emphasis in a picture by making a dark print, then lightening a small but important area by applying ferricyanide reducer on a brush.
See: Chemical after-treatment.

Developer application.
The pictures, right, were made by applying developer to the paper before exposure. Several methods were used: spattering with a toothbrush, above right, and with a floor-cleaning cloth, near right. The picture, center, had developer squeezed on to it from a sponge held 1 ft (30 cm) above the baseboard. The pattern, far right, was made by applying the developer with a piece of foam rubber.

Special black and white print materials

There are several black and white printing materials made for special purposes. Chlorobromide papers, such as Bromesko, give an image color which is a slightly warm black tone. By processing in a warm tone developer you can produce an image which is brownish red in color. Other bromide papers are made on brightly colored bases – silver, gold, fluorescent red, and so on. Used with normal developer, they give a black image on colored paper. Some of these papers can be bleached after normal processing with a solution which removes black and its underlying colored base from the dark parts of the picture. The result is a single color image on white. You can also buy bromide emulsion coated on to white plastic for making transparencies which must be illuminated from the rear. Finally there is a photo linen which can be processed and hung or pasted on walls.

Kodalith paper

Kodalith LP paper has a high contrast, orthochromatic emulsion which gives very dense blacks when processed in Kodalith developer. This sort of material is intended for graphic arts work, but you can use it to produce a whole range of unusual prints from normal negatives, if you control the development. The pictures below show some of the variations which are possible. Given normal exposure (speed is approximately the same as normal grade bromide paper) the full 2½ minutes development gives a high contrast print, with strong blacks and a generally neutral color image. If you give less than full development the image has a brown, or even a yellow appearance, with lower contrast. The rule is to increase exposure and decrease development to get more color in the image. You must time your development strictly with a clock, because you cannot see color changes when you are working under the deep red safelight required for this paper.

Right: normally exposed and developed image

Far right: normally exposed image on Kodalith paper

Below: grossly over-exposed and under-developed image on Kodalith paper

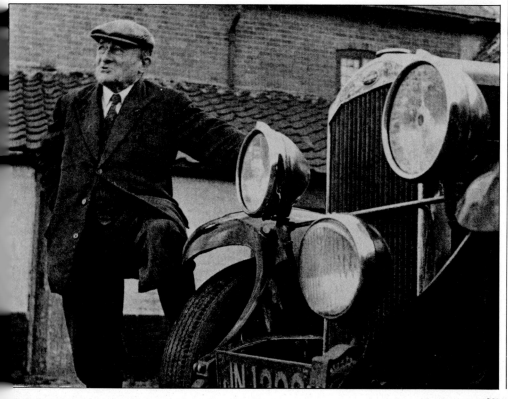

Sepia toning

You can sepia tone any black and white photographic image – negative or positive – on film or paper. Sepia toning is generally used for paper prints, converting the black image to sepia either as an effect in itself or as a preliminary to hand coloring. Start with a fully developed bromide print, well fixed and washed. Prints which are flat, under-developed or made on warm tone paper give poor image color. As shown, right, you work in normal room conditions, bleaching the black and white image and then "redeveloping" it in either sulfide or selenium sepia toner. The result is permanent and cannot be reversed.

1. Place a normally processed print in a tray of bleach for 2 to 3 minutes until the black tones fade to a washed-out straw color. Remove print and rinse in cold water.

The three printing stages. The picture below left, is an ordinary black and white original printed on bromide paper (chlorobromide papers are not suitable for sepia toning). It was bleached, bottom left, and then "redeveloped" to

2. Place the print in a tray of toner solution. The picture reappears within a few seconds in rich sepia, but you must leave it for about 5 minutes to reach full depth. Wash and dry in the normal way.

produce the sepia image, below. Sepia toning can add distinction to otherwise unremarkable pictures like that of the design and editorial staff of this book, below.

Selective toning. You can pick out areas of a picture in sepia – for example, brown figures against a black ground – by applying bleach and toner locally with a brush. For timing follow steps 1 and 2, left.

Applying your own emulsion

If you apply your own emulsion you can print actual photographic images directly on to canvas, wood, ceramic plates, metal buttons, even concrete or brick. You can buy a bottle of ready-mixed silver halide emulsion which simply needs warming and pouring over the base material. Plastic will need a pre-coat of polyurethane, and artist's canvas should be given a priming layer of gesso. Other non-porous surfaces should be pre-coated with the subbing which is normally supplied with the emulsion. You pour or brush on the emulsion and allow it to dry, then enlarge or contact print your negative and gently give normal processing.

Sensitizing a plate. The center of the decorated plate, above, was slightly warmed and then coated with subbing solution. Emulsion was then poured into the plate and rolled around to produce an even coating. The plate was placed under the enlarger and the exposure made.

Printing on an egg. Emulsion can generally be applied directly to porous surfaces like egg shells. Smooth, white eggs are best. Blow the egg through two holes pierced in the side not intended for printing. Then wash it carefully in warm, soapy water to remove any residue, and leave until thoroughly dry both inside and out. Mount the egg and pour warm emulsion over it, as described below. Make test exposures on coated pieces of broken shell.

Supporting the egg. It is easier to work with the egg if it is mounted on a small balsa wood block with an epoxy resin adhesive. After processing, the block makes a convenient display mount.

Coating and processing the egg. 1. Pour warm emulsion on to the egg in dim red or amber safelighting. Work over a dish, to catch any surplus. Two coats may be necessary. Leave to dry, preferably in total darkness.

2. Use the red filter on the enlarger. Position the egg correctly, focus at maximum aperture, taking account of the shell's curvature. Expose at the smallest aperture to increase image sharpness.

3. Dip the egg in film-processing tanks containing print developer, stop and fixer. Wash under running water and leave to dry. Take care not to touch the emulsion during processing.

Silkscreen printing

Photo-silkscreen printing is a method of printing pictures, using ink of any color, on to paper, fabric and other surfaces. You need a piece of silk or nylon fabric tightly stretched and stapled to a wooden frame. Pour silkscreen emulsion over the back of the screen, spreading it with a card. Then leave the coated screen in the darkroom to dry. If you are planning to silkscreen a simple line image, such as a silhouette or a copy of a drawing or text, enlarge your negative on to a sheet of lith film, and make it the size of your final image. This lith positive is pressed over the front of the sensitized silkscreen, and held down with glass. A foam plastic pad behind the material keeps the two surfaces in tight contact. You now expose the sandwich to a bright light source, such as sunlight, for 15 to 20 minutes. The silkscreen is "developed" in hot water, which removes the emulsion where it was unhardened by light. When dry, the area of screen corresponding to clear parts of the positive image is blocked by hardened emulsion, forming a stencil. Now you can press the front of the screen on to receiving material such as paper or cloth, and pour thick ink over the back. Use a flat-bladed rubber squeegee to press the ink through the unblocked areas of the silk. Carefully raise the screen and allow the paper to dry. You can make silkscreen prints with a full range of tones by working from an auto-screen image. Start with a bromide print which you copy on to 4 x 5 ins (10.2 x 12.7 cm) auto-screen film. Then enlarge this and proceed as for a line image. The result has a coarse dot pattern like a photograph in a newspaper.
See: Autoscreen

Simple photograms

Photograms provide a way of making pictures without a camera. The principle is simple enough; you lay out suitable objects on a sheet of bromide paper in the darkroom, then briefly switch on the white light to form shadows. After processing, these record as white shapes against a dark background.

Arranging photograms.
If you use an enlarger swing the red filter across the lens. Lay a piece of bromide paper, ideally grade 2, on the enlarger baseboard, and arrange your objects on top of it.

Lighting for photograms.
The photogram, left, only uses natural materials, while the photogram, right, is composed with man-made objects. Notice how objects not in total contact with the paper have an inner gray tone caused by light reflecting from their undersides. You need a light source giving a sharp, steady shadow. An enlarger well stopped down and at the top of its column is excellent. Both photograms were exposed for ten seconds.

Photograms using glass

Transparent glassware can form attractive photograms, particularly if it carries an etched or cut glass design. This will of course print as a negative. Glass objects such as ashtrays, wine glasses and tumblers, paper weights and vases are all good material. Remember, however, that bromide paper is only sensitive to blue light – glass of other colors will print as if semi-opaque. Check that your object is free from scratches, because the harsh exposing light will pick up every mark. If you want your glass to record finally as a positive image, make the photogram on sheet film or single weight bromide paper, then process and contact print this on to hard grade paper.

Oblique light sources. Tall objects, right, are made more interesting by exposing them to an oblique light source. Here a small torch was taped to a lighting stand and directed at about 30° to the paper.

Photograms with negatives

The visual possibilities of photograms are taken a stage further when actual negatives are combined with objects to form shadow patterns. Large format negatives are ideal, but they must be pressed down with a sheet of glass to maintain overall contact. A face can be made to appear in a locket-shaped shadow, or a landscape can be framed in real ferns. Plan out exact image size relationships by marking out the object shape on a piece of tracing paper first.

Making a combination photogram. To make a combination photogram like the one on the right, first contact print your hand on to the paper. Then develop the print halfway to the required density, rinse it, but do not fix it. Then blot it and dry it with a heated fan. Position the negative and the various patterned materials carefully on the paper surface to fit within the hand shape. Then re-expose through the enlarger and process normally. The sequence of events is described in detail in the series of diagrams below.

1. Position the red filter over the enlarger lens and place your hand on a sheet of normal grade bromide paper, then make the exposure.

2. Develop the print keeping the image slightly lighter than required in the finished result. Then rinse, blot off and dry with a heated blower. Do not fix. Remember the paper is still light sensitive.

3. Replace the paper under the enlarger with the red filter in place. Position the negative and surround it with flat pattern-forming objects or black paper. Remember that gaps print black.

4. Cover the objects and the negative with a sheet of glass and remove the red filter to make the exposure. Then give normal development, fixing and washing.

Enlarging for photograms

Instead of always having photogram objects in physical contact with the paper, they can be placed on a sheet of glass in the negative carrier and enlarged. Of course this technique limits you to items thin enough to fit inside the carrier. The lens should also be well stopped down to give sufficient depth of field. Insects, small flowers, patterned glass and transparent items of all kinds can be turned into dramatically enlarged forms. Furthermore, if you set up other objects on the surface of the paper itself all sorts of strange size relationships are possible. The picture, right, was made by putting the flat half of a transparent plastic developing tank reel in the carrier. The spiral shape was enlarged to suit a 4 x 5 ins (10.2 x 12.7 cm) portrait negative placed under glass in contact with the paper. A pair of darkroom scissors were laid beside the negative. However, the white scissor shape was too dominant on the first print so another exposure was made, and this time the scissors were removed halfway through the exposure.

Exposure for enlargement photogram. Correct exposure for the enlarged reel and contact portrait negative was eight seconds on soft grade paper. After four seconds the enlarger was switched off and the scissors were lifted from the paper. Then the remaining exposure time was given.

Images with fixer

Simple prints can be made by direct chemical action on photographic emulsion. Solutions can be poured, dribbled, brushed, or pressed on to paper or large format film to create patterns and shapes. Print fixer, although it is a bit messy, is the most convenient solution for chemical print-making. The hypo it contains prevents silver halides from developing, so that after development a white pattern is formed on a black ground. The simplest method is to take out a sheet of bromide paper and apply fixer by brush, stencil or other device, and blot off once. Then switch on the white light and place the paper in a dish of developer until the background becomes sufficiently black. Fix, wash and dry normally. The stencils can be made from greaseproof paper, and hypo applied on a damp pad, or you can use paper shapes soaked in the solution, or some form of raised printing surface. Remember, however, that fixer is somewhat corrosive and dries to a fine white powder which will contaminate materials and equipment. Work only on the wet bench side of the room. Wash your stencils very thoroughly, or throw them away, and remember that the developer is being contaminated by each print. Ideally, use a small quantity made up fresh each time.

Hypo print of a human hand.
1. To make a hypo print from your hand press your palm on to a soft pad comprising layers of rag soaked in print fixer. Aim to leave the entire skin surface moistened.

2. Place a sheet of single weight bromide paper face up on a soft rubber block. Gently but firmly press your hand in complete contact with the paper surface.

3. Place the paper in print developer and switch on the white light. Remove the print immediately it reaches a rich black tone. Fix, wash and dry normally. The finished print is shown below.

Making a positive print.
Although printmaking with hypo always results in a white image on a black ground, these tone values can be reversed. Do this by contact-printing the washed and dried paper negative on to another sheet of paper, under a piece of heavy glass.

Negative retouching

Retouching usually refers to working over the image by hand, using brush and pencil to remove or reduce blemishes, but in skilled hands it is also possible to alter local areas of tone, remove the entire background, or suppress unwanted detail. Unless you can acquire a reasonable degree of skill it is best to avoid negative retouching altogether and work only on the print. A spoiled print is much less of a disaster than a ruined original negative. On the other hand, good retouching on the negative means that blemish-free prints can be made in unlimited numbers. Roll-film is about the smallest size you can expect to retouch with any degree of success. Sheet films, 4 x 5 ins (10.2 x 12.7 cm) and upward, are rather easier, because of the larger image and the smaller degree of enlargement they will subsequently receive. 35 mm formats should be left alone, or else printed, retouched and copied. The essential negative retouching tools are a light box or improvised retouching desk, right, a fine sable brush, l, a bottle of retouching dye, 2, or tube of black watercolor, 3, a really sharp scalpel, 4, a watchmaker's glass, 5, for checking fine detail, a role of opaque tape, 6, and opaque paint, 7.

Spotting

Spotting is the filling in of clear specks (which would otherwise print black) until they match the surrounding tone, and so vanish. As an alternative you can simply turn the mark into an opaque speck. This will print as white and can be spotted-in quite easily on the enlargement. The usual blemishes which require spotting are tiny dust specks on the film surface during exposure, small air-bells during processing, or unwanted image detail, such as a misplaced hair in a portrait. Spots can be filled in with dye or water color, using a fine brush with a perfect point. Check first that the strength of dye is a reasonably correct match, using a piece of scrap film. Apply the dye with minute adjacent strokes. **See:** Spotting prints.

Improvised retouching desk. You can make an improvised light box or retouching desk with a simple frame support. White paper below the glass reflects light upward through the negative.

Blocking-out backgrounds

The term blocking-out means covering unwanted background detail with an opaque medium. This prevents the light from reaching the printing paper so that the subject appears against a clean white surround. Blocking-out is most often used for catalog illustration and record photography when the picture is to have a cut-out appearance on the page. Attach the negative firmly to the glass of the retouching desk. Black masking or foil tape can be carefully attached to the emulsion whenever the subject has a straight edge outline. The remaining outline is followed by hand using a medium size brush loaded with blocking-out solution. When the outline is completed fill in the larger area of background. Leave the blocking-out medium to dry slowly; too much warmth may cause it to crack.

Pinhole spotting. Fill the hole by stippling with appropriately diluted water color. Use only the very point of the brush, keeping it as dry as possible.

Dark marks

Dark specks on negatives should not be touched unless removal is essential; they are best retouched out as light marks on the print. A new scalpel blade can be used with care to reduce the emulsion, below. Alternatively, place a tiny speck of Farmers reducer (potassium ferricyanide plus hypo) on the blemish to lighten its tone chemically. **See:** Print retouching

Knifing. Brush the sharp point of the scalpel gently over the emulsion surface of the blemish. Stroke in one direction and then in others until its tone matches the surroundings.

Blocking-out. This requires a larger brush than that used for spotting. Use clean-edged opaque tape to block-out straight lines first. Then follow the remaining subject outline by hand.

Blocking-out to clarify shape. The print above was made from a 4 x 5 ins (10.2 x 12.7 cm) negative with its right half blocked-out only. Background removal greatly clarifies the subject shape although it gives a very stark and artificial appearance. A similar result could be produced by background bleaching on the paper print using iodine. However, this would have to be done on every print.

Print retouching

Retouching the final enlargement is much easier than working on the negative. The image is comfortably big; there is no subsequent enlargement to coarsen the retouching; and accidents are not irredeemable, because another print can always be made. Some bromide papers are easier to retouch than others. A mat surface is ideal. Glazed glossy is the most difficult, since its shiny surface shows up the less reflective retouched areas of the print.

White specks

These are the most common defects, usually caused by grit or small hairs, scratch lines or light abrasion marks on the negative. They can be filled in on the print with a fine stipple of black watercolor, or by using a wash of retouching dye diluted to match the surrounding tones. Watercolor is quick and easy, but it always shows on the surface of a glossy print. Mixing it with a little gum arabic from the flap of an envelope gives the pigment a more reflective surface finish. Retouching dye is better for glazed prints because, being waterproof, it allows the print to be glazed after retouching. You will find that a mat-surfaced print will accept pencil quite easily. Use a soft lead sharpened to a fine point and lightly stroke the area to be filled in so that small fine dashes are produced. These can be softened and merged with a piece of tightly rolled paper or your finger tip.

Black specks

The main method of retouching a black mark is to bleach it, or spot the negative, transforming it into a white speck. This is then treated as described above. Very small spots can be knifed in the same way as negatives. It may be easiest to knife the speck down to white and then spot it in at the required tone.

Tone modification

Provided you have some practice it is possible to lighten or darken large areas of tone, using an airbrush to spray water color or dye on the print surface. Graduated shading can be produced by using a fine spray from some distance back and gently moving the airbrush until the required tone is seen to build up.

Colored images

Toned prints can be treated in much the same way as black and white, using watercolor or dye of a matching tint. For color print retouching use the dyes recommended by the paper manufacturer. Color must be built up layer by layer.
See: Spotting negatives

Mask.
Head and shoulders must be masked so that no paint falls on them. Airbrush over the mask along the shoulders and up to the ears, because the edge here is hard.

Uneven background.
This needs airbrushing because it is an area of flat tone. To use a conventional brush would be impractical.

Soft edge.
Because of the soft edge formed by the man's hair this area must be retouched by hand instead of with an airbrush.

Scratch.
Where the scratch crosses the skin bleach it out. Then use a brush to build up gray tones to match the surrounding skin.

Assessing the problem

The print, above left, was made from an old negative severely damaged during storage. It is covered in marks and white specks. The density of the background is uneven, there is a glaring double scratch across the face. The illustrations, opposite, show how all these marks were gradually eliminated on the print to give the retouched print, above.

Retouching tools. 1. Palette for diluting and testing dye tone **2.** Clutch pencil with interchangeable leads **3.** Sable brush for spotting **4.** Dye **5.** Bleach **6.** Cotton swabs and cotton balls for smudging **7.** Scalpel **8.** Airbrush and aerosol **9.** Masking film **10.** Magnifying glass **11.** Soft rubber **12.** Tubes of paint – black, white and gray.

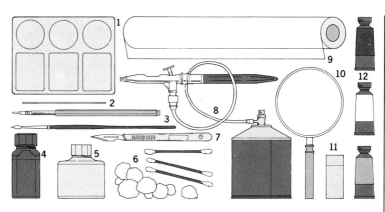

Repairing a damaged print. 1. Work on a clean, well-lit bench and secure the print with adhesive or by dry mounting it. First, bleach out the black scratch mark across the face area. Wash and dry the print.

2. Now you can build up tone in the white marks across the skin. Use retouching dye or watercolor on a spotting brush. Use paper to protect the print surface from handling marks.

3. Use a scalpel to remove any remaining small black specks from the face. You are now ready to begin work on the background. Since this has a plain tone the whole area can be airbrushed over with pigment to obliterate both black and white blemishes.

4. Lay on a piece of plastic masking material. Use a scalpel to cut out a hard edge around the shoulders and head. It takes practice to cut the plastic, but spare the print. Peel off the background area of mask, leaving the figure protected.

5. Using the airbrush about 4 ins (10 cm) above the print surface slowly build up an even gray tone. Do not spray up to the hair because this is a soft edge. Allow the work to dry thoroughly.

6. Carefully peel the mask away. Spot in any gaps or edge effects, in particular around the hair. Cut out a mat in clean card and attach this as a print surround.

Montage techniques

A montage is a construction of photographs arranged so that they join, overlap or blend with one another. It allows you to present impossible situations or events, create patterns and shapes and work with a disregard for the normal rules of perspective and scale. The technique consists of cutting and sticking prints one on top of the other, butt-joined, or mounted and free-standing like stage scenery. If necessary, you can re-photograph the result to give a print free of joins. Start off with component prints which all match in contrast and image color. They should be on single weight, matsurfaced bromide paper, which is easy to dissect and retouch. Make several spare prints to allow for errors in cutting and assembly. To produce a montage like the one below first dry-mount the background print on to stout card. Here the print of the hand was carefully cut out with sharp scissors. Taper the cut edge by sandpapering the back of the print. Give it a thin layer of adhesive and attach it in a premarked position to the main print. Retouch the edge as necessary.
See: Image color/ Surrealistic montage

Cut-outs

Another technique is to cut images out, mount them separately and set them up in different vertical planes for re-photographing. Use adhesive tape and cardboard or wood blocks to support your cut-outs. This technique can produce images which appear strongly three-dimensional and full of depth. Using a large aperture you can focus on just one cut-out to aid the illusion of depth.

Dissecting and rearranging

Another way of working is to dissect a print, and then reassemble it in a different way. A picture can be cut in to a pattern of slices, disks or squares, then rearranged out of register, or interleaved with another sliced photographic image.

Rearranging a portrait. Vertical slices of this portrait were moved and remounted.

Rotated segments

Cut a print into a series of circles by breaking a scalpel or razor blade and clamping this in the ruling-pen attachment of a pair of compasses. The cut circles can then be rotated slightly and reassembled.

Using positive and negative images. The picture, below, is constructed from two prints – one a positive and one a negative image. Rectangles regularly decreasing in size have been cut from each, then inter-leaved, mounted and re-photographed.

Two-way portrait

The absence of symmetry in the human face can be demonstrated to startling visual effect using two prints made from a full-face portrait, right. One print is enlarged conventionally, the other has the negative turned over in the carrier to give a laterally reversed image. Both prints must match exactly in size, density and contrast. You then montage one half of one print with the other half of the other.

Original portrait

Two right halves

Two left halves

Symmetrical patterns

Patterns can be formed by joining together several prints from one negative. The picture, right, for example, was constructed by combining four enlargements from the negative printed complete, below far right. First two matched enlargements were made normally, then two more were made with the negative inverted in the carrier. The effect is of broken, reflected abstracts like patterns seen through a kaleidoscope. With two mirrors, butted together at an approximate angle of 30°, you can test your patterns before printing and choose those which will be most effective. The combination of images which can be made in this way from parts of a photograph are virtually endless.

Kaleidoscope images. Like the picture, above right, the arrangement above uses prints made normally at top left and bottom right. The other prints were made through the reverse side of the negative.

Vertical symmetry. The pattern, above, uses the same prints as the arrangement, left, but they are now laid out with the normal prints both on the left hand side.

Patchwork montage

The apparent realism of photo-
graphy makes it an ideal medium
for juxtaposing unexpected
objects or themes in an atmos-
phere of fantasy or nightmare.
Careful planning and craftsman-
ship are essential for a convincing
result. Start with a definite idea,
but be prepared to change it if
new images suggest themselves
to you as you work. In making a
patchwork montage you can en-
dow a perfectly ordinary photo-
graph with absurd charac-
teristics, right. Use images in un-
likely combinations, such as the
grapes which replace the subject's
hair, right, or his lobster-claw hand.
You should make no attempt at
reality; the pattern of the images
is more important than the content
and for this reason it is probably
best to use pictures you already
have so that the components are
totally arbitrary.

Frieze montage

When you make a frieze montage,
right, you are still creating illusions,
but they are more formal and
organized than patchworks,
above. Make several prints of the
same image, then reverse the
negative in the enlarger and make
an equal number of reversed
prints. Mount right-reading and
reversed prints alternately to
make a long strip, right. If you use
a tall building as your subject it is
essential to have corrected verti-
cals so that they can be butted
evenly together. You will probably
have to use a camera with move-
ments to achieve this.
See: View camera/Shift lens

Reality in montage

The montage, right, differs from the two, opposite, in that it maintains an illusion of reality by using the same perspective and the same quality and direction of lighting in each element. The main interior was lit from low windows on the left, so the billiard table, hands, billiard balls, the figure and the seagull were also lit from that direction. With this kind of montage you must keep a careful check on perspective. This is easier to do if you use a large format or view camera, and place a tracing of one picture over the focusing screen when shooting another so that you can align the different planes exactly. A tracing, below, is also needed when you make prints to the required size. Prints must match in contrast and density. It is best to make a large montage and then copy it to give a smaller final print. Your surgery then becomes less noticeable.

Coloring black and white prints

Hand colored monochrome prints seldom, if ever, give the realism of a good color print or transparency. On the other hand the technique allows you complete control of individual hues, shades and tints. You can make highly interpretative, rather than realistic, color images, and you can color only the elements you want to emphasize. The best method of coloring prints is with colored dyes on a brush. You can use transparent oil colors or pastel chalks, but this is extremely difficult and requires an immense amount of practice. Choose a picture without too many dark tones, and prepare a light print on mat or semi-mat paper, because this is easiest to work on. Sepia tone the print, because you cannot effectively color over a dark gray or black; the underlying image would show through the colored dye tending to desaturate it. Dry mount the print before coloring it. As well as brushes you need a set of photo tint dyes, some cotton balls, blotting paper, water, and a plastic palette for mixing.
See: Sepia toning/Dry mounting

Choosing a print to color. An old black and white postcard, below, was chosen as a suitable image for hand-coloring. A mat-surfaced print of the image, light and without solid shadows, was sepia-toned and then colored with transparent dyes. The final result is shown on the facing page.

1. Choose a work area which is well-lit, preferably by daylight. Dry mount the sepia toned print and clean over the surface with an anti-static cloth to remove dust. Keep a spare print for testing colors.

2. Dampen the print surface with a cotton ball soaked in clean water. This will allow the dyes to be absorbed evenly by the gelatin.

3. Use the spare print to test color density before attempting to work on the real thing. Then begin by washing in large areas of color with a small piece of cotton.

Using local color

By limiting color to the main element in the picture, or even to some small detail, you can produce a strong, highly selective emphasis. You may decide that only the lips in a portrait should be colored, or give color to some flowers which would otherwise be lost in the background. In the picture, right, the figure is separated from the flagstones in a way which would be impossible with normal color photography.

Selecting color to increase impact. The picture, left, gains dramatically from the use of local color. Waterproof masking solution was carefully coated over the areas which were to remain uncolored. This made swabbing over the colored areas much easier. The mask was peeled off later.

3. HALLENCOURT (Somme) — La Poste

Edit. Vve Merchez, tabacs.

4. Work progressively from the largest area downward, until only the details are left for coloring in by brush.

5. Before starting the detailed work check over the balance and density of the color so far. Make adjustments where necessary now; you cannot wash over colored details later without smudging.

6. Using a brush of appropriate size you color in the small areas which remain. Where color must be particularly strong build up several layers, allowing each to dry before applying the next.

Color toning

You can color a print chemically by toning. Unlike dying which stains the gelatin over both light and dark areas, toning changes the black silver image into a color; blue, red, yellow and green are available. The result therefore resembles a color print more closely, although it gives a picture in one color only. Technically the process is similar to sepia toning. A fully fixed and washed black and white print is bleached, then re-developed in chemical toner, forming an image ranging from blue or green to yellow or red. You can finish off the result with hand coloring if you wish. It is also possible to tone different parts of a picture in different colors. Use waterproof masking solution to protect the second area when bleaching and toning the first.

Changing image quality. The already stark appearance of the print, right, was further accentuated by processing in a blue toner.

275

Permanent copying set-up

Sooner or later you will want to re-photograph a print or transparency, or copy a drawing or painting. Often this can be improvised on the spot with a camera, tripod and pair of lights. But anyone doing regular copying needs a permanent set-up for this type of work. The arrangement, below, for reproducing drawings, photographs and so on uses a large format camera which runs on rails. This ensures that the camera is always at right angles to the copy board, and allows quick, easy change of camera distance to suit originals of various sizes. Lights are rigged to give even illumination of a known brightness and exposures therefore become standardized for various combinations of films, types of original and sizes of reproduction.

Light sources

Any even source of lighting – tungsten lamps, flash, fluorescent tubes or daylight – can be used for copying. If you are shooting color, keep to the light source for which the film is balanced. Try to use a pair of lights at about 45° to the copy board. When copying by flash use studio units with modeling lamps, or hold a torch near each head and check for reflections.
See: Equipment: Lighting/Flash techniques

Obtaining even lighting. A quick, simple test for evenness of lighting from two lamps is to place an object such as a pencil at right angles to the copy board. Examine the shadows cast – they should be equal in tone and length.

Copying stand

For most copying work a vertical stand is the most convenient arrangement. It takes up little space, and the originals to be copied are easily laid out on the baseboard. You can either buy a unit made for the purpose as part of a camera system, or adapt an old enlarger column by fitting a pair of lights and mounting the camera in place of the enlarger head.

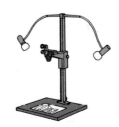

Lighting for a copying stand. The enlarger column, above, allows camera distance to be varied by turning a handle. Lamps are fixed to clamp-on flexible supports.

Photographing paintings

Paintings may present problems if they are behind glass or if the sheen of the paint itself causes reflections. Position the lamps one at a time, checking through the camera for glare. A polarizing filter over the lens often helps, particularly if you have polarizers over the lamps as well. Directional lighting should be given when texture is important.

Camera reflections. If a reflection of the camera threatens to appear in a glass surface, screen off camera and tripod with a large sheet of black card, above, leaving a hole for the lens.

Correcting parallax

Twin lens reflexes and viewfinder cameras need some correction to ensure that copies centered in the viewfinder are also centered on the film. Use a shift plate to move the camera so the lens is in the position previously occupied by the finder, or else modify your copy board so that it will move sideways and upward, or use the technique shown here.

2. On large tracing paper trace off the lines on the copy board. Then shift tracing until its corners register with the view-finder corners. Attach tracing to the board with a tape hinge.

Adapting a tripod

A right angle arm converts a tripod into a vertical copying set-up. Alternatively, use a camera clamp on the edge of a table or ironing board.
See: Camera supports

Copypod. A set of lightweight telescopic struts, above link together to support the camera over small originals like illustrations in books, stamps and so on.

1. Set up the unloaded camera with shutter open on "B". Place tracing paper across film path and check that the frame is centered on lines drawn on the copy board. Mark where picture center appears on the board.

3. Center each copy original under the tracing, and adjust size and focus looking through the camera viewfinder. Peel back tracing, shift original until centered to the lines on the board, and expose.

Types of original

Different originals – etchings, pencil drawings, water colors, colored lettering, old photographs – need slightly different methods of exposure and processing. If you are aiming for a pure black and white result expose on line or lith film and give appropriate high contrast development. Read exposure from a gray card held over the face of the original. Pencil sketches reproduce too contrasty this way, and look better recorded on normal contrast film; the same applies to wash drawings and photographs. If the original contains no color you can use a non-color sensitive film and process under bright safelighting. Measure exposure using the gray card technique or make highlight and shadow readings, if these areas are sufficiently large. Faded sepia photographs often copy excellently on ortho or non-color sensitive continuous tone film.

Filtering

If the original is stained, try photographing through a filter of the same color. Check by looking through the filter that the stain can no longer be seen. Shoot on panchromatic film. In the same way particular colors in diagrams, lettering and so on can be lightened or darkened on the final black and white print. The rule to follow is that a filter lightens its own color and darkens all complementary colors.

Color copying

Copying on to color film, particularly color transparency film, demands extra care in lighting and exposure. If you use tungsten lighting use new bulbs. Make several bracketed exposures. If shooting for a final color print, record some easily identifiable colored patches alongside the picture. These can be matched up when you make the print.
See: Black and white film/Black and white processing/Enlargements

Copying transparencies

Provided you have a close-up outfit, preferably for a single lens reflex camera, copying color slides presents no great difficulty. Make sure they are evenly illuminated from the rear, and if you are shooting in color use the right light source for the film. The main problem is one of contrast. Transparencies are intended to look good projected, not act as an intermediate stage for copies. Unless the original subject was flatly lit and low in contrast, the final copy may be disappointingly harsh. You can help matters by overexposing the copy one stop and then reducing development. Or you can use a copier which has a flashing facility, below. If necessary you can contact print a weak black and white negative mask, then register this with the original to reduce its contrast when copying.
See: Masking

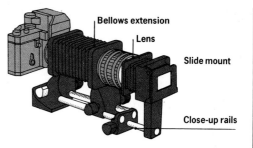

Bellows extension
Lens
Slide mount
Close-up rails

Bellows copier. Most extension bellows can be used to copy slides. You attach the bellows to a SLR camera body, fit the lens to the front, then connect this by more bellows to a transparency holder.

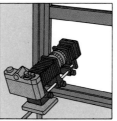

Bellows copier with daylight. With a bellows copying unit you can use daylight to illuminate the rear of the slide. Try to point the unit toward a slightly overcast sky. Measure exposure through the internal meter.

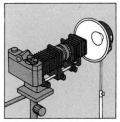

Bellows copier with a flood. Alternatively shoot on tungsten light color film, using a photographic flood as a light source. Do not approach too close: heat from the flood may damage the slide.

Transparency copier. Transparency copying is simple if you have a unit designed for the purpose. The camera, with macro lens and bellows, is mounted looking down on to a rear-illuminated panel supporting the transparency. The copier has a swing-over exposure meter and contains a low power electronic flash to make the exposure. The unit also contains a second small flash, reflected into the camera lens. This enables you to control contrast by flashing, the technique of slightly fogging the image during exposure.
See: Flashing

1. Set up the original transparency on the duplicator's light box. Load the camera with daylight color film. Adjust distance and focus until the picture, or the required part of it, fills the viewfinder.

2. Swing over the special meter cell. The large knob raises or lowers the internal flash and modeling lamp. Turn it until the meter dial reads zero.

3. Dial in the degree of fogging required. Low contrast originals may copy direct. If in doubt make several exposures with different fog levels.

4. Remove the meter cell. Switch selector from modeling lamp to flash. Check that camera synchronizing lead is attached and camera is set for flash. Make the exposure.

Color effects in the darkroom

A simple way to produce a bizarre color picture, right, is to shoot green foliage on infra-red Ektachrome color transparency film rated at double its normal speed, and then process this as if it were a color negative. When the result is projected, living vegetation appears green but most other subject colors reproduce as their complementaries, and tones are reversed.

Color solarization

Color transparencies and color negatives can be color solarized by fogging them to light about halfway through the first stage of processing, but this process is expensive and difficult to control owing to the large number of variables. This is why most color solarization and posterization effects are in fact shot and manipulated on black and white film, with the color added at a final color printing stage. The solarization, below, was

produced by the black and white method, but with the solarized positive printed on to color negative film, using a colored light source. When this was in turn printed on to color paper other colors were added by local shading, then changing filtration and printing-in again.

Color posterization

For color posterization, far right, make lith separations as shown for black and white, but then print these in turn on to one sheet of color negative film, giving a strong change of filtration for each exposure. To exaggerate grain, shoot on the fastest film available, under-exposing by up to 3 stops. Extend the development stage by about 100 percent.
See: Solarizing negatives/Posterization

Right: Pentax, 55mm, I.R. Ektachrome, 1/60 sec f5.6

Color posterization. 1-4.
See: Posterization, steps 1-4
page 245.

5. Substitute a piece of color film for the test piece of continuous tone film and interpose a CC100 filter of your choice between the black and white interpositive and the color film. Make a test strip.

6. Print through the three interpositives in turn, using three different color filters, on to color film to produce the final posterized negative.

Transparency masking effects

Masking is normally used to control contrast, but it can also produce special effects. For example, by registering a weak black and white negative with a color transparency all the highlight areas become equivalent to mid-tones, without great change of tone or color in darker areas. Landscapes take on leaden skies; faces and clouds turn dark and negative. If you offset the two films you can create a type of bas-relief. An odd masking effect can be achieved by taking two identical photographs of a subject, one on color transparency and one on color negative film. The transparency should be about 2 stops over-exposed. Register the images and enlarge on to color paper.
See: Bas-relief

Using a negative mask.
The picture, right, is a color transparency combined with a weak black and white negative.

Photographing nature

Photographs of nature range from the impressionistic to the documentary. The former tends to emphasize shape, form and texture while the latter relies on extreme accuracy for the records of biologists and naturalists. No matter how many times a subject has been photographed you will always be able to find a new way of illustrating some facet of its structure or behavior. While luck can play some part in contributing toward a good nature picture, patience is a vital factor. You will soon find that a knowledge of wildlife behavior is indispensable; you must be able to recognize where and when to find a subject before you can start. However, always remember that the subjects' well-being must come first. Unquestionably you will get most enjoyment and satisfaction from finding and photographing subjects in their natural habitats, but nature photographs can also be taken indoors. The main advantage of working in a studio is that the lighting can be controlled, the background selected and, if necessary, the subject confined. Technically, such photographs are often better than those taken in the field, but they cannot capture the mood of the surroundings.

Cameras and lenses
A single lens reflex, 35 mm or 2¼ ins sq (6 x 6 cm), with interchangeable lenses is ideal for nature photography. Cameras with through-the-lens metering are much quicker to use than a camera without an internal metering system, but for certain subjects an incident light reading made by a separate light meter is more accurate. Use a pentaprism viewfinder with your SLR for the majority of nature photographs; for action pictures of animals running or birds in flight this is essential. For low-level work, however, you will find a waist-level viewfinder much more convenient as it allows you to view the subjects by kneeling rather than lying flat on the ground. This kind of viewfinder cannot be used on cameras which have a fixed pentaprism, but you can modify fixed pentaprisms for downward viewing by attaching a right angle viewfinder to the camera eyepiece. It is a good idea to concentrate on one aspect of nature photography to begin with – flowers or insects; birds or mammals – because this enables you to get to know your subjects thoroughly and limits the amount of equipment you have to buy at one time. If you are interested in close-up work a macro lens is well worthwhile. If you begin to photograph birds you will soon realize that a long lens is essential. A

wide-angle lens is not vital but it is extremely useful for illustrating plants and animals in their natural habitat. Good pictures of mountain flowers can be taken with a wide-angle lens to show the plant with mountains behind.

Camera supports
Critical focusing is essential for close-ups because depth of field is reduced when the image size increases. Close-ups can be spoiled by camera-shake if the camera is hand-held, so you need a robust tripod. For convenience when stalking animals you may prefer to use a monopod, but you will get the most consistent results if you use a tripod for your pictures whenever you can. As field photography rarely involves working on flat ground, choose a tripod with legs which have individually variable extension and some facility for mounting the camera close to the ground. Tripods with a reversible center column enable you to do this and give an appropriate viewpoint for mosses, fungi and creeping alpine plants. Several useful low-level camera supports – all of them small and light enough to be carried in a gadget bag – are illustrated below.
You can encase your camera in a padded blimp, below, to reduce

mechanical sounds when you are photographing nervous animals.

Lighting
A flash is not an essential accessory for nature photography, but you will find it useful when working with color film under poor light conditions. It is obviously essential for nocturnal subjects. Relatively few people venture out to take photographs at night, and yet many mammals and several birds are active only at this time. There are also many moths which feed on night-scented flowers.

Blimp for Hasselblad

Making a ground spike. This low-level camera support, left, can be made from a metal tent peg attached to a ball and socket head.

Miniature camera supports. Low tripods like the one above are light and unobtrusive, and therefore ideal for wildlife photography. The "photo-beetle", left, has adjustable legs.

Photographing birds

You can either stalk birds in the field or sit in a hide and wait for them to return to a perch or nest. Great care must be taken not to disturb nesting birds, below, in case they desert the nest. You will have to build your hide gradually over several days. At each stage, retreat from the spot and make sure the birds continue to return to the nest. Tie back any branches obscuring your view, but never prune them. Take a companion with you when you enter the hide; when your companion leaves again most birds will believe the

Using hides. Birds that live near roads are used to cars, so successful pictures can be taken using a car as a hide. A car clamp, right, is a useful camera support. Large suction disks fix it firmly to a car window. If you want to photograph birds over an extended period in the wild, it is well worth building a special hide like the one, below right.

Nikkormat. 135 mm, Tri-X, 1/60 sec f.5.6

hide is empty and will lose their fear. Nervous birds react to any sound, so keep still inside the hide. Most SLRs are rather noisy in their shutter movements; to avoid disturbing the birds compose and focus on your subject in advance and lock up the mirror if your camera has a locking control. You can then make the exposure with much less noise and vibration. A car makes a good mobile hide for photographing birds feeding or drinking near a road. Baiting may lure them in closer.

Photographing birds in flight

Recording birds in flight is not easy, so you must expect a low success rate. For good results you will often need an extra long lens; it is best to use these with the camera braced against your body with a shoulder pod. For birds flying across your line of sight, prefocus the camera and pan round following the bird. Continue panning after taking the picture. To get a crisp image, use fast shutter speeds (1/500 to 1/1000 of a second). Slower shutter speeds can be used for birds flying directly toward you. If the head is sharp, the blurred wing tips of large birds will suggest movement.
See: Follow focus lens

Photographing insects

Many insects can be photographed with a standard lens and close-up accessories. Others necessitate the greater subject-to-camera distance gained when a longer lens (90 or 135 mm) is used with an extension tube. On bright sunny days available light is adequate even for slow films. In dull light, either use a fast film, possibly · double rated, or preferably electronic flash. With the double flash set-up, right, use one flash as the main light and the other as a fill-in.

Photographing fast-moving insects.
With flash heads on angle brackets, above, the camera and lights form one unit.

Hawk moths pairing. The mating hawk moths, right, were found resting on a grass stem. They remained there quite motionless for over an hour, allowing a slow shutter speed to be used on a calm afternoon. The low viewpoint against the light emphasizes the outline of the wings.

Right: Hasselblad, 80 mm and extension tubes, Ektachrome-X, 1/30 sec f11

Photographing animals

To photograph animals success-
fully you must be able to respond
quickly to their capricious behav-
ior. Your handling of the camera
must be instinctive, so that you can
concentrate entirely on antici-
pating the animal's next move.
If you go stalking wildlife, take the
minimum of equipment. Use a
monopod to support the camera;
it is both light to carry and quick
to erect. There are no rules about
lenses, but long and extra long are
both extremely useful, especially
for big game, below, and for birds,
opposite above right and opposite
below. To get natural pictures use
available light. The instinctive
behavior of the cold-blooded
skink, right, is well captured in this
shot of the animal basking in sun-
light. You will have to use flash, of
course, in dark woodlands and
caves, and for photographing
nocturnal species. Flash is also
useful for arresting movement and
for increasing the depth of field
in close-ups like the picture of the
spider, opposite top left. To get
good shots of big game you need
to be fairly close. The lion eating
its kill, below, was shot from a car.

Right: Nikkormat, 135 mm, Kodachrome II,
1/60 sec f.5.6
Below: Nikon, 200 mm, Kodachrome-X,
1/250 sec f4

Above: Hasselblad, 80 mm with
bellows, Ektachrome-X,
1/125 sec f8

Above right: Nikkormat, 500 mm,
Kodachrome 64, 1/125 sec f8

Grasping opportunities.
Always be ready for an
unexpected break. The blue
heron, right, was spotted zig-
zagging its way across a swamp.
Focusing was difficult until an
alligator suddenly rose within
feet of the heron which froze
rigid for a full 15 minutes until
the alligator submerged. This
allowed plenty of time for
setting the camera up on a
tripod and composing the
picture. Try to bring out the
color of your subjects by
including contrasting
vegetation like the green water
lettuce, right.

Right: Nikkormat, 200 mm,
Kodachrome 64, 1/125 sec f8

The seashore

Rocky shores swept by tides pro-
vide a wealth of subjects. By day
the creatures hide away in pools
and under rocks, but if you under-
stand their behavior you can obtain
some excellent shots. The ghost
crab, right, is rarely seen except
when it emerges to feed at low
tide. Crabs are timid and can move
fast, so it is best to photograph
them with a long lens. At night the
seashore comes alive and there is
great scope for flash photography.
Sea water and even salt spray
quickly corrode metal, so special
care must be taken to protect all
equipment. When you photograph
through water, watch out for dis-
tracting reflections on the surface.
Either screen the surface with a
black umbrella or use a polarizing
filter and hold your camera at
about 35° to the water.

Nikkormat, 20 mm, FP4, 1/250 sec f8

Photographing in an aquarium

Many small seashore and fresh-
water animals, as well as tropical
fish, can be photographed realisti-
cally, even though they are con-
fined in tanks. Photographs taken
through glass – especially plate
glass – will be much more suc-
cessful than those shot through
plexiglas. Make sure the front wall
is clean and the water clear. Use
a polarizing filter to minimize the
reflections of particles in the
water, and mask with black card
all shiny parts of the camera to
prevent reflections in the glass,
right. If you can, construct an

appropriate floor covering in the
tank. Take great care over the
background; black may seem
unnatural, but it provides a striking
contrast to brightly colored marine
life such as the file shell, below
right. Use electronic flash rather
than photofloods, as the latter
generate heat and warm up the
water. A single flash positioned
above the aquarium will simulate
daylight, but you can vary the pos-
ition and number of heads to suit
the subject. For both the file shell
and the whirlpool ramshorn snail,
below, two flash heads were used.

Above: Nikkormat, 55 mm
micro, FP4, 1/60 sec f16
Right: Hasselblad, 80 mm with
extension, FP4, 1/60 sec f16

Underwater equipment

The underwater photographer may be cold, confused and apprehensive. His portable photo-equipment should therefore be as simple as possible. Systems should be assembled and calibrated in advance, thereby minimizing the number of decisions to be made underwater. Equipment is subjected to many unavoidable knocks and must be robust as well as watertight.

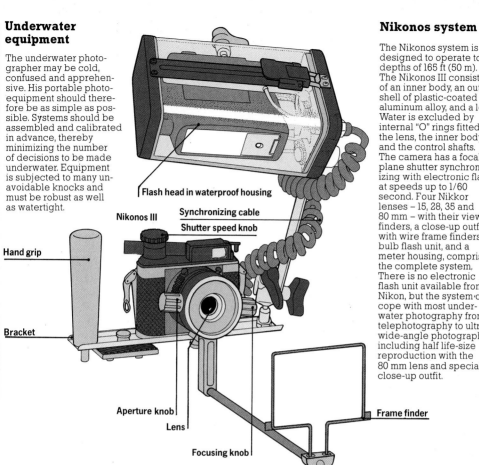

Flash head in waterproof housing

Nikonos III

Synchronizing cable

Shutter speed knob

Hand grip

Bracket

Aperture knob

Lens

Focusing knob

Frame finder

Nikonos system

The Nikonos system is designed to operate to depths of 165 ft (50 m). The Nikonos III consists of an inner body, an outer shell of plastic-coated aluminum alloy, and a lens. Water is excluded by internal "O" rings fitted to the lens, the inner body and the control shafts. The camera has a focal plane shutter synchronizing with electronic flash at speeds up to 1/60 second. Four Nikkor lenses – 15, 28, 35 and 80 mm – with their viewfinders, a close-up outfit with wire frame finders, a bulb flash unit, and a meter housing, comprise the complete system. There is no electronic flash unit available from Nikon, but the system can cope with most underwater photography from telephotography to ultra wide-angle photography, including half life-size reproduction with the 80 mm lens and special close-up outfit.

Underwater housings

Many manufacturers, make housings for their own cameras, while firms like Ikelite produce housings for a range of cameras. Making your own acrylic housing is not difficult; a wide variety of components is available.

Ikelite housing

Hasselblad housing

Lighting

Artificial lighting is essential for showing the full colors of marine life, except in the shallowest water, and as powerful amphibious units are very expensive it is worth considering the alternatives. Bulb flash units are powerful relative to their size, but below about 33 ft (10 m) they become increasingly unreliable. Electronic flash units are cheap to run and the short duration of their flash is extremely useful underwater. If you use a computer flashgun, a remote sensor housed beside the camera lens keeps the flash sufficiently brief to overcome the problem caused by back-scatter of light from suspended particles. Commercial housings are available for some surface electronic flashguns.

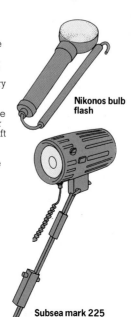

Nikonos bulb flash

Subsea mark 225 electronic flash

Exposure meters

As a rule you can use an ordinary exposure meter in a housing, but there is one amphibious meter, the Nikonos/Sekonic, pictured below.

Choosing a camera

When choosing a camera bear in mind your ability as a diver. The Nikonos system is best for an experienced diver, but you can take perfectly good photographs snorkeling around the rocks with an Instamatic providing it is housed.

Photographing underwater life

Underwater life is most plentiful in shallow water, say, the top ten meters, and this is well within the reach of the snorkel diver. However, an aqua-lung is essential for photographing animals and plants which live in deeper water, and it will also allow you time for coaxing reluctant sub-jects. The best way of adding background to a photograph of life forms is to shoot in a cave, below, and for this you will need flash. A sure way to attract fish in warmer waters is to crack open a sea urchin, right. An abundance of fish will arrive in seconds. It is easiest to get close-ups like the shot of the angel fish, below right, at night. The fish are drowsy, easily mesmerized by a flash-light and you can often pick them up.

Right: Rolleiflex, High Speed Ektachrome, 1/60 sec f8
Below: Bronica, 50 mm, Ekta-chrome-X, 1/40 sec f5.6
Below right: Rolleiflex with close-up attachment, High Speed Ektachrome, 1/60 sec f11

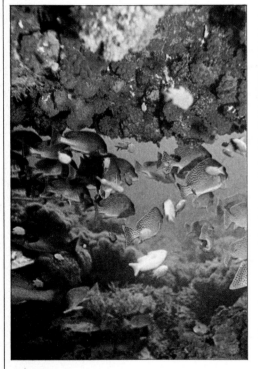

Low visibility shots

When visibility is low the closer you can get to a subject the better. With an extra wide-angle lens or lens attachment, a complete diver can be photographed from as close as 12 ins (30 cm). The nearest diver in the picture, right, was no more than 2 ft (60 cm) from the camera. The huge depth of field of these lenses allows the focus to be pre-set at about 6 ft (2 m) and left unaltered. The problem is that few flash units can cover this wide angle of view. Turbid water scat-ters light and lowers con-trast. Use fast film and improve contrast with a 3x yellow filter for black and white, or a color cor-rection 30 red filter for color; under-expose and over-develop.

Nikonos, 35 mm with wide-angle attachment, High Speed Ekta-chrome, 1/30 sec f5.6

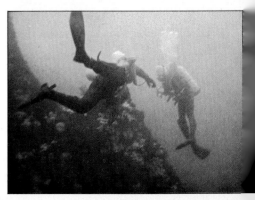

Underwater close-ups

Any area with a variety of life provides an endless supply of subjects for close-up photography and most rules governing macro photography on land apply under water. The Nikonos uses internally sealed tubes, but you can work with extension tubes on your SLR provided you have a longer lens housing. Flash is essential in underwater macro photography. The best set up is illustrated, below. You can keep timid or dangerous subjects at arm's length by using a telephoto lens with an extension tube.
See: Macro photography

Equipment for close-ups.
The pictures of the gem anemones, above, and the colonial sea squirts, right, were taken with a Nikonos camera fitted with extension tube and framer, left. Flash was directed from above at an angle of 45°.

Above and right:
Nikonos, 35 mm with extension tube, Ektachrome-X, 1/60 sec f16

Underwater landscape

Shallow water provides the best underwater landscapes, and very effective shots can be taken by a swimmer with a snorkel. However, flash fill-in can produce more effective pictures. It was used in the picture, right, to make the fish record more brightly, but remember that even with large flash units the light is only useful up to about 12 ft (4 m). Position flash well away from the camera-subject axis to reduce backscatter. You can use a second flash for modeling, and you can even use backlighting, slave triggered or on a long lead operated by a fellow diver.

Nikonos, 35 mm, Ektachrome-X, 1/60 sec f4

Light refraction underwater

Rays of light are bent, or refracted, as they pass through the interfaces of an underwater camera system. The acceptance angle of the lens, above right, is reduced by a third and objects appear a third larger and a third closer. This effect can be offset by using a wider angle lens. A dome port, below right, attached to your camera housing will prevent refraction. Refraction affects eye and lens equally, therefore set the distance on the camera scale as you estimate it with your eye.

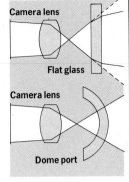

Camera lens

Flat glass

Camera lens

Dome port

Color underwater

The diagram, right, shows how water absorbs light selectively at the red end of the spectrum. You can restore color balance with an appropriate color filter. Try 12 red color units per 3 ft (1 m) of depth, so that at 12 ft (3·6 m) you use a medium strength red filter (CC50R). Experiment with smaller degrees of correction if you want some interesting results. Color balance is affected by water tints; in northern waters, often green with plankton, you may need to correct color with magenta filters instead of red. Below 20 ft (6 m) full correction becomes impossible without artificial light.
See: The components of color/Filters

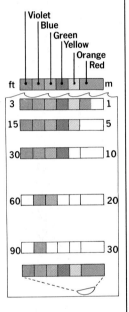

Violet
Blue
Green
Yellow
Orange
Red

ft / m
3 / 1
15 / 5
30 / 10
60 / 20
90 / 30

Exposure underwater

Ideally you should use an exposure meter, taking care not to point it at the surface. If you have no housed meter, either use the table, below, as a guide, or estimate exposure after first taking a surface reading. Open the lens by one stop just below the surface, and by additional amounts, depending on the visibility, for each extra 10 ft (3 m) of depth.

Depth	Clear calm water	Clear ruffled water	Average clarity	Slightly murky
Above surface	f16	f16	f16	f16
Below surface	f11	f8	f5.6	f4
15 ft (5 m)	f8	f5.6	f4	f2.8
30 ft (10 m)	f5.6	f4	f2.8	–
60 ft (20 m)	f4	f2.8	–	–
90 ft (30 m)	f2.8	–	–	–

Sun overhead/Shutter speed 1/60/50 ASA film

Choosing film

Use fast films for distant flash shots and when you are working in available light. 160 ASA is usual for color, increasing to 320 or 640 ASA with special processing. 400 ASA is good for black and white and can be pushed in processing up to 6400 ASA if necessary. Very fast monochrome films are of little use underwater because their increased speed results from extra sensitivity to red. For close-up work, slow films give better results – 125 ASA for monochrome and 25 to 64 ASA for color.

See: Black and white film types/Color film types/Uprating film

Low visibility techniques

Even clear underwater conditions are only as favorable for photography as a landscape in mist. Underwater visibility may be 100 meters in mid-ocean, but in a muddy estuary it will be virtually zero. There are many ways to cope with this. You can use long exposures (one or two minutes) with the camera firmly wedged between rocks. (You may find bright conditions require neutral density filters.) In murky water you can take down a transparent tube or plastic bag filled with clear water to place between lens and subject for close-up work. Another alternative is to use a flashgun with a polarizing filter fitted to it, together with a crossed polarizer over the lens. Give two stops extra exposure. The polarizers will reduce interference from light-reflecting suspended matter. As a rule restrict your photography to a third of the maximum visibility and concentrate on close-ups.
See: Polarizing filter/ Crossed polarization

Safety underwater

If you are not an experienced amateur diver you must undergo training before attempting underwater photography, because photo-equipment increases swimming resistance and causes earlier exhaustion. However experienced you are, you should never dive alone. If you dive overweight for extra stability on the sea bed, you must wear an adjustable buoyancy life-jacket. Beware of complex camera assemblies which may snag on lines and jeopardize an emergency escape, and remember nitrogen narcosis increases these problems with depth. If you discard gloves for greater dexterity beware the abrasion dangers of rocks and coral. Do not become so absorbed in your photography that you forget timing and find yourself with decompression problems. Finally, keep a constant watch for everything from urchin spines and jellyfish, to octopi and sharks.

The best locations

Throughout the world, underwater visibility is best and life is richest away from man's pollution. You are unlikely to find a wealth of underwater subjects in large river mouths or muddy bays. Look for steep rocky shorelines, coral reefs and atolls, and coasts swept by tidal streams. Tides carrying food particles travel past rocky headlands, so fish and other underwater life abound. Search sandy bays for flatfish and rays, and look for fish around the shelter of old ship-wrecks. Wrecks in themselves make excellent subjects for photography. Some of the best diving areas in the world are parts of the Mediterranean, the Red Sea, East Africa, the islands of the Caribbean, Florida, the West coast of America, the Pacific islands, Indonesia and the Great Barrier Reef.

Remote operation techniques

Sometimes you have to operate cameras from a distance – either because you cannot be physically behind the camera, or because pictures must be taken over an extended period of time. The camera may have to be raised on a telescopic mast or flown from a kite, to give a high viewpoint. It may be attached to the wing of an aircraft, the jib of a crane, or a skier's boot. Suitably protected and equipped with flash, a camera can be drawn through a drain or tunnel to record its internal condition. There are many natural history and surveillance applications where the camera can be triggered by the subject itself. For all this sort of work a motor-driven camera will be needed, unless the event offers you only one chance for a picture. Trigger arrangements vary. A radio transmitter, right, which sends an impulse to a small receiver in the camera, is the most versatile, but for short distances use a 20 ft (6 m) pneumatic release, or a solenoid wired to a battery. Alternatively, you can trigger the shutter through an "intervalometer," set to give pulses at regular intervals. A trigger can be arranged to set off several cameras so that you can record

an event from several directions at once, to get extra information or make measurements. A set of cameras may be needed to photograph simultaneously on four types of film, or through different filters. Multi-camera brackets and synchronous command units, below, are included in several advanced camera systems.

Solenoid operated shutter

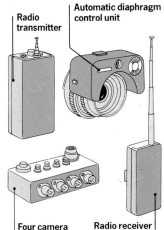

Radio transmitter

Automatic diaphragm control unit

Four camera command unit

Radio receiver

Making a remote control release.
Even if your camera offers no electrical release or motor drive you can sometimes improvise a remote control. The best arrangement is a small electrical solenoid, above, able to depress the shutter release when energized by a battery. Any device able to close an electrical circuit can be used to trigger a solenoid – the hands of a clock for example. The cheapest improvised system uses two rubber bands; the first band is arranged to prevent the second from pressing down the shutter release. You then use a cigarette or candle as a fuse, positioned so that it will eventually burn through the first band.

Setting up a remote camera

The problems you face in setting up a remote camera vary according to the nature of the job. If it involves leaving the camera ready for use all day some form of automatic exposure control will be needed. Use a coupled electronic flash, or a diaphragm control unit, above right, which alters the lens aperture to suit the changing intensity of daylight. In other circumstances– particularly for sports photography –you may have to position the camera just a few minutes before the event. For example, the pole vault wide-angle shot, right, was taken by a remote camera lying on its back close to the slot where the athlete places his pole. You can check viewpoint and focus from this awkward position by means of a right angle attachment for the finder eyepiece. The shutter can be triggered with a long electrical release. You must take the greatest care not to cause accidents by dangerous position-ing of the camera or the leads.

Nikon, 21 mm, Tri-X, 1/500 sec f11

Photographing from aircraft

If you can organise a trip in a small aircraft a high wing design is likely to offer fewer obstructions to your viewpoint than a low wing airplane. Try to avoid photographing through windows. This is unavoidable in an airliner but in a small aircraft you may be able to remove a window or door. Make sure you and your equipment are well strapped in. Exterior wind deflectors help to reduce air disturbance, but keep to the shortest possible shutter speeds and use a UV filter to help reduce blue haze. A hand-held SLR or a viewfinder camera fitted with a sports-finder are ideal for aerial photography. The same principles of lighting apply as when lighting landscape or still life. Low morning or evening sunlight emphasizes the earth's texture, trees and buildings.

Shooting landscape from the air.
The picture, below left, was taken through the open door of an aircraft at 5,000 ft (1,500 m). Hazy sunlight reflected from the river picks out its interesting shape. Extra development was given to compensate for loss of contrast caused by atmospheric haze. The photograph, below, was taken from a helicopter flying at 1,000 ft (300 m). Evening sunlight gives good resolution.

Below left: Pentax, 50 mm, Tri-X, 1/250 sec f8
Below: Leicaflex, 35 mm, Tri-X, 1/500 sec f11

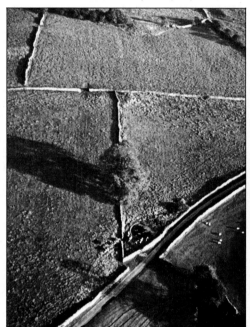

Using a kite

One of the most effective ways of taking aerial photographs is to fly your camera attached to a kite. Large format pictures will show the greatest detail on enlargement and will produce images from a similar height to that of the photograph, above right.

Parafoil. In theory you could attach a camera to any kite, but the parafoil, above, has a high weight-to-lift ratio. With an area of 25 sq ft (7.6 sq m) it can lift a 5 lb (2.3 kg) load. It will fly in winds of 4 mph upward.

Kite camera system. The camera is put in an aluminum box, right, and held by rubber mountings to minimize shock on landing. The box is fixed to a harness of wooden struts and aluminum straps and this is attached to the line when the kite is about 100 ft (30 m) in the air. The camera shutter is cocked, a rubber band placed over the shutter lever with a thread to restrain it from firing. This thread is looped into a saltpeter fuse which burns through and releases the shutter. You can make your own fuse by boiling piping cord in saltpeter: a 6 ins (15 cm) fuse will burn for about 2 minutes – long enough for the kite to reach about 1000 ft (300 m). Alternatively you can buy timed fuses.

Sky diving with a camera

Before you contemplate photo-
graphy in free-fall you must be an
experienced sky diver (at least
200 jumps). In free-fall your body,
parachute equipment and camera
are weightless and you travel
downward at a speed of 120 mph
(193 kph). As soon as you pull the
ripcord, however, the opening
parachute slows you to a speed
of 10.2 mph (17 kph) in the space
of one and a half seconds. Your
body is subjected to a force of
about 4 Gs (4 times the force of
gravity), with the effect that every-
thing you are carrying increases
in weight four times. It follows
that the less weight you carry the
better. The only way of retaining
your freedom of movement which
is essential, is to mount the camera
on your helmet. The advantage of
this is that your neck can act as an
excellent pan and tilt. With a
helmet mount you are, of course,
unable to look through the view-
finder, and to compensate for
this an optical sight is mounted
in front of the eye. Calibrated to
the camera, it will give you the
center of the frame and from this
you learn by experience to judge
the rest of the shot. Parachuting
normally takes place in fine
weather so you can pre-set expo-
sure on the ground before take
off. A shutter speed of 1/500 sec-
ond is ideal. If you pre-focus the
camera at about 20 ft (7 m) and
use a 35 mm lens you will be able
to get ample depth of field.

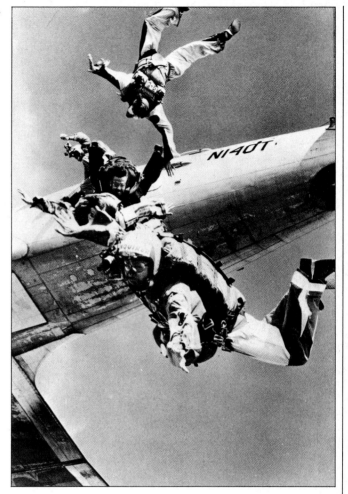

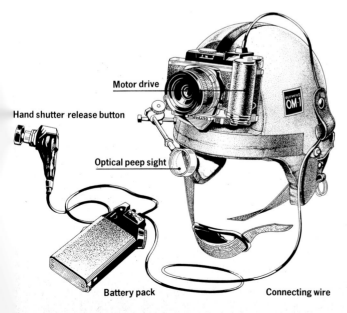

Shooting in free fall. The picture, above,
was taken half a second after the
photographer had jumped from the
aircraft, when he was traveling downward
at a speed of 32 ft (10 m) per second.
You can strap two cameras to your helmet
to take color and black and white pictures
simultaneously.

Olympus OM-1 with motor drive, 35 mm,
Plus-X, 1/500 sec f16

Motor drive

Hand shutter release button

Optical peep sight

Battery pack

Connecting wire

Equipment. The Olympus OM-1, securely
fixed in a cradle attached to the helmet,
forms the basis of an ideal system for free-
fall photography. It weighs about 2 lbs
(0.9 kg) with motor drive attached and is
operated by means of a wire which runs
inside the sleeve of the photographer's
jacket and is connected to a release button
held in his hand. Use medium speed film:
there is so much light in good sky diving
conditions that fast film is unnecessary.

Equipment for panoramas

Panoramic photographs can be produced by taking a sequence of pictures with an ordinary camera, rotated on a tripod pan head. These must be match printed, cut and joined. Special panoramic cameras make the job much easier by giving a 120°, 180° or even 360° view in one exposure. Usually the lens unit rotates, projecting the image through a moving slit on to curved film. Simpler cameras just use an extreme wide-angle lens to cover a long narrow picture format.

Arca Rotacamera

Panning head

Horizont

Linhof Technorama

A 360° panorama

The panoramic view below consists of twelve overlapping pictures taken from one position with an ordinary camera, which was rotated on a tripod between exposures until a total 360° was recorded. The problem with this method is that it is impossible to register both foreground and background elements. All off-center continuous horizontal lines, such as the roof lines of buildings, join up with noticeable changes of angle, and foreground objects near the sides of each picture align themselves against different parts of the background. These effects are worst with a wide-angle lens, but they can be minimized if you take as many pictures as possible, giving extensive overlap, say 40 percent. Then you use only the central strip from each negative. You can use a 35 mm camera and make the panorama from the enlargements, but it is difficult and time consuming to produce enlargements which match each other in density. It is much easier to work with a 2¼ ins (6 x 6 cm) camera, as was used for the panorama below, since you can produce matched prints simply by contact printing 12 negatives. You are, however, limited to a print 22 ins (56 cm) long. Once you have your matched contacts or enlargements, cut them up and mount them roughly with adhesive tape to check that the whole panorama is covered and to plan where to trim the individual prints. Then take another contact sheet, cut it up according to plan and butt mount the prints.
See: Mounting

Multi-viewpoint mosaic

You can use an ordinary camera for panoramic views shifting the camera viewpoint sideways between exposures and building a mosaic, right. This maintains correct horizontal lines throughout the mosaic, but can only work successfully if the subject is some distance away and has a plain foreground such as water or grass. This is because the regular shift in viewpoint between pictures means that some parts of the foreground are never recorded, as shown in the diagram, below. However, this does enable you to avoid trees, posts and other obstructions.

Single viewpoint panoramas

The picture, below, was taken with a panoramic camera which has a rotating lens system. Lines running horizontally through the image center are undistorted, but lines above or below curve toward each other. Long narrow horizontal structures appear to bow toward the viewer, and objects arranged in a curve about the camera record as one straight line. The camera viewfinder contains a spirit level to help ensure that landscape horizons are placed absolutely in the center of the picture.

Panoramic cameras are usually used for long, narrow horizontal views, but by holding the camera to take photographs vertically it is possible to produce distorted but acceptable pictures of full length figures, right, tall buildings and so on. Be careful not to include your own feet, and try to choose a viewpoint which is roughly central to the subject. In some cases the top and bottom parts of the picture will show the subject appearing to taper away symmetrically.

Above: Horizont, Tri-X, 1/125 sec f8 Right: Horizont, Tri-X, 1/60 sec f11

Mounting a mosaic. The picture, left, is a mosaic made up from three shots taken from the viewpoints indicated, far left. The first shot was taken from a viewpoint directly in front of the statue and the others from viewpoints in direct line with each of the towers. The way the three prints were cut up and mounted is shown by the brown lines above. Some of the foreground was missing, so grass has been added with an air brush.
See: Print retouching

Equipment

You can get good pictures of the sky at night simply with a camera on a tripod, or you can invest in elaborate telescopic systems. The main problem is that the subject is never still. As the earth rotates on its axis the field of view of a fixed camera or telescope sweeps once around the sky in a day. When recorded on film star images trail out into streaks whose length is proportional to the exposure time. If you use a single lens reflex with a normal lens you will get noticeably elongated star images, right, with any exposure over 20 seconds. To avoid trails you must keep exposures short, or else use an equatorial drive which will move the camera in such a way as to counter-act the earth's rotation. Even without such apparatus, modern films and lenses enable good star photographs to be obtained with even the simplest of cameras.

Exakta, 50mm, FP4, 2 mins f1.8

Equatorial drive. An equatorial drive unit, right, rotates smoothly in 23 hours 56 minutes about an axis which should point toward the celestial north or south pole, depending which hemisphere you are in. In the northern hemisphere the pole star is a rough guide being only one degree from the true north pole. You can buy an equatorial drive or you can build one using ready-made metal strips and cogs from a child's building kit. You can power the drive electrically or by clockwork.
See: The pole star

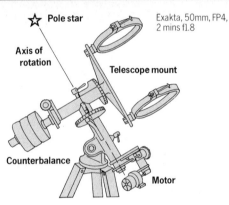

☆ **Pole star**

Axis of rotation

Telescope mount

Counterbalance

Motor

Choosing a telescope. A permanently mounted, 15 to 30 cm aperture, reflecting telescope is best for an amateur; use the full focal length for planets but reduce it to record nebulae and constellations. The longer focal lengths of refracting telescopes give a better image scale for planets. If you live in a city a portable telescope may be best, because you can take it to the most suitable viewpoints, namely high altitudes in the dark of the countryside. If you have a telephoto lens you can turn it into a telescope by fitting a special eyepiece. The whole combination can then be attached to the lens mount of a SLR through an extension tube.

Using a telescope. If you have a telescope or can use one belonging to a local astronomical society, the range of your camera will be greatly extended. For best results with a telescope a good equatorial drive with guiding arrangements is essential. The camera body should be attached to the telescope with a rigid adaptor that fits into the lens mount. This may either go in place of the telescope's eyepiece, with the film in the focal plane of the telescope, or fit over the eyepiece so that an enlarged view is projected on to the film for close-up pictures of the moon and planets. Focusing is usually through the lens.

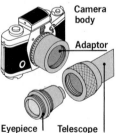

Camera body

Adaptor

Eyepiece **Telescope**

Telescope adaptors. The adaptor above links the camera body to the telescope's eyepiece. The adaptor below fits in place of the eyepiece.

Adaptor

Films and processing. Medium-speed material in the range 100 to 200 ASA is best for the planets, moon and sun. Color transparencies give excellent results, especially if projected in a completely darkened room. Fast films in the range 400 to 800 ASA are much the best for nebulae and stellar photographs; use uprated development. The shorter exposure times necessary for fast film reduce guiding errors, and reciprocity failure may be discounted for anything up to 30 minutes. Extended development increases film speed and brings out fainter stars. Print normally, on to hard bromide paper. If you send your transparencies to a processing laboratory ask for the film-strip to be returned uncut. The large areas of black sky make individual frames difficult to distinguish.

Stars at dusk

The exposure times required to show up the brighter stars (1 second to 1 minute), and to photograph buildings and landscapes at dusk are well matched. Effective compositions can result from silhouetting buildings against a starry sky soon after sunset, right. A wide-angle lens will enable maximum coverage.

The sun

The sun should never be observed directly through a telescope, nor should a camera be pointed straight toward it; eyes and camera can both suffer severely. The only safe way to photograph the sun without specialist equipment is to project its disk on to a piece of white card and to photograph that in the conventional way. Watch the image on the card closely and expose when atmospheric turbulence is at a minimum. Sunspots can be clearly seen and recorded, and their motion from day to day will reveal the sun's leisurely 25 day rotation.

Exakta, 50mm, FP4,
45 secs f1.8

Exakta, 15cm refractor, FP4,
1/60 sec f11

The moon

The whole moon, below left, can be shot with short exposures at medium apertures, say about 1/60 second at f11. A telescope with a focal length of about 6 ft (2 m) is necessary for a good image size, but virtually any telescope (or binocular) will do, and an equatorial drive is not necessary for so short an exposure. You can take detailed pictures of the moon with a hand-held camera body directed on to the eyepiece of a static telescope. As long as the camera is held square-on at the correct distance from the telescope's eyepiece, focus will be sharp all over. Take several shots using a range of exposures. The best time to catch a given crater, such as Scheiner, which is in the center of the picture, below, is when it is close to the terminator between the bright and dark sides of the disk.

Exakta, 15 cm refractor using eyepiece projection, FP4, 3 secs f120.

When and where to work

The best photographs of stars and nebulae will be obtained on cold, clear nights, but watch out for dew forming on your lens. For the moon and planets, which are of course much closer, a hazy sky is often preferable as there tends to be less atmospheric turbulence. In all cases the image should be as high in the sky as possible. It is best to choose a location away from lights and at as high an altitude as possible.

Manmade satellites

Point your camera at the altitude and bearing at which you expect a satellite to appear. Simply open the shutter and wait while it crosses the field of view. It will record as a white line across the star field, right. Interesting results are produced by objects that vary in brilliance, leaving an uneven trail across the picture.

Leica M2 equatorially mounted, 90 mm, Tri-X, 10 mins f4

Shooting stars

On an average night sporadic meteors, or shooting stars, appear at the rate of six an hour. At those times of the year when the earth intersects the orbits of meteor streams, the rate may increase to sixty an hour. Use medium speed film to record their trails which fall at an angle to the trails of the fixed stars, right. Exposures of up to one hour at f5.6 can be made without undue fogging. Faster film used at wider apertures requires shorter exposures, but meteor trails will be fainter.

Pentax, 55 mm with fisheye convertor, FP4, 66 mins f6.8

Constellations, planets and comets

With just a camera and a tripod you can, over a period of time, photograph the whole sky visible from your latitude. If you use an equatorial drive and long exposures, say up to 30 minutes, you will reveal a multitude of stars which are never visible to the naked eye. Star maps in newspapers and special publications, show which groups are on view in any month. Exposures, with the lens wide open, should be from five seconds upward. Again, just a camera and tripod can be used to record the shifting positions of the planets among the stars in the course of a year. Consult star maps. You will probably find that Mars and Jupiter, below right, record most strongly and frequently. If a bright comet becomes visible, below left, you can photograph it as often as possible, and build up an album of its changing appearances. To get good photographs of the planets a long effective focal length is necessary. This could be up to 65 ft (20 m) in which case a 15 cm telescope would give f120, but 33 ft (10m) at f64 will give a good image. The exposures required will be around two seconds for Jupiter, below, eight seconds for Saturn, 1/2 second for Mars and 1/15 second for Venus. These times vary a lot as the planets change size and brightness by considerable amounts, so it is wise to make several exposures around these figures.

Below left: Leica S type, 280 mm, Tri-X, 15 secs f4.8
Below: Exakta equatorially mounted, 15 cm refractor using eyepiece projection, FP4, 2 secs f120

The pole star

The pole star is one degree away from the celestial north pole. You can therefore use it to align an equatorial drive unit. To find the pole star, first find the seven star constellation, the Big Dipper (the Plough), right. An imaginary line between the two lower stars pictured here points to the pole star.
See: Equatorial drive

Exakta, 30mm, FP4, 10 mins f3.5

Nebulae

Seen through a large telescope nebulae look like faint clouds of light. Some nebulae, such as the Andromeda spiral and M101 in Ursa Major, below, are galaxies lying beyond our own system, while others like the Orion nebula, below right, are gas clouds, predominantly of hydrogen, within our own galaxy. Several of the brighter nebulae may be photographed with an ordinary camera lens and fairly short exposures but an equatorial drive is vital for good pictures of all nebulae, except Orion. Try pointing your camera at the constellation of Sagittarius on a fine summer's night or in the autumn at Scutum or Cygnus. Try to find an area of the sky which contains more than one nebula, such as the three in the constellation Leo, pictured right. Exposures can be from a few minutes to a couple of hours, depending on the size of the telescope, its maximum usable aperture and the accuracy of the driving mechanism. The exposure should be made with the film directly in the focal plane of the subject. The aperture needs to be as wide as possible, usually between f4 and f8, though the Orion nebula, below right, is sufficiently bright to record at smaller apertures.

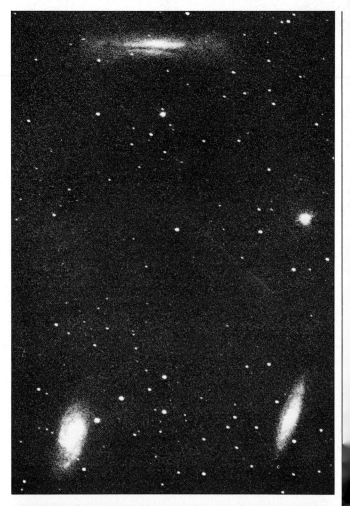

Above right: Leica S type equatorially mounted, 26 cm reflector, 103a-E Astro film, 25 mins f5.6.

Below right: Leica S type equatorially mounted, 26 cm reflector, Tri-X, 30 mins f5.6.

Below: Leica M2 equatorially mounted, 26 cm reflector, 103a-E Astro film, 30 mins f5.6

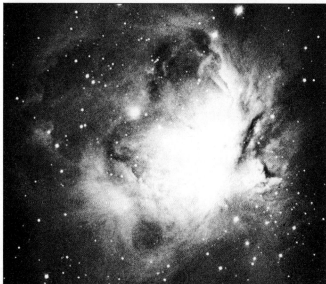

Stereo photography

Our ability to perceive the roundness and depth of three-dimensional objects is largely because of our binocular vision; the parallax differences between our two eyes. This difference in viewpoint results in slight variations in the way a foreground object aligns itself with elements in the background, below. The simplest way to recreate a stereo-scopic effect in a photograph is to take two pictures separated in viewpoint by a distance equal to the gap between a pair of human eyes – about 2½ ins (6 cm). This can be done with a special double lens camera, or a normal camera either shifted between exposures, or fitted with an optical beam splitter in front of the lens. After processing, the pair of pictures is projected or viewed in such a way that only the left eye sees the left hand picture and the right eye the right hand picture. The pictures then fuse together to form one three-dimensional image, as shown overleaf. Stereo photography is something well worth trying but choose a subject which offers strong linear depth, is well lit for form and texture, and can be imaged sharply throughout.

Stereo Realist

Duval

Left eye **Right eye**

Stereo vision. When you look at a group of objects the information received by your left eye differs from that received by your right eye. Try looking at two objects like those above, first closing one eye then the other.

Stereo cameras. Various double lens stereo cameras have been marketed, the most famous of which was the 35 mm Stereo Realist, above. Essential characteristics of a stereo camera are two matched lenses, with linked focusing, linked shutters and a common, usually direct vision, viewfinder. Some use ordinary 35 mm film, intermesh-ing the pairs of pictures in such a way that there are no wasted gaps. The Duval camera, above, uses 120 roll-film. It exposes pairs of pictures each 23.5 x 25 mm across the width of the film, 24 pairs to the roll. All stereo cameras allow you to expose twice with each lens capped in turn, so that you can shoot double the number of ordinary photographs.

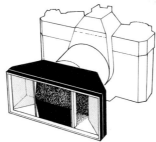

Pentax stereo adaptor

Beam splitting. One reason why stereo cameras have gone out of favor is that you can easily make stereo-pairs with an ordinary camera. The beam splitter, above, fits over the front of a standard lens on a 35 mm SLR camera. The front of the device observes the subject from viewpoints 2½ ins (6 cm) apart, reflecting the scene through the lens to form a pair of upright images side by side on the normal 24 x 36 mm frame. You operate the camera as usual, producing the same number of stereo pairs as you would normal pictures.

Making two exposures

Another way of making stereo pairs is to use a normal camera but take two pictures, moving the camera between each. Obviously this is only practical with still life subjects, landscapes and so on, which will not change from one moment to the next. Often you can just shift the camera sideways a few inches between exposures, but the job is made more precise by a sliding camera cradle which mounts on to the tripod. This allows just the correct length of shift and keeps the two viewpoints in absolute alignment.

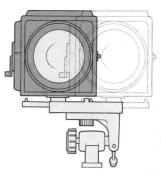

Stereoslide. This sliding cradle allows a quick sideways movement of the camera between paired exposures. Some models will allow a pair of identical cameras to be mounted side by side where they can be exposed simultaneously using a double cable release.

Taping two cameras. If you have two cameras you may be able to tape them baseplate to baseplate so that the lenses are spaced about 2½ ins (6 cm) apart. It is vital to press both shutter releases at the same moment. This improvised stereo camera gives full frame left and right hand pictures which are an advantage when projecting.

Mounting stereo pairs

Once you have exposed and processed your stereo transparencies the next stage is to mount and view them. The basic requirement for this is that the left hand image should only be seen by the left eye, and the right hand image by the right eye. First sort out your frames into correctly orientated pairs. Cameras vary in the way they position the stereo pairs along the film. This is further complicated by the fact that images always record upside down, and turning them right way up reverses the left/right relationship. With cameras such as the Duval, hold the picture pair right way up, then cut the two frames apart and exchange left for right before sealing into a

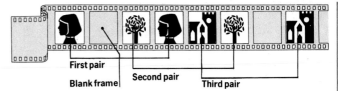
First pair
Blank frame
Second pair
Third pair

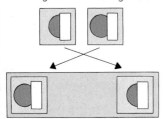

stereo mount. If you use conventional cameras in pairs for stereo photography one film will of course carry all the left hand pictures, and the other all the right hand pictures. Standard stereo mounts have a pair of 22 x 24 mm apertures, 2½ ins (6 cm) apart.

Stereo interleaving. Most 35 mm stereo cameras wind on a length of film equivalent to two frames between pairs of exposures. Stereo pairs are therefore interleaved, above. Remember to position each left and right frame correctly after cutting them from the processed film.

The hand viewer. The viewer, below, is designed for standard stereo mounts. The viewing lenses can be focused forward and backward together. On some models you can adjust the distance between the lenses. A pair of internal lamps operates from batteries or through a mains transformer.

Split frame stereo

If you use a stereo attachment, a beam-splitter, over the lens of a normal camera the processed transparency will contain two pictures, below. No re-orientation is necessary. The images together occupy a 24 x 36 mm frame, and fit a conventional transparency mount. A special hand viewer, bottom, reverses the action of the

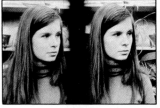

beam-splitter. Pictures taken at apertures smaller than f8 are usually the most successful. At larger apertures the dark separating band between the images begins to disappear, and the illusion of depth may be degraded by overlapping images. The system illustrated is designed for use with a 50 or 55 mm normal lens, but good close-up results can also be obtained with a macro lens. The ability to resolve the two images successfully through the viewer varies considerably from one person to another.

Stereo projection

To project stereo use either a special double lens projector for transparencies in stereo mounts, or a pair of normal projectors with left and right images in separate mounts. Arrange for the projected images to overlap on the screen, offset horizontally by about 10 per cent of their width. There are two ways of ensuring that each viewer sees only one picture with each eye. Both systems use eye glasses. You can fit a strong green filter over the lens of the projector showing the left hand image and a strong red filter over the other projector lens. Each member of the audience wears glasses with a green filter over the left eye and a red one over the right. You can make the glasses with sheets of colored gelatin. With this method, however, the colors of the transparencies are filtered out and the viewer sees only a monochrome picture. The other system uses polarizing filters on the projectors, one which polarizes light vertically and the other horizontally. This time the eye glasses have polarizing filters set so that only light from the left hand image pro-

jector will pass through the left hand eyepiece, and vice versa. Polarization allows pictures to appear in full color, but you must project on to a metallic screen. **See:** Polarized light

Projection systems. The projector, left, is specially designed for stereoscopy. It accepts pairs of pictures on a common mount. You can also use a pair of normal projectors, above, set up with their lenses as close as possible.

Close and distant subjects in stereo

As a rule, you take a pair of stereoscopic pictures which have a viewpoint separation of about 2½ ins (6 cm). This produces a good 3D effect unless everything in the picture is a great distance away, in which case the two pictures will barely differ. Similarly, if you are shooting subjects a few inches away the standard viewpoint separation will be so great that images cannot be fused together when viewed. Stereo pictures taken at great distances should be exposed with much wider separation, say 10 ft (3 m) at 500 ft (140 m). For stereo close-ups use one camera and shift it less than 2½ inches. A good guide is to make the separation between pictures about 1/50th of the subject distance for very distant views, and ¼ subject distance for close-ups of 10 ins (25 cm) or less.

Xography

This system produces 3D prints and transparencies which do not need to be viewed with special glasses. You have to use a large format view camera with an elongated cylindrical lens and a shutter aperture which scans 2½ ins (6 cm) from left to right during exposure. Ordinary black and white or color materials are used, but the camera has a moving cylindrical screen just in front of the emulsion.

How xography works. The basis of the xography process is a cylindrical "lenticular" screen shown greatly enlarged, above, which is built into the back of the camera just in front of the film plane. This makes the image record on the film as narrow, interlaced strips of left and right eye viewpoints. After processing you attach an inexpensive plastic embossed screen of the same design over the surface of the film or contact print. At normal viewing distance your two eyes look through the surface screen at different angles. The left eye sees only the image mosaic formed by left image strips and the other eye sees only right image strips.

Holography

Holography is a system of creating three-dimensional images without using lenses or cameras in the accepted sense. It uses a characteristic of light called wave motion. A still life subject is set up and illuminated by a laser, a device which emits a coherent (parallel-sided) beam of light. A large fine grain photographic plate receives reflected laser light from the subject as well as a reference beam split off from the original laser source. The interference pattern created by the mingling of the light reflected by the subject, which is now random, and the coherent light of the reference beam creates the holographic image.
See: Laser

Close-up of processed hologram. The small section, left, shows that, after processing, the hologram appears as an apparently random collection of smudges when viewed against diffused light. For 3-D viewing the hologram should be back-lit by a laser or a concentrated light source behind a pinhole.

Making a hologram. The equipment for exposing a hologram involves mirrors, pinhole apertures and a coherent light laser beam. The whole system requires extremely careful alignment and absence of vibration. No camera is required.

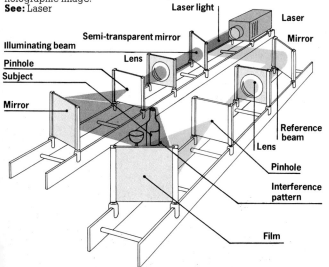

Laser light
Laser
Semi-transparent mirror
Mirror
Illuminating beam
Lens
Pinhole
Subject
Mirror
Reference beam
Lens
Pinhole
Interference pattern
Film

Laser
Hologram
Center view
Left view Right view

The hologram effect. When a hologram is illuminated from behind the reflected light waves from the subject are recreated and appear as a 3-D image to the viewer. When you move position in front of the projected image the subject's appearance changes as it would in reality. You can see, above, how the hologram appears when viewed from the left, center and right of the projector/hologram axis.

Photographing scale models

Tabletop railways, ships, aircraft and architectural models of all kinds can be photographed so that they look like the real thing. When you choose the camera viewpoint pay great attention to scale; work out how far above the base of the model the lens should be, so as to give an eye level or aerial viewpoint. Then select a lens with the right focal length to include the area you require. If you work with a view camera, use movements where necessary to improve depth of field and correct verticals. Stop the lens well down. Choose lighting quality and direction carefully, so as to simulate natural conditions. For a final touch of realism you can print in clouds, right.
See: Multiple exposure/ Using the view camera

Lighting models for realism.
For the picture, below, two floods were combined with a reflector board. Considerable drop front was used to preserve verticals. Linhof, 210 mm, HP4, 2 secs f4.5

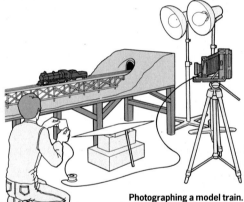

Photographing a model train.
The diagram, above, shows the set-up used for the picture, top. The mirror added catch-lights to the wheels and pistons. Linhof, 210 mm, HP4, 1 sec f4.5

Shooting exploded views

Sometimes for informative pictures of how a complex mechanism works, it is helpful to show exploded views in which components are laid out in their precise order of assembly and slightly separated from each other. In this way you can clearly identify each individual item and at the same time see how everything fits together. A plain, shadowless background is generally best for this, with soft, even top lighting to avoid complicated shadows. Lay out the components carefully in position on a horizontal sheet of glass supported over a separately lit background, but take care not to show reflections of the camera or lights in the glass.

Setting up an exploded view.
You can use a copy stand, right, for photographing an exploded view. Black card prevents the camera reflecting off the glass sheet.

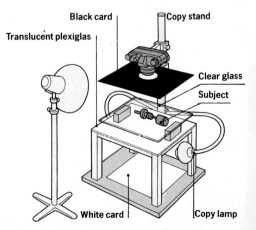

Black card
Copy stand
Translucent plexiglas
Clear glass
Subject
White card
Copy lamp

Instructional sequence

Instructional photographs are often most helpful when they appear in a sequence. Each picture should should show one particular stage of an operation simply and clearly, and the sequence as a whole should have a continuity which makes it easy to follow. If possible standardize your camera view-point, background and lighting. Exclude from the picture anything which is irrelevant to the particular point you are making. By shooting over the demonstrator's shoulder you will help the viewer identify with the various operations. Soft, fairly frontal lighting will show up detail, but make sure it does not destroy form. Make the image as large as possible and remember to indicate scale; this is most easily done by including hands.

All pictures: Hasselblad, 80 mm, FP4, 1/15 or 1/30 sec, f11 or f16

Laying out an instructional sequence.
1. The sequence on propagating geraniums, below, begins with an establishing shot, left, to show the various items needed.

2. Preparing the pot. The hand establishes the size of the pot.

3. Filling pots with compost. The multiple element is suggested here by including several pots in the background.

4. Compacting the soil. The hand is positioned so as to show how full the pot should be.

5. Taking the cutting. This close-up was shot with extension rings to give a detailed view of where the plant should be cut.

6. Typical selection of cuttings. The camera moves back for a general shot, but without loss of continuity.

7. Treatment with rooting powder. Notice how the carton, provides a rest for the hand, allowing a long exposure.

8. Planting in pots. The gentle firm pressure on the soil, is well conveyed by the detailed view of the fingers.

Fade and dissolve techniques

One irritating feature of showing transparencies, even with a magazine projector, is the black screen which occurs for a brief period between pictures. This can be avoided by using two projectors focused on a common screen. You then need some device to darken the image projected by one machine while the other brightens to full power. The effect on the screen is a gradual dissolve from one image into the next without a break. The simplest dissolve units are mechanical, like the home-made one, above. The idea is to arrange a sliding shutter device immediately in front of the two lenses so that moving a lever smoothly blocks one light beam and uncovers the other. A similar system uses large auxiliary iris diaphragms operated by linked sliding cables. But the best dissolve units have an electrical circuit which dims and brightens the projector lamps and

triggers the slide changes. The length of dissolve can be pre-set on timing dials, so that the pressing of a single switch triggers the dissolve and changes from slide to slide.

Tape with two projectors

Two projectors allow you to use the dissolve technique described on the left. You need a twin track recorder with your sound recorded on one track and the pulses which trigger the projectors on the other. You can build a system yourself by wiring two projectors and a modified tape recorder to a dissolve unit, or you can use a specially built slide-tape unit, below. Most audio-visual units allow two distinctly different signals to be recorded on the pulse track. These represent

slow and fast dissolve rates and trigger the dissolve unit accordingly. More sophisticated machines record a signal which allows the length of dissolve to be varied for each and every slide change. Some machines incorporate a pulse which will stop the program allowing a break in the display after which the machine must be re-started manually.

Two projector unit. This is a slide-tape unit, forming a plinth for a pair of rotary magazine projectors. The unit records and plays back audio and pulse signals on a tape cassette.

Slides with sound

It is possible to trigger a projector with pulses pre-recorded on tape. This opens up the whole area of synchronized sound and vision. Essential equipment for this is a twin track tape recorder. On one track you record your accompanying sound – music, commentary, effects and so on. On the other a pulse is recorded whenever the slide is to be changed. Both tracks are played

back simultaneously, but the pulse track is not heard on the loudspeaker. Instead it operates an internal switch which triggers the slide change mechanism. Once set up a tape-slide show will run on its own for the duration of the tape. Programs can be produced which contain almost as many effects as movies, but with better image quality and no film wear.

Modified cassette recorders. A few manufacturers produce modified versions of their standard cassette, like the one, left. These recorders have a simple built-in pulse track circuit for cueing a slide change. Switched to record and connected to the projection gear, slides change each time the synchronization button is pressed. On replay the tape will operate the slides automatically.

Multi-screen presentation

Multi-screen presentations of great complexity using racks of dual projectors illuminating a dozen or more screens are not uncommon. Collectively they can produce a mosaic forming a single huge picture, and the next moment break into many separate images.

Chequer board and other patterns are produced by temporarily blacking out certain screens or just flooding them with colored light. Screens are sometimes arranged in a semi-circle or a complete circle around the audience. All this is often accompanied by stereo or quadrophonic sound.

Recording technique

Sound for slide-tape presentations can be prepared from studio recordings using a microphone direct; from location recordings using a pocket recorder; or from records or tapes of music or sound effects. Ideally each recording should be made separately. They can then be fed through a mixer unit, below, before re-recording on the audio track of the audio-visual tape deck. Mixing allows you to edit out unwanted passages, adjust volume, add together various sounds or dissolve one into the other.

Microphone technique

The biggest problem with recording sound on location is extraneous noise. Like unwanted background detail in a photograph this is confusing and irritating, and usually impossible to remove later. Find out how directional the sound pickup of your microphone is. Hold it at the correct distance and angle to the person you are recording and use a woolen cowl over the microphone head outdoors to reduce wind noise.

Sound mixing desk. This is a simple three channel mixing desk. Inputs from phonograph, direct microphone or tape recorder have individual channel faders. The unit balances, mixes and finally feeds out for re-recording.

Pulsing a program

You can prepare a synchronized single screen program of, say, 36 35 mm slides using a self-contained back projection console like the one shown, right. As is usual in audio-visual work, just one side of an ordinary audio cassette is used. Programs containing 36 slides should last no longer than ten minutes, so a short (C30) tape will do. Some consoles accept transparencies in both portrait (upright) and landscape (horizontal) format without cut-off; others can only be used with landscape format. When pulsing the program, make sure that you give the slide change mechanism time to operate before you begin to speak, or you may find on playback that your commentary is obscured by mechanical noise.

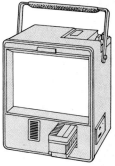

Hitachi SPS 1215 back projection console

1. Load the magazine with your mounted transparencies in correct sequence. Insert the magazine below the screen. Place a tape cassette in the record/replay unit.

2. Plug in the microphone and pulse control unit. Switch both tape channels to "record." Speak into the microphone and press the pulse button for each slide change. Alternatively tracks can be recorded one at a time.

3. Remove the microphone. Check that the slide magazine has returned to zero. Rewind the tape and set the recorder to "play." The machine will now replay the whole program automatically.

Special effects slides

Equipment for special visual effects should offer widely varied dissolve rates, and even allow one picture to be held on the screen while the other fades in and out in superimposition. For best results of this kind, images on successive transparencies should relate to each other in shape, color and tone.

Register board. A board with registering pins helps in the production of drawings for slides. Punched sheets of transparent acetate can be used to produce registered dissolving images.

Titles

Written titles are effective presented as negative images, white on a black ground. Black and white lith film is ideal. Part of the title can be carried on the first slide, dissolving to the full title on the next. Or you can have identical titles, the second one having key lettering picked out in colored dye.

Slide masks. Special slide masks cut from thin foil can be bought, or made, to slip into transparency frames. Small pieces of film showing different images can then be mounted in the same frame.

Shifting elements

A sequence of pictures may have an identical background with one element, perhaps a figure, which changes position. When the pictures are dissolved the background will appear continuous while the figure seems to move on the screen. These pseudo-animation effects require precise and consistent placing of the image on the screen. It is therefore essential to register each transparency within its plastic mount, so that identical images will not shift on the screen when one transparency is dissolved into the next.

Sandwiches

If you need to sandwich two transparencies in the same mount to form a composite image try to arrange them emulsion to emulsion, otherwise it will be difficult to project both on the screen at one focus setting.

305

Making a flick book

With a flick book, below right, you can replay an action sequence; you rapidly flip through a series of prints and the eye is deceived into seeing slight changes between images as if they were movement. Ideally, you should use a 2¼ ins square (6 x 6 cm) camera because this gives contact prints big enough to flip. Mount the camera firmly on a tripod, so that static objects remain unchanged throughout.

If you have a motor drive this will prevent disturbance when winding on. Use soft, overall lighting which remains consistent. Organize your model so that the action is performed in slow motion. Shoot plenty of film; you can always edit later. Contact print the film, leaving sufficient space on one edge of each picture to allow for binding. You can get 16 frames on an 11 x 14 ins (28 x 36 cm) sheet below, or 8 on a 10 x 8 ins (25 x 20 cm) sheet, below right.

Collating prints. Cut each frame from the sheet along three frame edges, below. Perforate the broad edge with a narrow width two pin punch.

Binding a flick book. There are various ways of binding up your sequence of prints. If you use a two pin punch, make sure each print is perforated in exactly the same place, or frames will appear to jump when flipped. Long plastic nuts and bolts can be used to screw the pack of prints together. Short sequences can be secured with large staples, or you can glue the binding edge of each print to the one below, then clamp the pack together until set. For best resistance to wear and tear make the prints on resin-coated bromide paper.

You can, of course, prepare flick books in the same way using color contact prints.

Contact sheet mosaics

Sometimes images which neatly merge are accidentally juxtaposed in a strip of film, right. You can use this principle to create a coordinated image on a contact sheet.

35 mm
You can make a long strip to show a 360° panorama with a 35 mm camera and a 135 mm lens. The long lens is necessary to eliminate foreground. It has an 18° angle of view, so 20 shots will cover approximately 360°.

2¼ ins square (6 x 6 cm)
As the film is usually wound on vertically you have to put the camera on its side for panoramas. This size is more suitable for mosaics than 35 mm because of the narrower negative rebates.
See: Panoramas

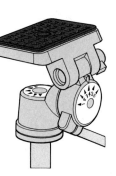

Making a mosaic. To produce a composite image, like the one below, it is best to make a "dry run" without film so that you can mark the appropriate angles on the tripod head, left. For this picture the vertical movement was determined by dividing the tower visually from top to bottom; the horizontal by reference points across the face of the building. Exposures were then made in sequence by combining vertical and horizontal numbered marks: 1+1, 1+2, 1+3, and so on. Pentax KX, 135 mm, FP4, 1/60 sec f11

12	8	4
11	7	3
10	6	2
9	5	1

Exposure sequence. The diagrams show the best sequence for producing mosaics using a complete film. 2¼ ins sq (6 x 6 cm) is shown above, and 35 mm below.

1	2	3	4	5	6
7	8	9	10	11	12
13	14	15	16	17	18
19	20	21	22	23	24
25	26	27	28	29	30
31	32	33	34	35	36

Filing negatives

Negatives are filed for safe storage so that they can easily be found when they are needed. Roll and 35 mm negatives should be cut into strips and kept in sleeves, either individually or in groups of strips which make up a complete film. Sleeves can be taped to the back of the contact sheet to which they refer. Alternatively the sleeve (and preferably the film too) can be given a reference number which also appears on the front of the contact print. Contact sheets can then be pasted into scrapbook albums and the negatives stored in boxes or drawers.
See: Contact printing

Negative containers. The sleeve, far right, accepts strips of 120 roll-film or 35 mm. Sheet films are stored in individual bags, near right. The negative file, below, contains alternating "pages" of negative bags and contact sheets. Having purchased the bags and sheets you can make this up yourself, using an ordinary ring binder.

Long term storage

Even when they have been properly fixed and fully washed, black and white negatives gradually deteriorate with time. This is accelerated by high temperature and high relative humidity, as well as by the chemical effects of fumes and solvents. Even the gum from self-adhesive tapes or non-photographic envelopes may in time cause stains or deterioration of the emulsion gelatin. Ideally, negatives should be stored at a temperature of about 70°F (21°C) at relative humidity of 30 to 50 percent. Very high relative humidity often causes negatives to stick to each other or their bags, and even encourages the growth of mold.

Transparency mounting

The simplest transparency mount consists of two pieces of cardboard with cut out picture apertures. The transparency is sandwiched between these two halves, which are usually self-adhesive. Card mounts are cheap, but they do not hold the film very flat for projection, nor do they offer protection from finger marks and abrasions. Card mounts 2¼ ins square (6 x 6 cm) are particularly likely to buckle when loaded into the projector. Plastic, glass faced mounts are much more satisfactory, but the mounting operation takes slightly longer. Glass surfaces may have to be cleaned first. Always ensure that the transparency is quite free of dust and finger marks, and mount your slides in a dry atmosphere. Trapped moisture may later form a damp patch during projection. Finally mark a black spot in the bottom left hand corner of the mount, holding the picture as it should appear projected on the screen.

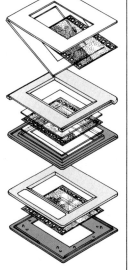

Mounts. A whole variety of commercial mounts include simple card types, top. The most popular mounts use pre-cleaned glass treated for Newton's rings which inserts into slide- or clip-shut plastic frames, center. Assembly time can be greatly reduced by using a simple hand mounting-press. Glassless plastic mounts, bottom, are widely used because they are strong, durable and easy to assemble.
See: Newton's rings

Filing transparencies

As with negatives, the twin functions of transparency filing are safe storage and efficient retrieval. Plastic sheets can be bought which contain twenty or more individual pouches for transparencies. These either fit a ring folder or can be suspended from hang bars in a standard office filing cabinet. Some projectors, such as the Kodak Carousel, use magazines which also give slides a useful measure of dust protection in storage. By keeping your transparencies loaded in this way pictures are always ready for projection.

Color transparencies

Processed color films should be stored where it is dark, dry and cool. Dyes fade more quickly than black and white images and detectable changes occur even after projection for an accumulated period of 20 minutes. Try not to project slides for more than about one minute at a time, and never leave them for periods propped up against a window or near other strong light sources. The worst storage areas are damp basements, or attics which in summer become very hot. Ideally, color films require a relative humidity of 25 to 30 percent. If stored away from light and kept at about 70°F (21°C) images remain stable for at least four years. Even then changes are often very gradual and with most subjects barely detectable. To retain color image for, say, 50 years without any appreciable change transparencies must be stored in a refrigerator at 36°F (2°C).

Mounting with adhesives

It is unwise to mount photographic prints using ordinary domestic adhesive or glue. A number of these contain chemicals which may attack the image. In general avoid fish glues, and acetone solvent household adhesives. Rubber gum is the safest, most durable adhesive for photographs. For giant enlargements wallpaper glue is easy and safe to use. Double sided self-adhesive tape or photographic album "corners" are adequate for quick mounting, but after a few years they may dry out and become detached.

Using an aerosol. Some adhesives suitable for photographic mounting are available in aerosol form. You simply give the back of the print a light spray, lower the print on to the mount and allow it to dry under gentle pressure. Aerosol applied adhesives are excellent for montage work.

Using rubber gum. Artists' rubber gum is a clean adhesive requiring no equipment apart from a spreader. Mounts should have a firm top surface. The solvent used in this gum may be highly inflammable: use it in a well ventilated place.

Dry mounting

This is the most effective way of mounting photographs. The process consists of placing a layer of shellac between print and mount, and then heating this sandwich under pressure. The heat briefly softens the shellac which then bonds the two surfaces together. In practice the shellac is either applied like paint from a tin of solution or, more often, takes the form of a sheet of shellac-impregnated tissue. To do the job properly you need an electrically heated dry mounting press and a tacking iron. Dry mounting has the important advantage that, unlike adhesives, no potentially injurious chemicals are introduced to the print. Indeed the shellac layer forms a chemical seal between print and mount, preventing any impurities in the latter from reacting with the image.

Mounting press. This is a top heated press, capable of exerting even pressure over the whole surface of the print. Heat is maintained by thermostat and the press allows temperature selection within 150° and 200°F (65° and 95°C).

1. Cover the back of the print with a sheet of dry mounting tissue. Using an electric tacking iron gently touch the center of the tissue, sticking it to the print.

1. First trim the picture to the required final size. Position it accurately on the mount, marking its position by a light pencil line.

2. Using the spreader, paint a thin layer of rubber solution across the back of the print and spread it evenly over the entire surface. Repeat this operation on the mount. Allow both to dry.

2. Carefully trim the print, with its attached tissue, to suit the picture composition. Print and tissue are now registered and equal in size.

3. Position the print accurately on the mount, face up. Holding down the center lift each corner in turn and tack down the tissue on the mount.

3. When both gummed surfaces are dry to the touch carefully bring them into contact. Align one edge to your pencil line, then gently smooth down the print, avoiding air bubbles.

4. Surplus dry gum can now be rubbed off the mount surround. This will also clean the mount and erase the pencil marks.

4. Cover the surface of the print with clean, dry cartridge paper. (An old glazing sheet is best for high gloss surfaced prints.) Place the sandwich in the press and apply pressure.

5. After 5 to 10 seconds release pressure and remove the mounted print. Check mounting effectiveness by gently bowing the board.

Mounts and frames

A well chosen mount or frame really shows off your work to advantage. The picture may look best simply flush mounted on to block-board. Or it may require a tinted cardboard mat – a thick card cut out in the center, right – to fill the border between the picture and the inner edges of its frame. Other effects are possible using shellac-coated sheets.

1. To prepare a mat first mark out the picture dimensions on suitable mat board. Using a metal straight edge and a sharp trimming knife held at 45°, cut along these lines.

2. Push out the aperture, then gently cut away any burrs remaining in the corners. Check that the bevel has remained true, with inner and outer edges parallel.

Framing with clips

A perfectly good frame can be made by sand-wiching a photograph between glass and ply-wood cut to size. The sandwich can be held to-gether with spring-loaded chrome clips, below, made specially for this purpose. Alter-natively the sandwich can be secured by

screwing in chrome or plastic mirror clips, above left, or you can use stationer's spring clips, above right, and remove the handles.

Making a frame

You can make your own frame out of any suitable material. The simplest technique is passe-partout, which just uses the mounted print, a mat (if necessary) and a sheet of glass, bound with adhesive tape on all four sides. Wooden mold-ings or metal extrusions for frames must have a suitable cross section and be of sufficient strength. They can be bought by the meter or in kit form from artists' supply stores. Small pic-tures can be framed using the simple wooden edging sold by the do-it-yourself store.

Ready-made systems

Various kits are sold for do-it-yourself framing. Ready-mitered lengths of metal or wooden frame material are sold in pairs. You therefore make up a frame for a rectangular picture from an appropriate pair of long lengths and a pair of short lengths. You join the lengths by glue and nail or by a patented catch system which requires no tools. The disadvantages of these kits are their expense and the limited range of set lengths.

Frame

Non-reflective glass

Card mount

Hardboard backing

Photograph

Assembling metal frames. Ready-made metal frame parts are usually joined together behind the corners with spring clips or screw clamps.

Picture cubes

Picture cubes allow five or six prints to slip into channels behind the faces of an apparently solid block of plastic.

Portraits for lockets

The problem of making a locket-sized photograph is that you cannot reduce the image with an en-larger to fit such a small area. The best solution is to position your subject so that the head fills about half the height of the viewfinder frame (on a 35 mm camera). A con-tact print of the photo-graph will give you a miniature.
See: Sepia toning

1. Very carefully mark off the required dimensions on the inner edge of the wooden frame material. Holding it firmly in a carpenter's clamp miter the ends at 45° with a saw.

2. Check that cut edges come together cleanly to form 90° corners. Glue and leave in a clamp to set. Large frames should have joins reinforced with long thin nails.

Folders and albums

Slip-in folders are for one photograph only, and are available in landscape or portrait format. The advantage is that you do not have to get involved with mounting procedures. Some folders have slots to hold the print at each corner. Others use a broad mat or surround behind which the unmounted print is slipped. Provided this mount is of good stout quality and the print not too large or too thick, the result is hard to distinguish from adhesive mounting. Slip-in albums retain prints in a rather different way, using overlays of transparent plastic, or holding them in large, spiral bound plastic envelopes. These need careful handling and occasional cleaning.

Slip-in folders. Simple mounts of this kind, above, are relatively inexpensive and quick to use. Against this you are limited to set picture sizes and proportions. The cover material may be embossed or carry a printed design.

Albums and folios. The simplest type of album consists of plain pages to which prints are attached by adhesive corners, slits, or double faced tape. Some use "cling" plastic overlay which allows prints to lie undisturbed without needing to be glued. Much more expensive, zip-up portfolio albums contain prints in plastic envelopes.

Plastic overlay

Adhesive corners

Portfolio album

Sending photographs through the mail

Photographic prints can be damaged beyond repair if they are sent through the mail insufficiently protected. Single unmounted enlargements are particularly vulnerable. Use cardboard stiffeners, or cardboard reinforced envelopes. These should be at least half an inch or so larger than the prints all round. A good method is to enclose your pictures in an ordinary envelope first.

Then sandwich the envelope between two pieces of corrugated cardboard, sticking it to one with adhesive tape. Place the whole in a strong Manila envelope just large enough to contain the cardboard. Large prints should be rolled and packed in a strong cardboard tube, sealed at both ends.

Exhibitions

When you plan an exhibition you should first measure the floor and wall display area available. You should take account of doors and windows; surfaces which will be obscured by pillars or fittings; and walls which will be insufficiently lit. Gauge whether partitions and island sites are needed to provide more hanging space. Work out where visitors will enter and leave, and decide whether it is important that they view the pictures in a particular order. If possible construct a miniature scale model in cardboard or balsa wood, and draw in the possible positions of exhibits. In general try to place one or more strong pictures at the entrance and in other key positions such as the ends of gangways. These can be dramatically lit. Variety is important. Try to avoid having prints all the same size and shape. Remember that people enjoy surprises and often prefer to explore a sequence of passages and bays rather than see the whole room at one glance. Center the pictures at eye level, 5½ ft (1.6 m) from the floor.

Size and lighting. The viewing distance space needed in front of each picture is about 1 to 1½ times its height. Take particular care over the positioning of lights. Oblique spotlights placed at ceiling level are excellent because any glare from the print surface is directed at the floor.

Use of space. This exhibition of photographs of Henry Moore and his work allows the visitor to take in large areas of the exhibition and at the same time view each picture independently.

Projection systems

A color transparency projected in ideal conditions is the finest way of viewing a color image. This is because a bright screen in a fully darkened room offers the widest range of tone and color values, provided you have a good projector. The two most important points in any projector are image quality (sharpness, brilliance and evenness), and mechanical efficiency (absence of heat and noise). The light output of the lamp and the aperture of the lens, plus distance and type of screen, determine image brightness. Do not try to project an excessively large picture; brightness will then be too low to do full justice to image colors. Projectors are made for every format up to 2¼ ins square (6 cm square). Simple machines still use a hand-operated mechanical sliding carrier for the transparency. But most types are now magazine loaded, and change slides automatically at the press of a button on a remote control lead: Focusing can also be done by remote control. Lenses are often of zoom design and allow some adjustment of the image size.

Basic projector. In a simple projector, below, light from a tungsten halogen lamp passes through an infra-red heat filter and is focused by condensers toward the projection lens. A motor-driven arm withdraws a transparency from the magazine to the projection gate, afterward replacing it and shifting the magazine along one notch. Lamp, heat filter and projection gate are fan cooled.

Previewing

Selection and final order of transparencies is most important. The relation of images, colors, mood and brightness must be considered in your program. You will soon discover just how dark or light transparencies need to be for best results on the screen. Also assess image sharpness, color balance, composition, expression and so on.

Handviewers. Some handviewers have a small built-in light source, but this may be warmer in color than the projector lamp. Remember that a filmstrip projector can be used for a quick preview of an uncut length of color film.

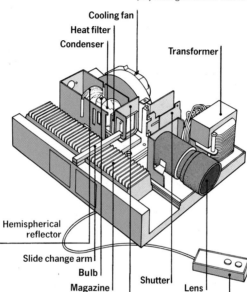

Cooling fan
Heat filter
Condenser
Transformer
Hemispherical reflector
Slide change arm
Bulb
Magazine
Projection gate
Shutter
Lens
Remote control

Hand loaded projector. Projectors for 35 mm transparencies and smaller are now usually magazine loaded, but hand-operated models are still common for the 2¼ ins square (6 cm square) size. The carrier has slots for two mounted transparencies side-by-side so that one is being projected while the other is being changed. This design is cheap and trouble-free, but slow to use and impossible to automate. Transparencies are easily muddled as they are loaded and unloaded into boxes in the dark.

312/313 **Magazine-loaded projector**

Magazine-loaded projector. Projectors which accept transparencies in magazines offer two great advantages. Pictures can be advanced automatically, and your program remains in correct order at all times. One of the best arrangements is a circular magazine, above. Mechanically this only has to describe a simple movement, and with a full magazine (most contain 80 slides) it is in position at the end of the program ready to start all over again. Some sophisticated projectors, above right, use a double optical system to give slow dissolves

or "snap" changes instead of the normal blank screen between pictures. The machine is effectively two projectors sharing a common magazine. There are two projection gates, and both lenses are arranged to project on to the same part of the screen. However, the lamp or lamps are so arranged that one image dims out as the other grows to full brightness.

Dissolve projector

Filmstrip projector. The filmstrip projector is primarily used for education and training. It accepts a low-cost uncut, unmounted strip of 40 to 60 35 mm transparencies from which pictures cannot of course be lost, or shown in the wrong order. The machine itself is exactly like a hand operated slide projector with a special holder for the strip. This is usually interchangeable with a slide carrier.

Projection conditions

Apart from the projector itself the most important influences on good projection are effective black out, and the correct screen size and screen surface to suit your audience. The darker the room the richer the blacks of your picture will be. Quite small quantities of light are enough to dilute them to dark gray. Relate screen width to the audience size. Ideally, viewers should all be between 3 and 7 widths of the screen away from it. To enlarge the picture move the projector further back or change to a shorter focal length lens. Do not overtax a small projector; doubling image size reduces illumination to one quarter and images will not show color brilliance fully. If necessary change to another screen surface, or if possible, fit a brighter bulb.

Projector to screen	150 mm lens	75 mm lens	50 mm lens
50 ft (15 m)	12 ft (3.6 m)	*	*
45 ft (13.5 m)	10½ ft (3.2 m)	21 ft (6.4 m)	*
40 ft (12 m)	9½ ft (2.8 m)	19 ft (5.6 m)	*
35 ft (10.5 m)	8 ft (2.5 m)	16 ft (5 m)	*
30 ft (9 m)	7 ft (2.1 m)	14 ft (4.2 m)	21 ft (6.4 m)
25 ft (7.5 m)	6 ft (1.8 m)	12 ft (3.6 m)	18 ft (5.4 m)
20 ft (6 m)	5 ft (1.5 m)	10 ft (3 m)	15 ft (4.5 m)
15 ft (4.5 m)	4 ft (1.2 m)	8 ft (2.5 m)	12 ft (3.6 m)
10 ft (3 m)	2½ ft (84 cm)	5 ft (1.5 m)	7½ ft (2.3 m)

*: Not practical

Projector lenses and image size. The table, above, gives the length of the longest side of a projected 35 mm slide relative to the focal length of the projector lens and the distance from projector to screen. This is demonstrated in the diagrams, below, which show how different projector lenses enable you to produce an image of a given size (in this case 7 ft (2.1 m) wide) on screen, with your projector at very different distances from the screen. In the diagram on the left the projector is fitted with a 50 mm lens and is 10 ft (3 m) from the screen. On the right the lens is 150 mm and the projector is 30 ft (9 m) from the screen.

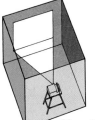

50 mm lens

150 mm lens

Screen surfaces. The most common projection screen has a mat white surface, such as cartridge paper, an emulsion painted wall, or a purpose made roll-up plastic screen. More reflective screens, with specially beaded or silver surfaces give a much brighter image, but this is only effective over a narrow viewing angle. Outside this the picture will appear dimmer than on a mat white screen. Highly reflective screens are useful for improving the performance of a low powered projector, or allowing a large screen to be filled at maximum brightness.

Back projection. Where space allows, the projector and the operator can be concealed behind the screen, which must be translucent, either of tracing paper or special plastic.

Making a light box

A light box is a most useful tool for sorting and comparing transparencies. You can also use it to examine or retouch negatives or any image on a transparent base. You can buy a box or make one yourself. Ideally a box should be designed to produce maximum light with minimum heat, giving a completely even illuminated surface. The best models use thermostats to keep the level of light constant. The light box, below, is built in wood and contains several color matching tubes placed 3 to 4 ins (8 to 10 cm) below a ³⁄₁₆ ins (5 mm) thick sheet of opal plastic. Always use fluorescent tubes rather than light bulbs, and ventilate the box.

Aluminum angle

Opal plastic sheet

Switch

Fluorescent tubes

Wooden box

Ventilation hole

Folding screens

The most practical screen is likely to be a folding model. A typical one is about the size of a golf bag when folded. First the vertical stand and feet are extended, at right angles to the rolled up screen. The top of the screen is then unrolled and hooked to the top of the stand. Folding screens are made with mat white or beaded surfaces.

Self-contained units

Special back projection display units allow color transparencies to be shown rather like television pictures. The advantage is that you do not need a separate screen. Usually the unit houses a conventional automatic projector fitted with wide-angle lens and mirror system to extend the image throw. Small self-contained units, below, fold down to the size of an attaché case.

Deciding what went wrong

Everyone produces a faulty photograph from time to time. Sometimes you can use the unexpected result to creative effect, but most faults are not worth repeating and you should take steps to prevent them. Either way it is important to discover the cause of the error before you discard the photograph. Apart from errors over which you have no control because they are produced by a faulty camera or film, the mistakes will occur in shooting, in processing or in printing. Try to decide which of these applies in each case. You will find that most errors at the shooting stage are limited to the picture area and do not affect the film overall. Processing errors affect both the picture and rebates, including the frame numbers and the other data the manufacturer pre-exposes along the edge of the film. Printing faults are easily categorized by comparing the printed image closely with the image on the original film negative or positive. You may, of course, get several faults occurring at the same time. If this happens, study all the categories which follow and try to identify each symptom.

Shooting faults

Comments which apply to negatives also apply to transparencies unless a specific statement is made to the contrary.

Unsharpness
Check the film image very carefully, using a magnifying glass. Overall unsharpness can be caused by gross misfocus, for example using a close-up lens to photograph a distant landscape, or by damage to the camera which has pushed the lens out of position. Condensation or grease on the lens also gives this effect together with a low contrast image. Any suggestion of several offset images or blur lines indicates camera shake. Use a faster shutter speed or learn to hold the camera steady. If only parts of the image are sharp, an impact may have disturbed the rangefinder. When only distant parts of the picture are sharp, the lens was either misfocused (perhaps you moved the camera nearer after focusing), or the ground glass focusing screen was the wrong way round. If only the middle distance is sharp you probably failed to stop down sufficiently for depth of field. This may also be the cause when only near objects appear sharp; otherwise you may have misfocused, or not screwed the lens fully into the body, or left a close-up lens or extension ring on the camera. Moving subjects appear blurred if you use too slow a shutter speed or fail to pan the camera effectively. Sometimes just one side, or the center, of the picture is unsharp. There are a number of possible reasons for this: a distorted lens panel; an extremely poor quality lens uncorrected for aberrations; film not lying flat owing to a damaged pressure plate or guide roller; sheet film badly loaded into the holder of a view camera; or the use of a view camera with the movements set incorrectly.

Thin negatives or dark transparencies
Thin negatives are usually caused by under-exposure; the result is loss of shadow information so that only the highlights show detail and contrast. Do not confuse this with under-development. You might have set the wrong film speed on the meter, or the meter may be damaged. Subject lighting conditions might have deteriorated between measuring and shooting or you might have forgotten the effect of a filter or close-up bellows. You might have just set the wrong shutter speed or aperture. Occasionally this occurs because the film is loaded facing the wrong way, which can happen with sheet film, or if you use a bulk film loader. Examine the

film to see whether the picture is laterally reversed. If you were using flash it could have fired at the wrong shutter synchronization or speed setting. If the film carries absolutely no image at all, except for the frame numbers or brand name, it has not been exposed. Either the shutter or mirror failed completely or you may have: forgotten to remove the lens cap; fired electronic flash on "M" synchronization; or processed a film which has never been in a camera, or one which did not take up properly and failed to wind on. Obstruction of part of the image may be caused by a camera strap, fingers, clothing or hair in front of the lens, or roll-film sealing-paper loose inside the camera. Fully extended bellows on a stand camera sometimes sag in the center, obscuring one end of the picture.

Dense negatives or light transparencies
Dense negatives are caused by over-exposure which produces good shadow detail but highlights which are burned-out. This can happen if you set the wrong film speed on your meter, if your meter is damaged, or if the subject lighting improves between measuring and shooting. The most common cause is failure to stop down, perhaps because of a faulty automatic diaphragm. If the film issues totally black frames (white on transparency films), the shutter may be sticking or light may somehow be entering the front of the camera. Images which have an overlay of fog running down the entire picture width are produced by winding or rewinding the film with the shutter open. This is particularly easy to do if you have motor drive on a slow shutter speed. If you have overlapping images throughout the film there is probably a fault in the film wind, or you may have put the same 35 mm film through the camera twice. Bars of fog across the full width of the film, picture and rebate, are caused by a badly fitting camera back, or strong light passing through the entry slot of the cassette.

Transparencies the wrong color
Color faults frequently occur because the wrong color lighting, relative to the film type, is used. Another possibility is that you forgot to remove a filter fitted for black and white work. You can get blue casts from heavily overcast conditions or excessive ultra-violet light at high altitudes. Counteract this with an ultra-violet absorbing filter. Unexpected color may be reflected from colored surfaces or mixed light sources.

Black and white film processing faults

Thin negatives
Thin negatives caused by under-development are also low in contrast; the image contains detail, particularly in highlights and mid-tones. This occurs if the developer is exhausted, too cold, diluted by mistake or given the wrong amount of time. To improve a thin negative, print it on hard paper, or try uranium intensification. If your film carries no images at all check for edge numbers and brand name along the film edge. If these are missing no development has taken place. You might have put the film in the fixer first, or mistaken developer for stop bath or another chemical. If the edge numbers are there, the film has not been exposed (see Shooting faults). If thin negatives have one or more bands of correct density along the entire length of the film the tank may not have been sufficiently filled with developer. Occasionally negatives are rendered thin by accidental bleaching, which can be caused by their being left too long in a strong rapid fixer solution, for example. Small droplet-shaped spots of lighter density, often darker around the edges, are caused by splashing a dry film, or by uneven drying. Drying marks cannot be removed, but with skilful retouching they may be disguised. Clear splash or finger-shaped marks are almost always caused by fixer reaching the film before development, perhaps from a wet bench top. Long, irregular white tracks along the length of the film are produced by severe abrasion. This is easily done by a finger nail or a piece of grit when the wet film is being sponged down, or occasionally by something scratching the film as it winds across the camera or through the mouth of the cassette. Small, distinctly rounded spots which appear clear or light in density are the result of air-bells clinging to the film surface during development. Avoid them by tapping the film reel after immersing it in the developer and agitating it regularly. Insufficient agitation is the root cause of most uneven, light patches on negatives. Sometimes films show quite large, clear patches with graduated edges, usually near the center of the frame. This is caused by successive coils on the film reel touching or adhering to each other during development, or by sheet films trapped in contact with one another. Small, irregular clear specks may be caused by dirt, hairs and so on stuck to the emulsion during processing, but it is more likely that this was printed on to the film during exposure.

Dense negatives
If the negative is contrasty as well as dark, with very dense highlights, it has been over-developed. In this case the edge numbers often appear very dark, too. The developer might have been too warm or too concentrated, or the film could have been processed for too long. Try a long printing exposure on soft grade paper, or reduce the negative chemically. If film and rebates are veiled with gray fog all over it may be because the material is stale, or because it has been exposed to x-rays or unsafe darkroom lighting. Fog can also be caused: by contaminated or unsuitable developer; by processing at an excessive temperature; if you remove the film too frequently for inspection. Slight fog, even right across the negative can be removed in weak ferri-cyanide reducer, and anyway it may not affect the printing quality of the negative. Most black "splashes" are caused by light leaks rather than processing. Areas of greater density or dark finger marks are often the result of developer or water being applied to the film before processing. Black scratch marks along the length of the film are caused by abrasions not quite severe enough to remove the emulsion and so leave white tracks. Crescent shaped, dark marks with soft edges are often found in roll-films which have been kinked when loaded into processing reels. Short, faint hair lines close together all over the negative are often caused by pre-processing "cinching" of the film –when a roll of film is held at one end and tightened. Sudden unrolling may form "static marks" – jagged black lines caused by electrical discharge when dry film is rubbed. Small black sharp-edged specks are either caused by chemical dust or undissolved particles in the developer. Mix your chemicals outside the dark-room and allow time for your solutions to dissolve fully before use.

Miscellaneous
Grain is not strictly a processing fault but it can be exaggerated in appearance by over-development in a coarse-working energetic solution. Uneven, milky patches are due to insufficient fixation. In time these may turn purple. Yellow or greenish stains may be the result of contamination between developer and fixer, or over-hot or exhausted fixer. You can often clear these in very weak ferri-cyanide reducer. White scum on the front or back of the film is formed by water deposits. It can be wiped off with a dry cloth.

Color processing faults

The causes and effects of some processing errors on color materials vary according to manufacturer and film type. The following is intended only as a general guide.

Transparencies
A dark, low contrast image with faulty color rendering, often bluish, may be the result of insufficient first development. You may be able to remedy this fault by using chemical reducer. Totally black film with no edge marking usually indicates the omission of bleach/fix stages. Unexposed film is also black but will display white edge numbers. A red, green or orange overall color cast and weak image density is often caused by safelight fogging. If, much to your surprise, the film comes out as a contrasty color negative it may have been processed in color negative chemicals by mistake, or the first developer may have been switched with the color developer. Color negative films or non-substantive reversal films, such as Koda-chrome, end up without images if processed in color transparency chemicals designed for substantive films of the Ektachrome type. Both kinds of reversal color film accidentally processed in black and white chemicals give black and white negatives. The results will have an overall stain, but the negatives can be printed on pan-chromatic bromide paper to give black and white prints. Black and white negatives formed on substantive (Ektachrome) type film can be given a bleach bath and then normal color processing to convert them to acceptable color negatives. (Consult the manufacturer for details.) Finally remember that many substantive color transparency films have an opalescent "unfixed" appearance when wet. This is quite normal and disappears as the film dries.

Color negatives
Incorrect density and contrast resulting from over- or under-development and other faults are similar to their black and white equivalents (see: Thin negatives and Dense negatives, opposite.) Most color negatives have an orange or gray built-in mask which to the uninitiated appears like fog, but is quite normal. This does, however, make detailed assessment of image colors impossible before printing. Blotches and stains usually indicate chemical contamination of solutions, exhausted color developer or insufficient agitation. Opalescent yellow stain which refuses to clear in the bleacher is usually a sign that the solution is exhausted.

Black and white printing faults

Try to separate errors, which occurred purely at the printing stage from defects in the negative itself. An unsharp print, for example, should be checked carefully for grain structure. If the grain is sharp the negative image is at fault; if grain and image are equally unsharp the error must be in the printing process. If this is the case check enlarger focusing or the pressure plate of the contact printing frame. A print with degraded whites has been either: over-exposed; fogged by the darkroom illumination or light spill from the enlarger; developed too long in exhausted or over-hot developer; or insufficiently fixed. The paper itself may be stale, or you may be enlarging a small dense negative in a larger size glass carrier, so that light is scattered from all round the image. Degraded (grayish) blacks are usually a sign of curtailed development, exhausted developer or under-exposure to a thin negative. A print may appear excessively harsh if you use too hard a grade of paper, but if this is the softest you have, try diluting the developer or masking the negative. If a print is too flat, even on the hardest grade paper, you can: use more concentrated developer; change to a point source enlarger; or print on lith paper. Uneven density may result from uneven illumination of the negative or uneven development; check that the paper goes right under the solution. Color stains are generally produced by excessive development, insufficient acid in the fixing bath, or insufficient fixing – the prints may have stuck together in the fixer. Inadequately fixed or washed prints tend to turn yellow or show purple or brown blotches during hot drying, or during storage. A double image denotes movement of enlarger head or easel; if the effect is local, jogging occurred between exposing and printing-in. Thin black lines, often in clusters, are produced by abrasion from dragging the paper over the edge of the box or masking easel. White specks denote dirt and debris lying on the negative, the carrier glasses, the paper surface, or (if very indistinct) on top of the enlarger condensers. Irregular, concentric marks known as "Newtons Rings" are produced by minute gaps between the negative and carrior glasses. A pale image, reversed left to right, means the paper was placed under the enlarger face down.

Color printing faults

Most of the tonal errors in color prints from color negatives have the same root causes as in monochrome printing, thus light prints are the result of under-exposure or under-development. One of the basic problems of color printing is inconsistency of tone and color between test strips and final print. This can be caused by variations in the voltage of the electricity supply, and you may need a voltage stabilizer to correct it. Changes may have taken place in the developer, particularly if there was a long gap between processing test and print. You are certainly likely to find a difference if the test is made on paper from one batch and the print on paper from another. You may get stained white borders and highlights from safelight fog, or if you examine the print in white light before bleaching is complete. This fault can also be caused by stale, wrongly mixed or over-heated developer, or insufficient rinses between solutions. Sometimes the color is wrong in one part of the picture when filtered correctly for other areas. This may well be a fault of mixed lighting and as such is a color negative error, although it is visually undetectable before printing. Similar defects occur in over- or under-exposed negatives, or in those given exceptionally long camera exposure times which cause reciprocity failure. Sometimes yellows appear degraded and the print shows a cyan cast which cannot be filtered out. If this happens you will probably find the infra-red absorbing filter is missing from the enlarger lamphouse, so that heat is affecting the red sensitive layer of the paper. Another problem sometimes occurs when cross printing one brand of color negative on to another manufacturer's color paper. Heavy basic filtration may be necessary to adjust the characteristics of the two, and this limits the range of filters you can use to suit the individual image. Some faults are peculiar to additive, or tri-color, printing. For example, blurred outlines all over the print and color fringes between dark and light parts are easily caused by shift of paper or enlarger head when filters are changed between two stages of the exposure.

Checking equipment

Even the best cameras, flashguns, enlargers and so on deteriorate sooner or later owing to wear or damage. Check your equipment from time to time, even if it appears to be working perfectly. It is often possible to detect potential faults, and a failure prevention routine can save you lost pictures and expensive repairs later. It is even more important to check as soon as an unexpected result occurs which cannot be attributed to processing, printing or your handling of the camera.

Cameras
Film fogging can sometimes occur through the back of the camera if the body is damaged or very old. One way to test this is to load the camera with a short length of film, then slowly rotate it near a bright lamp so that illumination reaches the body from all directions. If the processed film shows bars of fog replace it in the camera in its original position to find out where light is entering. If you suspect that your flash is not synchronizing properly, set up the flashgun facing the camera, then look through the empty body and fire the shutter at widest aperture. You should be able to see light through the shutter. Be particularly on guard with cameras which do not allow you to check the image formed by the taking lens. A TLR camera brought from a low temperature outdoors into a warm interior can develop a film of condensation over the back of the taking lens. Always check your meter and flashgun before going·on an assignment: the battery may be exhausted. Renew meter batteries at least once a year.

Enlargers
The check list for the enlarger should include its evenness of illumination. Check whether the lamp is beginning to blacken; make sure the lamp-to-condenser distance is correct for the size of enlargement and that the surfaces of the condensers and diffuser are clean. Examine the focusing movement and mounting of the lens, and test the lens for shift or loss of focus when stopping down. Dirt, condensation or finger marks accumulating on the lens will produce soft focus and a range of image tones which gradually deteriorates. Pinholes in the bellows, or a lamphouse warped by heat will produce light leaks which can result in veiling of the image.

Studying photography

A knowledge of photography should combine science, technology and art, and a good photographer also needs some understanding of human behavior and social conditions. A comprehensive photographic education should therefore cover much more than just the learning of techniques; it should include aesthetics and a study of the functions and social relevance of photographs.

In the US and in Britain, some courses are biased toward science, others toward art, and there are plenty of courses which concentrate on the technological and professional aspects. Obviously degree courses examine the subject more thoroughly than short certificate courses or evening studies. Graduate studies normally involve extensive individual research. This can be a thorough scientific investigation, but more often it takes the form of a visually supported thesis or dissertation, frequently with a historical bias. Photographs are now treated as works of art in most countries and this has made the study of photography a very broad field of opportunity, which can be divided into two areas. First, there is the study of photographic processes and their uses and secondly, the study of the photograph as art or artifact and as a vehicle for expression and communication.

In the first case the student studies the various applications of photography and at the same time trains to be a photographer; in the second case the emphasis is upon the "academic" considerations of the image, and for this you do not necessarily need to be a competent photographer. This pattern of studies in photography applies particularly in the US and to some extent, more recently, in Britain.

Training in the US

In the US, where photographic education became established earlier than elsewhere, the number and diversity of courses is considerable. At university you can take a full time course which will lead to a degree. There are literally hundreds of such courses throughout the US, usually offered by a university or state college fine art or design department. The courses or programs are multidisciplinary, so it is unusual for photography to be studied in isolation. Normally the student constructs a program of studies spanning a full three or four years study. Photography may be taken with subjects as disparate as anthropology, history or painting as minors. Each subject is given a credit value based on the number of hours per week and the number of weeks in the course. To gain a degree the student must achieve a certain total number of credits. American universities offer programs leading to bachelors, master of fine arts, and doctorate degrees in photography. As an alternative to a degree, you can take a course at a privately owned school specifically designed for the training of professional photographers. These courses tend to be short and specialized. For example, one establishment offers six-week courses in portraiture, wedding photography, color printing, and so on. The courses concentrate on producing photographs and marketing them and some are obviously very much better than others. The same applies to correspondence courses, which should be approached with caution. Probably the greatest number of people, however, train as photographers at night school, either attached to an art school or university, or run by the YMCA or a local community center. You can take part of a university course at night school, where the teaching will be of the same standard as at the university itself, and either take credits or work through the course without bothering with the credit. No matter which course you take, no one is going to be impressed by a string of qualifications. Employers will judge you by the quality of your pictures alone. There are so many courses in the US that they cannot be listed here. You can get lists of schools and courses at your public library, and catalogs of particular schools by writing to the school. High school vocational councils have information about courses, and you will find a full account in "Photographic Education in the USA" by Professor W. Hornel, published by Eastman Kodak.

Training in Britain

In Britain the study of photography has developed in quite a different manner. The courses have been linked closely to the professional body representing photographers in commercial, industrial and scientific photography, the Institute of Incorporated Photographers (IIP). This institute has been nominated by the British government to validate and oversee all full time courses, so developments in the past have almost all been linked to the profession of photography and to job opportunities. Only recently has photography been included in art or design studies or seen as a possible academic subject. Most courses, therefore, are of a professional training nature, with a few exceptions where professional training takes second place to a broader approach.

There are more than forty full time courses, which vary in length from one to three years. About twenty five part time professional courses also exist, and photography is now included as a supporting subject in more than twenty five art and design multi-disciplinary degree courses. One college has already attained degree status in pure photography and others seem likely to follow suit. Degree courses are financed wholly by the Department of Education and Science and students receive grants for living expenses for the full three years of the course. The two existing courses offer degrees in either photographic arts or photographic science.

The professional qualifying examination courses (PQE) are given status approaching that of degrees, and almost all offer three years preparation for professional practice. Four centers currently offer these courses which are validated by the professional body IIP. Several two year courses are available, many of which are validated by the IIP, who award "The Vocational Diploma." All these courses are designed to provide a training for professional assist-- ants and deal only with the commercial and vocational aspects of photography. Students may or may not receive grants. Opportunities for study in Britain are very limited and entry is governed by various constraints. Degree courses require the student to have passed five subjects in the general certificate of education (GCE) with two passes at advanced level. PQE courses also make this requirement but sometimes one advanced level pass is sufficient. Vocational Diploma courses require four GCE passes. Almost all courses require the applicant to present a portfolio of photographic, art or design work.

Professional photography

A professional photographer needs a very different attitude from that of the amateur. As a professional you can seldom afford the time the amateur lovingly devotes to his hobby. You have to keep a careful account of the time and overheads devoted to each job and these are generally much more costly than the materials themselves. At the same time you must be versatile, ready to tackle any kind of assignment, particularly when you first turn professional. You will have to have the energy and skill to organize your business books, costing, sales promotion and often the responsibilities of employing labor. The client expects to buy a reliable service, and if you make a mistake you may have to reshoot at a loss. Despite all these additional demands you should be able to turn out pictures which are imaginative, attain a high technical standard and serve a prescribed function.

Jobs and markets

Photography is a fragmented profession. It is diversified into all kinds of specialized applications and run by many groups of people. It can be broadly divided into photographic units which form parts of other organizations, and those which are independent and privately run. The former offers you the security and promotion prospects of working within a big firm. The latter gives greater scope for initiative and enterprise, and opportunities for greater rewards, but the consequences of failure can be very great as well. As an aspiring professional photographer you need to evaluate your own strengths and weaknesses. You should ask yourself whether you need to gain experience as an employee, or whether you are capable of starting out on your own. You should discover a market which not only needs good photography but can afford to pay for it. Choose the best area from which to operate, work out the potential market in terms of likely clients and survey the competition. Evaluate what you have to offer relative to the existing service. Decide whether you really want to face the uncertainties of turning professional or whether you might derive more satisfaction in the long term from remaining amateur.

Staff photographic units

Many large organizations run their own photographic departments. Hospitals need units to provide medical illustrations for case notes, reports, teaching aids and research into new forms of diagnosis and treatment. For this work you need sound technical knowledge, an objective approach and the interest and temperament to enjoy working in a medical environment. Much the same applies to forensic photography for the police force, and to scientific and technical photography as practiced in universities, the armed forces, government establishments and research associations. Staff photographers in museums provide high quality records of exhibits and new acquisitions, mostly for educational purposes. Press photographers employed on the staff of local or national newspapers need an inquisitive interest in people and events and the ability to work to deadlines and produce results under all conditions. Major industries of all kinds have internal photographic units. They tackle public relations and prestige publicity work, producing pictures for company publications, press pictures for distribution to the mass media, and illustrations for sales staff and training officers. Subject matter is obviously as varied as industry

itself and includes everything from space rockets to micro-electronics. The staff man obviously gets to know his particular organization more intimately than any outside photographer, but most managements also call in outside freelancers for jobs where a fresh visual approach is needed

Independent studios

Most independent photographic businesses run a"general practice", taking on most jobs that occur in their town or district. Work therefore covers weddings, portraits, and commercial pictures for local industry, design studios and other organizations too small to operate their own units. Studios in or near industrial centers can specialize in industrial and commercial photography only. Equally you might find it profitable to specialize in portraits and weddings. Specialization of any kind allows you to equip yourself properly, work toward a thorough understanding of subjects and market and build up a standard of excellence the general practitioner is unlikely to reach. Working from a major city, you may be able to build up a practice in fashion and advertising, freelance press photography, or illustrative pictures for greetings cards and calendars. Group photography for schools and institutions also falls into this category. Photography for mail order catalogs is big business for studios with sufficient warehouse space, front projection and other gear to cope with the work.

Combining photography with other interests

You may have special interests, skills or contacts which you can combine with photography to form a specialized freelance business. Fashion, natural history, sport, aerial and underwater photography are all examples of freelance businesses of this kind. Naturally, the narrower your specialization the smaller your potential market, and the less well equipped you will be to diversify if that market should collapse. On the other hand you will be entitled to command a higher fee for a particular type of subject or style of image which is unique to you. In highly paid areas such as advertising and editorial illustration originality is greatly sought after. You will be required to contribute some outstanding visual ideas, as well as reliability and technical know-how.

Running your own business

Professional photography, like any other business, needs to make a profit to survive. Good pictures alone are not enough. You need to be aware of business procedure and organize the essentials of accounting, costing and invoicing. Above all you have to be able to sell the product.

Starting a business
In most countries all you really need to set up in business as a self-employed photographer is a bank account, some personalized writing paper and invoices, a copyright stamp for marking the back of your prints, and an account book. Of course you will also need enough money for all the necessary equipment and materials, rent for work space, and something to live on until the business becomes self-supporting. You may be able to get off to a quicker start by setting up a partnership with another photographer. Together you can pool equipment, share a studio, a darkroom, telephone and contacts. Ideally each partner should contribute complementary elements – photographic or business expertise, premises or money. One partner might be concerned primarily with studio still life work, the other with people and events. You share costs and overheads, and you share profits. The trouble with these arrangements is that each partner is also liable for the other's losses. All business decisions must be joint or group decisions, and the withdrawal or death of one partner means that the others must buy out his share or find a replacement. Another way of establishing yourself is to join a cooperative. This is usually a studio and office complex in which everyone shares a reception area and secretarial services. Each photographer has his own office and telephone, but hires the studio and a darkroom by the hour as he needs them. He also contributes his share of general overheads. Individuals find their own commissions and charge as if they were a one-man business. Yet another way of starting is to buy a complete existing business; in this way you avoid some of the problems of the early years. If you are starting out on your own, consider carefully the type and location of the photography business you want to run. You may decide you need a shop front, or at least a showcase to display work to the public. If industrial photography is your speciality you should perhaps find premises close to an industrial area of the city. On the other hand, many clients and agencies are likely to be in the center of town, so for more general work you would probably do better to establish

yourself there. A third alternative is to operate from your home, though if this is in a suburb you may spend as much on traveling as you save in rent. You may already have some customers as an amateur photographer, but launching yourself as a self-employed professional is a serious, expensive and complicated process. You will probably need to borrow money from the bank, from friends, or sell property.

Keeping accounts and records
Even though you may intend to practice every economy and live on the smallest possible income during the early years you will have to know whether you are making or losing money month by month, and it is therefore essential to maintain business books right from the start. Begin by opening a separate bank account for the business. The bank's monthly or quarterly statement, together with your check records, will provide important basic financial information. But you also need a ledger in which to record all payments out or money received. This includes petty cash which can be drawn in lump sums from time to time, and kept in a cash box. Always get receipts for everything you purchase. In some countries, where value added tax operates, it will be necessary to keep separate account of the tax you pay out and the tax you charge to clients. At the end of each financial year hire an accountant to check your books, calculate net profit and prepare your tax return. Another vital book is a negative register. In this you note down the number and description of every picture taken, listed under date and under client. It is helpful to back up this register with a collection of contact prints – sheets of numbered prints pasted into scrapbooks to give immediate visual reference. You should also keep an inventory of all your equipment together with reference numbers, in case of loss or theft.

What to charge
You may be content to charge the going rate, which is the fee your competitors charge. Even so it is necessary to analyze whether you can make a profit at this price. Calculate how much it costs to run your business over a year, before a single photograph is taken. This means costing out general overheads, your salary (or at least living costs), interest on bank loans, and so on. From this work out cost per day, then add the cost of materials and all the incidental expenses for a particular job, including processing. This will tell you how much you must charge for

the job to break even, and then profit must be added on top. Some photographers charge a daily rate unless the work involves an exceptionally large number of pictures. Others price each individual job for an agreed number of pictures. Extra prints are charged additionally as and when they are ordered, and usually with a discount for quantity. Of course, you may decide to sub-contract some of this work to commercial color or black and white laboratories.

Promoting yourself
Selling yourself and your work is a vital part of professional practice. A portfolio of superb work, regular publication of your work and personal recommendations from your clients are perhaps your greatest assets. Always show examples of published material using your pictures; this demonstrates that other people have confidence in your ability. Confidence is important and needs to be supported by a thoroughly professional approach to each job. If you don't relish the selling side of business promotion it might be worth your while to employ a representative on a commission basis. Sales techniques used by the general practitioner include direct mailing of advertising material and special offers, and links with shops, cinemas and so on. You can begin to establish your name by having your work published and credited in local newspapers. Remember that for all their diplomas or certificates or memberships of professional bodies, most photographers are considered only as good as their last job. No one can succeed for long if the service they offer is unreliable or their photographs are unexciting.

Contracts in the US and Britain

Whenever a photographer buys or sells goods or offers his services, he is involved with contracts whether they are written or oral. For a contract to be legally enforceable, it must involve three essential elements: an offer, acceptance of the offer and consideration. Thus, if you offer your photographic services to a potential customer, you must state clearly that you are offering to take a certain number of pictures for a specific consideration on a specific date. Your offer must be unconditionally accepted by the customer. (If the customer accepts the offer but adds additional conditions to it, for example that you won't be paid at all if the customer doesn't like the photographs, then you have a counteroffer, not an acceptance of your offer.) The consideration is the quid pro quo that will be given in return for your promise to do the work. Money is the usual form of consideration but a promise to give you a credit as the photographer if your photograph is published may be equally important, particularly if you are just launching a career.

Many professional photographers have their own submissions forms which they use when dealing with publishers. These forms spell out the price for use of photographs. They also specify "kill" fees if the photographs are not used, and "holding" fees if the photographs are kept longer than a certain period of time. But these terms and conditions are not binding unless the customer agrees to be bound by them.

Since oral contracts are difficult to enforce in court, it is usually wise to have a written agreement. Then both parties know what the terms of their deal are, and they do not have to rely upon their recollections of the original discussion, which often turn out to vary when a dispute arises.

Once you have a binding contract, either party may enforce it if the other fails to abide by a material term that was agreed upon. Although a court can force one party to honor a contract, the usual remedy is money damages. However, litigation can be time-consuming and expensive, so most people try to settle their cases by negotiation rather than going to court.

Copyright

The principal means of exploiting a successful photograph is through copyright, which is the exclusive right, for a limited period, to make copies of an original work and to authorize others to do so.

Copyright in the US

The term of copyright under the present law in the US is 28 years from the date of first publication, with a renewal term of another 28 years. Under the 1909 Copyright Act (which will be replaced by the 1976 Copyright Act on January 1, 1978) copyright in the United States is secured by publication of the photographs with a proper copyright notice: © accompanied by the initials, monogram, mark or symbol of the copyright proprietor (your name, if you are the owner), provided that the proprietor's name also appears on some accessible portion of the photograph or on its margin or back. However, to secure full international copyright protection under the Universal Copyright Convention, all copies of your photographs should bear the © accompanied by the name of the copyright proprietor and the year of first publication. Registration of a claim of copyright and deposit of copies of the photograph are not a condition to securing a copyright, but are required prior to the commencement of any copyright infringement suit or the filing of a renewal application.

The 1976 Act alters the law and lengthens the period of copyright protection. It abolishes common law or statutory copyright under state law. Any photograph, whether created before or after January 1, 1978 and whether published or unpublished, will be protected by the 1976 Act when it is created. A work is considered "created" under the new Act when it is fixed by any method in a tangible medium of expression that can be perceived or reproduced. The form of copyright notice is similar to that in the 1909 Act but errors or even omissions in the notice need not be fatal to copyright protection and the position of the notice must merely be such as to give reasonable notice of a claim of copyright. In addition, the 1976 Act protects photographers who sell their photographs without reserving their rights. The presumption under the new Act is that transfer of ownership does not convey any rights in the copyright to the purchaser, unless there has been an agreement to that effect. The new Act also sets specific definitions of a "work made for hire." Since under the new Act a transfer of copyright is not valid unless the transfer document is in writing and signed by the owner of the copyright, it is safe to assume that photographers will be asked by publishers to sign more agreements than in the past. It is in the photographer's interest to make sure that he does not sign away his copyrights in the process.

Copyright in Britain

In Britain copyright lasts, in general, until the end of the period of 50 years from the end of the calendar year in which the author dies – or from the date of publication of the work. The Copyright Act, 1956, sets out the rules; section 3 defines "photographs" as within the expression of "artistic work." The author of such a work is entitled to the copyright. And the photographer is the author. But where a photograph is taken by him "in the course of his employment by the proprietor of a newspaper, magazine or similar periodical under a contract of service or apprenticeship, and is so made for publication in a newspaper, magazine or similar periodical," then the proprietor is entitled to the copyright. Subject to this, where someone commissions the taking of a photograph "and pays or agrees to pay for it in money or money's worth" and the photograph is made in pursuance of that commission, the person who commissioned the work is entitled to the copyright.

It follows that the best way to ensure your right to copyright is to provide that it shall be yours – and this is of supreme importance if you are commissioned to do the work, or if you take the photograph in the course of your employment by, or on behalf of, a newspaper, a magazine or periodical.

Glossary

A

Aberration The inability of a lens to render a perfect image of the subject often at the edges of the lens field. There are seven basic lens aberrations common in simple lenses which can be reduced by compound constructions. They are: astigmatism, spherical aberration, coma, chromatic aberration, lateral chromatic aberration, curvilinear distortion and curvature of field.

Absolute temperature The temperature at which most molecular movement ceases. It is often referred to as absolute zero ($-273^{\circ}C$) because it forms the base point of the Kelvin scale, which is used in photography as a means of measuring color temperature.

Absorption Light falling onto a surface which is partially or almost totally absorbed by that surface. The light which is absorbed is converted to heat while light not absorbed is either transmitted (by transparent or translucent surfaces) or reflected (by opaque surfaces).

Accelerator Chemical constituent in a developing solution which speeds up the action of the reducing agent in the solution. Such chemicals are usually alkaline.

Acetate base Non-inflammable base support for film emulsions which replaced the highly inflammable cellulose nitrate base.

Acetic acid Chemical used for stop baths (a 2% solution is usually recommended) and to acidify acid fixing solution. In the latter case a buffer (sodium metabisulfite) is frequently added to prevent the acid from decomposing the thiosulfate used for fixation.

Achromatic Lens system that has been corrected for chromatic aberration although on old lenses marked "achromatic" it may still be evident at maximum apertures.

Acid fixing solutions Fixing solutions which contain an acid to neutralize any carry-over of alkaline developer on the negative or print or from a contaminated stop bath. They should not be confused with acid hardening fixers (see "Hardeners").

Actinic The ability of light to cause a chemical or physical change in a substance. The actinic power of light during exposure causes the sensitive crystals in a photographic emulsion to change their structure thereby forming black metallic silver which creates the image.

Actinometer Early type of exposure calculator. A sample of the light sensitive material in use was exposed to light to darken it and then compared to a standard tint. The time taken to reach this standard formed the basis of exposure calculations.

Acutance Objective measurement of image sharpness. The steepness of the angle of the edge gradient between density boundaries in an image is used to express its degree of sharpness. The steeper the angle between these boundaries the greater the sharpness. As the angle becomes less acute the difference between the two densities becomes more diffuse and the image less sharp. Such measurements do not always correlate with subjective judgments as other factors play a part in the final effect.

Adamson, Robert, 1821-1848. Victorian photographer. Worked with D. O. Hill to produce excellent portrait and group photographs.

Additive synthesis Color system which uses a combination of the additive primaries (blue, green and red) to produce a range of colors representative of the subject. Early color photography was based on the use of this synthesis, e.g. Dufaycolor.

Aerial perspective Distance or depth effect caused by atmospheric haze. Haze creates a large amount of extraneous ultra-violet light to which all photographic emulsions are sensitive. This produces an overall density on the negative and subsequent print which often obliterates form and creates indistinct shapes lacking detail on distant horizons. Such an effect helps create tone differences, giving aerial perspective.

Aerial photography Has many uses and can be classified into different types. The most common uses are for mapping, reconnaissance, survey, and the recording of weapon or instrument tests while the different types include photography from air-to-air, air-to-ground and air-to-sea. Most aerial cameras except those used to record aircraft instruments use a large film format often of unconventional size, e.g. 5 ins (12.7 cm) square or 9 ins (22.9 cm) square in rolls of 100 ft (30 m). Cameras other than hand-held models are operated by the pilot or his observer using automatic controls which will release the shutter, wind on the film and tension the shutter. Exposure time is related to the speed of the aircraft and ambient light conditions. An ultra-

violet filter is important to combat haze. Cameras are bulky, often larger than 4 x 5 ins (10.2 x 12.7 cm) studio cameras and are usually fitted to special mountings within the aircraft. However some cameras, even of quite large format, are designed for hand-held photography, particularly in air-to-air and air-to-sea reconnaissance and observation. Processing of the film is identical to normal black and white and color although in the former the developer is often more contrasty than conventional developer types. Prints of air film are made as required but often only the negatives are "read" to provide the information required.

Agitation Method by which fresh solution is brought into contact with the surface of sensitive materials during photographic processing. It is particularly important during negative and print development, and during the initial stages of fixation. It is vital that the manufacturer's recommendations are followed for the degree of agitation required with particular materials, since agitation can markedly affect contrast.

Air brushing Method of retouching black and white or color photographs where dye is sprayed, under pressure, on to selected areas of the negative or print. Good quality airbrushing requires considerable skill and is very specialized work.

Albumen paper Printing paper invented by Blanquart-Evrard in the mid-19th century where egg whites were used to coat the paper base prior to sensitization. The albumen added to the brightness of the white base and substantially improved print highlights.

Alum Chemical used in acid hardening fixing baths. Two types are available, chrome alum and potassium alum. Potassium alum is preferred for fixing prints, as chrome alum is inclined to stain metallic silver green. The useful life of any hardening agent is usually shorter than that of the acid fixing bath.

Ambrotype Mid-19th century photographic process introduced in 1851-52 by Frederick Scott Archer and Peter Fry. It used weak collodion negatives which were then bleached and backed by a black background which produced the effect of a positive image. Ambrotypes quickly replaced the earlier Daguerreotypes because they were cheaper and easier to view.

Amidol Soluble reducing agent which works at low pH values.

Ammonium chloride Chemical used in toners and bleaches.

Ammonium persulfate Chemical used in super-proportional reducers. It is inclined to precipitate in solution and give erratic results.

Ammonium sulfide Pungent but essential chemical in sulfide or sepia toning. It is also an ingredient of some intensifiers.

Ammonium thiosulfate Highly active fixing agent used in rapid fixing solutions which works by converting unused silver halides to soluble complexes. It is not recommended for print fixation as its strong action can degrade blacks if fixing time is prolonged.

Anaglyph The result of forming stereoscopic pairs (three-dimensional images) from two positives each dyed a different color, usually green and red. The two images are either printed on a single sheet of paper slightly out of register or mounted as two separate images in a specially designed viewer. In both cases they are viewed through colored filters complementary to the colored image each eye must observe. Due to this ordered filtration each eye sees slightly different viewpoints of the subject which fuse together when viewed to produce a three-dimensional effect.

Anamorphic lens Lens capable of compressing a wide angle of view into a standard frame. A similar projection system can be used to reform the image on to a wide screen, e.g. Cinemascope.

Anastigmat Compound lens which has been corrected for the lens aberration "astigmatism."

Angle of incidence When light strikes a surface it forms an angle with an imaginary line known as the "normal", which is perpendicular to the surface. The angle created between the incident ray and the normal is referred to as the angle of incidence.

Angle of view Maximum angle of acceptance of a lens which is capable of producing an image of usable quality on the film.

Angstrom Unit of measurement used to indicate specific points or wavelengths within the electromagnetic spectrum. Visible light rays occur between 3900 Å (blue light) to approximately 7000 Å (red light). The indices between represent a variety of colors and saturations.

Anti-halation backing Dye used on the back of most films capable of absorbing light which passes straight

through the emulsion. In this way it reduces the amount of extraneous light that can be reflected from the camera back through the emulsion.

Antinous release Another term for a camera cable release.

Aperture Circular hole in the front of the camera lens which controls the amount of light allowed to pass on to the film. On all but very cheap cameras the size of the aperture is variable. The degree of variability is indicated by "f" numbers.

Aplanat Lens which has been corrected for spherical aberration.

Apochromat Lens corrected for chromatic aberration in all three additive primary colors.

Archer, Frederick Scott, 1813-1857. Englishman, inventor of the wet collodion process, published in 1851. Wet collodion largely superseded the calotype because of the increased speed and quality of the sensitive material. Later in 1852 with Peter Fry, he produced the ambrotype. Both of these processes became very popular and remained so until the introduction of the dry plate in the 1870s.

Arc lamps Photographic lamp in which the light is produced by passing an electric current through two carbon rods. The light produced is very bright and contains a high quantity of ultra-violet and blue light. As the carbon rods burn a white powdery ash is formed.

ASA Speed rating for photographic materials devised by the American Standards Association. The rating is based on an arithmetical progression using an average gradient system.

Aspherical surface Lens surface with more than one radius of curvature, i.e. the surface does not form part of a sphere. It helps compensate for many lens aberrations common in simpler lens designs.

Autochrome Early, commercial, color photography process in which the principles of additive color synthesis were applied. A mixture of colored starch grains dyed in the additive primaries of blue, green and red were overlaid in the form of a random screen on to a normal black and white panchromatic emulsion. This screen acted as a selective filter during exposure and produced different densities in the image related to the color and its intensity in the subject. When processed to a positive and viewed by white light, the same filtration screen present in the film produced a good colored impression of the subject. Such

transparencies were rather dim when compared with the color transparency system used today.

B

Back focus The distance between the back surface of a lens and the focal plane. It is not always equal to the focal length. In wide-angle, retro-focus constructions the back focus is much greater than the focal length which allows room for mirrors etc. within the camera construction, as in the 35 mm single lens reflex.

Background Area behind the main subject which can be anything from colored paper to a projected transparency or a specially built set. In close-up photography, differential focusing will sometimes cause the most distant parts of the subject to become background. A subject will usually stand out from lighter or darker tones than itself, but will merge if the background is similar so it is wise to use these considerations if background control is possible. Where selection of background tone is not possible, careful choice of lighting on to the background may provide a suitable effect.

Back projection Projection system often used to create location backgrounds in the studio. Location scenes are photographed then projected on to a suitable screen in the studio to create a background for objects placed in front. It is important that the direction of the lighting on the foreground objects matches that of the projected transparency and that background color and intensity are balanced with the subject in the foreground.

Bag bellows Short flexible sleeve used on large format cameras in place of normal bellows when short focal length (wide-angle) lenses are employed.

Baird, John, 1888-1946. Pioneer of television in Great Britain.

Ballistic photography Photography of weapons, ammunition and projectiles usually used for analysis.

Barium sulfate Compound used in the manufacture of photographic printing paper to give bright white highlights in the final print.

Barn doors Accessory used on spotlights and floodlamps to control the direction of light and width of the beam.

Barrel distortion One of the

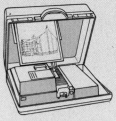

Back projection unit

Barn doors

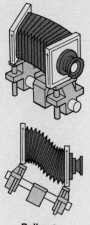

Bellows

common lens aberrations, where straight lines at the edge of the field are caused to bend into the shape of a barrel. It is caused by an asymmetrical lens construction, where the diaphragm is placed to the front of the optical system.

Baryta Coating of barium sulfate applied as the foundation to fiber-based printing papers.

Base Support for a photographic emulsion that may be paper, cellulose, triacetate, glass, estar etc.

Bas-relief Photographic image effect usually produced by printing from a negative and a positive sandwiched together in the enlarger, slightly out of register. The method produces a simplified image by reducing tonal gradation and creating a form of line representation. It will often have a slightly three-dimensional effect.

Batch numbers Set of numbers printed on packets of sensitive materials to indicate a common production coating. The batch number is given because slight variations of contrast and speed occur between batches of the same type of photographic material. This information is particularly important to the photographer using color materials and where automated systems are being used for mono-chrome printing.

Beam splitter Mirror and prism system capable of partly reflecting, partly transmitting light.

Bellows Light-tight, folding sleeve which can be fitted between the lens and the film plane.

Between-the-lens shutter Shutter usually placed within the components of a compound lens close to the diaphragm.

Bi-concave lens Simple lens or lens shape within a compound lens, whose surfaces curve toward the optical center. Such a lens causes light rays to diverge.

Bi-convex lens Simple lens shape whose surfaces curve outward, away from the optical center. Such a lens causes light rays to converge and form a real image.

Binocular vision The visual ability to determine three dimensions. Stereoscopic photography depends on the use of binocular vision.

Bitumen Hydro-carbon which hardens by the action of light. It was used by Joseph Nicéphore Niépce, the Frenchman, to produce the world's first photograph early in the 19th century.

Blanquart-Evrard, Louis, 1802-1872. Frenchman who improved the calotype process by introducing paper coated with albumen.

Bleach Chemical bath capable of rehalogenizing black metallic silver.

Bleaching Stage in most toning, reducing and color processing systems. The black and white silver image created by exposure and development can be bleached back to a halide which is then capable of density reduction (reducing), complete removal of the black metallic silver image by fixing (color processing) or being converted to a dye image (toning).

Bleach-out Method of producing line drawings from photographic images. The photograph is processed in the normal way, its outlines sketched, and the black metallic silver image then bleached away to leave the drawn outline.

Bleed Term used to describe a picture with no borders, which has been printed to the edge of the paper.

Blocking out Selected areas of a negative are painted with an opaque liquid on the non-emulsion side. As light is unable to penetrate these areas they appear white on the final print. It is used extensively in industrial photography to remove unwanted backgrounds, e.g. to isolate a piece of machinery from its surroundings.

Bloomed lens See "Coated lens."

Blur Unsharp image areas, created or caused by subject or camera movement, or by selective or too inaccurate focusing.

Borax Mild alkali used in fine grain developing solutions to speed up the action of the solution.

Box camera Simplest type of camera manufactured, and first introduced by George Eastman in 1888. It consists of a simple, single element lens, a light-tight box and a place for a film in the back. Shutter and aperture are usually fixed at $\frac{1}{25}$ second at f11. No focusing is necessary as the lens is set to the hyperfocal distance which gives acceptable images providing the subject is not too close.

Brady, Matthew, 1823-1896. American who has become famous for his photography of the American Civil War.

Brewster, Sir David, 1781-1868. Pioneer of stereoscopy, which involves the production of three-dimensional images using two photographs and specially constructed viewers.

Brightfield Method of illumination used in photomicrography which will

show a specimen against a white or light background.

Brightness range Subjective term describing the difference in luminance between the darkest and lightest areas of the subject, in both negative and print.

Bromide paper Most common type of photographic printing paper. It is coated with an emulsion of silver bromide to reproduce black and white images.

Brownie Trade name given to early Kodak box cameras.

B setting Letter used on the shutter setting ring, indicating that the shutter will stay open while its release is depressed.

BSI Abbreviation for British Standards Institute.

Buffer Chemical substance used to maintain the alkalinity of a developing solution, particularly in the presence of bromine which is produced during development. It is also a general term applied to any compound or chemical which assists in maintaining the characteristics of a solution.

Burning-in See "Printing-in".

C

Cable release Flexible cable used for firing a camera shutter. It is particularly useful for exposures of long duration where touching the camera release by hand may cause camera-shake and subsequent blur.

Callier effect A contrast effect in photographic printing caused by the scattering of directional light from an enlarger condenser system. The negative highlights are of high density and scatter more light with little or no scattering from negative shadow areas, which are of low density. This gives a print of higher contrast than a contact print. On diffuser enlargers the light is pre-scattered and the contrast effect is very much less. The contrast difference between condenser and diffuser enlargers is approximately half a grade.

Camera movements Mechanical systems most common on large format cameras which provide the facility for lens and film plane movement from a normal standard position. The movements can create greater depth of field in specific planes, and can correct or distort image shape as required.

Camera obscura The origin of the present day camera. In its simplest form it consisted of a darkened room with a small hole in one wall. Light rays could pass through the hole to transmit on to a screen, an inverted image of the scene outside. It was first mentioned by Aristotle in the 4th century BC and developed through the centuries as an aid to drawing. During the 16th century bi-convex lenses were added to the basic apparatus. The first person to attempt to put light sensitive materials and the camera obscura together was Thomas Wedgwood, son of the potter Josiah, around about 1800. The Frenchman Nicéphore Niépce succeeded in this and established a permanent record in 1826.

Cameron, Julia Margaret, 1815-1879. English photographer famous for her portrait photographs of eminent 19th century personalities.

Canada balsam Liquid resin with a refractive index similar to glass. It is used for bonding elements in compound lenses.

Candela Unit which expresses the luminous intensity of a light source.

Candle meter Also known as a lux and defined as the illumination measured on a surface at a distance of one meter from a light source of one international candle power.

Candle meter second Unit of illumination related to exposure time, more often referred to as one lux-second.

Carbon arc See "Arc lamps".

Cartridge Quick loading film container, pre-packed and sealed by the manufacturer.

Cassette Light-tight metal or plastic container holding measured lengths of 35 mm film, which may be loaded straight into the camera.

Caustic potash Highly active alkaline used in high contrast developing solutions to promote vigorous development. Highly corrosive and poisonous.

Caustic soda See "Caustic potash".

CC filters Used primarily for color correction in subtractive printing processes in color photography. The color shift values are calibrated in mireds and are available in sets of yellow, magenta and cyan. CC filters can also be used on the camera in adjusting color temperature.

Centigrade Scale of temperature in which freezing point is equal to 0°C and boiling point to 100°C.

Changing bag Opaque fabric bag, which is light-tight and inside which

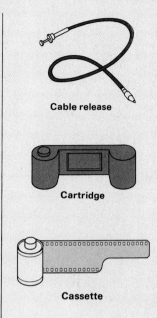

Cable release

Cartridge

Cassette

sensitive photographic materials may be safely handled.

Characteristic curve Performance graph showing the relationship between exposure and density under known developing conditions. It can provide information on factors such as emulsion speed, fog level and contrast effect. The study of photographic materials in this way is known as sensitometry.

Chemical fog An even, overall density on film or paper. It is exaggerated by over-development and is caused by unexposed silver halides being attacked by the reducing agents in the developing solution.

Chloride bromide paper Photographic printing paper coated with a mixture of silver bromide and silver chloride, producing warm tone images in the print.

Chromatic aberration The inability of a lens to bring light from the same subject plane but of different wavelengths, that is, of different color, to a common plane of image or focus.

Chrome alum Chemical used as a hardener in fixing baths.

Circle of confusion Disks of light on the image, formed by the lens from points of light in the subject. The smaller these disks are in the image the sharper it appears. Once they reach a size that can be perceived as disks rather than points, that part of the image is considered to be unsharp.

Clerk-Maxwell, James, 1831-1879. Scottish scientist who first demonstrated the formation of white light and spectral colors by additive and subtractive synthesis, thus interpreting the earlier Young-Helmholtz color vision theory.

Coated lens Lens with air-glass surfaces which have been coated with magnesium fluoride to reduce lens flare.

Cold cathode illumination A low temperature fluorescent light source common in many diffuser enlargers, which is inclined to reduce contrast and edge definition.

Collodion process Known as "wet collodion" and invented by Frederick Scott Archer in 1851. It was a great improvement on the earlier calotype process because of the large increase in speed gained by exposing the plate whilst still "wet", but it had the disadvantage of requiring bulky equipment which had to be carried around. It became one of the major processes until the introduction of the dry plate in the 1870s.

Color sensitivity The response of a sensitive material to colors of different wavelengths.

Color synthesis Combinations of colored light or dye which will produce a colored photographic image. Such systems are either additive or subtractive and based on James Clerk-Maxwell's early experiments of the 19th century.

Color temperature A scale which expresses the color quality and content of a light source and is calibrated in Kelvins (K) or mireds (micro reciprocal degrees).

Coma Lens aberration which creates circular patches of light at the edges of the lens field.

Combination printing The printing of more than one negative on to a single sheet of paper to achieve a particular effect.

Complementary color Two colors are complementary to one another if, when combined in the correct proportions, they form white light. The term is usually applied to the dye colors which are complementary to the primary additive colors of transmitted light. These are used in three-color subtractive printing and are as follows:

Primary	Complementary
blue	yellow (green + red)
green	magenta (blue + red)
red	cyan (blue + green)

Compound lens Lens system consisting of two or more elements. Compound lens designs can be more complex than this simple definition suggests. This complexity enables the designer to make maximum apertures larger, improve resolution and reduce lens aberrations.

Concave lens See "Bi-concave lens".

Condenser Optical system which concentrates light rays from a wide source into a narrow beam. Condensers are used in spotlights and enlargers.

Contact paper Printing paper used only for contact printing. It is usually coated with a silver chloride emulsion of very slow speed.

Contact printer Apparatus used for making contact prints. Equipment ranges from a contact printing frame to more sophisticated boxes with safe lighting, exposing source and glass diffusing shelves all built in.

Continuous tone Term applied to monochrome negatives and prints, where the image contains a gradation of density from white through gray to black, which represent a variety of subject luminosities.

Contrast Subjective judgment on the difference between densities or

luminosities and their degree of separation in the subject, negative or print. Contrast control is an important element in photography and is affected by: inherent subject contrast; subject lighting ratio; flare factor of lenses; type of negative material; degree of development; type of enlarger; contrast grade and surface quality of paper.

Converging lens See "Convex lens".

Convertible lens A compound lens made in two sections, the elements of which are arranged so that when one part is unscrewed it provides a new lens with approximately twice the original focal length.

Convex lens A simple lens which causes rays of light from a subject to converge and form an image.

Cooke triplet One of the most important lenses in lens history, designed by H. D. Taylor in 1893. It consists of three basic elements and has a maximum aperture of f6.3. It is from this basic design that most normal focal length lenses of today have evolved.

Copper toning Chemical process used for toning monochrome prints. See "Toners".

Copyright laws Laws which govern the legality of ownership of a particular photograph or piece of work.

Correction filter Filter which alters the color rendition of a scene to suit the color response of the eye. Most black and white panchromatic films, although sensitive to all the colors of the spectrum, do not have the same response to these colors as the human eye. Correction filters help compensate for this difference, and are usually yellow to yellow-green.

Coupled rangefinder System of lens focusing which combines the rangefinder and the focusing mechanism, so that the lens is automatically focused as the rangefinder is adjusted.

Covering power The maximum area of image of usable quality, which a lens will produce.

Coving Plain curved background which has no edges, corners or folds and gives the impression of infinity. It can be used to create an abstract background by casting shadows or projecting colored light on to it.

Cross front Camera movement which allows the lens to be moved laterally from its normal position.

Crossed polarization System of using two polarizing filters, one over the light source and one between the subject and the lens. With certain materials, particularly plastic, crossed polarization causes bi-refringent

effects which are exhibited as colored bands. This effect is frequently used in investigations of stress areas in engineering and architectural models. Crossed polarization can also be used to eliminate reflections.

Curvature of field Lens aberration causing a curved plane of focus. In practice the loss of sharpness is often compensated for by depth of focus.

Cut film Negative film available in flat sheets. The most common sizes are 4 x 5ins (10.2 x 12.7 cm) and 8 x 10ins (20.3 x 25.4 cm).

Cyan The blue-green subtractive primary color which absorbs red and transmits blue-green; that is, white light minus red.

D

Daguerre, Louis Jacques Mande, 1787-1851. Introduced the Daguerreotype, the first commercial photographic process, in Paris on August 19th, 1839. In the early part of the 19th century he worked with Nicéphore Niépce, and it would appear that the first commercial process evolved from their combined efforts. Daguerreotypes took the world by storm and were most successful in the field of portraiture. When Daguerre died in 1851 his "one shot" process was being superseded by improvements in the calotype and the introduction of the much cheaper ambrotype process.

Daguerreotype process Photographic process where the sensitive material comprised silver nitrate coated on a copper metal base, and a positive image was produced by a single camera exposure and mercury "development". The image was made permanent by immersing the plate in a solution of sodium chloride or weak sodium thiosulfate.

Dallmeyer, John, 1830-1883. Lens designer, who introduced the "rapid rectilinear" in 1866.

Darkcloth Cloth made of a dark material and placed over the head and camera back to facilitate the viewing of images on a ground glass screen, particularly on large format cameras.

Darkfield Method of illumination used in photomicrography which will show a specimen against a dark or black background.

Darkroom Light-tight room used for processing or printing, which incorporates safelights suitable for the materials in use.

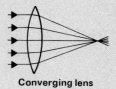

Converging lens

Diaphragm

Darkslide Light-tight film holder for large format cut film.

Definition Subjective term used to describe the clarity of a negative or print. It can also apply to a lens or photographic material, or the product of both, and commonly refers to the resolving power achieved.

Densitometer Instrument for measuring the density of silver deposits on a developed image by transmitted or reflected light.

Density Amount of silver deposit produced by exposure and development. It is measured in terms of the logarithm of opacity, where opacity is the light-stopping power of a medium.

Depth of field The distance between the nearest point and the farthest point in the subject which is perceived as acceptably sharp along a common image plane. For most subjects it extends one third of the distance in front of and two thirds behind the point focused on.

Depth of focus The distance which the film plane can be moved while maintaining an acceptably sharp image without re-focusing the lens. It is equidistant in front and behind the plane of optimum focus.

Detective cameras Popular Victorian cameras which were designed to appear as bowler hats, pocket watches or binoculars.

Developer Chemical bath containing reducing agents, which converts exposed silver halides to black metallic silver, so making the latent image visible. Other chemicals known as accelerators, preservatives and restrainers are added to the bath to maintain the action of the reducing agents. There are three basic types of black and white developer. The formulae given below are typical examples of each type.

General purpose MQ developer
This developer can be used for both film and paper, depending on the dilution. Use the following formula:

Metol	2 gr.
Hydroquinone	12 gr.
Sodium carbonate	7 gr.
Sodium sulfite	50 gr.
Potassium bromide	1 gr.
Water to 1 liter	

Fine grain developer
This general purpose developer for negative materials gives a fine grain and can be used with most types of film.

Metol	2 gr.
Hydroquinone	5 gr.
Borax	2 gr.
Sodium sulfite	100 gr.
Water to 1 liter	

High contrast developer
This developer produces a very high contrast result.

Solution A

Hydroquinone	25 gr.
Potassium metabisulfite	25 gr.
Potassium bromide	25 gr.
Water to 1 liter	

Solution B

Potassium hydroxide	50 gr.
Water to 1 liter	

Prepare a working solution by mixing equal parts of A and B just before use. At a temperature of 68°F (20°C) development should occur in 2-3 minutes.

Development The process of converting exposed silver halides to a visible image. Accurate development is achieved with an appropriate developer, suitably diluted at the right temperature. Length of development and amount of agitation also affect accuracy of development.

Diaphragm Term used to describe the adjustable aperture of lens. It controls the amount of light passing into the camera and may be in front of, within or behind the lens. This term can also be applied to shutter types, e.g. iris diaphragm shutter, a set of interposing leaves, which open and close at a variable rate to produce a between-the-lens shutter.

Diapositive Positive image produced on a transparent support for viewing by transmitted light, e.g. a transparency.

Dichroic fog Purple-green bloom usually seen on negatives and caused by the formation of silver in the presence of an acid. It can occur in a fixing bath which has become contaminated by developer or which is becoming exhausted. The colloidal stain produced cannot be satisfactorily removed.

Diffraction Light rays scatter and change direction when they are passed through a small hole or close to an opaque surface. When a lens is stopped down to a very small aperture, e.g. f45, diffraction occurs and affects the quality of the image. Optimum image quality is usually found mid-way through the marked aperture range, where aberrations are being offset and diffraction has yet to occur.

Diffuser Any material that can scatter or diffuse light. The effect is to soften the character of the light. The closer a diffuser is to a light source the less it scatters the light.

DIN. Deutsche Industrie Norm (German standards organisation).

DIN speed Film speed system used

by the German standards organisation. It is based on a logarithmic scale and is represented by a number printed on the film carton or box. A change of $+3°$ in rating indicates a doubling of film speed, e.g. 21° DIN is twice as fast as 18° DIN, and 15° DIN half the speed of 18° DIN.

Diopter Unit used in optics to express the power of a lens. It is the reciprocal of the focal length expressed in meters. The power of a converging lens is positive, and its power expressed by a positive sign, e.g. 50cm convex lens

$$+\frac{1}{0.5} = +2 \text{ diopters.}$$

The power of a diverging lens is negative, and its power expressed by a negative sign. e.g. 25cm concave lens

$$-\frac{1}{0.25} = -4 \text{ diopters.}$$

Disdéri, André, 1819-1890. Introduced the carte-de-visite in the mid-19th century, which gave a great impetus to portrait photography.

Dish development Method of development used for processing single sheets of cut film or paper prints by immersing in a shallow dish of developer and agitating by rocking the dish. With dish development oxidation rapidly shortens the useful life of the solution making frequent changes necessary.

Dispersion The ability of glass to bend light rays of different wavelengths, and hence different colors, to varying degrees. The degree of dispersion depends on the type of glass, the angle of incident light, and the refractive index of the glass.

Diverging lens A lens which causes rays of light coming from a subject to bend away from the optical axis, i.e. a concave or negative lens.

Dodging Control of exposure in photographic printing achieved by reducing exposure to specific areas of the paper.

Double extension Characteristic of large format view and monorail cameras which enables the bellows to be extended to twice that of the focal length of the lens in use. It is used for close-up photography.

Driffield, Charles, 1848-1915. Worked with Ferdinand Hurter on the study of photographic emulsions, which provided the basis for modern sensitometric study and produced the first practical performance curve for a photographic emulsion, the H and D curve. Their work helped establish basic criteria for modern film speeds such as ASA and DIN.

Drying marks Marks on the film emulsion caused by uneven drying and resulting in areas of uneven density, which may show up on the final print. On the back they are caused by scum and can be removed, but on the emulsion side there is no satisfactory way of removing them.

Dry mounting Method of attaching prints to mounting surfaces by heating shellac tissue between the mount and the print.

Dry plates Term used to describe gelatin-coated plates in the days when the wet collodion process was still popular. The term is now only used in historical contexts.

Ducos Du Hauron, Louis, 1837-1920. French scientist who formulated the principles of additive and subtractive color processes in a book called *Les Couleurs en Photographie; Solution du Problème.*

Dufay, Louis D., dates unknown. Originator of an early color process, known as Dufaycolor, which makes use of an integral, ruled-screen, tricolor filter.

Dye sensitizing All silver halides used in black and white emulsions are sensitive to blue light. Early photographic materials possessed only this sensitivity. In 1880 Dr. H. Vogel evolved a method of making silver halides sensitive to other colors, which led to the production of the orthochromatic and panchromatic materials in use today.

Dye transfer prints Method of producing color prints via three color separation negatives, e.g. color transparencies. Negatives are used to make positive matrixes, which are dyed in subtractive primaries and printed in register.

E

Eastman, George, 1854-1932. American manufacturer who offered photography for the mass market by incorporating a sensitive emulsion on a flexible support with the famous Kodak "box" camera (1888).

Eberhard effect Border effect occurring in the developed image and described in 1926 by G. Eberhard. It shows itself as a dense line along an edge of high density and as a light line along an edge of low density. It occurs most often in plates that are developed flat in solution not sufficiently agitated.

Electronic flash Artificial light

Diverging lens

Dry mounting press

Electronic flash

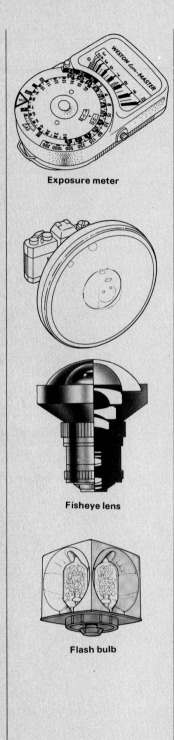

Exposure meter

Fisheye lens

Flash bulb

source produced by discharging an electronic charge through a gas-filled tube. A single tube will produce many thousand flashes.

Emerson, Peter Henry, 1856-1936. Eminent English photographer who became an advocate of the "naturalistic" photograph, producing fine landscape photography in the late 19th and early 20th century.

Emulsion Light sensitive material which consists of a suspension of silver halides in gelatin and which is coated on to various bases to produce photographic plates, films and paper.

Enlargement Term used to describe a print larger than the negative used to produce it.

Expiry date Date stamp on most film boxes indicating the useful life of the material in terms of maintaining its published speed and contrast.

Exposure In photographic terms this is the product of the intensity of light and the time the light is allowed to act. In practical terms the aperture controls intensity or amount of light and shutter speed controls the time.

Exposure meter Instrument for measuring the amount of light falling on or being reflected by a subject, and usually equipped to convert this measurement into usable information, such as the shutter speed and aperture size required to take a reasonable photograph.

Extension tubes Metal tubes used on small format cameras, to extend lens-film distance, enabling magnification greater than x 1.

Extinction meter Early type of exposure calculator.

F

Fahrenheit scale Scale of temperature named after its German originator G. D. Fahrenheit. In this scale, the freezing point of water is 32°F and its boiling point is 212°F.

False attachment Compositional effect used to produce images in which objects in the foreground and objects in the background both appear to be on the same plane. This effect can be achieved in several different ways.

Farmer's reducer Used for bleaching negatives and prints. See "Reducers".

Fenton, Roger, 1819-1869. English photographer. First to document war scenes in the Crimean War during 1855.

Ferric chloride Bleaching solution used on negative materials.

Filters Colored glass, gelatin or acetate disks, which modify the light passing through them, mainly in terms of color content. They can be used both at the camera and at the printing stage, to correct or alter the appearance of the final photograph.

Fine grain developers Film developers which help to keep grain size in the photographic image to a minimum. Most modern fine grain developers are capable of achieving excellent results without loss of film speed.

Finlay, Charles, died 1936. Invented the mosaic screen additive color process known and marketed as Finlay Color.

Fish-eye lens Extreme wide-angle lens with an angle of view exceeding 100° and sometimes in excess of 180°. Depth of field is practically infinite and focusing is not required. It produces highly distorted images.

Fixation Chemical bath which converts unused halides to a soluble silver complex in both negatives and prints, making the image stable in white light. Two types in common use are sodium thiosulfate, and a more active type, ammonium thiosulfate.

Fixed focal length Camera system whose lens cannot be interchanged for a lens of different focal length.

Fixed focus Lens-camera system that has no method of focusing the lens. The lens system is focused on a fixed point, usually at the hyperfocal distance. With the use of a medium size aperture (f11) most subject distances from 6ft to infinity can be rendered reasonably sharp. Most cheap cameras use this system.

Flare Non-image forming light scattered by the lens or reflected from the camera interior. It is much reduced when glass-air surfaces within the lens system are coated (bloomed) with metallic fluorides and the camera interior is a mat black. Flare can affect film by causing a lowering of image contrast.

Flash Artificial light source giving brief but very bright illumination. It is produced by the combination of certain gases within a transparent tube. There are two types: electronic, which may be used repeatedly, and expendable in which the bulb can be used only once.

Flash synchronization Method of synchronizing flash light duration with maximum shutter opening. There are usually two settings on a camera, X and M. X is the setting

used for electronic flash, in which peak output is almost instantaneous upon firing. M is for most expendable types of flash (bulbs) which require a delay in shutter opening of approximately 17 milliseconds, to allow the bulb output to build up.

Floodlight Artificial light source with a dish-shaped reflector and a 125-500 watt tungsten filament lamp producing evenly spread illumination over the subject.

f numbers Numbers on the lens barrel indicating the size of the aperture relative to the focal length of the lens. f numbers are calculated by dividing the focal length of the lens by the effective diameter of the aperture, e.g. 55 mm lens, effective aperture 5 mm = relative aperture f11. All lenses stopped down to the same f number should transmit the same amount of light. Each change of number indicates a doubling or halving of the size of aperture, with the exception of maximum aperture in some cases.

Focal length The distance between the rear nodal point of the lens and the focal plane, when the focus is set at infinity.

Focal plane Imaginary line perpendicular to the optical axis which passes through the focal point. It forms the plane of sharp focus when the lens is set at infinity.

Focal plane shutter Shutter which lies just in front of the focal plane. Light sensitive film positioned at the focal plane is progressively exposed as the shutter blinds move across it.

Focal point A point of light on the optical axis where all rays of light from a given subject meet at a common point of sharp focus.

Focusing System of moving the lens in relation to the image plane so as to obtain the required degree of sharpness of the film.

Focusing screen Ground glass screen fixed to the camera at an image-forming plane, enabling the image to be viewed and focused.

Fog Density produced on a negative or print by chemical processing or accidental exposure to light, which does not form part of the photographic image.

Fog level Term used to describe the amount of density produced on film emulsions during processing, when unused halides are converted to black metallic silver.

Format Size of negative, paper or camera viewing area.

Fox-Talbot, William H, 1800-1877.

Englishman who invented the first usable negative/positive photographic process, called the calotype. The process was not seriously marketed until 1841, by which time Daguerreotypes were well established. It therefore took some time for the process to be accepted.

Fresnel magnifier Condenser lens used at the center of some ground glass viewing screens to aid focusing.

Fresnel lens Condenser lens used on spotlights to gather together the rays of light coming from a source and direct them into a narrow beam.

G

Gamma Measurement used in sensitometry to describe the angle of the straight line portion of a characteristic curve of a photographic emulsion. It expresses the degree of development and is a form of contrast measurement.

G curve Average gradient of a characteristic curve. It describes and expresses similar characteristics to gamma. Most manufacturers' recommended development times for films are related to specific \overline{G} levels.

Gelatin Medium used on photographic materials as a means of suspending light sensitive halides.

Glaze Glossy surface produced on some (not RC) printing papers. It is achieved by placing the wet print on to a heated drum or clean polished surface. Glazed prints produce denser medium blacks than their mat counterparts.

Gold chloride Soluble chemical used in gold toners.

Gradation Tonal contrast range of an image, e.g. soft, normal, contrasty.

Grade Classification of paper contrast. Paper contrast ranges from 0 to 5, i.e. soft to very hard. It should not be assumed that similar grade numbers from different manufacturers have equivalent contrast characteristics.

Graininess Clumps of silver halide grains in the emulsion which are visible in the photographic image because of spaces between the grains. They are produced in the process of exposure and development and are most noticeable in even, mid-tone areas of a print.

Grains Exposed and developed silver halides which have formed black metallic silver grains, producing the visible photographic image.

Granularity Objective term describing the amount that silver

Floodlight

Focusing screen

Glazing machines

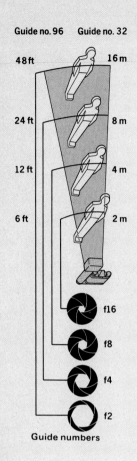

Guide no. 96 Guide no. 32

48 ft 16 m
24 ft 8 m
12 ft 4 m
6 ft 2 m

f16
f8
f4
f2

Guide numbers

halide grains have clumped together within the emulsion.

Ground glass screen Translucent glass sheet used for viewing and focusing the image on all large format and some reflex cameras.

Guide number Term sometimes used to describe a flash factor, which provides a guide to correct exposure when using flash.

H

Halation Diffused image usually formed around bright highlights of the subject. It is caused when light passes straight through the film, strikes the camera back and is reflected back through the film.

Halogens Group of chemical elements. In photography, three of these, bromine, chlorine and iodine are used with silver to produce light sensitive crystals.

Hardener Chemical often used with a fixing bath to strengthen the physical characteristics of the emulsion. The most common chemicals used are potassium or chrome alum. Formalin is sometimes used in continuous processing machines because of its rapid action.

Helmholtz, Hermann, 1821-1894. German physicist who worked with Young in developing the Young-Helmholtz theory of color vision.

Herschel, Sir John, 1792-1871. Son of Sir William Herschel. Discovered the thiosulfates (fixing agents) and did much research in the field of photographic chemistry.

Herschel, Sir William, 1738-1822. Discovered infra-red rays, which are electromagnetic rays invisible to the human eye. He also devised a method of measuring and recording these rays.

High contrast developers/films Solutions and materials used to produce high contrast images.

High key Photograph which contains large areas of light tones, with few mid-tones and shadows.

Highlights The brightest areas of the subject, represented on a negative by dense deposits of black metallic silver, but reproducing as bright areas on the positive print or slide.

Hill, David Octavius, 1802-1870. Scottish photographer who worked with Robert Adamson to produce many fine calotype portraits of eminent figures in the 19th century.

Holography Complex system of photography, not requiring camera or

lens, in which laser beams are used to create a three-dimensional image on a fine grain photographic plate.

Hydrochloric acid Chemical used in some bleaching solutions. It is highly corrosive.

Hydrogen peroxide Chemical used in hypo clearing agents.

Hydroquinone Reducing agent. It is used in developers to provide high contrast results in the presence of a strong alkali. It can also be used in conjunction with metol/phenidone to provide general purpose and fine grain solutions.

Hyperfocal point The nearest point to the camera which is considered acceptably sharp when the lens is focused on infinity. When a lens is focused on the hyperfocal point, depth of field extends from a distance halfway between this point and the camera to infinity. This principle is used in fixed focus viewfinder and box cameras.

Hypersensitizing Method of increasing the light sensitivity of a photographic emulsion prior to exposure. This formula can be used to provide an approximate increase of 50 percent in the film speed.

0.880 ammonia	3 ml.
Pure alcohol	24 ml.
Water to 1 liter	

Working in total darkness, the film or plate is immersed in the solution, drained and dried quickly. It should be used as soon as possible after treatment.

Hypo Common name for a fixing agent, derived from an abbreviation of hyposulfite of soda, the misnomer applied to sodium thiosulfate during the 19th century.

Hypo eliminator (clearing agent) Chemical bath which removes traces of fixing agent from an emulsion. This formula can be used with both negatives and prints, but is more often used on prints.

Hydrogen peroxide	100 ml.
0.880 ammonia	10 ml.
Water to 1 liter	

Prepare this working solution just before use. Immerse washed prints for about 10 minutes, (prolonged immersion may reduce density of highlights), and wash again.

I

Image plane A plane commonly at right angles to the optical axis at which a sharp image of the subject is formed. The nearer the subject is to

the camera, the greater the lens-image plane distance.

Incident light Light falling on to a surface, not reflected by it.

Incident light reading Measurement, by light meter, of the amount of incident light falling upon a subject. The light meter is placed close to the subject, pointing toward the light.

Infectious development Development action which occurs in processing "lith" materials. The oxidation of hydroquinone produces new and highly active reducing agents, semiquinones, in the presence of a low quantity of sodium sulfite. This creates a very high contrast result.

Infinity In photographic terms, a distance great enough to be unaffected by finite variations. In practice this relates to most subjects beyond 1000 meters or, in landscape terms, the horizon.

Infra-red Rays that occur beyond the red end of the electro-magnetic spectrum and invisible to the human eye. They can be recorded on specially sensitized films, producing images in black and white or color not usually obtainable on photographic materials.

Integral tri-pack Three emulsions, usually of different character, coated on to the same base. The system is used mainly on color materials and also on some special purpose black and white materials.

Integrating Term used to describe a method of arriving at an exposure setting by taking an average of the light readings from the bright areas and the shadow areas of the subject.

Intensification Chemical method of increasing the density of the photographic image. It is only suitable for treating negative materials and works better on negatives which have been under-developed rather than under-exposed. The process involves bleaching then re-development. There are a number of formulae. For chromium intensifier it is as follows:

Solution A
 Potassium bichromate 25 gr.
 Water to 500 ml.
Solution B
 Hydrochloric acid,
 concentrated 25 gr.
 Water to 500 ml.

As a standard procedure, use 10 parts of A to 5 parts of B. Increase the amount of A to achieve a greater degree of intensification. If, when the negative is completely bleached, a yellow stain remains, rinse in a weak 2 percent solution of potassium metabisulfite. Rinse in water and re-develop in a general purpose MQ

developer, low in sulfite. Fine grain developers are not suitable. Wash and dry the intensified negatives in the usual way.

Intermittency effect A number of short, separate exposures will not produce the same photographic result when combined as a single exposure of equivalent total duration. This phenomenon is known as the intermittency effect.

Inverse square law States that, when the light source is a point, illumination on a surface is inversely proportional to the square of the distance of the light source, i.e. twice the distance, half the light.

Inverted telephoto lens Lens construction which gives a short focal length with a long back focus or lens-film distance. It enables wide-angle lenses to be produced for small format cameras, where space is required for mirrors, shutters, etc.

IR or R setting Mark usually in red, found on many camera lens mounts. It indicates the focus change required for infra-red photography. A change in focus is necessary because the visible rays by which we focus are refracted more than the long wavelengths beyond the visible spectrum.

Iris diaphragm Continuously adjustable lens aperture consisting of interposed metal leaves. Adjustment is made by moving the aperture ring on the lens barrel.

Irradiation The physical structure of the emulsion and the distribution of the silver halide grains cause rays of light to be scattered as they travel through the emulsion. The effect is loss of definition, and is greater with fast, i.e. thicker, emulsions than with slow, i.e. thinner, emulsions.

I setting Mark found on some cheap box cameras which indicates an instantaneous shutter speed of approximately $\frac{1}{50}$ second.

Ives, Frederic, 1856-1937. Invented the photochromoscope for viewing color diapositives. These were produced from a single plate which was made from three negatives, each recording a primary color.

J

Joule Unit used to quantify the light output of electronic flash. A joule is equal to one watt-second or 40 lumen-seconds. The measure is used to compare flash units in terms of light output.

Lamphouses

Lens hood

K

Kelvins (K) Units of measurement on the absolute temperature scale. They are used to measure the relative color quality of light sources, which can vary from 2000K to beyond 10,000K.

Kilowatt One thousand watts. A measure of the power of an electrical light source, which is sometimes more useful than the watt.

Kostinsky effect Development effect in which dense image points are inclined to move apart, relative to each other, and light image points to move together, relative to each other. This occurs because developer is not being equally distributed over the image points and is rapidly exhausted where two heavily exposed image points are close together. Because development continues on their outer surfaces, they appear to move apart. Agitation distributes developer and prevents the effect occurring.

L

Lamp General term used to describe the artificial light sources used in photography.

Lamphouse Light-tight housing of an enlarger or projector, which contains the light source.

Lantern slides Old term used to describe transparencies.

Laser Abbreviation for Light Amplification by Stimulated Emission of Radiation. It is an intense collimated coherent light source of a very narrow band width. The strength of this source varies considerably between 1 milliwatt and 1 megawatt. Some lasers produce a continuous emission of light in a regulated pulse pattern. At the moment its main use in photography is in the production of holograms.

Latensification Method of increasing relative film speed by fogging after exposure and before development. It can be achieved by chemical or light means. There are three methods of latensification.

Chemical bath
 0.5% solution potassium metabisulfite
 0.5% solution sodium sulfite
Immerse the exposed negatives in a mixture containing equal parts of the two solutions. Rinse and continue the the normal processing cycle.

Chemical vapor
The exposed negatives are placed in a closed container with a small amount of mercury or sulfur dioxide. After about 24 hours the film is processed as usual. The amount of exposure needed varies with different types of sensitive material and should be assessed by trial and error. Results tend to be inconsistent.
Light
The film is briefly exposed to a low intensity light before development. The best light source is an evenly illuminated out-of-focus surface. The correct amount of exposure is best established by trial and error.

Latent image The invisible image produced by exposure which can be made visible by development.

Latitude The degree by which exposure can be varied and still produce an acceptable result. The degree of latitude varies with emulsion type. Faster films tend to have greater latitude than slower films. In photographic printing, soft grade papers have greater latitude than hard papers.

Lens Optical element made of glass or plastic and capable of bending light. In photography, a lens may be constructed of single or multiple elements. Basically there are two types of simple lens: converging and diverging. Converging lenses are convex and cause light to bend toward the optical axis. Diverging lenses are concave and cause light to bend away from the optical axis. Both are used in compound lenses, but the overall effect is to cause convergence of light rays.

Lens hood An opaque tube, usually metal or rubber, that prevents unwanted light from falling on the lens surface.

Lens system Describes the type and quantity of lenses available for use with a particular camera. It also describes the construction of a particular lens type.

Lenticular screen A lens system consisting of a screen containing a number of small lenses. There are two applications of lenticular systems. They are used in some exposure meters to gather light and to determine the angle of acceptance of light by the meter, so that it approximates the angle of acceptance of the camera lens. A lenticular screen consisting of a number of lenses set in rows can be used at camera stage to produce stereoscopic images by synthesizing binocular vision. The image produced this way is viewed

through a matching lenticular screen to give a three-dimensional effect.

Light Visible radiated energy which forms that part of the electro-magnetic spectrum in the wavelength range 4000-7000 Å (400-720 nm). This range of wavelengths indicates the change in color along the visible spectrum, from violet to dark red.

Light sources General term applied to any source of light used in photo-graphy, e.g. sun, tungsten filament, flash bulb, reflectors.

Light trap System of entry to a dark-room which allows easy access, but prevents unwanted light entering.

Line image Photographic image consisting of black areas and clear film, i.e. white. Such images can be produced from other line images or from continuous tone subjects, by using high contrast film, paper and developers.

Local control Method of controlling the final quality of a print by increas-ing ("printing-in") or decreasing ("dodging") the exposure given to localized areas of the print by selective masking.

Long-focus Describes a lens in which the focal length is much greater than the diagonal of the film format with which it is used.

Low key Photograph in which tones are predominantly dark and there are few highlights.

Lumen Unit of light intensity falling on to a surface.

Lumen-second Unit used to measure the total light output of a photographic source.

Luminance Measurable amount of light which is emitted by or reflected from a source.

Luminous flux Intensity of a light source, measured in lumens.

M

Macrophotography Photography which produces an image larger than the original subject without the use of a microscope. The magnifi-cation possible in macrophotography is usually not greater than x10.

Maddox, Richard Leach, 1816-1902. Introduced the concept of the silver halide gelatin emulsion, from which the dry plate developed.

Magenta The complementary color to green. It is composed of blue and red light.

Magnification Size of the image relative to the size of the subject used

to produce it. It is an expression of the ratio of the subject-lens distance to the image-lens distance. When object distance = image distance, magnification = 1. It also refers to the ratio of print size to negative size, i.e. enlargement.

Masking System of controlling negative density range or color saturation through the use of unsharp masks.

Matrix In photography, a relief image, usually made from gelatin and used for processes such as dye transfer printing.

Mercuric chloride Chemical used in certain types of intensifier, i.e. mercury intensification.

Mercury vapor lamp Artificial light source produced by passing current through mercury vapor in a tube.

Metol Reducing agent which is soft working, especially in the presence of a weak alkali. Often combined with hydroquinone, producing MQ fine grain, general purpose, and print developers. Can cause skin irritation which should be treated immediately.

Microflash Electronic flash of very short duration used to illuminate subjects traveling at very high speed, e.g. ballistics.

Micron One millionth of a meter. It is sometimes used to describe the wavelength of light instead of the Angstrom unit.

Microphotograph Photograph produced to a very small size. Usually used for recording documents and books, which can be viewed in a microfilm reader.

Millimicron One thousandth part of a micron. Like microns, it is a unit that can be used to express the wavelength of light.

Miniature camera Term commonly applied to cameras with a format size of 35 mm or less.

Mired Abbreviation for the term micro reciprocal degrees, a scale of measurement of color temperature. The mired value of a light source is calculated by dividing 1,000,000 by its color temperature in Kelvins.

Mirror lens A lens system which uses mirrors within its internal con-struction. Most lenses of this type have a mixture of reflecting and refracting optics and are known as catadioptric lenses. They are normally used to achieve extremely long focal lengths with short barrel extension, by allowing light rays to be reflected up and down the lens tube before reaching the emulsion.

Moholy-Nagy, Laslo, 1895-1946. Hungarian photographer and

Microphotographs

Miniature camera

Mirror lens

Negative carrier

painter, who originated a great deal of abstract imagery and collage using photography as a base medium.

Monobath Single solution which combines developer and fixer for processing black and white negatives. It is a quick, simple system but it does not allow for development control.

Monochromatic Light rays of a single wavelength. Also used loosely in talking of a single color.

Montage Composite picture made from a number of photographs.

MQ/PQ developers Developing solutions containing the reducing agents metol and hydroquinone or phenidone and hydroquinone.

Muybridge, Edward James, 1830-1904. English photographer, who was the first to record animal motion in a sequence of photographic images.

N

Nadar Name adopted by the first aerial photographer, G.F. Tournachon, who took photographs from a captive air baloon.

Negative The image produced on a photographic emulsion by the product of exposure and development, in which tones are reversed so that highlights appear dark and shadows appear light.

Negative carrier Supports the negative between the light source and the enlarging lens of an enlarger.

Negative lens Simple, concave lens that causes rays of light to diverge away from the optical axis.

Neutral density Technique which makes possible shorter printing times in color printing. The color pack is simplified by removing the filter of the lowest value, which indicates the level of neutral density within the pack. The other two color values are adjusted by subtracting an equal value from each.

Neutral density filter Describes a gray camera filter which has an equal opacity to all colors of the spectrum and so does not affect the colors in the final image. It is used to reduce the amount of light entering the camera when aperture or speed settings must remain constant. It is useful in architectural photography, for example, when a long exposure is required to obliterate people from the scene.

Newton's rings Rings of colored light produced when two glass or transparent surfaces are in partial contact. Often observed in transparency glass mounts and glass negative carriers.

Niépce, Joseph Nicéphore, 1765-1833. Frenchman credited as the inventor of photography. In 1826, using a camera, he fixed a permanent positive image on a pewter plate coated with bitumen of Judea. He later formed a partnership with Daguerre, but died six years before Daguerre's process became a commercial success.

Nitrate base Early flexible film support which was highly inflammable. It was used extensively in the film industry before the introduction of acetate.

Nitric acid Used in emulsion manufacture, in toners and in bleaches. It is highly corrosive.

Nodal plane An imaginary line passing through the nodal point, perpendicular to the optical axis.

Nodal point There are two nodal points in a compound lens system. The front nodal point is where rays of light entering the lens appear to aim. The rear nodal point is where the rays of light appear to have come from, after passing through the lens. Nodal points are used for optical measurements, e.g. to calculate focal length.

Non-substantive (Transparency film). Name given to color film in which the color couplers are not contained within the emulsion, but are introduced during processing. These films must be returned to the manufacturer for processing.

Normal lens Describes a lens with a focal length approximately equal to the diagonal of the film format with which it is being used.

O

Objective Term normally used to describe a lens that faces the subject, as in microscopes and telescopes.

Opacity The light stopping power of a medium expressed as a ratio of the incident light to the light transmitted.

Open flash Method of flash operation using the following sequence: shutter opened, flash fired, shutter closed. Usually shutter duration is unimportant since the available light is much dimmer than the flash.

Optical axis Imaginary line passing through the center of the lens system.

A light ray passing along this axis would always travel in a straight line.

Ordinary emulsion Applied to photographic emulsion which is only sensitive to ultra-violet and blue light.

Orthochromatic Used to describe an emulsion which is sensitive to blue and green light, but insensitive to red.

Over-development Term indicating that the amount of development recommended by the manufacturer has been exceeded. It can be caused by prolonged development time or an increase in development temperature, and usually results in an increase in density and contrast.

Over-exposure Expression used to indicate that the light sensitive material has been excessively exposed. This can be the result of light that is either too bright, or has been allowed to act for too long. Over-exposure causes increased density and reduced contrast on most photographic materials.

Over-run lamps Tungsten light source specifically used at a higher voltage than normal to increase light output and achieve constant color temperature. It has a very short life and is worked at normal voltage except when exposures or exposure readings are being made.

P

Panchromatic Photographic emulsion sensitive to all colors of the visible spectrum and to a certain amount of ultra-violet light. This sensitivity is not uniform throughout the spectrum.

Panoramic camera Camera with a special type of scanning lens which rotates on its rear nodal point and produces an image of the scanned area on a curved plate or film.

Parallax The difference between the image seen by a viewing system and that recorded on the film. Variance occurs as subjects move closer to the taking lens. Only through-the-lens viewing systems avoid parallax error.

Paraphenylenediamine Reducing agent used in some fine grain and color developers.

Pentaprism Optical device, usually fitted on to 35mm cameras. which makes it possible to view the image while focusing. A mirror device laterally reverses the image so that the scene is viewed through the camera upright and the right way round.

Permanence tests Methods of establishing whether long term permanence of an image has been achieved. Two tests can be made during the processing cycle.

Test for adequate fixation
Place a few drops of a 10 percent solution of sodium sulfide on the unused rebate of a fixed bromide print. If the area turns light brown, the emulsion still contains unused halides and is inadequately fixed. If, after a further 15 minutes the same result is obtained, the fixing bath is exhausted and should be discarded. This test can also be used on a negative rebate. The usual way of ensuring permanence of a negative is to fix it for twice as long as it takes for the film to clear.

Test for adequate washing
Stock solution

Potassium permanganate	2 gr.
Sodium carbonate	1 gr.
Water to 1 liter	

Using two separate containers, collect samples of water from the surface of the print or negative and from the water *source*. Add a few drops of the stock solution to each sample and observe the change in color. If the colors of the two samples differ, it indicates that fixer is still present, and washing should be continued until the two samples change to similar colors.

Perspective The relationship of size and shape of three-dimensional objects represented in two-dimensional space. In photography, linear perspective is controlled by viewpoint and is represented by diminishing size and converging planes. Aerial perspective is a depth effect produced by haze where objects lose form and are essentially recorded in terms of shape and color. This lack of detail gives a visual impression of distance.

Petzval lens Early lens system designed by Joseph Petzval. It had a very wide aperture and was relatively free from aberration. Many modern lenses have developed from this simple three-element design.

Phenidone Reducing agent used in many fine grain solutions which, in the presence of hydroquinone, produces good general purpose and print developers.

Photo-electric cell Light sensitive cell. Two types are used in exposure meters. A selenium cell generates electricity in proportion to the amount of light falling upon its surface. A cadmium sulfide cell offers a resistance to a small electric charge when light falls upon it. Cadmium

Panoramic cameras

Photomicrography

sulfide cells are more sensitive than selenium, especially at low light levels. However, their sensitivity to red is poor by comparison.

Photoflood Artificial light source using a tungsten filament lamp and a dish reflector.

Photogram Pattern or design produced by placing opaque or transparent objects on top of a sensitive emulsion, exposing it to light and then developing it.

Photogrammetry Method of making precise measurements from photographs. Used extensively in map-making (from aerial photographs), architectural planning, and engineering drawing.

Photometer Instrument for measuring light being reflected from a surface. It works by comparing the reflected light with a standard source produced within the photometer. The small angle of acceptance means that often light from small areas of a subject can be measured from the camera position.

Photomicrography System of producing larger-than-life photographs by attaching a camera to a microscope. Magnification is x10 or more.

pH scale Numerical system running from 0-14 and used to express the alkalinity or acidity of a chemical solution. 7 is neutral. Solutions with a lower pH value are increasingly acidic, and those with a higher pH value are increasingly alkaline.

Physical development A system of development in which silver is contained in suspension within the developer and is attracted to the emulsion by silver halides which have received exposure, i.e. a form of intensification. Pure physical developers have not been successful, partly because proportional development is difficult to control.

Physiogram Photographic pattern produced by moving a regulated point of light over a sensitive emulsion.

Pinacryptol Yellow and green dye powders which are used in desensitizing solutions.

Pincushion distortion Lens aberration causing parallel, straight lines at the edge of the image to curve toward the lens axis.

Pinhole camera Camera without a lens which uses a very small hole pierced in one end to allow light to pass through and form an image on the back of the camera which can be covered by film. Diffraction and light fall-off determine the optimum pinhole size and image distance needed

to achieve maximum image quality.

Plane Imaginary straight line on which image points may lie or which passes at right angles through a set of points perpendicular to the optical axis.

Plate Early photographic glass plates coated with emulsion.

Plate camera Camera designed to take glass plates but often adapted to take cut film.

Polarization Light is said to travel in a wave motion along a straight path, vibrating in all directions. Polarization can be brought about with a polarizing filter which causes light to vibrate in a single plane only, reducing its strength. Polarizing filters are used over camera lenses and light sources to reduce or remove specular reflection from the surface of objects.

Polarized light Rays of light that have been restricted to vibrate in one plane only.

Portrait lens Lenses produced specifically for portraiture. They usually have a long focal length and produce a slightly diffused image. In variable portrait lenses sharpness can be controlled by the photographer and the effect observed at different apertures.

Positive In photography, the production of prints or transparencies in which light and dark correspond to the tonal range of the original subject.

Positive lens Simple lens that causes light rays from a subject to converge to a point.

Posterization Photographic technique using a number of tone separated negatives which are printed on to high contrast material. A master negative is made by printing these in register. The final print from this contains selected areas of flat tone in place of continuous tone.

Potassium bichromate Chemical used in chrome intensifier.

Potassium bromide Chemical used as a restrainer in most developing solutions and as a rehalogenizing agent in bleaches.

Potassium carbonate Highly soluble, alkaline accelerator used in most general purpose and print developing solutions.

Potassium chloride Chemical used in some bleaches and sensitizers.

Potassium citrate Chemical used in blue and green toners.

Potassium dichromate See "Potassium bichromate".

Potassium ferricyanide Chemical used in Farmer's reducer as a bleach. Also used as a bleaching agent in many toning processes.

Potassium hydroxide Caustic

potash. Highly active alkali, used as the basis of high contrast developing solutions.

Potassium iodide Chemical used in bleaches, toners and intensifiers.

Potassium metabisulfite Acidifyer used in fixers and stop baths. Also used as a preservative in some developers.

Potassium permanganate Chemical used extensively in reducers, bleaches, toners and even dish cleaners.

Potassium persulfate Chemical sometimes used in super-proportional reducers.

Potassium sulfide Chemical used in sulfide (sepia) toning.

Potassium thiocyanate Chemical used in some fine grain developers as a silver solvent. It is also used in gold toners.

Preservative Chemical, commonly sodium sulfite, used in developing solutions to prevent rapid oxidation of the reducing agents in use. It oxidizes rapidly in air and "immunizes" the developing solution until it becomes exhausted.

Primary colors The three primary additive colors of the spectrum in terms of transmitted light are blue, green and red. (In painters' pigments primary mixing is considered to consist of blue, yellow and red).

Principal axis An imaginary line which passes through the centers of curvature of all the lens elements.

Principal planes Imaginary lines which pass through the nodal planes of a lens system.

Printing-in System of local shading control used in printing in which additional exposure is given to selected areas of the print.

Prism Transparent medium capable of bending light to varying degrees, depending on wavelength.

Process lens Lens system designed specifically for high quality copying.

Projection printing See "Enlarging".

Projector Apparatus used to display enlarged still or moving images on to a screen.

Proportional reducer Chemical method of reducing excess density and contrast from a photographic negative. See "Reducers".

Pyro Reducing agent once used in developing solutions.

Q

Quantum Smallest, indivisible unit of radiant energy.

Quarter plate Old film size of historical interest. It is still commonly used to describe old 3¼ x 4¼ ins (8.3 x 10.7 cm) cameras.

Quartz-iodine lamp Outdated term for the tungsten halogen lamp.

R

Rack and pinion focusing Mechanical focusing system used on most stand and monorail cameras. A pinion engages a rack on a slide. Focusing is achieved by turning a knob or wheel near the lens or image panel which moves the lens or image panel, thus altering focus.

Rangefinder A focusing system which measures the distance from camera to subject. The angle of convergence of light rays reaching the lens increases as the subject to lens distance decreases. Changes in this angle size are converted into distance figures. The coupled range-finder is a similar system linked to the camera lens so that rangefinder and lens work together.

Rapid rectilinear Lens system composed of two matching doublet lenses, symmetrically placed around the focal aperture. It was introduced by Dallmeyer and Sternheil and removed many of the aberrations present in more simple constructions.

Reciprocity failure Photographic emulsions are manufactured to give reasonable speed rating characteristics over a narrow band of exposure time. Outside this range reciprocity failure occurs and an increase in exposure is required in addition to the assessed amount. This can be achieved either by increasing intensity or time.

Reciprocity law States that exposure = intensity x time, where intensity is equal to the amount of light and time is equal to the time that amount is allowed to act upon the photographic emulsion (Bunsen & Roscoe, 1866).

Reducers Solutions which remove silver from negatives or prints. They are used to diminish density and alter contrast on a photographic emulsion.

Farmer's reducer
A cutting reducer which removes equal amounts of silver from the whole surface. The effect is a reduction in density and a slight increase in contrast. The formula is as follows:
Solution A
 Sodium thiosulfate 100gr.
 Water to 1 liter

Prism

Projectors

Quartz-iodine lamp

Single lens reflex camera

Twin lens reflex camera

Solution B
 Potassium ferricyanide 20 gr.
 Water to 1 liter
To prepare a working solution, use
100 ml. of A, 20 ml. of B and 200 ml.
of water. This mixture does not keep.
The reduction continues until it is
stopped by immersion in running
water, followed by a bath of sodium
thiosulfate and then a final wash.
Proportional reducer
This removes image density in pro-
portion to the amount of silver
present. The result is a reduction in
density and contrast. The formula is:
Solution A
 Potassium permanganate 0.25 gr.
 10% solution sulfuric acid 15 ml.
 Water to 1 liter
Solution B
 Ammonium persulfate 25 gr.
 Water to 1 liter
Prepare a working solution by mixing
1 part of A to 3 parts of B. With
constant agitation, reduction should
take place in 1-4 minutes. After
reduction, soak negatives in a
1 percent solution of potassium
metabisulfite for a few minutes, then
wash normally.
Ammonium persulfate reducer
This solution has the effect of
reducing density, contrast and high-
lights. The formula for this reducer is:
Ammonium persulfate 3.3 gr.
Sulfuric acid, 10% solution 10 ml.
Distilled water to 1 liter
The mixture does not keep and must
be used immediately. It should be
discarded when it begins to go milky.
Immerse negatives until the required
amount of reduction has occurred,
then dip them in an acid fixer or a
5 percent sodium sulfite solution.
Reducing agent Chemical in a
developing solution which converts
exposed silver halides to black
metallic silver.
Reflected light reading Measure-
ment, by light meter, of the amount of
reflected light being bounced off a
subject. The light meter is pointed
towards the subject. Because
surfaces reflect different amounts of
light according to their characteristics,
reflected light readings are specific
to the areas from which the reading
is taken.
Reflection Rays of light which strike
a surface and bounce back again.
Specular reflection occurs on even,
polished surfaces; diffuse reflection
occurs on uneven surfaces, when
light scatters.
Reflector Any substance from which
light can be reflected. It also describes
white or gray card used to reflect

from a main light source into
shadow areas.
Reflex camera Camera system
which uses a mirror to reflect
incoming image rays on to a ground
glass screen, providing a system of
viewing and focusing. Two types:
single lens reflex, using a retractable
mirror behind the lens; twin-lens
reflex which uses a fixed mirror
behind a viewing lens. The twin-lens
system is subject to parallax error.
Refractive index Numerical value
indicating the light-bending power of
a medium such as glass. The greater
the bending power, the greater the
refractive index.
Rehalogenization Process by which
black metallic silver is converted back
to silver halides. It is used in bleaching
for toners and for intensification.
Relative aperture Measurable
diameter of the diaphragm divided by
the focal length of the lens in use
and expressed in terms of "f"
numbers, marked on the lens barrel.
Replenishment Addition of
chemicals to a processing solution to
maintain its characteristics, e.g.
developers are replenished with re-
ducing agents as the old ones are
exhausted through use.
Resolving power The ability of the
eye, lens or photographic emulsion to
determine fine detail. In photography,
the quality of the final image is a
result of the resolving power of both
the lens and the sensitive emulsion.
Resolution is expressed in terms of
the lines per millimeter which are
distinctly recorded or visually
separable in the final image.
Restrainer Chemical constituent of
developing solutions which helps
prevent reducing agents from
affecting unexposed halides and
converting them to black metallic
silver. It reduces chemical fog.
Reticulation Regular crazed pattern
created on the emulsion surface of
negatives which is caused by extreme
changes of temperature or acidity/
alkalinity during processing.
Retouching After-treatment carried
out on a negative or print, in the form
of local chemical reduction, local dye
or pencil additions or air-brushing.
The purpose is to remove blemishes
on the negative or print, or to treat
particular subject areas to improve
the final effect.
Reversal materials Materials
specifically designed to be processed
to a positive after one camera
exposure, i.e. black and white and
color transparencies, reversal color
print papers.

Rinse Brief clean water wash between steps of a processing cycle which reduce carry-over of one solution into another.

Rising front Camera movement enabling the front lens panel to be raised or lowered from its central position on most view and monorail cameras. One of its principal uses is to maintain verticals in architectural photographs.

Robinson, Henry Peach, 1830-1901. Outstanding English photographer of the period, famous for multiple-printed images of carefully constructed dramatic groups.

Roll-film adaptor Special attachment for cameras designed for cut film or cassette loading, enabling roll-film to be used.

Roscoe, Sir Henry, 1833-1915. Englishman who worked with Robert Bunsen during the 1850s, carrying out investigations on the effect of light on photographic emulsion. They defined the Bunsen-Roscoe Law of Reciprocity.

S

Sabattier effect (Pseudo-solarization.) The part-positive part-negative effect formed when an emulsion is briefly re-exposed to white light during development, and then allowed to continue development.

Safelights System of darkroom illumination to which the photographic emulsions being handled are insensitive. This applies to a wide range of materials from printing paper to orthochromatic films. Manufacturers' safelight recommendations are readily available and should be followed.

Schulze, Johann Heinrich, 1687-1744. Discovered the actinic power of light on a mixture of chalk and silver nitrate.

Selenium cell Light sensitive cell used in many types of exposure meter. It generates electricity in direct proportion to the amount of light falling upon its surface. Sensitivity is poor at low light levels.

Sensitive material In photography, refers to materials that react to the actinic power of light.

Sensitometry Scientific study of the response of photographic materials to exposure and development. This establishes emulsion speeds and recommended development and processing times.

Separation negatives Black and white negatives, usually prepared in lots of three or four, which have been taken through filters which analyze the color composition of an original in terms of blue, green and red. They are used particularly in photomechanical color printing and dye transfer printing processes.

Shading See "Local control".

Sheet film Alternative term for cut film.

Shellac Natural resin with a low melting point. In photography it is mainly used on dry mounting tissue.

Shutter Mechanical system used to control the time that light is allowed to act on a sensitive emulsion. The two types most common on modern cameras are the between-the-lens diaphragm shutter and the focal plane shutter.

Silver halides Light sensitive crystals used in photographic emulsions, i.e. silver bromide, silver chloride and silver iodide. They change from white to black metallic silver when exposed to light.

Silver nitrate Chemical combination of silver and nitric acid. It is used in intensifiers, physical developers and photographic emulsion manufacture.

Silver recovery Systems of reclaiming silver from exhausted solutions. Three methods are used: sludging, metal exchange and electrolytic.

Sky filter Filter, usually yellow, which has a graduated density across its surface. It is used to absorb sky light, particularly in landscape photography, and acts by selectively holding back highly actinic light through the various densities. The densest area holds back the most light.

Slave unit Mechanism which fires other flash sources simultaneously when a photo-electric cell is activated by the illumination emitted by a camera linked flash. With electronic flash the effect is so immediate that illumination from the series can be used with any shutter speed (except in the case of focal plane shutters, which must be set at a minimum of $\frac{1}{60}$ second). With expendable flash bulbs, which take longer to reach peak output, delay can occur, and it is only practicable to synchronize all light sources at speeds of $\frac{1}{10}$ second or longer.

Slide Alternative term for projection transparency.

Snoot Cone shaped shield used on spotlights to direct a cone of light over a small area.

Safelights

Snoot

Spotlight

Stereo cameras

Sodium bichromate Chemical used in intensifiers, toners and bleaches.
Sodium bisulfite Chemical used in fixing baths as an acidifying agent.
Sodium carbonate Alkaline accelerator used in many general purpose and print developers.
Sodium chloride (Salt.) Used in some bleaches and reducers.
Sodium hexametaphosphate Water softener.
Sodium hydrosulfite Used as a fogging agent in reversal processing.
Sodium hydroxide Highly active alkaline accelerator used in conjunction with hydroquinone to produce high contrast developers.
Sodium metabisulfite Used as an acidifying agent in acid fixing baths.
Sodium sulfide Pungent chemical used in sulfide (sepia) toning.
Sodium sulfite Chemical commonly used as a preservative in many developing solutions. In some fine grain formulae, in the presence of metol, it also acts as a restrainer, accelerator and silver solvent.
Sodium thiocyanate Alternative to potassium thiocyanate as a silver solvent in physical and ultra-fine grain formulae.
Sodium thiosulfate Chemical used in many fixing solutions. It converts unused halides to a soluble complex which can be removed by washing.
Soft focus Diffused definition of an image, which can be achieved at the camera or enlarging stage. A special lens or a diffusion attachment can be used on the camera or enlarger, or a diffusion screen can be attached.
Soft focus lens Lens, uncorrected for spherical aberrations, used to produce a soft focus effect.
Solarization Reversal or partial reversal of the image by extreme over exposure. Similar results can be achieved with the Sabattier effect.
Solubility In general terms, the ease with which a solid will mix homogeneously with water to provide a chemical solution. Specifically, solubility is defined by the amount that a given quantity of a substance will dissolve in a given amount of liquid, at a specified temperature.
Spectral sensitivity Relative response of a photographic emulsion to each of the colors of the spectrum, including infra-red and ultra-violet.
Spectrum Usually used in reference to the visible part of the electromagnetic spectrum, i.e. the colored bands produced by diffraction, and arranged according to wavelength, when white light is passed through a prism.

Speed Sensitivity of a photographic emulsion to light. Films are given ASA and DIN numbers denoting speed characteristics.
Spherical aberration Lens fault which causes loss of image definition at the image plane. Its effects are reduced by stopping down.
Spotlight Artificial light source using a fresnel lens, reflector, and simple focusing system to produce a strong beam of light of controllable width.
Spot meter Used to get accurate light readings of a small part of a subject. It uses a narrow angle of view to measure within limited areas.
Spotting Method of retouching. Blemishes or unwanted details are removed from negatives or prints by brush and dye or pencil.
Stabilization Alternative method of fixing. Unused halides are converted to near stable compounds, insensitive to light. No washing is required.
Stand Alternative name for tripod, e.g. camera stand.
Stand camera Large format camera usually mounted on a rigid stand.
Stereoscopy Method of creating a three-dimensional effect on a two-dimensional surface using a pair of images taken from slightly different viewpoints, and viewed through specially made stereo-viewers.
Stock solution Processing chemicals which may be stored in a concentrated state and diluted just before use.
Stop Aperture of camera or enlarging lens.
Stop bath Chemical bath whose purpose is to stop development by neutralizing unwanted developer. This increases precision of development and prevents carry-over of one chemical into another during development.
Stopping down Reducing the size of the lens aperture and thus the amount of light passing into the camera. It increases depth of field.
Stress marks Black lines on a photographic emulsion caused by friction or pressure.
Subtractive synthesis Combination color system used in modern photographic materials. The complementary colors of yellow, magenta and cyan are formed to provide a reasonably full color image.
Sulfide toning Conversion of a black metallic silver image into a brown dye image. Usually known as sepia toning.
Sulfuric acid Highly corrosive chemical used in reducers.
Supplementary lenses Additional

lens elements used with the standard camera lens to provide a new focal length. They tend to reduce quality.

Swing back/front Term used to describe the moveable lens and back panels of most view and monorail cameras. They allow manipulation of perspective and depth of field.

Synchro-sunlight System of combining daylight and flash to achieve a controlled lighting ratio.

T

Tanks Containers for holding chemical solutions for processing films and plates. Some are for darkroom use only, others for daylight loading and others must be loaded in the dark, but can be used in daylight.

Taylor, Harold Dennis, 1862-1942. Lens designer. He patented the famous Cooke triplet in 1893.

Technical camera See "View camera".

Telephoto lens Compact lens construction which provides a long focal length with a short back focus.

Test strip Trial and error method of calculating exposure in photographic printing. A number of exposures are given to a strip of emulsion, over important areas of the image to help judge the correct exposure for the final print.

Texture Broadly, the surface character of an object, e.g. rough, smooth. In photography, careful control of lighting can be used to describe a surface by adding a tactile quality in terms of depth, shape and tone suggesting three dimensions.

Time gamma curve See "Gamma".

Tone In simple terms, refers to the strength of grays between white and black. It relates to the brightness, lightness and darkness of a subject and is determined by illumination. Photographically, tone change is represented by variable density.

Toners Used to change the color of the photographic print by chemical baths. Through a system of bleaching and dyeing, the black metallic silver image is converted to a dye image.

Sepia (sulfide) toning
This produces warm brown tones. The formula is:
Bleach
 Potassium bromide 50gr.
 Potassium ferricyanide 100gr.
 Water to 1 liter
Dilute 1 part to 9 parts water just before use.

Sulfide toner
 Sodium sulfide 200gr.
 Water to 1 liter
Dilute 1 part to 6 parts water just before use.
Bleach the print in the first solution until it turns a very light brown, then rinse briefly in running water. Immerse it in the sulfide bath for about 1 minute and wash thoroughly for about 30 minutes. Once used, the solutions should be discarded, but the stock solutions will keep indefinitely in dark bottles. Sodium sulfide has a characteristic pungent smell, and should only be used in a well ventilated room.

Blue toning
This changes the black parts of a print to blue. The bleach and toner are combined in one solution.
Bleach
 Potassium ferricyanide 2gr.
 Sulfuric acid, concentrated 3ml.
 Water to 1 liter
Blue toner
 Ferric ammonium citrate 2gr.
 Sulfuric acid, concentrated 3ml.
 Water to 1 liter
Prepare a working solution by mixing equal parts of bleach and toner just before use. Immerse the washed prints until the required amount of toning has been reached, and wash to remove any slight yellowing of the white areas.

Copper toning
The tones produced range from warm brown to light red, depending on the time the chemicals are allowed to act. Once again, bleach and toner are combined in one solution.
Bleach
 Potassium ferricyanide 6gr.
 Potassium citrate 28gr.
 Water to 1 liter
Copper sulfate toner
 Potassium citrate 28gr.
 Copper sulfate 7gr.
 Water to 1 liter
Prepare a working solution by mixing equal parts of bleach and toner just before use. Keep prints immersed in the solution until the required tone has been reached.

Tone separation (Posterization.) Process of reducing the tonal range of a photograph to a very restricted range. The final result has strong highlights and deep shadows with a set number of intermediate tones.

Transmitted light Light which is passed through a transparent or translucent medium. The amount of light transmitted depends on the density of the medium through which it is passed and on the brightness of

Darkroom loading tank

Daylight loading tank

Telephoto lens

Viewfinders

the incident light source. Transmitted light is always less than incident light, but the amount of loss depends on the density of the medium through which light is being passed.

Transparency Positive image, in black and white or color, which is produced on a transparent film.

Tripack Photographic material, used in color photography, consisting of three emulsion layers of different sensitivity each on its own base It is used to obtain three separation negatives with a single exposure.

Triple extension Camera system in which lens-image distance can be extended by as much as three times its focal length. It is particularly useful for close-up photography.

T-setting Camera speed setting which indicates "time" exposure, i.e. longer than one second. The shutter opens when the release is pressed and closes when it is pressed again.

"T" stops More accurate measurement of light entering a lens than "f" numbers. Whereas "f" numbers represent the ratio between measured diameter and focal length, "t" stops are based on actual light transmission at different diameters.

TTL Abbreviation of through-the-lens metering, a metering system in which a suitable light-sensitive cell within the camera body measures exposure from image light passing through the lens.

Tungsten filament Artificial light source using a tungsten filament contained within a glass envelope. The tungsten produces an intense light when an electric current is passed through it. This is the basic artificial light source used in photography.

Tungsten-halogen lamp Improved version of the normal tungsten lamp. It is much smaller and more consistent in color temperature as the glass envelope used is non-blackening.

Type-A color film Color film balanced to artificial light sources at a color temperature of 3400K.

Type-B color film Color film balanced to artificial light sources at a color temperature of 3200K.

U

Ultra-violet (u-v) That part of the electro-magnetic spectrum from about 400|nm down to 10 nm. It is invisible to human beings, but most photographic materials are sensitive to it.

Ultra-violet radiations are more prevalent on hazy days and in distant views. Their effect is to increase aerial perspective. This may be reduced by using an u-v absorbing filter, which has no effect on camera exposure.

Under-development Reduction in the degree of development. It is usually caused by shortened development time or a decrease in the temperature of the solution. It results in a loss of density and a reduction in image contrast.

Universal developer Name given to a number of developing solutions, usually MQ, indicating that they can be used for processing both films and papers. This is done by adjusting the dilution.

Uprating Increasing the manufacturer's recommended film speed. This can be done either by hypersensitizing, using specially prepared proprietary developers, or by a two-stage process of development.

Uranium nitrate Chemical used in toners and intensifiers.

V

Variable contrast papers Printing papers in which the contrast can be varied depending on the color of the printing light. This can be altered by using different color filters.

Variable focus lens Alternative term for zoom lens. It is a lens in which the focal length can be altered without the addition of supplementary attachments.

View camera Large format stand camera, which has a ground glass screen at the image plane for viewing and focusing.

Viewfinder System used for composing and sometimes focusing the subject. There are several types: direct vision, optical, ground glass screen or reflex.

Vignetting Printing technique where the edges are faded out toward the border of the print.

Vintage cameras Many early cameras can be used to achieve interesting effects. Lenses were often uncorrected for many of the basic aberrations and produce effects such as soft focus, diffusion at the corners of the picture and perspective distortion. The plates needed for these cameras can be cut from sheet film, using a template.

Vogel, Hermann, 1834- 1898.

Published the first original research on dye sensitizers. This led to the extension of emulsion sensitivity over the whole range of the visible spectrum, and provided a basis for ortho and panchromatism and three-color photography.

W

Washing Final part of the processing cycle, which removes the residual chemicals and soluble silver complexes from the emulsion.
Water softeners Methods of eliminating most of the minerals and salts found in hard water. These can form a layer of scale on equipment using large quantities of water, and might contaminate chemical solutions. There are two types of water softener, physical filtration systems or chemicals.
Watt-second Alternative unit of energy, equal to the joule.
Wavelength Describes the distance from wave-crest to wave-crest between two corresponding waves of light in the electro-magnetic spectrum. Wavelengths are measured in nanometers (nm) and Angstrom units (A).
Wedgwood, Thomas 1771-1805. Son of the famous English potter. Worked with Sir Humphry Davy, and successfully produced images on sensitized material by the agency of light, but were unable to fix the image. They published the results of their work in 1802.
Wet collodion Much improved calotype developed by Frederick Scott Archer. A sensitized glass plate was dipped into a bath of silver nitrate and exposed while still wet. The improved speed characteristics made much shorter exposures possible.
Wetting agents Chemicals which, when used in minute quantities,

reduce the surface tension of water. They are usully added to the final wash of films and plates to improve draining and thus prevent drying marks from forming.
Wide-angle lens Lens with wide covering power. It has a focal length which is less than the diagonal of the film format with which it is being used.

X

Xerography Photographic process which uses an electrically charged metal plate. On exposure to light the electrical charge is destroyed, leaving a latent image in which shadows are represented by charged areas. A powdered pigment dusted over the plate is attracted to the charged areas, producing a visible image on paper.
Xography System of photography which produces prints and transparencies with a three-dimensional effect. A cylindrically embossed lenticular screen is placed in contact with the film and a shutter behind the lens is arranged to scan the subject during exposure.
X-ray Electro-magnetic radiations beyond ultra-violet which, when passed through a solid object and allowed to act upon a sensitive emulsion, form an image of the internal structure of the solid.

Z

Zoetrope Early device for creating the illusion of continuous motion. A sequence of still pictures was viewed so quickly through slits in a rotating drum, that the images appeared to merge.
Zoom lens See: "Variable focus lens."

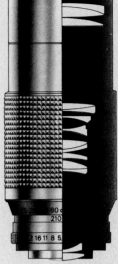

Zoom lens

Index

Acknowledgments

I owe special gratitude to Leonard Ford who took on the immense task of writing the text for this book. I also owe gratitude to Michael Langford who has contributed greatly in the making of this book – for his help with the text and his many suggestions. I would like to give special thanks to Roger Pring, who directed the project, and the team of editors, art editors, designers and illustrators who pieced together the mass of information, photographs, diagrams and text; the effort and skill they gave went far beyond mere duty. Other people I would like to thank are: Roger Bounds, Michael Pearcy, Tom Boddy, David Bradfield, Frank Thurston, Michael Hoppen, Tom Picton, Fred Duberry and the many models, both amateur and professional, who appear in this book. Thanks are also due to: Polaroid (UK) Ltd and Reiji Motomura of the Hoya Corporation for the loan of special equipment; John Raddon of Rank Photographic for the loan of Pentax equipment; and the Royal College of Art Library. Finally I would like to my wife, Julia, for her constant help and encouragement.

John Hedgecoe

Dorling Kindersley Ltd would like to give special thanks to Andrew Popkiewicz who set the standard for the illustrations and diagrams and produced a large proportion of them. Special thanks must also go to Amy Carroll, Charles Elliott, Frederick Ford, Kenneth Hone, Caroline Oakes, Sean Rawnsley, Régis, Lucillo Rossi of Arnoldo Mondadori Ltd, Mary-Lynne Stadler, and, for the typesetting, Barry Steggle, John Rule, Bob Langley, Brian Perry, David Blower, Kathy Elson and the staff of Diagraphic.

Photographs were all taken by John Hedgecoe with the exception of the following:
Michael Allman 110-113
Heather Angel 280-284
Michael Barrington-Martin 42tr
Mike Blore 278tr
Gerry Cranham 123,162tr,166-9, 172b,289
Philip Dowell 223
Robert Forrest 294-5,297tr,b
Tim Glover 286tr
Stuart Jackman 262
Julian Holland 130tc,c,254tc
John Lythgoe 286cr
Chris Meehan 128,160r
Stuart McLeod 230 (make-up by Régis)
Brian Monaghan 302
W. E. Pennell 296,297tl,298
George Perks 40,106,108b,109b,132, 144l,c,220b,221
Roger Pring 119,164b,258r,259, 263cl,307
David Reynolds 156b,192tr
Gordon Ridley 286b,287tl,tr
Peter Scoones 286cl,287b
David Waterman 291

Key: t:top, c:center, b:bottom, l:left, r:right.

Illustrations and studio services by:
David Ashby
Paul Buckle
Paul Colbeck
Graham Corbett
Brian Delf
Frederick Ford
Gilchrist Studios
Nicholas Hall
Kenneth Hone
Julian Holland
Terri Lawler
Richard Lewis
Jim Marks
Nigel Osborne
Andrew Popkiewicz
QED
Jim Robins
Les Smith
Sutton/Paddock
Studio Briggs
Roger Twinn
Venner Artists
Jackie Whelan
Michael Woods

Photographic services by:
Art Repro
Ron Bagley
Dyble+Rose
Negs
N.J.Paulo
Presentation Colour
Bill Spencer
Summit
Tantrums

Typesetting:
Diagraphic Ltd
TJB Photosetting

Information and technical assistance was kindly provided by:
Agfa Ltd
Laurie Atkinson, Laptech Ltd
Bowens Ltd
Harry Collins, Rank Photographic
Sarah Dale
Dixons Ltd
Duval Cameras Ltd
Electrosonic Ltd
Gossen GmbH
Hanimex Ltd
Jürgen Hanson, Hasselblad A/B
Hoya Corporation
Introphoto Ltd
Keith Johnson Photographic Ltd
Ray Klarnett, Gordon AV Ltd
Steven Mathewson
Pelling + Cross Ltd
Photargus, Paris
Photax Ltd
Photopia Ltd
Procter Cameras
John Raddon, Rank Photographic
Sean Rawnsley
P.M.Sutherst, Kodak Ltd
James Teboul
Technica Ltd
Ken Vaughan, Marine Unit Ltd
Michael Wheeler Ltd
Tim Williams